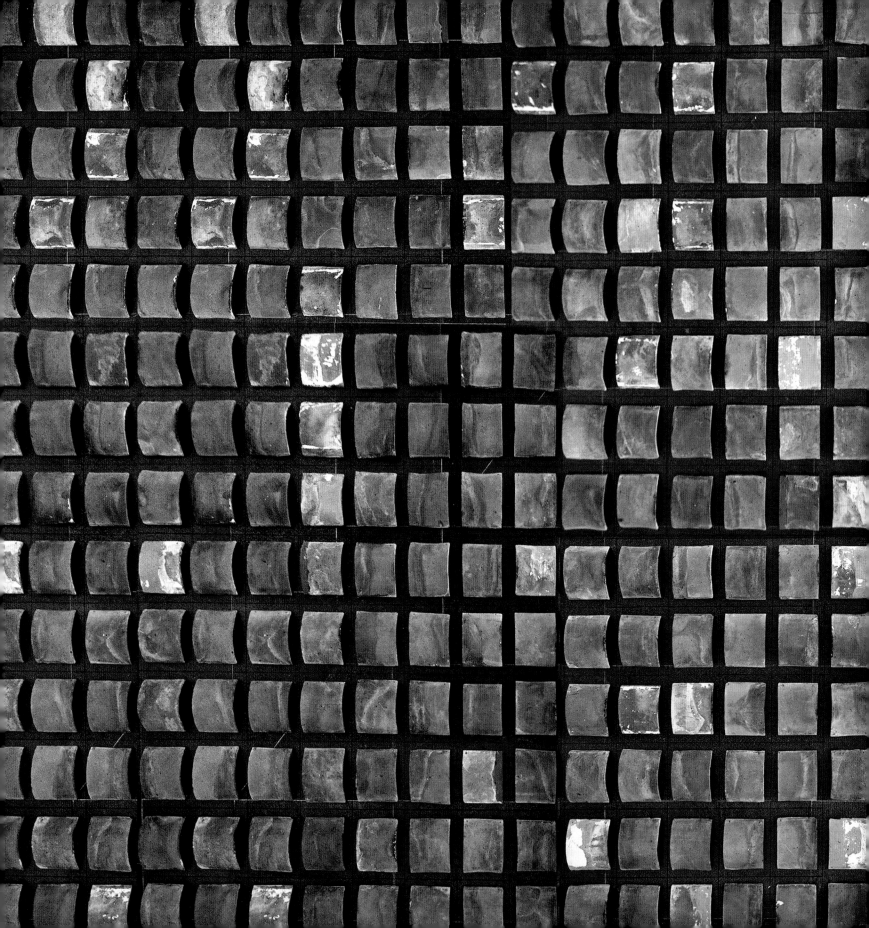

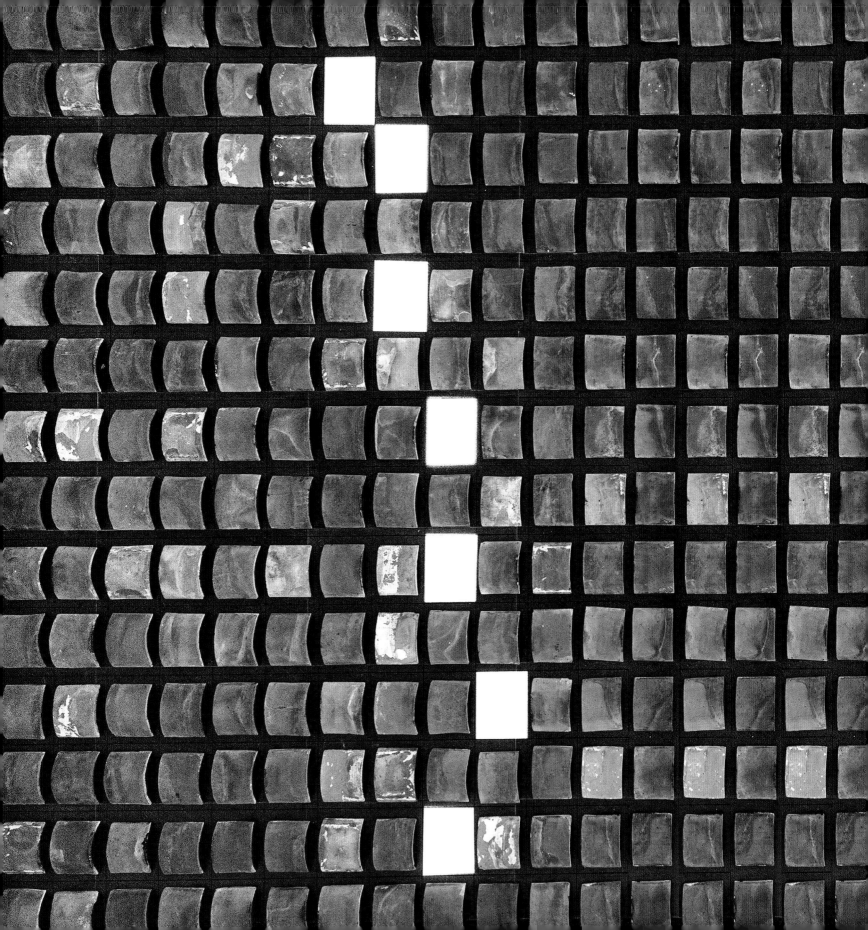

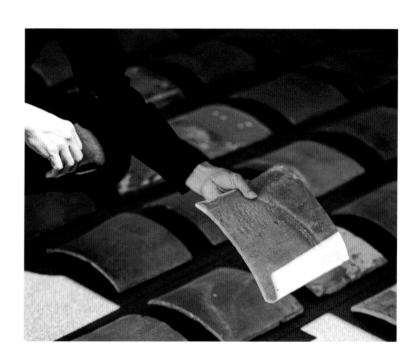

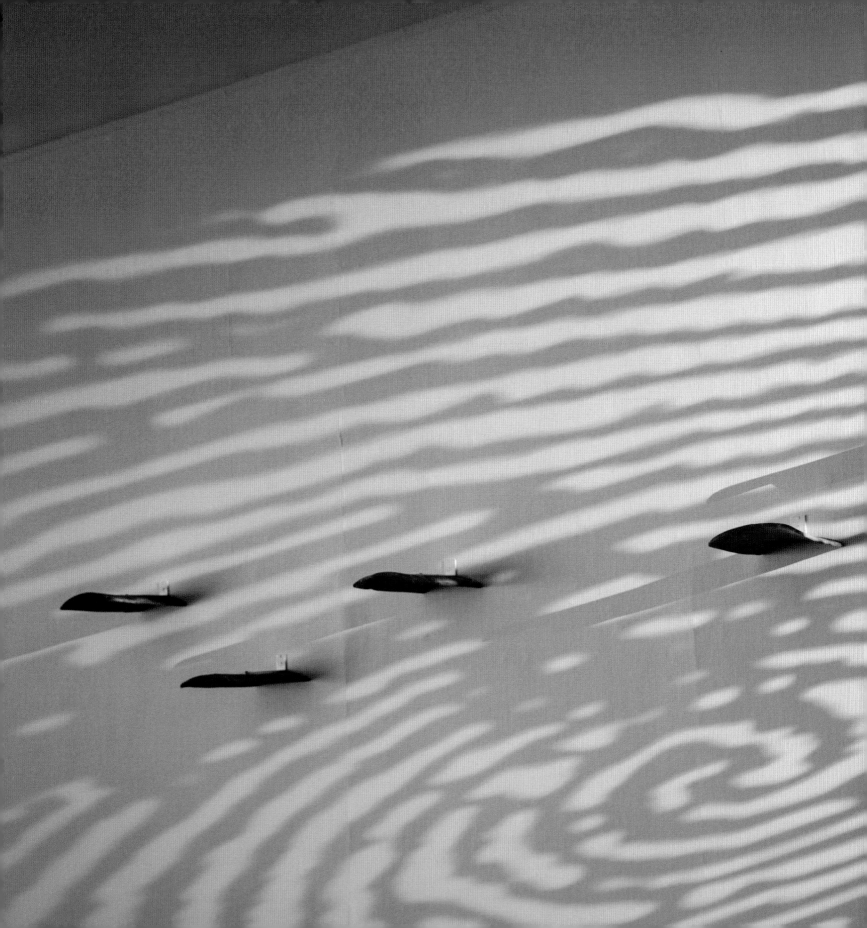

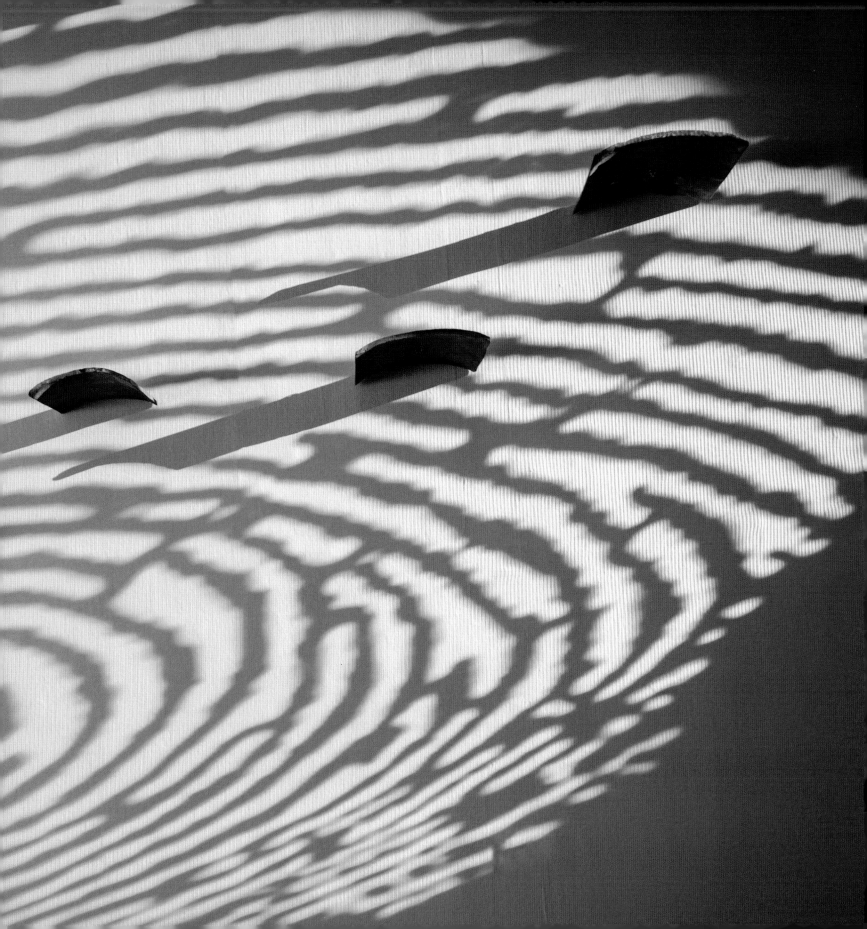

七拾 Qī Shí

Contents 目录

放弃了什么

WHAT HAVE I FOREGONE

付出了什么

WHAT HAVE I GIVEN

SEVENTY YEARS OF MY LIFE
IN RETROSPECT

回望人生七十年

看见了什么
WHAT HAVE I SEEN

听见了什么
WHAT HAVE I HEARD,

得到了什么
WHAT HAVE I GAINED

放下了什么
WHAT HAVE I LET GO OF

在起落之间，
重新拾起的，又是什么？

BETWEEN THE UPS AND DOWNS,
WHAT EXACTLY HAVE I PICKED UP ANEW?

19世纪末20世纪初，大批广东人移居香港，其中包括不少画家，而广东画家的到来给这个城市带来了与岭南画派一脉相承的学术主张。从20世纪中期到改革开放后的香港回归，兼容中西的香港画坛愈发强化自己的身份认同，逐步深入探索独有的艺术风格。特别在广东艺术的持续影响下，其开放包容的环境给这个连通世界的重要地区带来新的文化资讯，促使其传统水墨艺术的现代化转型。冯永基作为新一代香港画家在中国水墨画推陈出新的道路上不断成长，将传统水墨艺术与西方现当代艺术思潮融合，发展出香港这个独具地区特色的水墨文化和创作面貌。冯永基一直对祖国悠久的历史文化和艺术传统有着至深的情结与热爱。他坚持研习中国水墨，并不断思考和探索对水墨艺术的认知与见解。对空间环境、造型的敏感，让冯永基自幼留下不少优秀的绘画作品，直至大学阶段赴美升学，从新闻系、社会系辗转至建筑系学习并辅修艺术，回国后在建筑设计领域深耕多年，硕果累累。如果说建筑师的学识与经验给予了他最初的艺术察觉，那么水墨画则提供了另一精神栖地。

从中国美术史的发展线索来看，山水画的发展与绘画观念的变更形影相伴。古人在对时间、空间的形而上思考中不断揣摩眼见自然，在形而下的传移写照中融入了自己对人生、自然、世界的理解与顿悟。唐代张彦远在《历代名画记》中强调"经营位置"在绘画六法中的重要性。有着多元文化与建筑学科背景的冯永基，其画面经营十分讲究，经营位置既展现了艺术家对构图的智慧和谋略，又要求艺术家对于画面主次关系的取舍与把握，可谓艺术创作中非常全面而综合的能力。作为一名兼具建筑师与水墨艺术家双重身份的冯永基，在中西方艺术思潮与建筑哲学的影响下，对于新材料、新工艺，对古典、现代装饰及建筑新的重新思考和观念凝结，让其在水墨创作生发出独有的力量。传统中国画的发展跨越历朝各代，在传承变化中不断创新，延续至今。冯永基的水墨创作扎根中国传统媒介，融入了西方现代艺术的新构成主义与色彩学原理，加以建筑学专业的多维视角和画面把控力，令其水墨图像既被赋予强烈的形式感，又充满诗意，其极具个人风格的观念和绘画语言，将目之所及的城市与自然美景构建于笔端生动的水墨气韵之中。

随着新时代粤港澳人文湾区的繁荣发展，广东美术馆不断聚焦粤港澳文化艺术方面的研究与交流，将以香港、澳门为代表的不同地区但同根同源的艺术面貌呈现给观众。本次由广东美术馆主办的"「七拾」水墨心境 时空赋能——冯永基艺术展"，可谓是对冯永基数十载艺术生涯的一次全面回顾。作为我馆粤港澳大湾区年度重要艺术家个案，展览涵盖水墨画、建筑装置、影像等多种媒介，试图尽可能全面地呈现艺术家冯永基的绘画风貌及多维度的艺术成就，并以艺术家至爱的乒乓球运动为线索展现其游走于水墨和建筑之间的创作体验。感谢香港特别行政区康乐及文化事务署辖下的香港艺术馆及香港文化博物馆，还有香港大学美术博物馆对本次展览的藏品支持，感谢本次展览的策展人皮道坚先生以及所有工作团队的共同努力，为我们呈现如此恢宏而细腻的展览，让观众在冯永基的水墨建构中感受香港艺术家独有的艺术情怀。

王绍强

2023年4月于广州二沙岛
/
广东省美术馆协会会长
广东省美术家协会副主席
广东美术馆馆长

At the turn of the twentieth century, many from Guangdong migrated to Hong Kong, and amongst them were many painters whose arrival in the city had brought with them academic propositions that can be traced back to the artistic lineage of the Lingnan School of Painting. From the mid-twentieth century to the return of Hong Kong subsequent to the reform and opening-up, the Hong Kong art community, known for its compatibility with both Chinese and Western elements, has since reinforced its identity and gradually deepened its unique artistic style. Especially under the continuous influence of the Guangdong art, the open and inclusive environment has brought new cultural information to this important region that connects the world, further promoting the transformation and modernisation of traditional Chinese ink art. As part of the new generation of artists from Hong Kong, Raymond Fung has been growing on the innovative path of development of traditional Chinese ink painting, integrating both traditional Chinese ink art and Western contemporary art trends that further extenuates Hong Kong's unique regional interpretation of ink art culture and creativity. Raymond has long held deep sentiments and enthusiasm towards the history, art and culture of the Motherland. He has consistently been studying Chinese ink art and has been pondering on and exploring his personal understanding, as well as interpretation of this discipline. Raymond's acute awareness of space and form has been instrumental to his excellent artistic creations since childhood. He later forayed into the studies of journalism, sociology and eventually read architecture with minor in art during his university days in the United States. Since returning to China, Raymond has worked diligently for years and has accomplished impressive feats in the field of architectural design. If professional knowledge and experience of an architect have given Raymond his initial perception of art, then it seems he has found his spiritual habitat through ink painting.

Throughout the development trends of Chinese art history, the evolvement of Chinese landscape painting has been intertwined with the changes in Chinese art concepts. The ancients had often pondered on the observable nature while engaging in constant metaphysical contemplation of time and space. Subsequently, they incorporated their own understanding and insights of life, nature and

the world through their physical depictions of art and literature. The Tang Dynasty painter, Zhang Yanyuan emphasised the importance of "disposition" in the six rules of painting as recorded in his *Li Dai Ming Hua Ji - Famous Paintings through History*; multicultural and well-versed in architectural academia, Raymond is highly skilled in managing disposition in his paintings. Management of disposition not only demonstrates an artist's wisdom and strategy in the composition of a painting, but it also demands the ability to discern and master the primary and secondary relationships of a painting; and such skill has been considered a very comprehensive and integral ability in artistic creation. As someone who holds the dual identity of being an architect as well as an artist, Raymond has been influenced by both Chinese and Western art trends and architectural philosophies. His rethinking and conceptualisation of new materials and techniques, classical and modern decoration as well as architecture have led to his uniquely powerful ink art creations. The development of traditional Chinese Painting spans across various dynasties and generations, constantly innovating through legacies and changes to the present day. Raymond's ink painting creations are rooted in traditional Chinese mediums while incorporating principles of new constructivism and colour theory from Western contemporary art. His creations have also been infused with multidimensional perspectives and visual control from the field of architecture, which endow his ink paintings with both a strong sense of form and completeness that radiates poetic sentiments; Raymond's personal style and artistic language render the beauty of urban and natural landscape within his sight, vividly capturing the dynamic style and rhythm of ink art through the tip of his brush.

As the Guangdong–Hong Kong–Macao Greater Bay Area enters into a new era of prosperous humanistic development, the Guangdong Museum of Art is constantly focusing on the research and exchange of cultural and artistic aspects between Guangdong, Hong Kong and Macao, with the aim of showcasing to our audience that the artistic expressions from different regions such as Hong Kong and Macao are not just diverse, but are also rooted in the same lineage. This exhibition organised by the Guangdong Museum of Art titled *Qī Shí - An idyllic state of mind, coloured by time and space – A Raymond Fung Art Exhibition* can be regarded as a comprehensive retrospective of Raymond's decades-long artistic career. As an important artist in the museum's annual showcase from the Guangdong–Hong Kong–Macao Greater Bay Area, this exhibition attempts to comprehensively present Raymond's painting style as well as his multifaceted artistic achievements through the various mediums of ink painting, architecture, installation and visual image; while using Raymond's favourite sport of Ping Pong as a clue to explore his cross-cultural creative experience in between architecture and art. We are grateful for the substantial support given to this exhibition by Hong Kong Museum of Art and Hong Kong Heritage Museum under the Leisure and Cultural Services Department, HKSAR, as well as the University Museum and Art Gallery, University of Hong Kong. We are also grateful to the curator, Mr. Pi Daojian and all team members for their collective efforts for presenting such a magnificent and delicate exhibition, and for showcasing Hong Kong artists' unique ink art sentiments through Raymond's composition of his craft.

Translated by Christopher Hau

Wang Shaoqiang

April 2023
Ersha Island, Guangzhou

President, Guangdong Art Museum Association
Vice Chairman, Guangdong Artists Association
Director, Guangdong Museum of Art

横跨建筑和绘画两个领域的香港艺术家冯永基，早在15岁便开始了自己的艺术创作。他早年师从何百里，以香港郊区的自然风景为对象，创作一些传统"岭南派"风格的作品。1984年通过徐子雄接触到吕寿琨所倡导的香港新水墨运动，从此放弃了早期"岭南派"风格的写生画法，创作风格大变。兴起于20世纪六十年代的香港新水墨运动在坚实的本土美学体系和哲学根基之上，将抽象艺术当作个人自我表达的有力工具，推崇在作品内涵和艺术语言上与国际潮流对接，以适应新时代社会、政治和科技的转变。在这一转变过程中，传统的山水画题材被本土化、抽象化的全景构图和层层晕染所取代，突出了水墨媒介的独特质感和艺术家随心挥洒的灵性表现升华。

仅凭对绘画之社会、经济、政治等因素的外向型研究，或对绘画之风格和图像的内向型研究，都很难准确把握冯永基艺术创作的全貌。作为横跨建筑和绘画两个领域的艺术家，建筑学拓宽了冯永基对事物的感知和理解，让直觉成为他心灵活水的源头，因之他得以挣脱理性的束缚对空间构成之基本元素点、线、面感觉敏锐、驾驭自如，这赋予了冯永基水墨画艺术以独特的现代艺术语言魅力。对物质材料的天生敏感和对水墨媒介之时空意味的探索精神，令冯永基55年来从未间断过对建筑与绘画关系的思考，时间与空间的赋能，承载图像的物质媒材和被承载的图像叙事之间的极富张力的结合，便自然而然地成为了冯永基艺术创作风格的突出表征。本次展览中，一件由四百余块旧建筑瓦片铺砌出来的大型装置《乒乓》便暗示着艺术家与建筑和水墨的这样一种难解情缘。

中国山水画艺术是水墨画艺术乃至中华文化的象征符号，山水画被看作是中华文化精神的集中表达。中国现当代水墨艺术的一个核心内容是对中国山水画艺术"澄怀味像""以形媚道"传统的领悟与弘扬。当"澄怀味像""以形媚道"指向当代精神，成为当代精神的一种东方表达，中国现当代水墨艺术便凸显着一种对"诗情""诗性"和"诗意"的寻觅与探求，以其独特的精神意象，对抗物质化时代消费主义的低俗趣味。这是"画中有诗"这一中国画传统的现代转换。冯永基的现代水墨画艺术是这一现代转换过程中的成功案例。

冯永基的现代水墨作品，主要以山川林木、自然花草为题材，虽依然延续

中国传统山水画立轴与长卷的基本图式，或大山大水气势宏阔，或边角小景余韵绵长，但常以大的色块分割画面，抽象意味浓郁，空间感极强。从1980年代中期开始，冯永基创作了《隐在深山隔世间》《山水协奏曲》系列等作品，在这些作品之中，大面积色块对整体画面的分割，令其色彩渲染极具表现性。之后，出于其建筑师的直觉，冯永基不断地探索各种新材料、新工具和新技法，通过它们之间的排列组合对水墨语言进行拓展，对于不同的作品，他会选用不同的宣纸、颜料和笔，来凸显不同的肌理和质感。冯永基常在作品中将具体的语义符号系统转化为一套色彩能指系统，通过相近图式、类似技法下色彩的变换来凸显自己的心境意绪，以实现自然对象的意义转换。如在作品《十八式》中，色彩斑斓的外部世界被抽象为十八联立轴，色彩象征意蕴的切换构成如交响乐章般的起伏跌宕。艺术家采用同一种画笔、不同的宣纸、不同的颜色、不同的颜料创作这18副屏条，为的是观察不同宣纸所带来的作品肌理与质感变化。在《宋彩华姿》系列作品中，冯永基将敲碎的陶瓷覆盖在宣纸上，之后注入水和颜料，以此将瓷器的温润色泽和肌理通过拓印这种传统语言方式展现出来。而在《呼吸》和《生命》系列中，艺术家则追求颜料和材料之间的化学反应，并通过"行动"的方式来创造出新的作品肌理和质感。在这些作品中，他选用了不渗水的日本纸和高饱和度的颜料，将大量水和颜料泼洒在画布上，之后盖上保鲜薄膜并用手对颜料进行按摩，挤出颜料中的空气，待颜料干涸之后形成强烈而鲜明的脉络。这种前所未有的方式，令媒材的物性尽情凸显，从而构成一种新的景观，让观者在色与墨的交响之中生发对环境的关注，感受自然的灵性与生命的意义。大面积的泼墨、泼彩配以拓印技法所制造出的变化丰富而微妙的肌理感，令画面沉浸于色彩与水墨的交响之中，是张大千、刘国松等人之后对中国传统水墨语言之破旧立新的延续推进。但与他们不同的是，冯永基能以"碎片化"的多轴联屏构建宏大历史文化场域，将观者引入思想的境地……艺术家让由"意"与"象"所构成的二元复合结构交融并汇，创造性地将自己的人生感受和艺术想象融进极具特色的风景意象之中。"风景"与"心境"的相互流动，提供了复杂微妙的虚廓自由度，含蓄内敛地将欣赏者引向对东方哲学智慧的向往。艺术家借景写意、凝心寓情，令"风景"与"心境"相互渗透，情与景相互为文。冯永基因此而找到一种能将自然、历史与人生融合在一起的当代水墨表达方式——水墨心境。

建筑师的"场所精神"——对空间构造、体量感知、细节直觉的敏感，除了给冯永基不断带来材料创新的灵感外，也让其作品的时间与空间意味不断自然生成。从1991年的《大地的和唱》系列开始，艺术家就开始大量采用屏条这种形式进行创作。起初，采用这种形式主要是受制于物理空间的限制：香港的艺术家工作室普遍面积不大，为了适应海外展馆大型的墙面和运输的方便，只能将大幅的作品进行切分，而这种切分却带来了意想不到的展示效果。

中国绘画史中的条幅形式由隋唐时的"屏障""屏风"形制演变而来，到宋元时期渐始流行。作为文献记载的最古老的中国绘画形式之一，屏风常常被看成是一种准建筑形式，也是亚洲特有的一种空间与平面相结合的艺术呈现方式，其基本功能就是分隔空间。冯永基利用屏条的形式，通过空间分割、连结和扩展来重构传统的线性与现代的抽象绘画空间，并进一步将图像诗意化。在《千秋》一作中，冯永基用二十四联屏来暗示中国古代各朝所编撰的二十四部史书——《二十四史》，以象征历史上中国朝代的更替和历史的循环反复，又用连绵不绝的山峰来感叹中华大地的气象万千，绵延于山峰之间的云雾则系战争硝烟的能指。而屏条的运用能帮助创造不同"真实"之间的界限及其相互转换的契机，使不同的真实具有相异的空间、时间及其思想和行为，实现了时间和空间的互文。而在《十八式》这件作品中，色彩斑斓的外部世界被抽象为十八联立轴，冯永基通过相近图式下的色彩变换来凸显自己的心境意绪，色彩象征意蕴的切换构成如交响乐章般的起伏跌宕。而在作品的陈列上，艺术家有意拉开了各个屏条的距离来调节视觉间距，增强画面的层次感和透视感，并调节画面的平衡和节奏。而屏条间的距离被抽象为"留白"，使单调的墙面演化为一种创造性的空间，以激发观者的想象力和创造力，十八面屏条因而成为十八扇"窗"，人们可以"透过美好与落寂、愉快与悲观等不同心态观赏到各异景致"[1]，展现出一种包容的智慧。

"诗者，志之所之也，在心为志，发言为诗"[2]，如前所述，中国现当代水墨艺术凸显着一种对"诗情""诗性"和"诗意"的寻觅与探求。冯永基将其对生命、环境、战争的思绪注入进水墨语言的创新和绘画物理空间的再造之中，其通过借景写意、凝心寓情，让"风景"与"心境"的相互流动，情与景相互为文，提供了复杂微妙的虚廓自由度，含蓄内敛地将欣赏

者引向对东方哲学智慧的向往。冯永基因此而找到一种能将自然、历史与人生融合在一起的当代水墨表达方式，是"画中有诗"这一中国画传统的现代转换。在晚期现代性语境之下，随着科技环境的改变，人们的时间观、历史观也随之发生改变。线性的、完整的和逻辑化的时间观被改构为一种"碎片化"的时间观。对历史的结构性解读也演变为一种"碎片化"的解读。时间和空间的"脱域"[3]使得人们能够对于时空和历史进行自由的解构和重组。冯永基将这种"碎片化"的解读方式运用到自己的作品之中，同时也对"风景"与"心境"之关系进行了现代性的阐释。中国山水画通常被当作是一种心灵慰藉和遁世隐逸的题材，可让那些面对都市化生活中的迷茫、困顿和压迫的人们小憩于"林泉之志"，为"烟霞之侣"，将对精神蒙养的追求作为逃离现世物事的替代性选择。而冯永基则通过自己对自然、历史和人生的独特解读将这样一种消极避世的沉思蒙养转换为积极理性的自省，从而构建起一种新的，能将本土文化价值观念与当代生活感知结合起来的水墨心境审美意向。

[1] 艺术家语。

[2] 郝敬撰，向辉点校，《毛诗原解 毛诗序说》，中华书局，2021年，第1页。

[3] 英国社会学家安东尼·吉登斯在《现代性的后果》中提到的概念，意指社会关系从彼此互动的地域性关联中，从通过对不确定的时间的无限穿越而被重构的关联中"脱离出来"。

皮道坚

策展人
华南师范大学教授

Hong Kong artist Raymond Fung, who straddles the fields of architecture and painting, began his journey on artistic creation at the tender age of fifteen. Under the early tutelage of Mr. He Baili, he crafted works in the traditional Lingnan School style, inspired by the natural landscape of Hong Kong's suburbs. However, in 1984, upon encountering the Hong Kong New Ink Movement advocated by Mr. Lui Shou-Kwan through an introduction by Mr. Chui Tze Hung, Raymond abandoned his early Lingnan style and underwent a major transformation in his artistic expression. The Hong Kong New Ink Movement, which emerged in the 1960s, took abstract art as a powerful tool for individual expression based on a solid local aesthetic system and philosophical foundation. This movement advocated for works that were in sync with international trends in their content and artistic language, as well as those that respond to the changing social, political and technological conditions of the new era. In this transformative process, traditional landscape painting motifs were supplanted by localised and abstract panoramic arrangements and layered renditions, highlighting the unique texture of ink mediums and the spiritual expressions of the artist's uninhibited brushstrokes.

A comprehensive understanding of Raymond's artistic creations is difficult to achieve through a mere external examination of social, economic and political factors influencing his painting; nor would the same be achievable through an inward-looking research into his painting style and imagery. As a multifaceted artist, Raymond's perception and understanding of the world has been broadened by his study of architecture, allowing intuition to become the very source of his creative inspiration. As a result, he has been able to liberate himself from the confines of reason, and to feel and control the basic elements of point, line and plane in spatial composition with sensitivity and ease. This has endowed Raymond's ink art with a distinct charm in modern artistic language. His innate sensitivity to materials and his exploration of the spatiotemporal meaning of ink medium have led him to continuously contemplate the relationship between architecture and ink painting for the past fifty-five years. The empowering combination of time and space, along with the highly-

tense fusion between material medium of the image and the narrative of the image, has naturally become a prominent characteristic of Raymond's artistic style. In this exhibition, a large installation titled Ping Pong, made up of over four hundred pieces of old building tiles, suggests the artist's enigmatic relationship with architecture and ink painting.

Chinese landscape painting is a symbolic representation of ink art and even Chinese culture, and is considered a concentrated expression of the Chinese cultural spirit. A core element of contemporary Chinese ink art is the comprehension and promotion of the traditional concepts of "clearing the mind to savor the essence" and "using natural form to delight the mind" found in Chinese landscape painting. When these concepts are directed towards contemporary spirit and become an expression of the Chinese culture, contemporary Chinese ink art highlights the search for and exploration of "poetic sentiment," "poetic character" and "poetic meaning", while using its unique spiritual imagery to resist the vulgar taste of consumerism in a materialistic era. This is a modern transformation of the traditional Chinese painting concept of "poetry within a painting". Raymond's contemporary Chinese ink art has been a successful example of this transformative process.

Raymond's contemporary ink art works mainly depict mountains, rivers, forests and natural flora. Although they adhere to the basic traditional format of Chinese landscape painting, such as vertical and long horizontal scrolls, his works often utilise large colour blocks to divide the picture, imbuing it with abstract elements and a powerful sense of space. Beginning in the mid-1980s, Raymond created works such as Beyond Horizon and Landscape Concerto, wherein he employed this same technique to segment the overall composition of his paintings and added much expressiveness to the colour rendering of his works. Guided by his intuition as an architect, Raymond constantly explores various new materials, tools and techniques to expand the language of ink art through their arrangement and combination; selecting different types of rice paper,

pigments and brushes for different works to highlight their various textures and nuances. In addition, Raymond often transforms specific semantic symbol systems into a system of colour identifiers, using similar techniques and patterns to highlight his state of mind, and to achieve a transformation of the meaning of natural objects. For instance, in the work 18 Shades in Ink, the colorful external world is abstracted into eighteen vertical scrolls, with the switching of colours symbolising the ups and downs of a symphony. The artist uses the same brush, but different rice paper, colours and pigments to create these eighteen screens in order to observe the changes in texture and quality brought about by these variations. In the china in China series, Raymond covers smashed ceramics on rice papers, and then injects water and pigment to reveal the warm colors and textures of the ceramics through traditional printing techniques. In the Breathing and Life series, Raymond pursues chemical reactions between pigments and materials, creating new textures and qualities through the depiction of "movement". In these works, he uses non-absorbent Japanese paper and highly saturated pigments, splashing a large amount of water and pigment onto the canvas, pressing out the air in the pigment with his hands, and allowing the pigment to dry, creating strong and vivid vein-like textures. This unprecedented method allows the properties of the medium to fully manifest, forming a new landscape that awakens viewers' attention to the environment and to feel the spirituality and meaning of life. The large splashes of ink and colour, combined with the rich and subtle textures created by printing techniques, immerse the painting in a symphony of colour and ink, continuing in the tradition of breaking new ground in the language of traditional Chinese ink art, following in the footsteps of Zhang Daqian and Liu Guosong. However, unlike them, Raymond can construct a grand cultural and historical field with a "fragmented" multi-axis screen, leading viewers into a realm of thought. The artist blends the dual composite structure of "meaning" and "image" in a creative way, integrating his life experiences and artistic imagination into distinctive landscape images. The flow between "idyllic scenery" and "state of mind" provides a complex and subtle form of structural freedom, gracefully leading viewers towards a longing for Chinese

philosophical wisdom. The artist uses landscapes to express his feelings and convey his emotions, allowing the "idyllic scenery" and "state of mind" to permeate each other and to become a part of the literary world. Through this, Raymond has found a contemporary ink art expression that integrates nature, history and life into a unified whole—the Idyllic State of Mind.

An architect's "place-making spirit" represents his sensitivity to spatial construction, volume perception and intuition for details. Such traits not only continue to inspire Raymond's innovative usage of materials, but also generate a natural meaning of time and space in his works. Starting with *The Echo of Nature* series in 1991, the artist began to use screens extensively in his creations. Initially, such form was mainly adopted due to physical space limitations: the studios of Hong Kong artists were generally small, and in order to adapt to the large walls of overseas exhibition halls and facilitate transportation, large works had to be cut into sections. However, such a method actually brought about unexpected and unique display effects.

The scroll form in the history of Chinese painting evolved from the "pingzhang" (screens) and "pingshang" (partitions) forms of the Sui and Tang dynasties, and gradually became popular during the Song and Yuan periods. As one of the oldest forms of Chinese painting documented in literature, the screen is often seen as a quasi-architectural form and a unique Asian art form that combines space and plane. Its basic function is to divide space. Raymond uses the form of screen strips to reconstruct traditional linear and modern abstract painting spaces through spatial division, connection and expansion to further poeticise images. In *Dynasties*, Raymond uses a twenty-four-link screen to imply the twenty-four official Chinese historical texts compiled by various dynasties in ancient China—the Twenty-Four Histories—symbolising the alternation of dynasties and the cyclical nature of history. The continuous mountain peaks express the diverse terrain of the Chinese land, and the clouds and mist between the peaks represent the metaphorical smoke of war. The use of screens helps to create boundaries between different "realities"

and opportunities for their mutual transformation, enabling different realities to have distinct spaces, times, ideas and behaviors, thus realising the intertextuality of time and space. In the work *18 Shades in Ink*, the colorful external world is abstracted into eighteen vertical scrolls. Raymond highlights his emotional thoughts through color changes under similar patterns, and the change of color symbolism constitutes a symphony-like of ups and downs. In the display of the work, the artist intentionally adjusts the visual distance by separating the screens to enhance the sense of depth and perspective, adjusting the balance and rhythm of the picture. The distance between the screens is abstracted as "boundless space", transforming the monotonous wall into a creative space that stimulates viewers' imagination and creativity. The eighteen screen strips thus become eighteen "windows", through which viewers can "appreciate diverse sceneries through different mindsets, such as those of beauty and desolation, joy and sorrow",[1] demonstrating a kind of inclusive wisdom.

"The poet is one whose thoughts reside in his heart, and whose words are expressed through poetry".[2] As such, contemporary Chinese ink art highlights a search for and exploration of "poetic sentiment", "poetic character" and "poetic meaning". Raymond injects his thoughts on life, environment and war into the innovation of ink art language and the reconstruction of physical painting space. By using borrowed scenery and concentrated emotions, he allows the mutual flow of "idyllic scenery" and "state of mind", with emotion and scenery mutually complementing each other, providing a complex and subtle degree of structural freedom. This reserved and restrained approach leads viewers to long for Chinese philosophical wisdom. As a result, Raymond has found a contemporary ink art expression that integrates nature, history and life, which is a testament to the modern transformation of the traditional Chinese painting concept of "poetry within a painting". In the context of late modernity, with changes in the technological environments, people's views of time and history have also changed. A linear, complete, and logical view of time has been restructured into a "fragmented" view of time. Structural

interpretations of history have also evolved into a "fragmented" interpretation. The "disembedding"[3] nature of time and space allows for free deconstruction and reorganization of time, space and history. Raymond applies this "fragmented" interpretation to his own work, while also providing a modern interpretation of the relationship between "idyllic scenery" and "state of mind". Traditional Chinese landscape painting is often seen as a topic of solace for the soul and seclusion from the world, allowing those facing confusion, distress and oppression in urban life to take refuge in the "aspirations of the forest and springs" with the "companionship of mist and clouds", pursuing spiritual nourishment as an alternative to escaping worldly affairs. Raymond's unique interpretation of nature, history, and life transforms this negative escapism into positive rational introspection, constructing a new ink aesthetic that combines local cultural values with contemporary life perceptions.

Translated by Christopher Hau

[1] Artistic language

[2] Hao, Jing and Xiang, Hui (eds) (2021) *Mao Poetry Original Interpretation: Mao Poetry Preface*, Chung Hwa Book Co., p.1.

[3] The concept mentioned by British sociologist Anthony Giddens in "The Consequences of Modernity" refers to social relations that are "disembedded" from their local context of interaction and reconstructed through infinite transgressions of uncertain time. (Giddens, A. (1990) *The Consequences of Modernity*, Cambridge: Polity Press.)

Pi Daojian

Curator
Professor, South China Normal University

看见 了什么

WHAT HAVE I SEEN

人到七十，我以一套七连屏画作《七拾》为自我勉励，反映了更深层的心路历程……或许人生如同一场造化，每一天能欣然活着，就是一天的收获。在此，我十分感谢广东美术馆的支持，让我能够举办这场个人艺术展"「七拾」水墨心境 时空赋能 —— 冯永基艺术展"，留下了丰富的回忆和永恒的收获。

此次展览将于2023年5月在广东美术馆举行，作为人生70岁的一个圆满总结。展览作品将用建筑、装置和水墨画三种媒介呈现。主轴是一幅由四百余件旧瓦片砌成的特大乒乓球桌装置。乒乓球是我最喜爱的运动，乒乓球桌由两扇台板构成，球来球往之间，拼凑成了我对建筑和水墨的两份情缘。

展览现场以旧瓦片所拼凑的装置来自香港茶具文物馆的屋顶，当时因翻新而被更换下来。这些瓦片后来以艺术形式重新演绎，曾在2019年香港艺术馆，以装置《与吴冠中对话》展出，而今，以喜爱的乒乓运动为灵感，以作品《乒乓》再度呈现。

平放的瓦片就如一张乒乓球桌，在一来一回间，意味着人生路上，建筑和水墨的对话。装置中，抽起了七件瓦片，隐含"拾起"七段有起有落的人生。而拾起的七件瓦片，则悬挂于墙上，成为另一装置，呼应了此次展览的主题"七拾"，标志着我在艺术上突破的一年。在此，特别感谢又一山人的义助，担任展览艺术顾问，并亲自制作了纪录短片。

在整个展览中，还可看到广东美术馆与中国香港策展团队的个人剪影，他们包括皮道坚、王绍强、又一山人、徐子晴、王斯琪、黄海蓉、赵婉君、张艺等人，展示了共同的参与和合作精神。

冯永基

2023 初春

The title of this art exhibition—*Qī Shí 七拾*, encapsulates the literal sense of experiences "picked up" in the last seven decades. It also bears a homophonic resemblance to the Chinese words *Qī Shí* (*七十*) which is directly translated into the word seventy.

On my seventieth birthday comes another set of seven individual panels of paintings—*Qī Shí* to spur myself on. It reflects a deeper level of my emotional journey thus far: perhaps life is what you make it, living each day with joy will give you something to gain for yet another day. I would like to convey my deepest appreciation for the invaluable assistance provided by the Guangdong Museum of Art to bring to fruition this art exhibition of mine titled *Qī Shí – An idyllic state of mind, coloured by time and space*, imparting endearing memories and eternal gains for me to cherish.

This exhibition will be held in May 2023 at the Guangdong Museum of Art serving as a fitting culmination for my seventieth year. The exhibition will include works in the three mediums of architecture, art installation and ink painting with the centrepiece being a large ping pong—themed installation constructed by placing over four hundred pieces of old roof tiles together. Ping pong is my favourite sport, and as the ball bounces back and forth on the ping pong table, it aptly embodies my romantic encounters with both architecture and ink painting.

The old roof tiles showcased at the exhibition have originated from the roof of the Flagstaff House Museum of Tea Ware. Initially meant to be discarded as they were being replaced, these pieces eventually found their place in my installation *Dialogue with Wu Guanzhong* exhibited at the Hong Kong Museum of Art in 2019. Presently, drawing inspiration from my fondness for the sport of table tennis, these tiles are showcased once again in the form of the art installation, *Ping Pong*.

The tiles have been laid flat to resemble a ping pong table, with the ball bouncing back and forth symbolising my lifelong dialogue with both architecture and ink painting. In this installation, seven pieces of tiles have been "picked up" to imply the seven stages of life with their ups and downs. The seven tiles that have been picked up are then suspended on the wall, forming another installation that resonates with the theme of this exhibition, "Qī Shí", marking my artistic breakthrough for this year. I would like to express my appreciation to anothermountainman for providing artistic advice for the exhibition and creating a short documentary.

Within the exhibition space, there are art installations made up of the silhouettes of the team members from the Guangdong Museum of Art and the Hong Kong, China curator teams. These include Mr. Pi Daojian, Mr. Wang Shaoqiang, anothermountainman, Ms. Karen Tsui, Ms. Phyllis Wong, Ms. Huang Hairong, Ms. Zhao Wanjun and Mr. Zhang Yi; all of whom have demonstrated a shared spirit of participation and collaboration.

Translated by Christopher Hau

Raymond Fung

2023 Spring

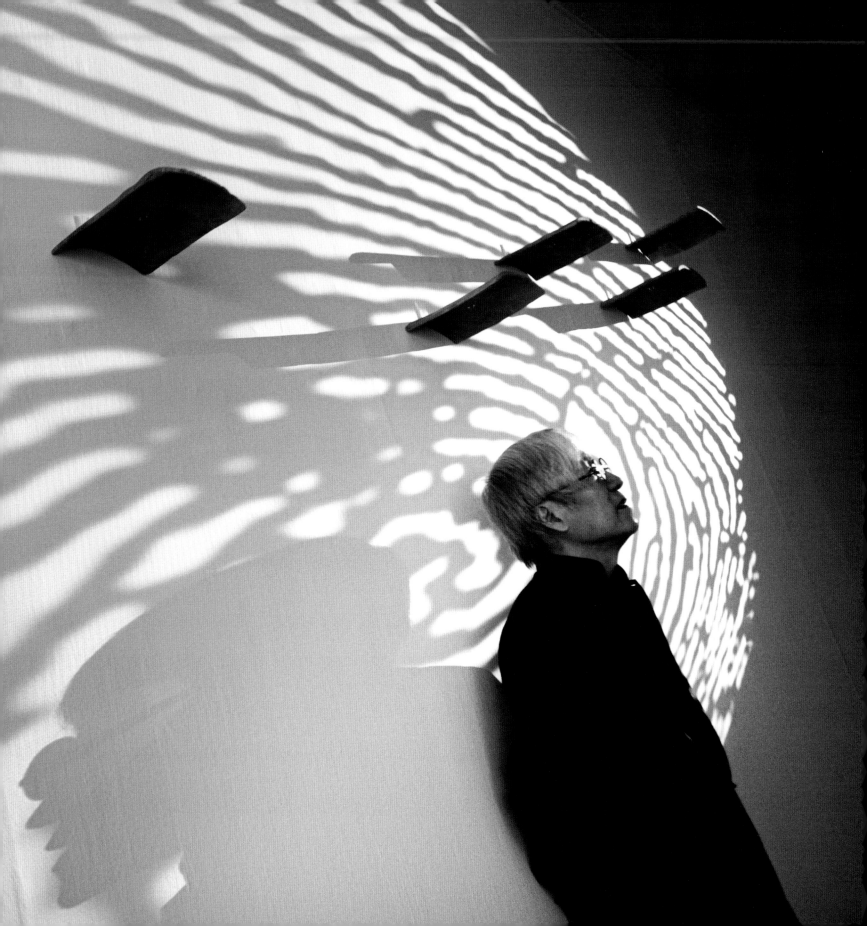

听见了什么

WHAT HAVE I HEARD

重新拾起的，又是什么？

WHAT HAVE I SEEN

WHAT EXACTLY HAVE I PICKED UP ANEW?

WHAT HAVE I SAID

WHAT HAVE I LET GO OF

WHAT HAVE I GIVEN

WHAT HAVE I FOREGONE

看见了什么

放弃了什么

付出了什么

架不了什么

这是一个"嘈杂"建筑的年代。大部分媒体追捧的建筑都倾向追求浮夸的造型以及炫目的视觉效果,因而淡化了建筑的真正价值。在这样的大环境下,冯永基的建筑往往给人耳目一新的感觉,好像一泉清水。你造访他的建筑作品,不一定会惊叹窒息。但感受完他的作品,你会意犹未尽,如沐春风,并对包括建筑在内的整个环境有更进一步的欣赏。

把冯永基的作品归纳为"极简主义",是一个太表面的判断,"极简"基本上是一个视觉风格,但冯永基的创作,似乎是基于一个更深层的信念:认真负责的设计,应该是"以少见多"(Building less for more)。因此进行建筑创作时,应该是以最少的资源,去达到最有效的空间及视觉效果。而最终目的,不一定是单纯着眼建筑本身,而是着眼整体环境,以及使用者及访客的心灵感受。

能够体现这个信念的典型作品之一,是冯永基在1999年完成的代表作"卫生教育展览及资源中心",这座建筑运用简单且节约成本的建筑元素,例如钢梁组合的柱廊,外露的结构及机电系统,将建筑的新旧翼与九龙公园的一角融合,成为一个活化的新公共领域。外露的结构和机械系统也是人体解剖学的隐喻,而这正呼应了此建筑的内容与展品主题。

另外一个有意义的作品,是2004年的西贡海滨公园。在这个原来毫无个性特色的空地上,冯永基以简单且相对含蓄的方式引进一些建筑及艺术元素,例如突显视觉走廊的五个古钟、象征保佑出海渔民的庙宇,以及一系列由简单钢板构成的纸船雕塑,上面印着战时报章片断,引起居民对历史的追忆。整体而言,既为一个重生的公共空间赋予个性,亦适当地勾起跨代追思。

冯永基最重要的作品,无疑是2006年的香港湿地公园。大部份媒体报导都将重点放在面向湖水的建筑正面造型。这固然是一个大师级的建筑造型,但最令我心动的,却是建筑的入口,一道微斜的草坡,巧妙地把访客的目光及脚步引向最高点,在那高处,风光无限,一览无遗。同时建筑大堂的透明玻璃后,湖光隐隐显现,邀请访客入内探索。这些简单的设计策略,

一方面将建筑地貌与周围环境融为一体，淡化了建筑的庞大体量，另一方面在访客未曾进馆之前，已有效地提升他们的兴奋及期待。

以上的成就，无疑归功于冯永基作为建筑师的技巧及经验。但单凭技巧经验，实在不足以解释他作品中的灵性。我觉得他在这方面有两大天赋：一是对物料、构图及触觉的感性敏锐；二是对环境的爱护，以及对使用者情感体验的同理心。在湿地公园博物馆的设计中，这两点是特别明显的。

中国人一向认为艺术是人性的表现。在儒家信念中，道德与艺术相辅相成，而至最高境界时，道德与艺术将自然而然融合统一。

冯永基是一位切切实实的艺术家，他持守对生命人道态度，既拥抱、亦超越纯粹的美学艺术追寻。在我看来，他能在艺术及建筑领域中取得如此成就，此乃最根本原因。

严迅奇

国际知名建筑师

This is an era of "noisy" architecture, where most media praise buildings that pursue ostentatious shapes and dazzling visual effects, often to the detriment of the true value of architecture. Amidst this environment, Raymond Fung's architectural works often provide a refreshing and rejuvenating experience, akin to that of a spring of clear water. Visiting his architectures may not necessarily leave one awestruck and breathless, but having experienced his creations, one is likely to be left with a lasting impression, a sense of well-being, and an even deeper appreciation for the entire environment, including its architecture.

To categorise Raymond's work as "minimalist" would be a superficial judgment. While "minimalism" is primarily a visual style, Raymond's creative process seems to be rooted in a deeper belief that responsible and conscientious design should be about "Building Less for More". Therefore, creating architecture should involve using minimal resources to achieve the most effective spatial and visual results. The ultimate goal should be holistic and not only focused on the architecture itself, but also the overall environment, as well as the emotional experiences of its users and visitors.

One of the emblematic works that embodies this belief is the "Health Education Exhibition and Resource Centre", completed in 1999 and designed by Raymond. The architecture employs simple and economical architectural elements, such as steel beam colonnades and exposed structural and mechanical systems, to seamlessly blend the old and new wings of the architecture with the corner of Kowloon Park, creating a revitalised public space. The exposed structural and mechanical systems also serve as a subtle metaphor for human anatomy, which is the central theme of the architecture's content and exhibits.

Another meaningful work worthy of a mention is the Sai Kung Waterfront Park which was completed in 2004. In this previously characterless space, Raymond introduced a few buildings and art elements in a simple and relatively subtle manner. For instance, he

incorporated five antique bells that highlight the visual corridor, a temple that symbolises blessings for fishermen, and a series of paper boat sculptures made of simple steel plates printed with fragments of wartime newspapers, evoking memories of the past for local residents. The overall effect not only gives the reborn public space a unique identity, but also appropriately stirs intergenerational reminiscence.

Undoubtedly, Raymond's most significant work is the Hong Kong Wetland Park, completed in 2006. While most media reports emphasised the architecture's facade facing the lake during its construction, what impressed me the most was the entrance, a slightly sloping grassy hill that ingeniously directs visitors' attention and footsteps towards the highest point, where the scenery is breathtakingly infinite. Meanwhile, the lake's shimmering water is visible through the transparent glass walls of the lobby, inviting visitors to explore within. These simple design strategies blend the architecture's topography with the surroundings, downplaying its imposing physical presence, while effectively enhancing visitors' excitement and anticipation even before they enter the park.

The achievements mentioned above are undoubtedly due to Raymond's skills and experience as an architect. However, it cannot be solely attributed to his technical expertise, as his works possess a spiritual quality that cannot be explained through skill and experience alone. I believe that he has two major talents in this regard: first, a sensitive intuition for materials, composition and tactile sensations; second, a deep love for the environment and empathy for the emotional experiences of its users. These two talents are particularly evident in the design of the Wetland Park Museum.

It is in the Chinese psyche that art is the ultimate personification of a being. In Confucianism, morality and art complement each other, and in the ultimate scenario, both realms naturally blend to become one.

Raymond is a thorough artist who embraces and transcends the pursuit of pure aesthetic art in his humane attitude towards life. In my view, this is the fundamental reason for his remarkable achievements in the fields of art and architecture.

Rocco Yim

World-renowned Architect

建筑透视图（一）（二） Architecture Perspective（1）（2）　│　针笔纸本印刷 Rapidograph sketch　│　31 X 43cm　│　1978

港岛北岸 Island North ｜ 针笔画 Rapidograph ｜ 55 X 100cm ｜ 1985

香港湿地公园的设计流露着一丝含蓄的东方神韵，勾画出主轴线的完美，即天、地、人与大自然造物之间的一次大合奏。

The design of the Hong Kong Wetland Park reveals a subtle oriental charm, outlining the main axis—a grand symphony of the sky, the earth, human beings and the creations of nature.

香港湿地公园 Hong Kong Wetland Park ｜ 2005

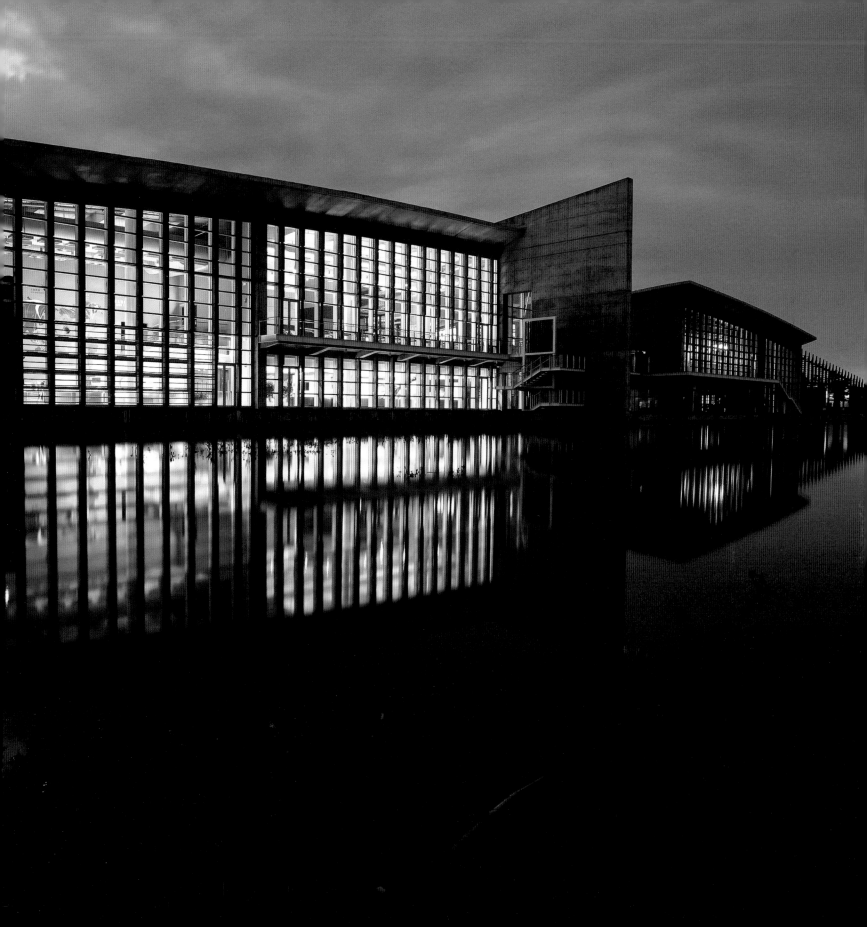

"环保轩"改自旧邮局，以环保理念为设计目标，虽只有90平方米，但麻雀虽小，五脏俱全。

The Wan Chai Environmental Resource Centre is a conversion of an old post office, with the goal of incorporating environmental protection concepts into the design. Despite being only 90 square meters in size, it is fully equipped and functional, proving that good things come in small packages.

湾仔环境资源中心 Environmental Resource Centre, Wan Chai ｜ 1993

图书馆以"一本书"的形态作为门面，拉趟式的玻璃设计犹如书本拉出的内页，呈现图书馆的开放时间。

The library features a façade in the shape of "a book", and the sliding glass design resembles the pages of a book being pulled out, displaying the library's opening hours.

建筑署图书馆 ARCH. S. D. Library ｜ 2006

图为中国香港特别行政区政府的贵宾室，该设计不经意间展示出香港悠久的历史和深厚的文化底蕴。

The VIP room of the Hong Kong Special Administrative Region Government inadvertently showcases the history of unearthed cultural relics in Hong Kong over six thousand years, highlighting its profound cultural significance.

香港国际机场政府贵宾厅 Government VIP Lounge | 1997

此屋属于一个热爱歌唱的家庭，设计上刻意投射文人气息及音乐为主轴。

This house belongs to a family who loves to sing, and its design deliberately incorporates elements of literati culture and music as the main themes.

郑宅室内设计 Interior design of Cheng's Residence | 2007

山顶公园翻新工程以重现昔日风貌为主，亦以减少建筑体量，保留诺大空间为本。

The renovation project of the Victoria Peak Garden focuses mainly on restoring its former style, while also reducing the volume of the architecture and preserving the vast open space.

山顶公园 The Peak ｜ 与景国祥共同设计 Jointly designed with K. C. King ｜ 2008

愉景湾高尔夫球会所是该住宅区第一个完成的建筑项目，饶有意义。

The Discovery Bay Golf Club is a meaningful endeavor as it was the first project completed in this unique resort style residential community.

愉景湾高尔夫球会所 Discovery Bay Golf Club ｜ 1987

人们总是把西九文化区解读为"地产项目",建筑师要洗脱这世俗观念,把它重塑成文化地带的预告篇。

People often interpret the West Kowloon Cultural District as a "real estate project", but architects need to shake off this secular concept and reshape it as a prologue to a cultural district.

西九龙海滨公园 West Kowloon Promenade │ 与罗超逸及刘蔚茵共同设计 Jointly designed with Michael Law and Sofia Lau │ 2007

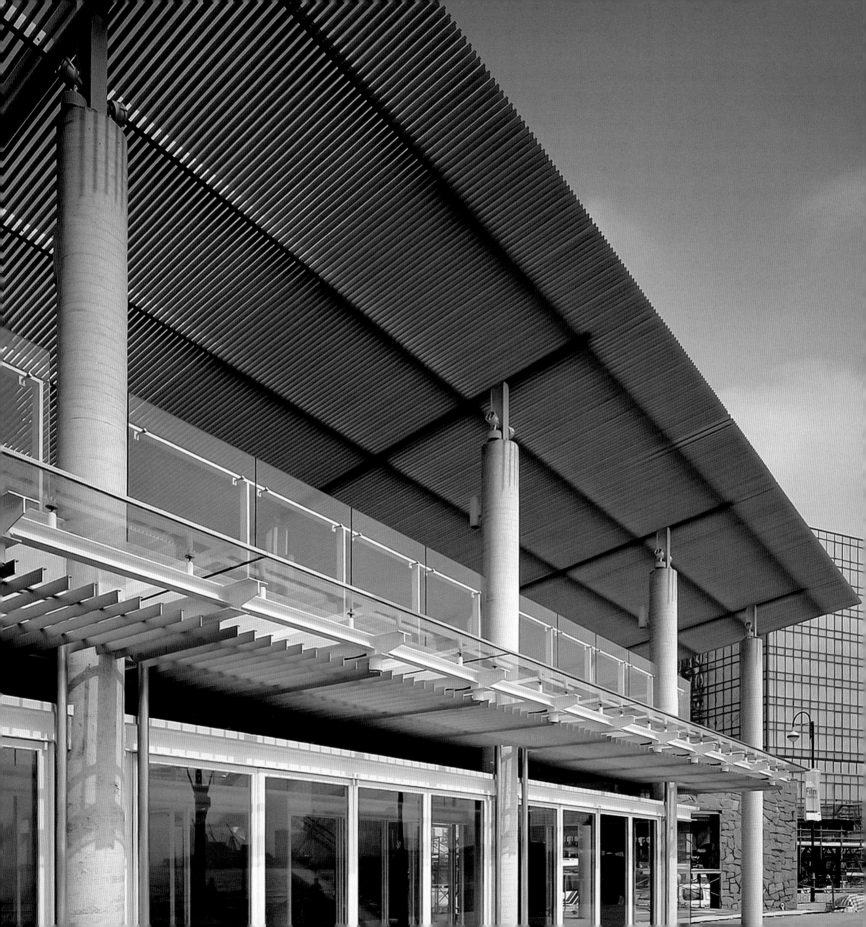

这片海滨最重要的价值是其优美的海港与两岸风景。设计上化繁为简，将弃用的泵房重建成海滨茶座，以重现更舒畅及有生命力的维港。

The most significant aspect of this promenade lies in its beautiful harbor and the shores surrounding it. In terms of design, simplicity was emphasised, and the abandoned pump house was rebuilt into a seaside tea house to recreate a more comfortable and vibrant Victoria Harbour.

尖沙咀海滨美化工程 Tsim Sha Tsui Promenade ｜ 与周安远及景国祥共同设计 Jointly designed with Daniel Chow and K. C. King ｜ 2006

愉景湾是中国香港早期由私人发展的现代化市镇，也是最庞大的私人屋苑。

Discovery Bay is a modern town in Hong Kong, China that was developed by private entities in the early days, and it is also the largest private residential estate.

愉景湾一期 Discovery Bay Phase 1 ｜ 1985

展览中心内「露骨」的设计，就如参观者走进建筑物赤裸裸的内脏，与关于人类生老病死的展览主题，互相呼应。

The exhibition centre's "blunt" design is akin to visitors walking through the naked interior of the architecture, echoing the human themes of birth, aging, sickness and death that are explored in the exhibitions.

卫生教育展览及资源中心 Health Education Exhibition and Resource Centre ｜ 1996

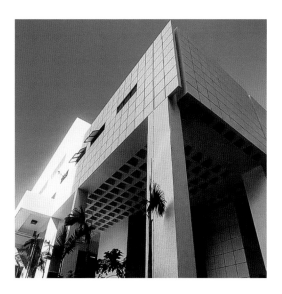

柴湾体育馆的特色是，在原有的街市上加建，既保持环保的原则，设计上又能互相融合。

The distinctive feature of the Chai Wan Sports Centre is that it was built on top of the existing Chai Wan Market, adhering to the principle of eco-friendliness while achieving a seamless integration of design.

柴湾体育馆 Chai Wan Sports Centre ｜ 1988

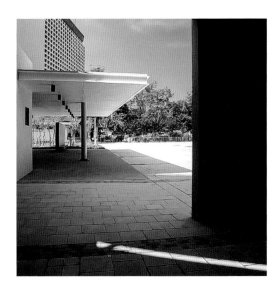

维多利亚公园的改造是以人为本。设计前先采取「用家调查」，发现大多市民都希望保留原有的功能与角色。

The transformation of Victoria Park has been a human-centric endeavor. Prior to its design phase, a "user survey" was conducted, revealing that the majority of the public wished to retain the park's original functions and roles.

香港维多利亚公园 Hong Kong Victoria Park ｜ 与李翘彦及黄德仪共同设计 Jointly designed with Michael Li and Joanna Wong ｜ 2002

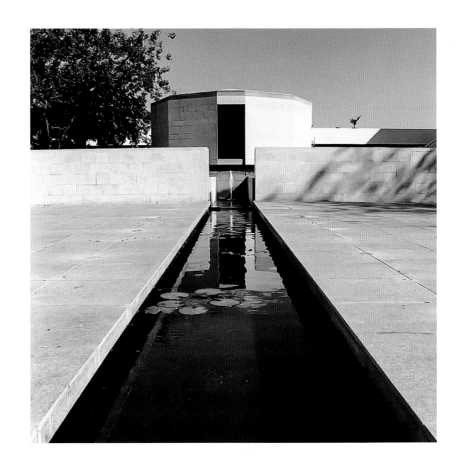

大会堂早已是包浩斯風格的一个典范，在改造过程中，以尊重原有的建筑设计特色为本。

The City Hall has long been a prime example of the Bauhaus style, and during the renovation process, great emphasis was placed on preserving and honoring the building's original architectural design and distinctive features.

大会堂纪念公园 City Hall Memorial Garden ｜ 1993

位于上海淮海中路的启华大厦，是中国改革开放后首批港人返乡投资的缩影。

The Qi Hua Tower located on Shanghai's Middle Huaihai Road is a testament to the first wave of Hong Kong, China investors who returned to invest in China after the country's Reform and Opening-up policy.

上海启华大厦 Shanghai Qi Hua Mansion ｜ 1987

建筑师将饶宗颐大师献给中国香港的"墨宝"转化为一个户外大型雕塑，由38株巨型木柱组成，感受"心无罣碍"的智慧。

The architect transformed the "calligraphy treasure" dedicated to Hong Kong by Master Jao Tsung-I into a large-scale outdoor sculpture, composed of 38 colossal wooden columns, evoking the wisdom of "the unhindered mind".

心经简林 Heart Sutra ｜ 与景国祥共同设计 Jointly designed with K. C. King ｜ 2005

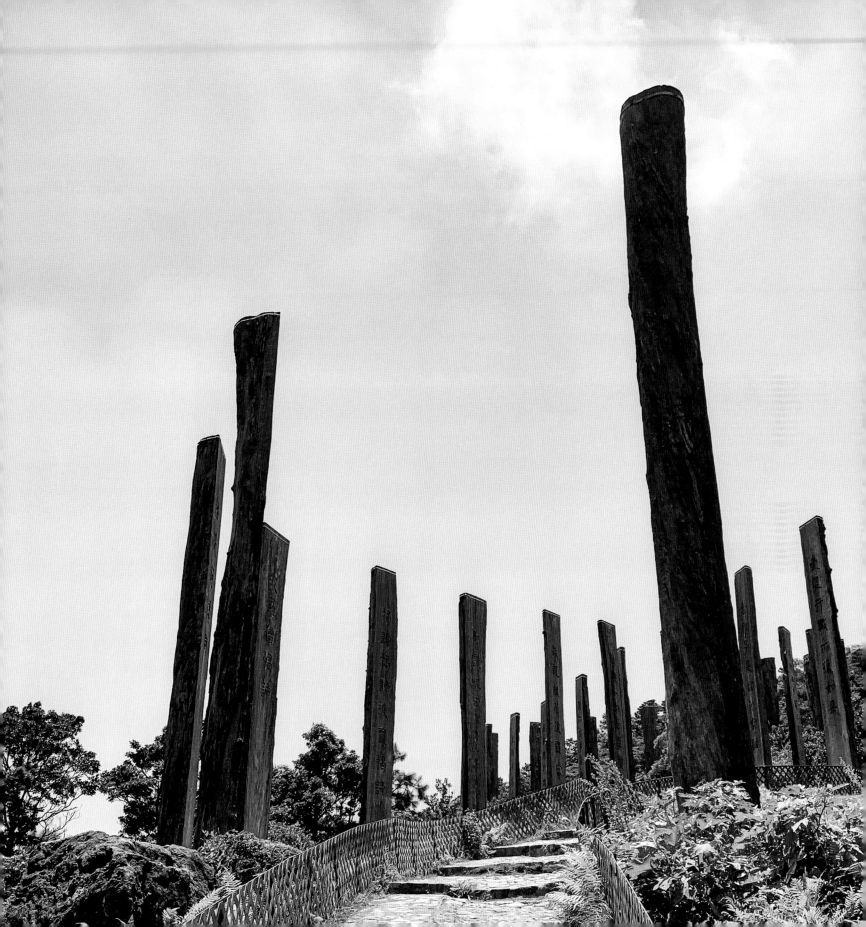

光影的虚实，就犹如画作的留白、建筑的空间所营造的气氛，带来一种既写实又抽象的描绘。

The interplay of light and shadow resembles the use of blank space in painting and the atmosphere created by the spatial design of architecture, resulting in a depiction that is both realistic and abstract.

艺术家工作室 Artist's Studio ｜ 2016

设计运用怀旧的手法，展览香港电灯公司百年来的各色灯柱，并借着香港人的剪影，展示中国香港的生活百态。

The design employs a nostalgic approach, showcasing a variety of lamp posts used by the Hong Kong Electric Company over the past century. By incorporating the silhouettes of Hong Kong residents, the exhibit also portrays the diverse lifestyles found throughout Hong Kong, China.

爱丁堡广场 Edinburgh Place │ 2002

有感于"长城脚下的公社"的艺术理念,建筑师以浪漫色调及活泼的图案打造村屋,并以"图花源"命名。

Inspired by the artistic philosophy of the "Commune by The Great Wall", the architect designed the village houses with romantic hues and lively patterns, and named it the "Flower Box".

图花源 Flower Box ｜ 2008

设计师以一灰一白，衬托出两代人的主色调，碰撞出简约利落之感。

The designer used shades of gray and white to highlight the main colour schemes of two generations, creating a simple and neat contrast.

渭州道独立屋 Private House on Wiltshire Road ｜ 2018

这是设计团队的宏愿，尝试缔造"城市设计"的港式样板，提出"西贡视觉走廊"的整体概念。

This is the design team's ambitious attempt to create a Hong Kong-style model for "urban design", proposing the overall concept of the "Sai Kung Visual Corridor".

西贡海滨公园及视觉走廊 Sai Kung Waterfront Park and Visual Corridor | 与景国祥及施琪珊共同设计 Jointly designed with K. C. King and Ida Sze | 2002

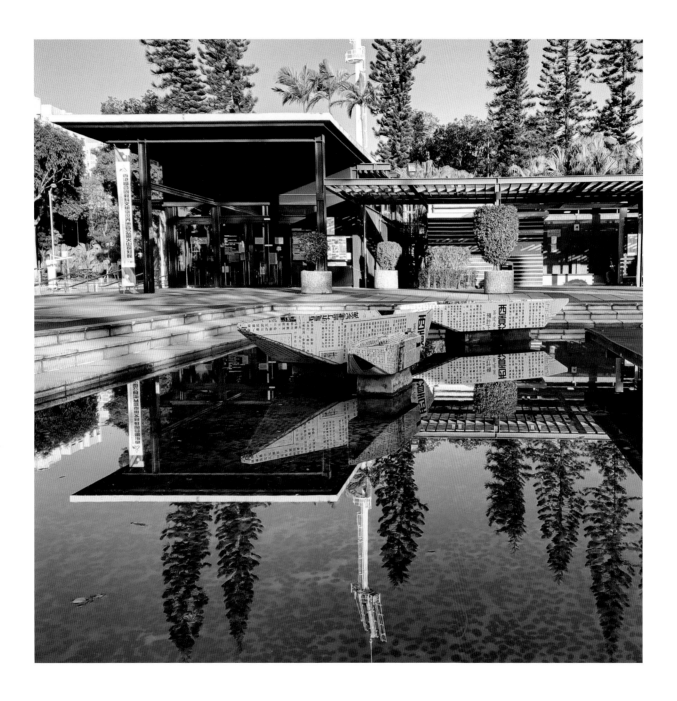

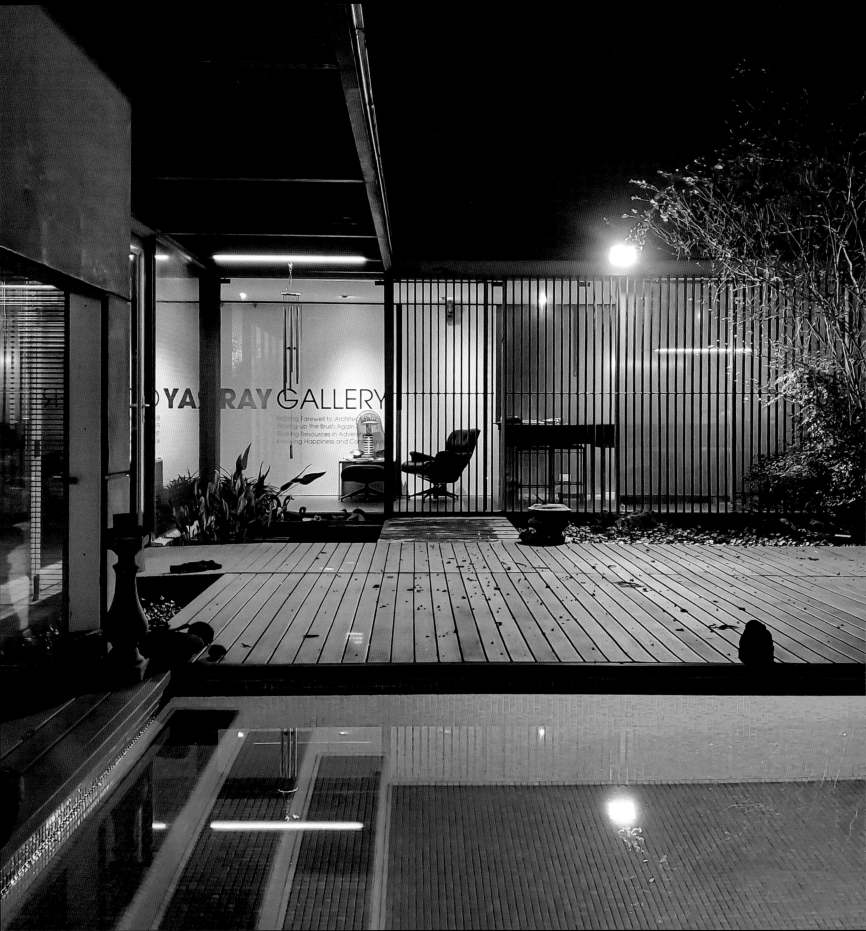

"班门"代表建筑师，"弄"是弄堂，亦可作动词，含"玩弄"之意；指一所让建筑师把玩的居亭。

"Archi" represents the architect, while "villa" refers to a spacious residential space, which can also be used as a verb (in Chinese), meaning "to play with". Together, the name refers to a residential pavilion designed and to be played with by an architect.

班门弄 Archivilla ｜ 2002

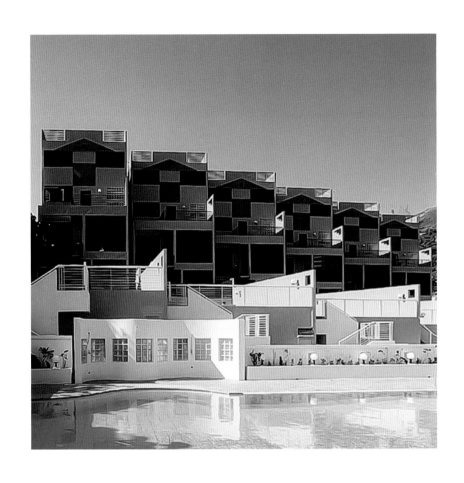

洋房的设计流露着现代建筑的风格，与赤柱的休闲气息不谋而合。

The design of the western-style houses exude a modern architectural style that blends seamlessly with the leisurely atmosphere of Stanley.

赤柱滩道五号 Stanley Crest No. 5 | 1988

阳明山庄是20世纪八十年代中国香港最豪华的屋苑，更是引入住客会所的先例。

The Hong Kong Parkview was the most luxurious residential estate in Hong Kong, China in the 1980s, and set a precedent for the introduction of clubhouse facilities for residents.

阳明山庄 Hong Kong Parkview | 1985

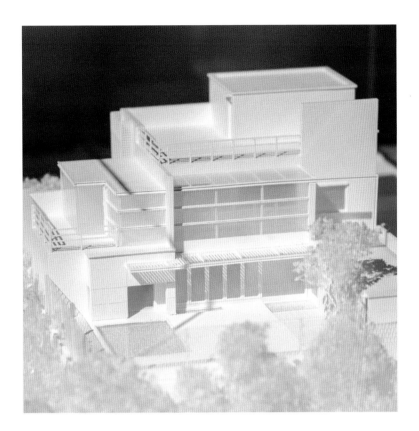

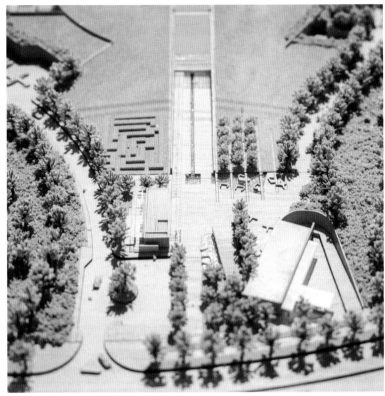

班门弄 Archivilla
建筑模型 Architectural Model

香港湿地公园 Hong Kong Wetland Park
建筑模型 Architectural Model

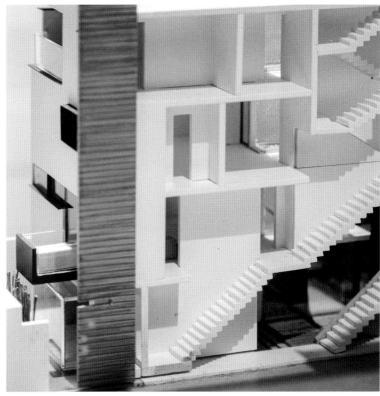

香港尖沙咀海旁餐厅 Tsim Sha Tsui Promenade Restaurant
建筑模型 Architectural Model

渭州道独立屋 Private House on Wiltshire Road
建筑模型 Architectural Model

得到了什么

WHAT HAVE I GAINED

什么

冯永基是杰出的中国现代水墨画家，也是多年来带领建筑署团队追求设计卓越的建筑师，更是一位热心投身城市空间文化改革的香港市民。同时作为画家与建筑师的冯永基，在他的建筑作品里表现了什么设计特色，哪些是与他的绘画世界交错叠合的？又有哪些是与绘画平行而互补的发展？

20世纪上半叶，现代建筑的发展在多方面受到现代绘画的启发。除了熟知的柯比意（Le Corbusier)和立体派绘画的关系，密斯凡德罗（Mies van der Rohe）和莱特（Wright)建筑平面构成也受到了荷兰画家蒙德里安（Mondrian)与风格派艺术的影响。在冯永基的私人住宅、室内设计以及建筑设计作品中，我们除了可以从风格派艺术的特色，看到他对空间形式元素的构成与立面层次的掌握，更可看到冯永基经由对建筑元素的材质与建构表现，展现出他对细部设计的驾驭能力。而在冯永基的水墨画世界里，无论主题形式如何演变，我们总能看到他驾轻就熟地掌握平面构成，抽离和界定元素，形成层次叠加的空间深度。

荷兰风格派艺术（De Stijl)除了蒙德里安，艺术家凡杜斯布赫（Van Doesberg)进一步将风格派绘画"新雕塑主义"（Neo-Plasticism)发展成为空间的组合元素。风格派健将李特维德（Rietveld）在其家具与住宅设计中，将弹出式平板、阳台等实用空间元素从立方体的墙体向外拉出，使之成为浮动的层板与脱离重力的雕塑表现。李特维德的实验住宅清楚表达了建筑墙体与楼板作为独立构成元素，脱离立方块的面皮，和柯比意住宅系列骨皮分离的理论不谋而合，影响到八十年代纽约五人组的白派风格。

密斯·凡·德罗在早年的设计提案中采用透视图拼贴的艺术手法，表现出他对建筑材质与空间层次的深刻思考。在巴塞罗纳展览馆中，密斯透过摄影媒介彰显了建筑的双重形式：空间与材料的矛盾与暧昧特质，包括室内外空间的隔墙、地板与水池；玻璃与金属、玛瑙与大理石、石灰岩与混凝土的材质对比与层次，光影的反射与沉淀，形成了空间真实与虚幻的美感叠加。而密斯的空间层次与材质美学，更隐藏在他精准的构造细部之中。

作为能精湛掌握现代建筑语汇的建筑师，冯永基建筑里的风格派形式，与空间层次的材质表现有什么独特的意义？

回答这个问题，我们必须把冯永基的设计作品放在香港战后现代建筑的发展语境下来看。八十年代的香港建筑，虽然先后有外来的汇丰、中银大楼等经典作品，但随着上一代优秀建筑师如葛登布朗，木下一、何弢等人逐渐的淡出执业舞台，九十年代的建筑在商业地产与后现代的语境下面临了设计形式论述的真空。标志性公共建筑如文化中心、艺术馆、科学馆、中央图书馆等的先后建成后，我们看到香港建筑与构造形式的困境：因法律规范与预算机制对面积效益的要求颇高，建筑逐渐放弃了早期与现代建筑的回廊出檐等室内外间珍贵的过渡性空间。在失去了早期现代建筑简洁朴素的空间表现后，富裕社会提出对提升建筑材质的期望，以厚重混凝土框架结构为主的的大型建筑日益占据主导，但设计上的回应却很无力——只能以磁砖石材或铝板表皮包裹加上后现代时尚的造型。而冯永基的住宅设计和他在建筑署参与的公共建筑项目，就针对了这个设计真空的年代，他用建筑风格派的形式语汇来表达建筑材质与建构的关系，以混凝土的重与钢构木板的轻再建材料，为香港建筑带入一股新的生命力。

层次与构成

冯永基美学能力突出，他在建筑的立面与室内设计中，充分发挥了作为画家的平面构图能力，驾轻就熟地从立面中抽离建筑元素，创造出丰富的立体构成。这些构成元素与层次透过冯永基熟练的构图得到组合——无论是垂直墙体凸显或水平楼板出挑，还是适当用阳台或遮阳板为室内外之间提供关键的过渡层次。在西贡图花源、班门弄的立面、维多利亚公园和湿地公园的建筑，冯永基都采用了这样的设计手法，在混凝土主体结构外加上了一个钢构造与玻璃的空间层次。除了提供遮阳避雨的过渡空间环境，更在混凝土"重"的视觉效果外，加上一层钢构造"轻"的美学表现。

除了对隔墙、门板、等元素的层次界定，无论是墙板的横竖分割，还是天花与吊灯钢丝的垂直线条，冯永基的室内空间都印证了他对线与面的调控能力，对整体与细节的重视。正如风格派艺术家凡杜斯布赫在室内设计的雕塑和材料中展现出的个性，冯永基的室内设计也轻松地展现了他对材料的敏感度，以及他作为画家对材料质感的执着。

材料与建构

面对香港八十年代建筑材质美感的贫乏，与公共建筑的混凝土磁砖文化盛行，冯永基努力突破框架，在建构中加入新的构成元素与层次，采用木地板与木百页等自然材料，以及轻构造表现的钢和玻璃。而在建筑署的多个公共建筑里，除了在公共空间使用大量的室外木地板，还使用了粗犷的毛石与细致的清水混泥土，再加上维多利亚公园建筑的玻璃砖、尖沙咀海滨长廊的丰富铺地、湿地公园的蚝壳墙体，这些都是冯永基和他的同事们争取耕耘的成果。

建构的逻辑与诗意离不开建筑的材料美感。作为建筑师，冯永基对结构的构造与材料的构成都是严谨的。无论从班门弄的窗框楼板与木地板的叠合关系，或从图花源的木百叶、冲孔版、钢索与骨架的交接系统，冯永基都能清楚展现他对细部设计与工艺的功力。无论是尖沙咀海滨走廊的清水圆柱与工字梁、L型百叶与顶层玻璃的构建，或是西贡公众码头与广场凉亭的构造，冯永基和他建筑署的同事都能形成了一种遮阳避雨的功能逻辑。

文化与地景

从尖沙咀、西九龙和西贡海傍的公共空间，到维多利亚与湿地公园的地景，冯永基传承风格派的现代建筑语汇，从立体雕塑的层次逐渐拓展向大地与自然地景。

在西贡海傍由万宜游乐场到公众码头的系列广场空间中，冯永基及其团队成功融合了建筑、自然景观与环境艺术，他们将建筑的玻璃钢架凉亭、廊道与木铺地穿插进老社区原有的庙宇、球场与校舍之间，将空间延伸至海岸的码头长廊与探知馆前地，结合纸船的公共艺术，使这片区域成为香港最成功的城市空间之一。作为艺术家，冯永基还运用折纸的公共艺术形式，在其他建筑的公共广场与地景上成功融合了建筑、景观与城市的空间文化与环境艺术，例如香港湿地公园的草坡地景，爱丁堡广场的雕塑剪影，尖沙咀百年纪念公园的植栽、铺地与雕塑。

冯永基关心香港设计发展，对建筑文化的推动永远是热情洋溢而义不容辞。犹记得我在2007年担任香港首届建筑双年展策展人时，冯永基是大馆

展览能够冲破层层关卡、顺利推进的幕后主力之一。2018年，作为威尼斯建筑双年展的香港展馆策展人，我很高兴邀请到冯永基参与"垂直肌理100个塔楼"的主题设计，并请他提出对香港高密度塔楼的构想，思考自由空间的塔楼类型。在面积为36平方厘米、高度为2米的有限空间内，冯永基提出的不是具象的建筑空间形式，而是抽象的艺术概念与草根的文化符码：象征香港高密度空间的、在长方盒内最能紧密排列的鱼蛋丸。我看了冯永基兼具幽默与批判的答案后不禁莞尔，这应该是他对建筑与艺术之间无限可能的注脚。

王维仁

香港大学建筑学院教授

Raymond is an outstanding contemporary Chinese ink painter, an outstanding architect who has led his colleagues at the Architectural Services Department to pursue design excellence for many years, and a passionate resident of Hong Kong who has devoted himself to cultural reform in urban spaces. As both a painter and an architect, what design features does Raymond incorporate into his architecture, and how do they intersect with his world of painting? What parallel and complementary developments can we observe?

In the first half of the twentieth century, modern architecture was inspired by modern painting in many ways. In addition to the well-known relationship between Le Corbusier and Cubism, we see the influence of the Dutch painter Mondrian and the De Stijl movement on architects such as Mies van der Rohe and Wright, who were adept at creating flat planes and constructing space. In Raymond's residential, interior and architectural designs, we can see not only the characteristics of the De Stijl movement, but also his mastery of spatial elements and façade hierarchy. Through his use of material and construction in architectural elements, we can see his ability to control the details of design. In Raymond's world of ink painting, regardless of the evolution of themes and forms, one can always see his adeptness at composing flat planes, extracting and defining elements, as well as creating layered spatial depth.

In addition to Mondrian, artist Van Doesberg further developed the De Stijl movement's "Neo-Plasticism" into a combination of spatial elements. In the furniture and residential designs of De Stijl pioneer Rietveld, functional space elements such as pop-out flat panels and balconies were pulled outward from cube-shaped walls to create floating slabs and sculptures that transcended gravity. Rietveld's experimental homes clearly demonstrate the independence of building walls and floors as composition elements separate from the surface of the cube, echoing the theory of the dissociation of structure in Le Corbusier's housing series, which in turn influenced the White Style of the New York Five in the 1980s.

In his early design proposals, Mies van der Rohe demonstrated his profound pondering on architectural materials and spatial hierarchy through collages of perspective drawings. In the Barcelona Exhibition Hall, Mies showcased the dual forms of architecture through the medium of photography: the contradictory and

ambiguous traits of space and material, including partition walls, floors and water pools that separate indoor and outdoor spaces; and the contrasting and layered materials of glass and metal, agate and marble, limestone and concrete, with the reflection and precipitation of light and shadow, forming a superimposed aesthetic of space that is both real and illusory. Mies' sense of space and material aesthetics are further hidden in his precise structural details.

As an architect with a superb command of modern architectural vocabulary, what unique significance does Raymond's expression of De Stijl form and style in his buildings, along with material expression of spatial hierarchy, hold?

To answer this question, we must look at Raymond's design works in the context of the development of post-war modern architecture in Hong Kong. In the 1980s, as the previous generation of outstanding architects such as Gordon Brown, James Hajime Kinoshita and the late Ho Tao gradually retired from the practice, although classic works such as the HSBC and Bank of China buildings were completed one after another, the architecture of the 1990s was faced with a vacuum of design discourse in the context of commercial real estate and post-modernism. With the completion of iconic public architectures such as the Cultural Centre, Art Museum, Science Museum and Central Library, we see the dilemma of Hong Kong's architecture and construction forms: as regulations and budget mechanisms demand area efficiency, architectures gradually abandoned the valuable transitional spaces between indoors and outdoors, with verandas and eaves that were present in early and modern architecture. After losing the simple and plain spatial expression of early modern architecture, faced with society's expectations for the improvement of building materials, large architecture with heavy concrete frame structures have increasingly dominated, but design can only respond with skin coatings of ceramic tiles, stone or aluminum panels, along with post-modern fashion styling, resulting in a powerless response. However, Raymond's residential designs and his participation in public architectures at the Architectural Services Department targeted this era of design vacuum. By using the formal vocabulary of the De Stijl movement to express the relationship between building materials and construction, and by constructing with a mix of concrete weight and steel-wood panels' lightness, he brought a

new vitality to Hong Kong's architecture.

Layers and Composition

Raymond Fung, a highly skilled architect with an exceptional aesthetic sense, fully utilises his abilities as a painter to detach the architectural elements from the façade and create rich three-dimensional compositions. He skillfully combined the composition of these elements with layers, be it the protrusion of a vertical wall, the projection of a horizontal floor slab, or the appropriate use of balconies or sunshades to provide critical transitional layers between indoor and outdoor spaces. Whether in the façades of the Sai Kung Flower Box or Archivilla, or in the architectures of the Victoria Park and the Wetland Park, Raymond's design technique of adding a steel structure and glass layer outside of the main concrete structure provides not only a transitional space for shade and rain protection, but also adds a layer of aesthetic expression through a light steel structure in contrast to the heavy visual effect of concrete.

In addition to defining the layers of elements such as partitions and doors, Raymond's interior space, whether it be the horizontal and vertical division of wall panels or the vertical lines of ceiling and pendant lights, demonstrates his ability to regulate lines and surfaces and his emphasis on the overall and details. Just as the sculptural and material personality was shown in the interior design of De Stijl artist Van Doesburg, Raymond's interior design effortlessly exhibits his sensitivity to materials and his persistence as a painter in terms of material texture.

Materials and Construction

Faced with the lack of material beauty in Hong Kong's architecture in the 1980s and the concrete brick culture in public architectures, Raymond strives to break through the framework by using new compositional elements and layers, incorporating natural materials such as wooden floors and wooden venetian blinds, and incorporating light steel and glass into their construction. In multiple public architectures at the Architectural Services Department, in addition to using a large amount of outdoor wooden flooring in public spaces, there are also rough stones, delicate fair-faced concrete, the glass bricks of Victoria Park's buildings, the rich paving of the Tsim Sha Tsui waterfront promenade, and the oyster shell walls of the Wetland Park, all of which are the fruits of

Raymond's and his colleagues' efforts.

The logic and poetry of construction cannot be separated from the beauty of materials in architecture. As an architect, Raymond is rigorous in the construction of structures and the composition of materials. Whether it is the overlap relationship between the window frame floor slab and wooden floor in Archivilla, or the joint system of wooden venetian blinds, perforated plates, steel cables and structural skeletons in the Flower Box, Raymond can clearly demonstrate his proficiency in detailed design and craftsmanship. In the construction of the clear water columns and I-beams, L-shaped louvers, top glass of the Tsim Sha Tsui waterfront promenade, as well as the public pier and plaza pavilion in Sai Kung, Raymond and his colleagues in the Architectural Services Department have also formed a functional logic for their structures that act as a shade and rain shelter.

Culture and Landscape

From the public spaces along Tsim Sha Tsui, West Kowloon and Sai Kung's waterfront to the landscapes of the Victoria Park and the Wetland Park, Raymond inherits the vocabulary of modern architecture from the De Stijl movement, gradually expanding from three-dimensional sculptures to the earth and natural landscapes.

Raymond and his colleagues have successfully combined architecture, landscape and environmental art in a series of plaza spaces along the coastline from the Man Yee playground to the public pier in Sai Kung. They incorporated the architecture's fiberglass pavilions and corridors, wooden floorings with existing temples, playgrounds and schools of the old community, leading the space towards the pier promenade and the plaza in front of the Discovery Centre. Combined with the paper boat public art, this area has become one of the most successful urban spaces in Hong Kong. As an artist, Raymond has also successfully integrated architecture, landscape, and environmental art in other public plazas and landscapes using origami-inspired art forms. Whether it is the grassy knolls of Hong Kong Wetland Park, the sculptural silhouettes of Edinburgh Square, or the plantings, flooring and sculptures of the Tsim Sha Tsui Centenary Memorial Park, Raymond has skillfully combined the cultural and environmental elements of architecture, landscape and urban space.

Raymond, who cares deeply about the development of design in Hong Kong, is always enthusiastic and committed to promoting architectural culture. I remember when I curated the first Hong Kong Biennale of Architecture in 2007, he was one of the key players who helped to overcome the various hurdles behind the scenes, ensuring the smooth progression of the exhibition at the Hong Kong Cultural Centre. Ten years later, in 2018, as the curator of the Hong Kong Pavilion at the Venice Biennale of Architecture, I was pleased to invite Raymond to participate in the theme design of "Vertical Fabric: Density in Landscape". I asked him to propose his vision for high-density towers in Hong Kong, and to consider the possible types of towers for free-space living. Within a restricted space of 36 square centimeters and 2 meters high, Raymond proposed not a concrete architectural form, but an abstract artistic concept and grassroots cultural symbol—the fish balls, which were very tightly arranged in a rectangular box, symbolising the high density of Hong Kong. His answer, which was both humorous and critical, made me smile with appreciation, as it is perhaps his footnote on the endless possibilities between architecture and art.

Wang Weijen

Professor, School of Architecture, University of Hong Kong

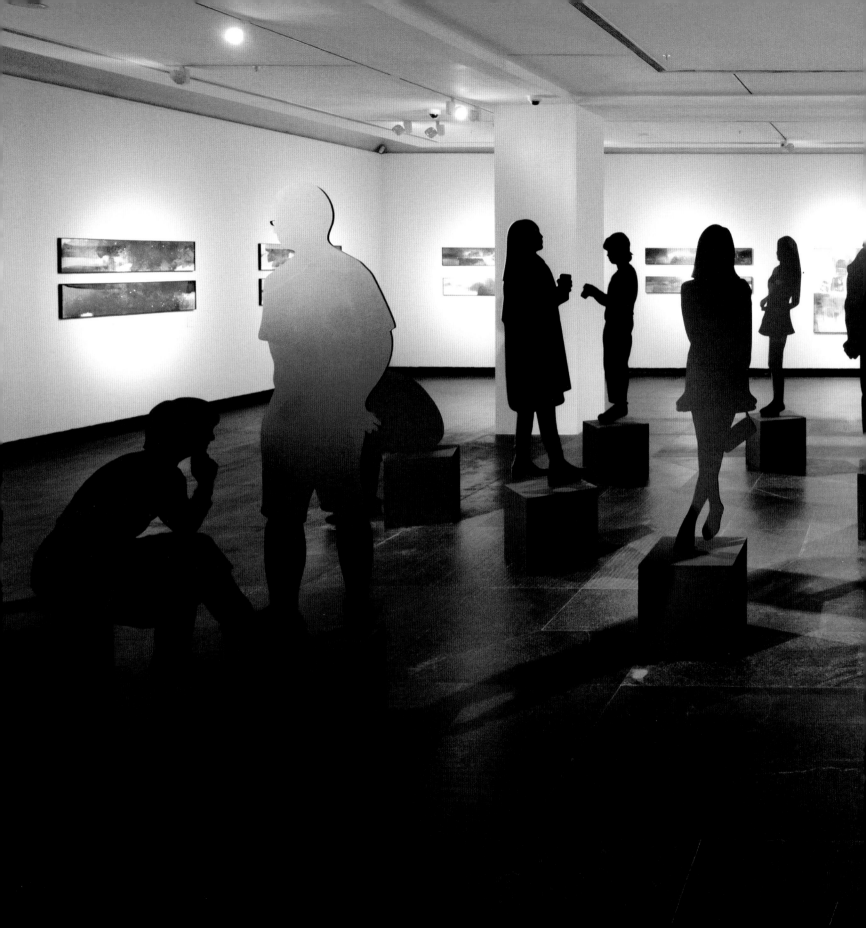

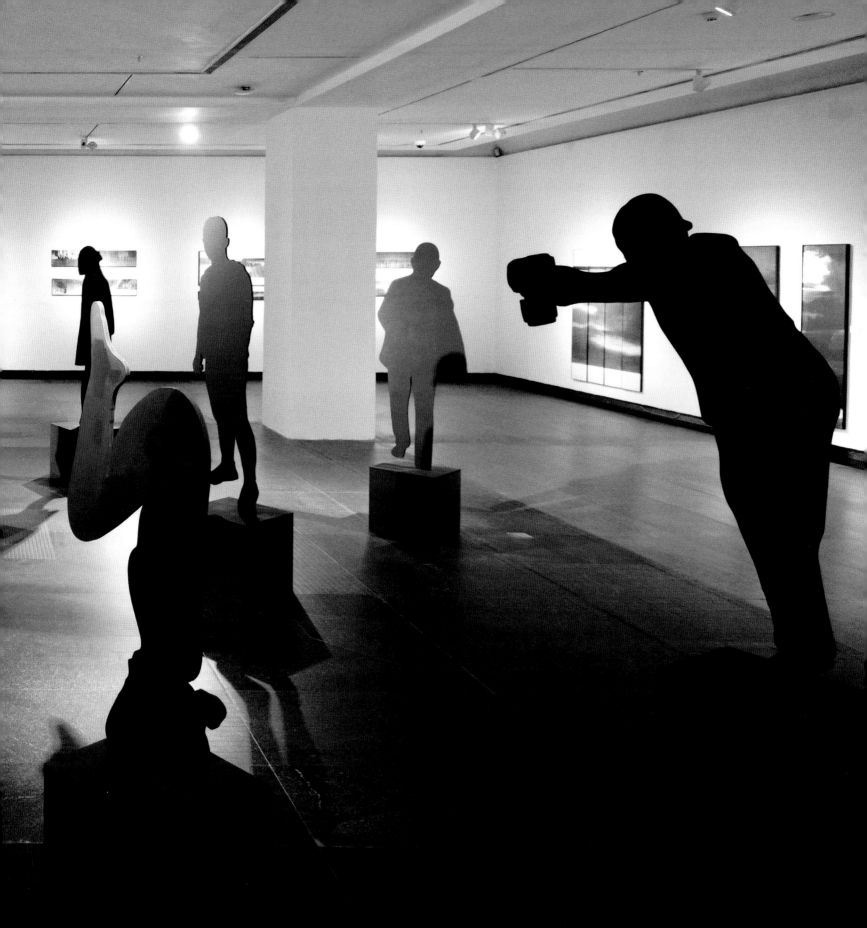

若一種食物帶著一種魔法，不知你會吃下多少種魔法？

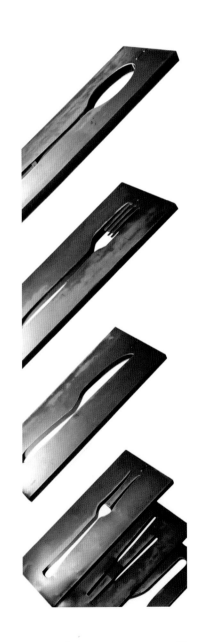

刀叉 knife and fork
位于尖沙咀海旁的裝置 Installation at Tsim Sha Tsui Waterfront │ 140 X 30cm │ 2023

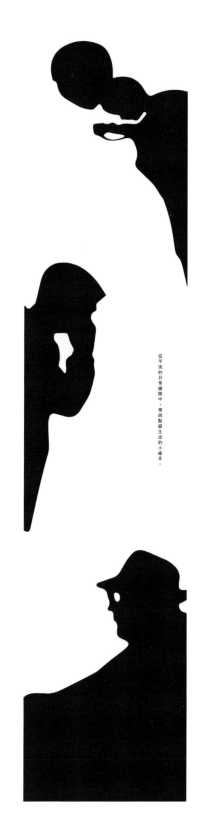

從平淡的日常縫隙中，尋回點綴生活的小確幸。

剪影 Silhouettes
位于爱丁堡广场的装置 Installation at Edinburgh Place │ 140 X 30cm │ 2023

承載感謝與念想的紙飛機，隨風來到你身旁。

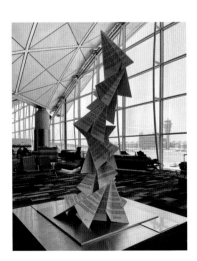

折纸飞机 Origami Aeroplane
位于香港国际机场的装置 Installation at Hong Kong International Airport ｜ 140 X 30cm ｜ 2023

瓦片 Tiles
曾展出于香港艺术馆的艺术装置 An installation exhibited at the Hong Kong Museum of Art ｜ 140 X 30cm ｜ 2023

將瓦片化作蝶燕，老宅龍述出心底話，你又希望與誰人對話？

遙遠的路程，已不再是不可觸碰的距離。

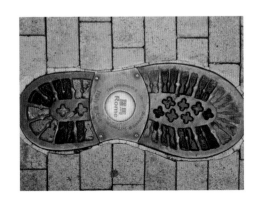

鞋印 Shoe Prints
位于尖沙咀百年纪念公园的装置 Installation at Centennial Park, Tsim Sha Tsui ｜ 140 X 30cm ｜ 2023

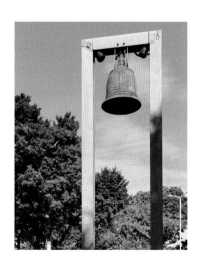

铜钟 Bronze Bell
位于西贡视觉走廊的装置 Installation at Saigon Visual Corridor ｜ 140 X 30cm ｜ 2023

就讓昔日的玩意、昔日的記憶，幻化為一種情懷。

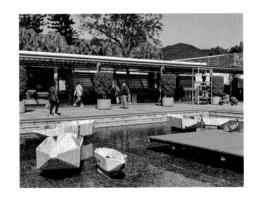

纸船　Paper Boats
位于西贡海滨公园的装置 Installation at Sai Kung Waterfront Park ｜ 140 X 30cm ｜ 2023

這橢殼砌成的影壁背後，又藏了一個怎樣的後花園？

蚝壳 Oyster Shells
位于香港湿地公园的装置 Installation at Hong Kong Wetland Park ｜ 140 X 30cm ｜ 2023

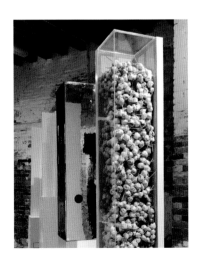

威尼斯建筑双年展 - 鱼蛋 Venice Biennale of Architecture - Fishball
装置艺术 Installation │ 2018

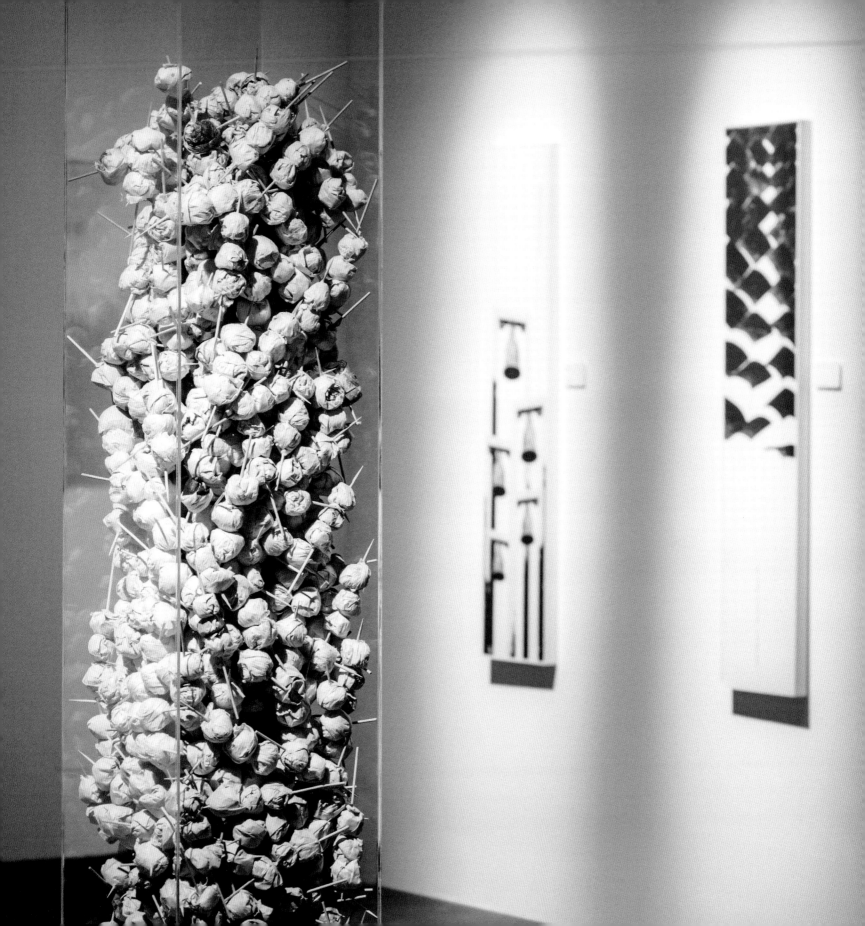

放弃了什么

WHAT HAVE I FOREGONE

熟悉中国近现代艺术史的人都知道，20世纪六十年代，还在大陆艺术家极力强调为现实政治服务的时候，身处海外与港台的艺术家因为处在比较宽松的文化背景之中，故早有与世界现代艺术同步的探索。譬如，身处法国的赵无极与身处香港的吕寿琨，还有身处台湾的刘国松等人，已经在积极探索将西方抽象艺术的观念与技法引入水墨画，结果也引发了抽象水墨的诞生。从艺术史的角度看，这绝对是具有转折意义的大事，故很值得学者们认真研究。事实上，他们所确立的这一伟大艺术传统，只是到改革开放以后才传入大陆，由此不仅引发了抽象水墨在大陆的出现，也大大促进了其发展，关于这一点，我们可以做专题研讨，在这里不宜多谈。

现有资料清楚表明，虽然艺术家冯永基先生早年曾师从何百里，进而以香港郊区的自然风景作为对象，创作了一些类似于传统"岭南派"风格的作品。但自从于1984年接触到吕寿琨所倡导的香港新水墨运动后，他便在创作风格上发生了翻天覆地的变化。我甚至感到，正与台湾艺术家陈其宽先生一样，冯永基先生由于长期行走在建筑与绘画两大领域，加之在学习或借鉴西方现代抽象艺术时，特别注重加强与传统文脉的内在联系，所以便给新水墨的发展带来了具有个人特点的探索方案，而这无疑对于海内外从事新水墨的艺术家都有所启示。

出于孤陋寡闻之故，过去我对冯永基先生与作品并不了解，近日通过认真阅读他的作品，以及皮道坚老师与王绍强馆长的文章，方才有了大开眼界之感。

在我看来，如果严格按西方抽象艺术原教旨的定义加以衡量，冯永基先生的大多数作品都算不上纯粹的抽象艺术，所以我倾向于认为，他的相关作品更应该属于"半抽象艺术"的范畴。

那么，何为我所说的"半抽象艺术"呢？一部艺术史告诉我们，西方原教旨的抽象艺术乃是在反对传统写实绘画与学院派的背景中诞生的，其首先强调画面上的纯粹构成效果，即重视对画面空间的表现以及对点线面的安排，以追求音乐一般的视觉效果。另外，强调相关艺术家在创作中必须抛弃任何对自然外表和语义信息的表现，为的是排除观众看画时产生任何对自然现象和非艺术主题的联想。以最早的"青骑士"康定斯基的绘画艺术中的绝对抽象语言为例，他其实是想借助于音乐的声律来解决欣赏者对画面的解读。而所谓抽象性也是依附人们对音乐的具体情感节奏来理解的。从此出发，我们不难发现，冯永基先生多年来不断推出的许多作品，显然

已经有意无意地偏离了西方正宗抽象艺术的定义与方向，这也使他走出了一条完全不同于西方抽象艺术的发展路子。正是基于这方面的考虑，我认为是不是还要用抽象艺术的概念来加以定义他的艺术值得商榷。由于尚未找到更好、更准确的概念，我在这里且以 "半抽象艺术" 的说法来称呼他的相关作品——意指其实际处在了纯粹的抽象艺术与具象艺术之间。

概括地看，冯永基先生的"半抽象艺术"有以下两大特点：其一是具有"意向化"特点，其二是具有"符号化"特点。

应该说，属于前者范畴的作品，要么强调从传统文化，如山水画中汲取营养，要么强调从自然现象中汲取营养，然后再进行升华，进而转换为艺术作品。代表性作品有《七拾》等等。若以艺术史作为线索，这一艺术传统最早是由旅法艺术家赵无极建立起来的。1957年他在美国接触到抽象表现主义绘画后，因颇受震动，便毅然放弃了先前用象形文字符号进行象征表现的创作路子，转向了更加直接表述精神、宣泄情感的表达方式。加上曾经深受中国传统文化的浸润，赵无极在努力追求将抽象审美与精神意境相结合时，还试图从对传统艺术与自然景观的直觉感悟中升华出较为抽象的艺术语言，故让人常常能够通过画面中那迅捷洒脱的笔触、朦胧幽深的空间、依稀可辨的山水韵味生发出许多审美的联想。这是以中国传统意象美学为根基的"半抽象"形态绘画，既表现了天人合一、虚静忘我的艺术境界，又没有简单照抄古代绘画；既突出了抽象绘画中超理性、无指向性或自足性的特点，又成功地拉开了与西方抽象绘画的距离。按我的理解，在很大程度上，赵无极是通过西方重新发现了东方，他给相关中国艺术家的重要启示是：在向欧美抽象艺术学习或借鉴的过程中，努力吸收其有价值的东西是很有必要的，但同时还应该想办法从传统中寻求具有现代价值的东西加以转换！

相对而言，冯永基先生属于后者范畴的作品要更多一些，其创作特点就是或者注重从传统山水画与近现代的文化物，或者注重从自然现象中提取一些文化符号来进行艺术表达。这类作品大都具有抽象和具象的两极意义：首先，画面中的具体符号无疑是较为具象的；其次，它们被艺术家加以处理之后，在画面上具象的意义就消失了，而观念的信息则会涌现。如《难忘时分》《细说当年》《六拾》等作品就非常说明问题。还需指出的是，在具体的表现过程中，冯永基先生特别强调对传统水墨表现手段的转换与借用，即不仅仅注意将书法线条的中锋或侧锋、圆润或干涩、隐与显、宽与细的变化，还有大泼墨的手法巧妙的转换到画面上，同时十分注意画面线条与块面之间的对比，结果也有效强调了对于绘画过程中有关时间性的表达，对此，我们怎么评价都不为过！

鲁虹

2023年5月26日于武汉合美术馆／

四川美术学院教授
武汉合美术馆执行馆长

Those familiar with the history of modern and contemporary art in China know that in the 1960s, when Chinese Mainland artists were emphasising on serving political reality, artists in overseas, Hong Kong and Taiwan were already exploring modern art in sync with the world due to their relatively relaxed cultural background. For example, Zao Wou-Ki in France, Lui Shou-kwan in Hong Kong, and Liu Guosong in Taiwan had already been actively exploring the introduction of Western abstract art concepts and techniques into ink painting, which also led to the birth of abstract ink painting. From the perspective of art history, this was definitely a significant turning point and worthy of serious study by scholars. In fact, this great artistic tradition they established was not introduced to the Mainland until after the reform and opening up, which not only led to the emergence of abstract ink painting in Chinese Mainland but also greatly promoted its development. We could have a special seminar on this topic, but we won't discuss it much here.

Existing information clearly shows that although the artist Mr. Raymond Fung was taught by He Baili in his early years and created some works similar to the traditional "Lingnan School" style with Hong Kong's suburban natural scenery as the subject, he underwent a revolutionary change in his creative style after being exposed to the Hong Kong New Ink Movement advocated by Lui Shou-kwan in 1984. I even feel that, like the artist Chen Chi-kwan from Taiwan, Mr. Fung's long-term experience in both the fields of architecture and painting, along with his emphasis on strengthening the internal connection with traditional context when studying or drawing on Western modern abstract art, has brought a personal exploration plan with individual characteristics to the development of new ink painting, which undoubtedly inspires artists engaged in new ink painting both at home and abroad.

Due to my own ignorance in the past, I was not familiar with Mr. Fung and his works. However, after carefully studying his works and the articles by Mr. Pi Daojian and Director Wang Shaoqiang, I have now broadened my horizons.

In my opinion, if we strictly measure Mr. Fung's works according to the definition of Western abstract art, most of them cannot be considered purely abstract art. Therefore, I tend to think that his related works should belong to the category of "semi-abstract art".

What do I mean by "semi-abstract art"? Art history tells us that Western pure abstract art was born in the context of opposing traditional realistic painting and academicism. It first emphasises the pure compositional effect on the picture, that is, it values the expression of the picture space and the arrangement of points, lines, and planes to pursue a musical-like visual effect. In addition, the relevant artists emphasise that they must abandon any representation of natural appearance and semantic information in their creation, in order to exclude any association with natural phenomena and non-artistic themes when the audience views the painting. Taking the absolute abstract language in the painting art of the earliest "Der Blaue Reiter" by Kandinsky as an example, he actually wanted to use the sound of music to solve the viewer's interpretation of the picture. The so-called abstraction is also understood through people's specific emotional rhythms in music. From this perspective, it is not difficult to find that many of Mr. Fung's works over the years have obviously deviated intentionally or unintentionally from the definition and direction of Western pure abstract art, which has led him to embark on a development path that is completely different from Western abstract art. Based on these considerations, I think it's worth discussing whether the concept of abstract art should still be used to define his art. As I have not found a better or more accurate concept, I use the term "semi-abstract art" to refer to his related works—meaning that they are actually between pure abstract art and figurative art.

In summary, Mr. Fung's "semi-abstract art" has the following two characteristics: Firstly, it has an "intentionality" feature, and secondly, it has a "symbolic" feature.

It can be said that the works belonging to the former category

either emphasise drawing nutrients from traditional culture, such as landscape paintings, or drawing nutrients from natural phenomena and then sublimating them into art works. Representative works include *Qī Shí*. If we take art history as a clue, this artistic tradition was first established by the artist Zao Wou-Ki, who was studying in France. After he was exposed to abstract expressionist painting in the United States in 1957 and was deeply shocked by it, he resolutely abandoned his previous creative approach of using pictographic symbols for symbolic representation and turned to a more direct expression of spirit and emotional release. In addition, having been deeply influenced by traditional Chinese culture, Zao Wou-Ki tried to sublimate a more abstract artistic language from his intuitive perceptions of traditional art and natural landscapes when he was striving to combine abstract aesthetics with spiritual mood. Therefore, one often associates many aesthetic associations with his paintings through the swift and free brushstrokes, hazy and profound space, and discernible landscape charm in the picture. This is a "semi-abstract" form of painting based on Chinese traditional image aesthetics, which not only embodies the artistic realm of unity of nature and man as well as emptiness and tranquility, but also does not simply copy ancient paintings; it highlights the characteristics of irrationality, non-directedness, or self-sufficiency in abstract painting, while successfully distancing itself from Western abstract painting. In my understanding, to a large extent, Zao Wou-Ki rediscovered the East through the West. His important revelation to relevant Chinese artists is that while it is necessary to absorb valuable things from learning or referencing Western abstract art, they should also find ways to transform things with modern value from the tradition.

Relatively speaking, Mr. Fung's works belong more to the latter category, and his creative characteristic is either to focus on drawing from traditional landscape paintings and cultural objects from modern times, or to extract cultural symbols from natural phenomena for artistic expression. These works mostly have both abstract and figurative meanings: first, the specific symbols in the picture are undoubtedly more figurative; secondly, after being processed by the artist, the figurative meaning disappears on the picture, and conceptual information emerges instead. Works such as *The Unforgettable Moment*, *Once Upon a Time*, and *6 Ten* are excellent examples of this. It should also be noted that in the concrete process of expression, Mr. Fung particularly emphasises the transformation and borrowing of traditional ink and wash techniques, not only paying attention to the changes of the central or side strokes, roundness or dryness, hiddenness or visibility, width or fineness of calligraphic lines, but also skillfully transferring the technique of splashing ink onto the picture. At the same time, he pays great attention to the contrast between the lines and the blocks on the picture, which effectively emphasises the expression of temporality in the painting process. We cannot overemphasise the value of this approach!

Lu Hong

26th May, 2023
United Art Museum, Wuhan

Professor, Sichuan Fine Arts Institute
Executive Director, United Art Museum, Wuhan

冯永基所描绘的不是风景,而是这片土地的情感实质。 — Katie Hill

这场回顾展记录了杰出建筑师和艺术家冯永基教授生命的七个十年,首次汇集其广泛的创作,追溯自20世纪八十年代以来其艺术生涯的演变。冯氏于9岁时,首次为他"生于斯,长于斯"之地的香港作画,这幅早期的针笔画展示了他对城市景观细致入微的描绘,也体现了他年少时便对建筑和空间的敏锐直觉。在之后的艺术实践中,这些线条完全消失,取而代之的是湿润的大笔触,让墨料可在宣纸中自然渗透。在平衡虚与实、空间与体量的关系中,他逐渐发展出一种抽象风格,以回应现代主义水墨画的传统。这些创作所激活的意象真实与虚幻并存。在他的许多作品中,香港土地和岛屿的轮廓被精心绘制的水墨线条勾勒出来,并通过一种奇妙的转换手法变得普遍且永恒——意象不再指一个具体的场域,而是走向了中国诗歌和哲学传统中呈现精神维度的宇宙观。

冯永基的艺术语言植根于自20世纪五十年代以来在东亚发展起来的当代中华抽象艺术,博采众长,融合了不同艺术流派的元素:现代主义、战后抽象绘画以及在过去20年间蓬勃发展的当代水墨。解读他的作品需要同时参照地区和全球艺术史:中国抽象艺术的先驱是五十年代中期台湾的五月画会,以及在香港由吕寿琨领导的新水墨运动——这个团体在六十至七十年代期间获得了空前的成功,是香港现代艺术史的一个重要里程碑;在更广阔的背景下应看到东亚大都市中心之间的相互影响(如香港、上海、东京和台北)、战后全球抽象艺术的跨国发展以及冯氏于20世纪七十年代间在美国接受的建筑师培训。

冯永基出生于20世纪五十年代初的香港,他的一生跨越了这座城市战后数十年的时光。这一段引人入胜的历史涵盖了一个国际都市快速崛起的过程——从港英时期的重要贸易中心,至21世纪今日中国的大都会。在香港,节奏急促的商业界和新兴产业与杂乱无章的老巷形成鲜明的对比:考究的大型高层建筑、古旧的廉租房以及密集的商业街穿插着随处可见的咖啡馆、酒吧、精品店与小型文化空间,点缀以绚丽多彩的热带植物……除了城市景象,大自然也是香港风光中的常客,这在冯永基作品的空灵优美中便可见一斑——他从自身视角出发,试图远离拥挤的城市空间,唤起海湾与远景的意象……

此次展览取名为"七拾",可被解读为对冯永基成就的一次全面回顾。标题里的"拾"字,具有拾取或捡拾的含义。无论是作为年轻一代艺术家的

导师和榜样，还是作为身兼数职（艺术家、公共建筑师）的文化生产者，他所做出的贡献都应当被提及，因此观众可以从这场回顾展中，了解到冯永基对文化遗产的全心投入。透过冯氏自20世纪八十年代以来的艺术转变中，从各种具象题材（如竹子、山景或小猫）探索绘画技巧的小型作品，到长期以来对抽象山水形式的探索——于过去20年间，他在中国水墨画的谱系之下逐渐发展，并演变出了一种全新形态、且充满表达性的诗意诠释。冯永基于20世纪八十年代创作了一批探索抽象形式的绘画，展现出了他对黑色粗线条的钟爱，它们被粉红或橙色的斑块所切割、衬托——这是由20世纪画家发展起来的一种香港现代美学，代表人物为吕寿琨（1919-1975）。1954年，吕氏在香港举办了他的首个展览，在对水墨的创新探索之中开创了一种独特且充满活力的抽象形式（这对冯氏的影响得到了艺术家本人承认）。吕氏于20世纪七十年代创作的禅画是中国现代主义激进派的绝佳典范：极简主义的范式下结合了活泼的大笔触与红色的涂抹，加以生气勃勃的构图，演变出独一无二的美感。冯氏对这一传统的致敬可见于他充满活力的大泼墨，以及运用色彩来创造光感。

在冯永基的孩童时代，大规模移民给这片狭小的土地带来了严峻的住房危机。快速增长的人口挤进了现在可容纳超过 700 万人的垂直建筑物中。第二次世界大战结束后，人口在十年内从区区 60 万增加到 250 万；与此同时，数十万人为求谋生从大陆涌入，在脆弱的自建棚户区中过着一贫如洗的生活。今日的香港大都市是一个在高强度环境下各类元素堆积而成的迷人混合体，且近年来艺术界持续扩张，美术馆如雨后春笋般成立：翻新的香港艺术馆、新建的西九文化区及其旗舰建筑M+博物馆（其艺术展亭将举办冯永基的小型回顾展）。这个创新的建筑空间使他能够展示作为当代艺术家更具实验性的一面：一件由旗杆屋茶具文物馆的屋顶瓦片和乒乓球桌组成的装置作品充满了视觉冲击力，不仅象征着他对乒乓球这项运动的热情，还展现了他在跨学科和媒介创作的灵活度。这两个元素的结合将这城市的建筑遗产与日常愉悦的社交活动联系起来。整件作品横跨展览场馆的室内与室外空间，连接着里和外——就像是冯永基的生活和工作一般，在本土和国际之间游走。

作为深深投入香港生活和文化的居民与文艺领袖，冯永基融合了一种存在于香港历史内部的现代主义风格——基于国际性与本地性在香港总有碰撞冲突的事实。作为数十年来亚洲的主要经济中心的国际大都市，香港却仍存在其本土文化拥有极强独立性的悖论。例如，很少有香港建筑师拥有全球知名度，同时其艺术家也直到近期才被国际范围内的艺术界认可。

冯永基的生平中充满了有趣的轶闻：父亲的缺席，以及为此而杜撰"他去卖咸鸭蛋了"的故事——这是在20世纪五十年代香港的很常见的一种职业。冯永基提到："这个故事是小时候人们问及父亲时，妈妈教我的模范答案。"在这个小细节中，可以从字里行间解读出一系列社会问题，比如单身母亲应付爱管闲事的邻居、在经济不宽裕与社会成见下为生，还有一个小男孩对这些微妙社会张力的深刻洞察。在对香港街头文化的生动描述中，他回忆道，"每天下午四点，我喜欢去大笪地跳蚤市场看一个小贩用热麦芽糖画龙的表演。"冯氏出生于龙年，由于年份的特殊性，母亲自然地期望孩子能取得很高的成就——当然事实也的确如此。虽说没有受过系统的学术训练，冯永基的早期绘画仍经常得奖，他的杰出天分也逐渐崭露头角。然而，直至20世纪九十年代初，香港都不是一个欣赏艺术文化的城市——毕竟，在经济的高压下，绘画能有什么作用？比方说董建平等人于20世纪八十年代共同创立了艺倡画廊，其中很多客户对文化和艺术持有高度实用主义的态度，会要求与家具相匹配的画作。冯永基的绘画追求与香港城市文化的扩张和成熟同步，这些变化随着一座重要地标的落成而被记录下来，如冯氏的导师何弢于20世纪七十年代设计的香港艺术中心等。

冯永基的水墨画极具个人主义色彩，不仅对当代地方和文化环境做出回应，同时也与悠久的优美诗歌传统遥相呼应。他强化和扩展了水平和垂直的空间动态，应合着中国山水画派的核心理念。他虽突破了自宋朝（960-1279）年以来逐步发展的山水传统，其个人风格仍继承了他所认可的山水画大师的遗产。例如受人尊敬的明代大师石涛（1642-1707），同时冯永基也受到了现代画家张大千（1899-1903）的影响——其因使用飞溅的色彩和大面积抽象来对山水做出解读的华丽实验而闻名。

冯永基使用加长的卷轴组织水平和垂直空间。在他的立轴作品中，水平视点被分开以安排画面空间——这样整洁的绘画构图即可以看作是一个连续的整体，又是一系列的视觉元素的组合。他的作品极简、抽象、简洁，但散发出一种充满激情和雄辩的诗意感性。其中的细节丰富多彩，同时清晰可辨的纹理、斑点和色调将观众带入一个更加错综复杂的世界——而其中墨的色调、裂缝和饱和度是打开大门的钥匙，精心地与深浅颜色各不相同的调性融合。捏碎的纸张被用来创造景深和裂缝，这也是当代许多画家使用的技术，例如活跃于五十、六十年代中国现代主义前沿的刘国松。

如果仅看此次展出的作品的外表，便不会意识到其背后制作工艺的复杂——这是一项要求处理画面张力时能够收放自如的高超技术，需要对运

笔的技法和纸张的吸水性有着深刻的理解和熟练的掌握。冯氏提及他很早便认识了实虚规则的必要性，并试图将这一原则运用到绘画中。正如油画家使用工具来制造纹理和表面效果一样，水墨画家也在尝试推动媒介的进步。在2020年新冠肺炎时期创作的《生命》系列中，冯永基使用保鲜膜做出褶皱，将墨通过按压融入画面，以实现一种叶片的质感。正如在3812画廊的展览图录中所提及的，这个系列集中展现了他对生命、呼吸以及环境的关注。同时，他对自然的自觉审视也与岭南画派大师杨善深的作品相呼应。

水墨的地形地貌学："黑或白，空或满"

研究香港这座城市有助于我们从地理和美学层面上理解战后水墨艺术，尤其适用于理解冯永基的作品。密集的建筑环境与岛屿海湾气息的沿海文化也反映着其现代艺术的发展脉络。具有强烈个人风格的创新型水墨画家，如吕寿琨、周绿云、王无邪和方召麐，都为这一文化领域做出了贡献，他们以粗放的笔触、色调、调色板和纹理来突破水墨艺术的边界，经常将个人的在地性作为一个重要的参照点。一些艺术家继承了广东现代水墨风格，将其元素跨过边境带入香港，发展了一种独特的艺术语言：植根于中国南方的水墨范式，同时有所创新。

冯永基与这座城市的深厚联系在个人和公共领域都得到了发展。作为建筑师，他参与了为公众服务的重要项目，例如旨在保护和研究野生动物的香港湿地公园，发展与丰富了这座城市的特色，同时吸引了本地人和游客。在冯永基的水墨艺术实践中，对香港的情感将其与历史更悠久的中国文化表达方式联系在一起。绘画的装裱，尤其是立轴作品，让其看起来像一排窗户。通过这些窗户，我们被带入一种充满表现力和沉浸式的深度视觉领域，唤起了一个超越框架限制的空间维度。当回想起欧洲大教堂的彩色玻璃窗或明清时期的一系列绘画，我们可以看到统一的主题贯穿于一种重复的模式之中，而眼睛需要将其转换成单一的视觉叙事才能理解。它们被分割到若干面板中，与中国经典中的其他作品相呼应。如山水画，香港艺术馆馆藏的明代画家蓝瑛的12幅立轴组成。在《十八式》（2018）中，图像的变化加剧了视觉上的不协调感，风景图像几乎有一种模糊的摄影感，有着"可读又不可读"以及"似与不似"的效果。这让观者能够更大程度地运用想象力，去感受画面中的山水意境。

光线、季节、角度和视点都在这一系列的垂直面板中被唤起。在每一幅画和整个系列中，我们都能感受到一种被狭隘视野所限制的广阔景观，这或许反映了人眼及其视野范围的限制，或指向了我们在面对大自然的无垠时感知能力的局限。《白沙湾的早晨》（1994年）主要由若干深蓝色、灰色、黑色和棕色的水墨大块面组成。色块与色块间的留白将观众的目光聚焦于光线之中。它的构图和结构几乎是纯粹抽象的，它精彩记录了艺术家对一个特定地点的艺术回应——冯永基从特定的一天、特定的时间以及特定的角度体验那一独特瞬间的感受。因此这幅画本身变成了永恒，成就了它作为时代作品的文化地位。同时，画中景深产生了无边无际之感，便使其超越了时代局限。

窗户作为远景这一元素在西方艺术史上有着悠久的讨论，通常起侧面描绘光线和表达心理监禁的作用。这些画作本身就是窗户：向远景敞开，直接将视野框定在由抽象风景构成的想象世界上，消除了再现的需要。这些作品所包含的考究、标准的线条被湿墨浸染而产生的变化无穷的广阔之感所抵消，而围绕着它们的宽敞、活跃的空隙提供了缓冲，至此，水墨之间的互动达到了如古代经典《道德经》中所描述的虚实动态平衡。在画面中，颜色、饱和度、色调和斑点共同构成了一种视觉深度，能够将视线由宏观视域引导至微观。在宇宙图像中，唤起只能用太空科技的望远镜和卫星才可观测到的渺小的不可见粒子与浩瀚的星辰大海的意象。

冯氏的绘画中对自然世界的描绘似乎对应了他对一个外在、甚至超越于人造环境的地域的理解。如果中国绘画传统一直被解释为一种内心和外在世界的对话，那么其中的山水图景也可以被视为一种基于特定现实地形的诗意诠释。然而，无论是冯永基的单幅还是联屏画，都可以说是跨越不同地形的现实，体现了个人沉浸在与自然融为一体的状态——例如香港群岛上星罗棋布的众多岛屿、蜿蜒曲折的海湾以及揭示精神与情感的内在心景。

在香港远离市中心的郊区，有许多山间行道，蜿蜒而上可登高欣赏陆地和海湾全景。六联画《香港百里寻》（2009）——大榄涌、河背水塘、大帽山、笔架山、马鞍山、粮船湾，纸本设色，包含了6幅26x193cm的横轴，用一种空灵的特纳风格描绘了香港迷人的景致。其中一部分作品，如大榄涌水塘选取了位于大榄涌与河背水塘的一个特殊视点俯视而作，在冯氏个性化的诠释中被赋予了更高的诗情画意，成为一件富含情感深度和共鸣的精彩作品。冯氏对风景有着深切的关怀，通过一丝不苟的观察将其转化成艺术创作，于现实和心灵层面将其内化。这些作品象征着一种地方的联结与归属感，它们对香港的刻画穿透表层，唤醒了这座城市的内在灵魂。

建筑、水墨与环境

我们可以对水墨画与建筑学做一个性质对比：前者是柔软的、流动的、无法控制的、发散的和不可预测的；后者是坚实的、可测量的和三维的。这两个截然不同的学科是如何相互关联的？它们之间的关系又是什么？水墨画创作于宣纸或丝绸的二维空间中，其发展与鉴赏和理论研究已有一千多年的辉煌历史。当代水墨画继承并吸收历史的精华，将其作为一种知性意识的形式，与长期以来关注人与自然和世界的主客体关系哲学联系起来。同时，建筑史也是源远流长，且在现代发生了翻天覆地的变化，反映了建筑在工业革命、技术进步以及两次世界大战后的地缘政治转变之后一个世纪内的生活方式、环境及功能性的剧烈变化。

由于在美国接受的教育，冯永基的建筑实践是主要是西式的，但他的建筑中融入了许多中国文化的元素，例如在冯永基设计的私人住宅中，线条简洁，空间经过精心的设计以求良好的舒适感和采光，并融以中国文化元素，以一种当地化的语言与现代生活空间互动。他近期的作品将视角转向了生态议题——如《碧水？》（2011）标志着他对日益严重的气候危机带来的环境和污染问题的回应。在他的《呼吸》（2020）系列中，呼吸的概念被赋予了黯淡的内涵：画面带着试图突围兼轻微撕裂之动感，在浓厚的深蓝色层下，仿佛有一股被压抑的暗流正在抑制着一些更纯净的物质。如果冯永基描绘的不是水的现实形象，那么这些元素当然可以被解释为对世界面临严峻的环境难题的隐喻。图像上半部分的开放画域反映了鲜明的明暗与阴阳对比。在其他更大尺幅的作品中，当我们沉浸于自然图景的丰富多彩之时，可从散布在画面之中的笔触和斑点感受到气韵生动，即谢赫（6世纪）的六法之一。视线在画面之中游走，然后深深沉浸其中——就像对自然的体验，既是瞬时的，又是叠加的。此时，不如停下来观察、呼吸和感受，让画面带领我们进入一个更深层次的感官体验。

学者Cordell D. K. Yee对"气韵"的讨论中指出：

"'气韵'这个复合词的使用至少可以追溯到六世纪，当时的评论家谢赫（约500-535年）用它来指代个人和象征性的活力、'呼吸'与和谐、创作的'共鸣'。画家追求气韵以达到绘画的目的——用四世纪画家顾恺之的话来说，就是'以形传神'。画家所要表现的'气'包含两种内在：被描绘对象的内在和画者自身的内在。在美学理论中，这两者是密不可分的：对外部现象的内在及其潜在本质的认识需要艺术家的主动感知。"

欣赏冯永基的作品的关键在于感知力——即使看到它们第一眼便能激发观者的审美情趣，但如果不经过审慎的思考，便难以对其有深刻的理解。

冯永基的画作以传统窄幅卷轴呈现。横轴和竖轴的样式都有，但都不是挂轴，而是融合了传统的纸本水墨媒介和西方于墙面展示的艺术形式。艺术展示方式的新转变改变了中国语境下绘画的理念——从手卷形式（文人小群体在私人社交环境中短暂观看）转变为现代时期室内装饰画（永久欣赏）。在这个观看的概念中，欣赏作品的时长很重要。就像Dawn Delbanco指出的那样，"这种偶然的观看与呈现形式息息相关。"

在这场对冯氏过去作品的深刻而全方位的回顾中，我们看到了一系列对现代水墨画史做出重大贡献的作品。它们为我们的世界注入了共鸣，提醒人们，与地方的深刻联系可以催生诗意的视觉表达。也许冯氏的作品能让我们对这个充满已知与未知、真实与想象的宇宙产生更深理解。他近来呼吁尊重并保护自然——这不仅是一种诗意的欣赏，更是一种绘画行动主义。冯永基对艺术和生活的谦逊态度是一个典范，告诉我们看似平凡的人如何脱颖而出，一个时刻如何成为永恒。

何凯特

伦敦苏富比艺术学院亚洲现代与当代艺术课程项目总监

Fung does not depict landscapes so much as the emotional essence of the land. — Katie Hill

In this retrospective exhibition of the distinguished architect and artist Professor Raymond Fung marking seven decades of his life, a wide range of works are brought together for the first time tracing his evolution as an artist since the 1980s. At the age of 9, Fung first sketched his home city, Hong Kong. This early line-drawing shows a meticulous attention to detail in his careful tracing of the city, indicating the artist's early architectural instinct and sense of place. In his later artistic practice, these lines would dissolve completely in favour of broad liquid brushstrokes that allow the ink to seep naturally in huge expanses. Carefully balancing space and volume, solid and void, Fung has developed his own contemporary engagement with the lineage of ink painting in the modern period. These works that activate landscapes are both real and imaginary. In many of his works, the contours of the land and islands of Hong Kong are referenced in the painterly sweeps of ink. Then, in a kind of magical transformation, they are rendered timeless and universal as landscapes belonging not to a single place but to the spiritual dimension of the cosmos in the spirit and style of the Chinese poetic and philosophical tradition.

Operating within the language of contemporary Chinese abstraction that has evolved since the 1950s in East Asia, Fung's work incorporates elements of modernism, post-war painterly abstraction and the gestural freedom of ink in the expanded field that has taken off in the past two decades in the region. Pioneering groups of Chinese abstraction were the Fifth Moon group in Taiwan from the mid-1950s and in Hong Kong, the New Ink Movement led by Lui Shou Kwan. The movement gained unprecedented momentum in the 60s and 70s, marking an important milestone in Hong Kong's modern art history. In this context, global and local art histories come into play in the reading of Fung's works, when we consider the interplay between the metropolitan centres in East Asia, such as Hong Kong, Shanghai, Tokyo and Taipei, and the transnational developments of global abstraction in the post-war period, added to Fung's training as an architect in the USA in the 1970s.

Born in Hong Kong in the early 1950s, the life of Raymond Fung spans the decades of the city's post-war history. This is a fascinating history encompassing the intense development of an international city that became a key trading hub during the Hong Kong-British period leading up to the 21st century metropolis of today. Made up of a heady mix of sleek high-rise and large-scale housing projects, old tenement buildings, densely packed streets of shops and restaurants, the fast-paced business world and new developments contrast architecturally with the higgledy-piggledy steep lanes of old Hong Kong with its rich and wonderful tropical foliage, filled with cafes, bars, boutiques and small cultural spaces. Beyond these contrasts, nature has endured as a constant presence in Hong Kong's scenery, and this is visible in Fung's works of ethereal beauty, evoking the bays and vistas beyond the densely packed city space explored from a deeply personal standpoint.

The exhibition's concept of 70 years (七拾) can be read as a conscious recollection of Fung's achievement, implicit in the word 'shi' (拾) in its title, with its connotations of 'picking up' or collecting. Fung's contribution as a professor and role model to the younger generation and as a cultural producer juggling numerous creative roles as artist and civic architect should also be noted in a retrospective that nevertheless can be seen as also looking ahead in his commitment to an enduring legacy. From the 1980s onwards, it is possible to track Fung's artistic evolution. From the smaller works exploring technique through a variety of figurative subject-matter such as bamboo, mountainous scenes or a kitten, to his longstanding development of abstract landscape forms, the lineage of Chinese ink painting is expanded into new expressive poetic interpretations that have been honed and refined in the past twenty years. Works exploring a new form of abstraction in the 1980s, show an inclination for forceful thick black lines cutting across the space set off by patches of pinks or oranges that light up the monotone, in a distinctly Hong Kong

modern aesthetic developed by twentieth century painters such as Lui Shou Kwan (1919-1975). Lui held his first exhibition in Hong Kong in 1954, pioneering a unique form of vibrant abstraction in his innovative use of ink, an influence acknowledged by Fung. Lui's Zen paintings from the 1970s are stunning examples of radical Chinese modernism, combining huge energetic brushstrokes and daubs of red in minimalist, exuberant compositions that are aesthetically unique. Fung's homage to this lineage is visible in his vibrant, vast splashes of ink and the use of colour and gold to create touches of brilliance.

When Fung was a child, mass immigration caused huge housing challenges on the small landmass on which a rapidly increasing population was squeezed into vertical buildings now accommodating over seven million people. In the aftermath of World War II, the population grew from a mere 600,000 to 2.5 million within ten years, as hundreds of thousands poured over from the Mainland to search for a new life, existing on almost nothing in fragile self-built shanty towns. The metropolis of today is a heady mix of all the elements accumulating in an intense environment that more recently has gained an expanded art scene of galleries, the renovated Hong Kong Museum of Art and the new cultural district of West Kowloon with its flagship building of M+ Museum, the smaller pavilion of which will host Fung's smaller retrospective exhibition. This dramatic architectural space will allow a more experimental side of Fung's practice as a contemporary artist, with the visually exciting installation made up of the roof tiles from the Flagstaff House Museum of Teaware and a ping pong table, signifying not only his own passion for the game but also perhaps his agility in working across disciplines and media. These two elements are brought into play to connect the architectural legacy of the city with the joyful social activities of the day-to-day. Cutting through the exterior wall of the pavilion to spill outside it, the installation connects the interior with the exterior, as central aspects of Fung's life and work.

As a local resident and a cultural leader deeply invested in the life and culture of Hong Kong, Fung forges a type of modernism intrinsic to the city's history, as a space where the international has always collided with the local. A global metropolis that has for decades acted as a major economic hub in Asia, Hong Kong has nevertheless retained the paradox of its local culture staying close to its roots, exemplified by the fact that very few Hong Kong architects are known globally and its artists are only recently being acknowledged in the art world within the international context.

Fung's biography is full of fascinating details by his own account: the absence of his father, and the apocryphal story of his leaving to "sell salted duck eggs" is a wonderful evocation of an occupation so telling of the world of 1950s' Hong Kong. This story, according to Fung, "was the model answer taught by my mum for answering people's questions when I was a child." In this personal detail, a range of social issues can be read between the lines, of a single mother fending off inquisitive neighbours, the need to survive socially as well as economically, and the perception of a small boy intrinsically understanding these nuanced social sensitivities. In a lively account of the street culture in Hong Kong, Fung recalled, 'At four o'clock every day, I liked going to the Possession Point Flea Market to see the performance of a hawker using grilled hot maltose to draw dragons.' Fung was born in the year of the Dragon, leading to inevitable parental expectation of high achievement as a child due to this special year of birth, which later came to be. Playing down his lack of academic prowess, there was clearly outstanding talent emerging through his early drawings regularly sent in to win competitions. Yet, right up to the early 1990s, Hong Kong was not a city that appreciated artistic culture—after all, in a situation of economic survival, what use is a painting? In the early days of galleries such as Alisan Fine Arts, co-founded by Alice King in the 1980s, buyers would ask for paintings that matched the furniture in a highly functional approach to culture and art. Fung's pursuit of painting lies in parallel with the city's cultural expansion and maturation, delineated by important landmarks such the building of the Hong Kong Arts Centre designed by Fung's mentor, the late Mr. Tao Ho in the 1970s.

Fung's ink painting is highly individualistic, as contemporary works responding to place and cultural contexts, as well as to the long lineage of the refined poetic tradition. Horizontal and vertical spatial dynamics are expanded and emphasised echoing key tenets of the Chinese landscape genre. Breaking through conventions of the shanshui tradition, with its constant slow shifts over a thousand years since the Song dynasty (960–1279), Fung's individual style contains legacies that he acknowledges such as the revered Ming master Shi Tao (1642-1707) and the modern painter Zhang Daqian (1899-1903), known for his flamboyant experimentation with the medium and expansive interpretation of landscape through splashes of colour and sweeping use of abstraction.

Fung's paintings are organised in elongated scroll formats, both vertical and horizontal. In his vertical series, the horizontal viewpoint is cut through, allowing a spatial arrangement through which uncluttered pictorial compositions can be seen as both a continuous whole and as a series of glances. His work is minimalist, abstract and uncluttered, yet exudes a poetic sensibility that is also impassioned and eloquent. The details within it are rich and varied, as the use of textures, flecks and tones can be discerned, drawing the viewers into a more intricate world that can be tracked through the tones, cracks and saturation of the ink, carefully fused in different tonalities of colour and depth. Crunched-up paper is manipulated to create depth of field and fissures, in a technique used by many painters in the contemporary period such as Liu Guosong, who was at the forefront of Chinese modernism in the 1950s and 1960s.

The works on display in the exhibition belie the complex ways that they are produced, in a technical feat that involves a carefully-managed tension between control and release, requiring enormous skill in the use of the brush and the level of absorbency of ink on the paper. Fung mentions that he learned about the need for solid and void and later transferred the principle into paintings. Just as tools are used by oil painters to create texture and surface effects, ink painters also experiment with ways to push the medium further.

In his 2020 *Life* series, executed during the Covid-19 pandemic, crinkles are created using clingfilm, the ink is massaged in to blend areas together, to achieve the textural qualities of the leaves. In this series, as mentioned in his 3812 Gallery exhibition catalogue, his concern for broader themes of life, breath and the environment have come to the fore. His conscious examination of nature also echoes the Lingnan School painters, as evident in the works of the Lingnan master, Yang Shanshen.

The topography and terrain of ink: "being black or being white, being empty or being full"

Hong Kong as a context for ink painting in the post-war period informs Fung's work geographically and aesthetically. Comprising a dense built environment with the culture of a coastal area full of small islands and bays, these features also inform its modern artistic development. Innovative ink painters with strong personal styles such as Lui Shou Kwan, Irene Chou, Wucius Wong and Fang Zhaolin, all contributed to this cultural field, pushing the boundaries of ink with the use of broad brushstrokes, tonality, palette and texture, often in response to the immediate location as an important reference point. Some of those with a legacy of modern ink styles in Guangdong, brought elements of style across the border and developed a distinct artistic language that both lingered in and departed from the language of ink in Southern China.

Fung's deep connection with the city has evolved within both the personal and the public domain. His role as architect working on important projects serving the public such as the Hong Kong Wetlands Park designed to preserve and research wildlife, has transformed and enriched the city and added to its development and status for both locals and visitors alike. In his artistic practice of ink painting, his emotional response to place connects him to a much longer history of Chinese cultural expression. The framing of the paintings, especially in his vertical series, allows the work to appear as a "row" of windows through which we are brought into a depth of vision that is expressive and immersive, evoking a spatial dimension

beyond the confines of the frame. Recalling stained-glass windows in a European cathedral or series of paintings from the Ming and Qing periods, there is a pattern of repetition with a unified theme running through it that the eye needs to make sense of as a singular visual narrative. Sliced into panels, they echo other works in the Chinese canon such as Landscapes, made up of 12 vertical scrolls by the Ming dynasty painter Lan Ying at the Hong Kong Museum of Art. In *18 Shades of Ink* (2018), the sense of visual dissonance is exacerbated by the variation of imagery and there is almost a sense of blurred photography in the images of landscape that simultaneously do and do not make "readable" sense, "a 'likeness and unlikeness' effect, leaving the viewer to feel the artistic concept of a landscape with much larger scope of the imagination."

Light, season, angle and view-point are all evoked in this series of vertical panels. In each one and then the whole, we get a sense of a vast landscape limited by our narrow view, perhaps mirroring the limit of the human eye and its range of vision, or the limits of our perceptual abilities when confronting the enormity of nature. In Morning at Hebe Haven (1994), the painting is largely made up of several large areas of ink wash in deep blue, grey, black and brown, giving way to an open patch onto the Haven that draws the eye across to the light. Almost purely abstract in its composition and structure, it is a stunning reminder of an artistic response to a specific location, experienced in the moment by the artist from a specific viewpoint on a particular day at a particular time. Yet the painting itself becomes timeless, fulfilling its cultural place as a work of its time, but also beyond time, as the depth of field produces a sense of boundless infinity.

The window as vista has a rich history of discussion in Western art history, used as a device for the depiction of light and psychological confinement. These paintings act as the windows themselves, opening out to vistas that directly frame the view onto a world imagined via abstract landscapes, eliminating the need for representation. The strict and formal lines these works are held within, are offset by the moody, soaked expanses formed by the wet ink, and the spacious, active voids that surround them offer relief, completing the dynamics still extant in the world of ink painting as an interplay of solid and void, as described in the ancient classic of the *Dao De Jing*. Within them, depth is brought about by colour, saturations, tonality and added flecks, moving the eye from the macro-vision to the micro-vision, in a cosmic image evocative of the universe from minute invisible particles to the vast galaxies and distant planets only brought to the human eye through powerful telescopes and spacecraft in technologies used for space exploration.

The painterly description of the natural world in Fung's paintings seems to answer to his understanding of a terrain that is viewed outside of the built environment, or even beyond it. If Chinese painting traditions have always been construed as a dialogue with the inner and outer worlds, these landscapes can also be seen as poetic interpretations, whilst hinting on certain topographical realities. Nevertheless, the painterly description in the works, whether the single works or the multiple ones presented as a unified series, arguably spans different realities—the reality of the terrain, such as the numerous islands dotted across the Hong Kong archipelago and their curvaceous bays viewed from above, or an inner mindscape describing a state of mind or feeling, in which one is immersed as one with nature.

In Hong Kong, away from the urban centre, there are numerous walking trails within its landscape allowing for elevated walks in the hills, giving panoramic vistas across the lie of the land and its bays. Paintings such as *Across the Country Road* (2009)—Tai Lam Chung, Ho Pui Reservoir, Tai Mo Shan, Beacon Hill, Ma On Shan, Leung Shuen Wan, Ink and colour on paper, a set of 6 horizontal scrolls measuring 26 x 193 cm, is a set of sweeping horizontal views that are Turner-esque in their ethereal qualities, yet each is a view of a specific Hong Kong location, some of which, such as the Tai Lam Chung reservoir, is indicated as a particular view of Tai Lam Chung and Ho Pui Reservoirs, seen from an elevated position and given a heightened

poetic transformation in Fung's individualistic interpretation as stunning works of emotional depth and resonance of the landscape. Fung deeply cares about the landscape, taking it in, literally and metaphorically, through his thoughtful observation and translation into the art form. Signalling a kind of ownership and connection of place, the very soul of Hong Kong is activated in these works, that go deep behind and beyond its outward appearance.

Architecture, ink and the environment

There is an intrinsic contrast in the disciplines of ink painting and architecture. One is soft, fluid, uncontrollable, expansive, and unpredictable; the other is rigid, measurable and three-dimensional. How can these two very different disciplines relate to one another and what is the relationship between them? Operating in the two-dimensional on paper or silk, ink painting has a long and revered history that is rich with connoisseurship and scholarship spanning ten centuries or more. The idea of a contemporary ink painting contains and absorbs this history as a form of intellectual consciousness that connects it to a long lineage of philosophical engagement in the concern for man's subjective relationship to nature and the world. Architecture also has an ancient history and has dramatically altered in the modern period, reflecting changes in lifestyle, the environment and its very function during a century of radical transformation in the aftermath of industrial revolution, technological advances and geo-political shifts following two world wars.

Fung's architectural practice is a Western one, as he was trained in the USA, but many elements of Chinese cultural motifs are incorporated in his buildings, for example, in private houses designed by Fung, the lines are clean; the spaces carefully designed for comfort and light, and Chinese cultural features are built in for a local response to modern living spaces. More recently, his works have taken an ecological turn—titles such as *Clean Water* (2011) mark a response to issues of pollution and environmental challenges during the growing climate crisis. In his *Breathing* (2020) series, the idea of breath takes a sometimes-darker turn, with a sense of oppression in

the weight on the thick blackened surface, which is slightly broken up at points, in a seeming effort to break through. Underneath a dense layer of dark blue gives the appearance of a suppressed undercurrent under which something purer has been suppressed. If this is not a literal image of water, it could certainly be interpreted as a metaphor for the serious environmental challenges weighing on the world. The open void in the upper half of the image provides a stark contrast of light and dark, yin and yang. In other, larger scale works, the idea of qiyun (spirit resonance), one of the six principles of Xie He (6th century), can be discerned in expansive brushstrokes and specks dotting the space, as we become immersed in the view of a landscape and the richness within it. The eye moves across in a broad glance and is then drawn in more deeply, just as an experience of nature is both instant and cumulative, bringing deeper sensation as we stop to observe, breathe and absorb the scene.

As noted by the scholar Cordell D. K. Yee, in his discussion of the term qiyun, breath resonance:

"The use of this compound dates back to at least the sixth century when the critic Xie He (fl. ca. 500-535) used it to refer to personal and representational vitality, or 'breath' and harmoniousness, 'resonance' of execution. By striving for qiyun, a painter could achieve the purpose of painting, 'to express the spirit through form,' in the words of Gu Kaizhi, a fourth-century painter. The 'breath' that painters tried to express involved two senses of innerness: the innerness of the objects represented and the innerness of the painter. In aesthetic theory the two were inseparable: recognition of the innerness, the underlying essence, of external phenomena required the active perception of an artist."

Perception is also key to experiencing Fung's works, since they cannot be immediately understood without a slower contemplation, even if they elicit an aesthetic appeal at first sight.

Fung's paintings are formatted in traditional dimensions of the narrow scroll, both horizontally and vertically and yet, they are not

hanging scrolls, since they are mounted and presented on a solid base, thereby operating between the traditional medium of ink on paper and the Western form of art that is fixed and viewed on a wall. The turn for new displays of art altered the very idea of painting in the Chinese context, when the move from the handscroll format, in which small gatherings of literati viewed temporarily in a private social context, changed to the idea of pictures on a wall decorating an interior for permanent viewing in the modern period. The experience of time is important to this idea of viewing and, as Dawn Delbanco points out, "this occasional viewing has everything to do with format."

In this impressive and extensive recollection of Fung's work over a lifetime, we are confronted with a set of works that make a significant contribution to the history of ink painting in the modern period. They breathe resonance into our world, in a reminder of how a deep connection of place gives rise to poetic visual expression. Perhaps Fung's oeuvre brings us closer to understanding the universe in its evocation of the known and the unknown, the real and imaginary. His recent plea for respect of nature and its preservation adds a call to arms that is not only poetic appreciation, but also a kind of painterly activism. Fung's humility and approach to art and life is an exemplary reminder of how the seemingly ordinary can become extraordinary and a moment can become timeless.

Katie Hill

Academic Lead - Asia at Sotheby's Institute of Art, London

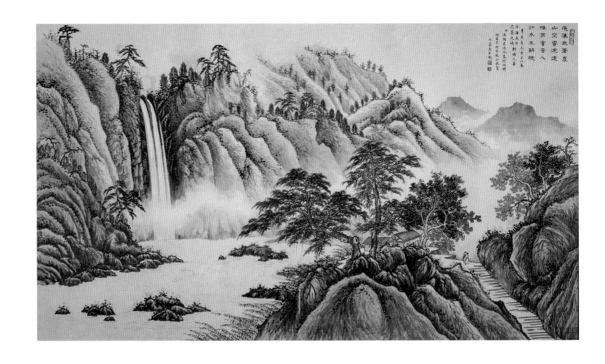

飞瀑漱苍崖 Waterfall ｜ 水墨设色纸本 Ink and colour on paper ｜ 55 X 100cm ｜ 1971
私人收藏 Private Collection

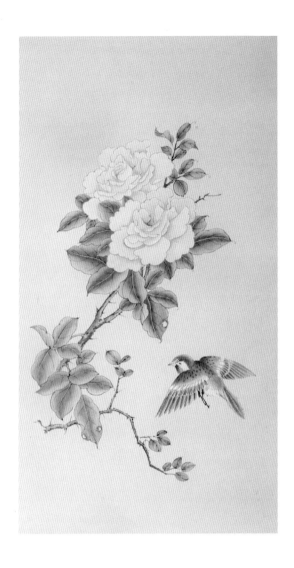

早期花鸟 Early Years Floral Painting
水墨设色纸本 Ink and colour on paper ｜ 65 X 30cm ｜ 1971

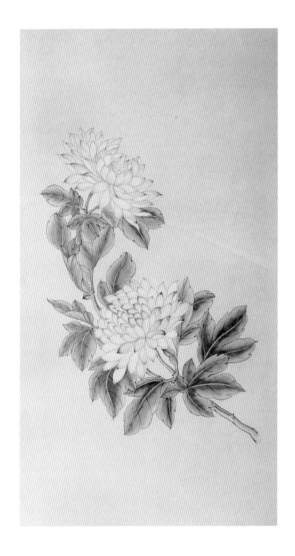

早期花鸟 Early Years Floral Painting
水墨设色纸本 Ink and colour on paper ｜ 60 X 32cm ｜ 1971

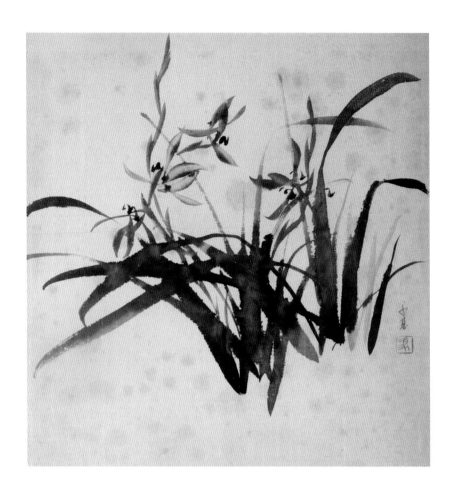

兰花 Orchid
水墨设色纸本 Ink and colour on paper ｜ 38 X 38cm ｜ 1998

早期人像 Early Years Portrait
水墨设色纸本 Ink and colour on paper ｜ 45.5 X 30cm ｜ 1984

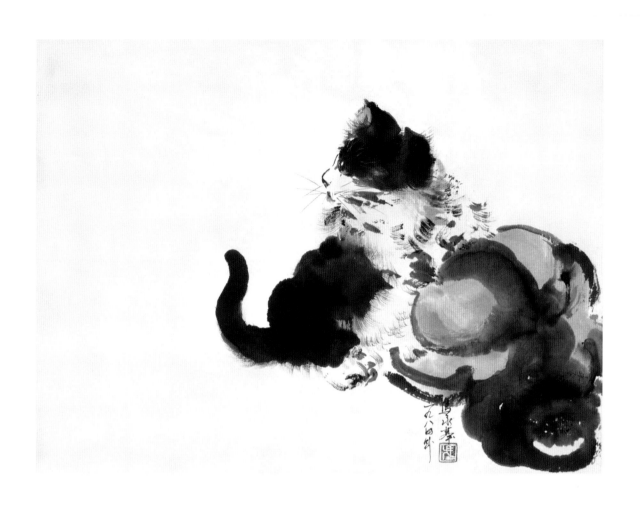

宠爱 Spoiled with love ｜ 水墨设色纸本 Ink and colour on paper ｜ 33 X 43cm ｜ 1984

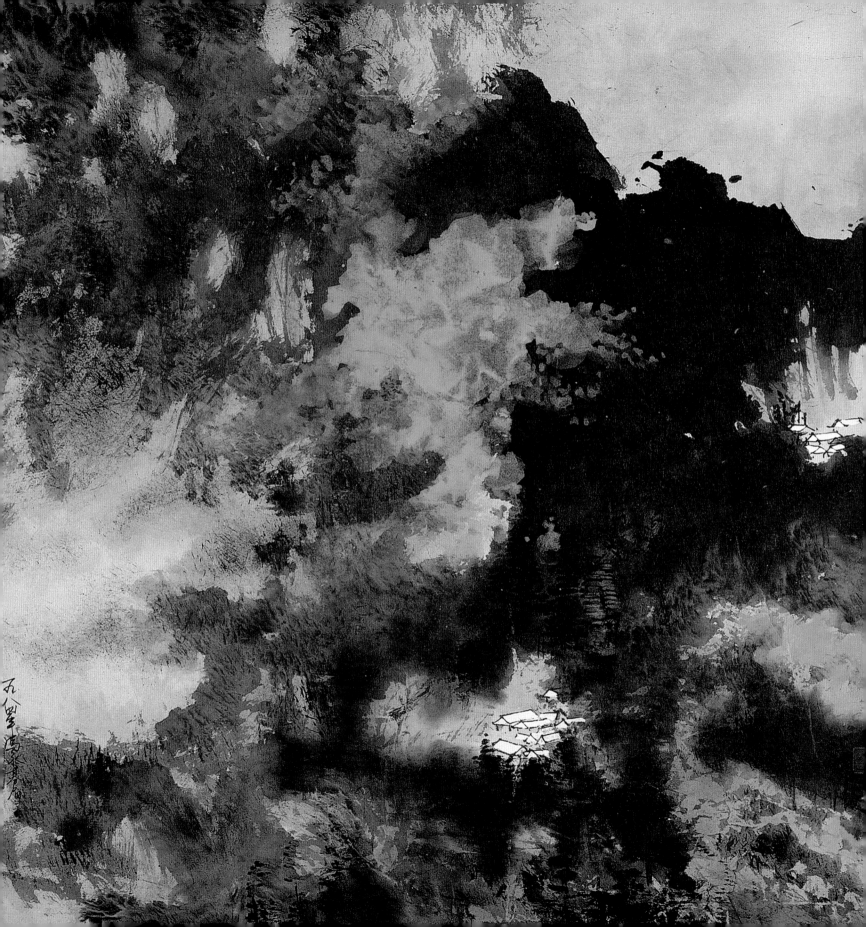

隐在深山隔世间 Beyond Horizon │ 水墨设色纸本 Ink and colour on paper │ 59 X 62cm │ 1984

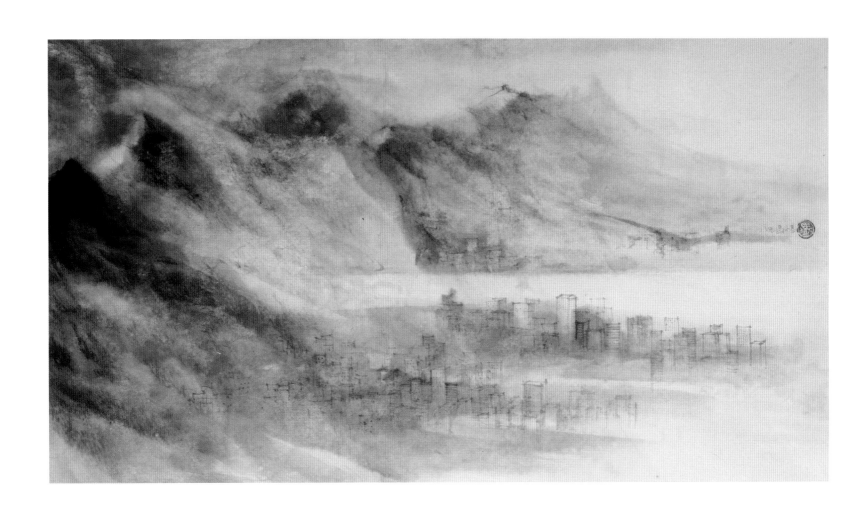

早期岭南派山水（一）Early Lingnan Style Landscape Work（1）│水墨设色纸本 Ink and colour on paper │ 48 X 80cm │ 1984

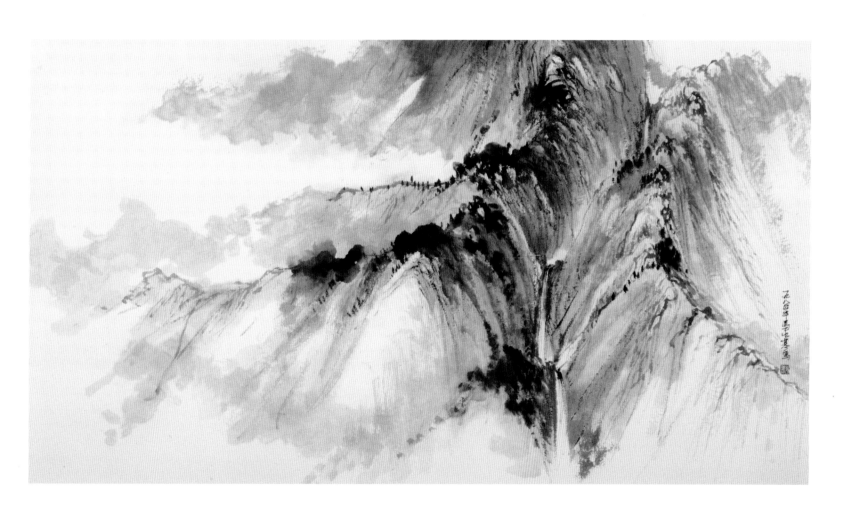

早期岭南派山水（二）Early Lingnan Style Landscape Work（2）│水墨设色纸本 Ink and colour on paper │48 X 80cm │1984

早期岭南派山水（三）Early Lingnan Style Landscape Work（3）｜水墨设色纸本 Ink and colour on paper｜48 X 80cm｜1984

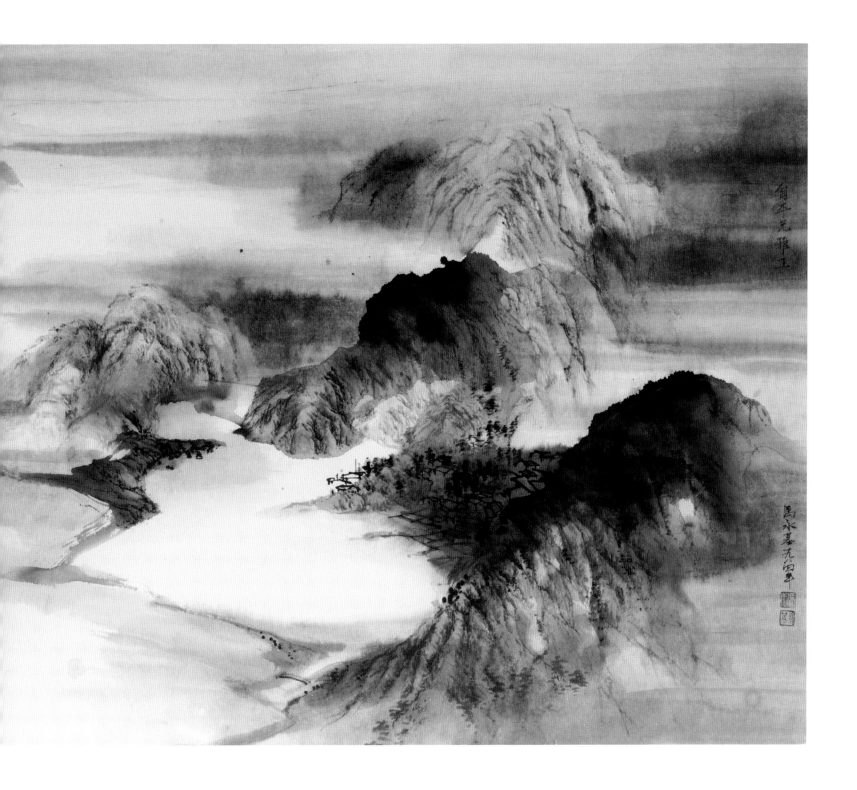

画作绘于1985年，不仅是艺术家开展个人风格的阶段，也是香港艺术馆收藏的个人早期作品。

The painting was fashioned in 1985, representing not only a stage of development in the artist's personal style, but also one of his early works that now forms part of the collection at the Hong Kong Museum of Art.

山水协奏曲第一乐章 Landscape Concerto No.1 ｜ 水墨设色纸本 Ink and colour on paper ｜ 68.5 X 68cm ｜ 1985
香港艺术馆藏品 Collection of Hong Kong Museum of Art

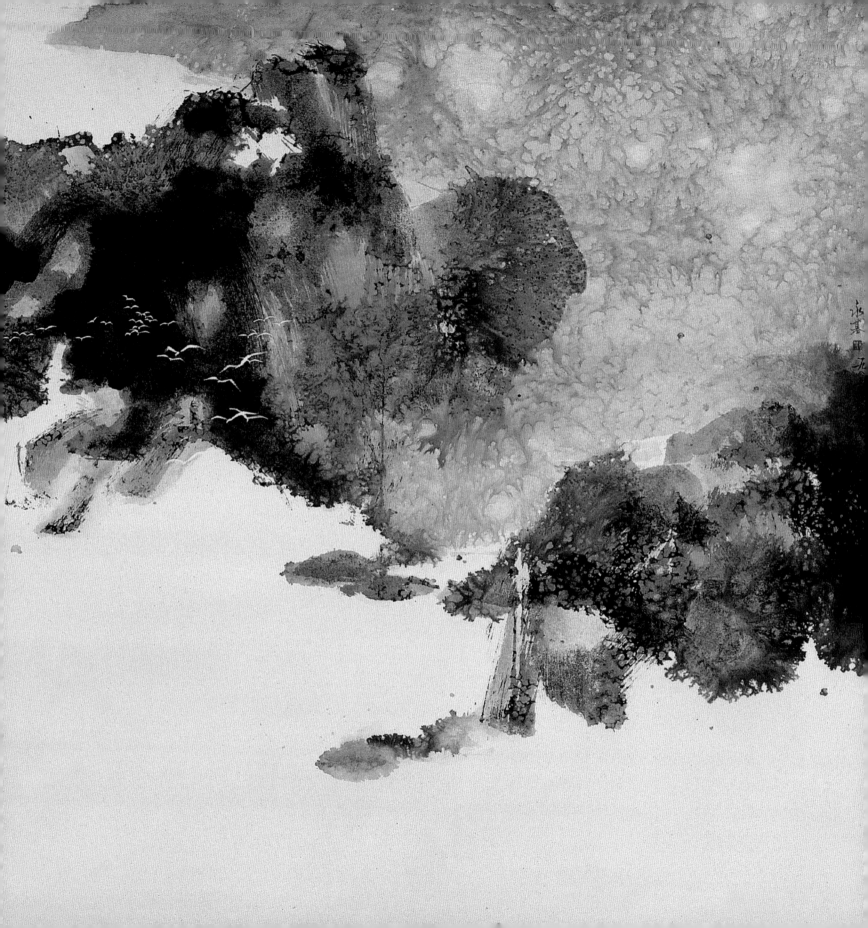

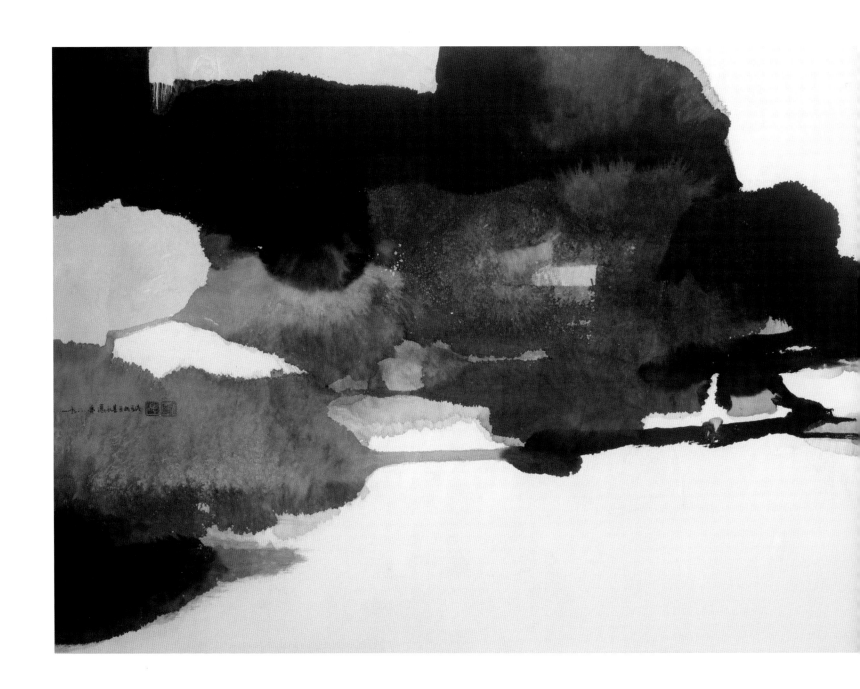

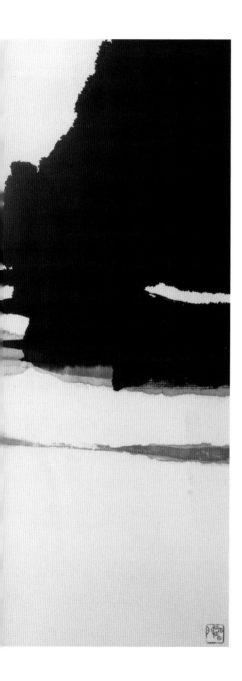

跳跃 The Great Leap ｜ 水墨设色纸本 Ink and colour on paper ｜ 93 X 174cm ｜ 1986
私人收藏 Private Collection

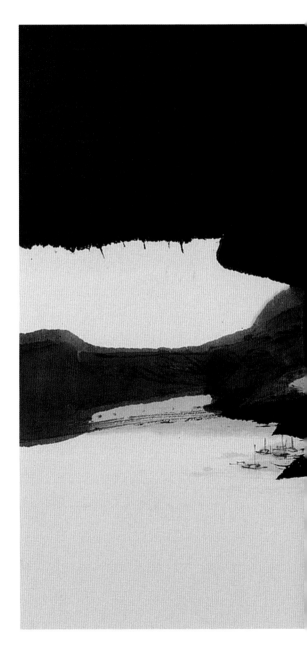

大地稀音 Great Land in Silence ｜ 水墨设色纸本 Ink and colour on paper ｜ 69.5 X 137cm ｜ 1989
香港艺术馆藏品 Collection of Hong Kong Museum of Art

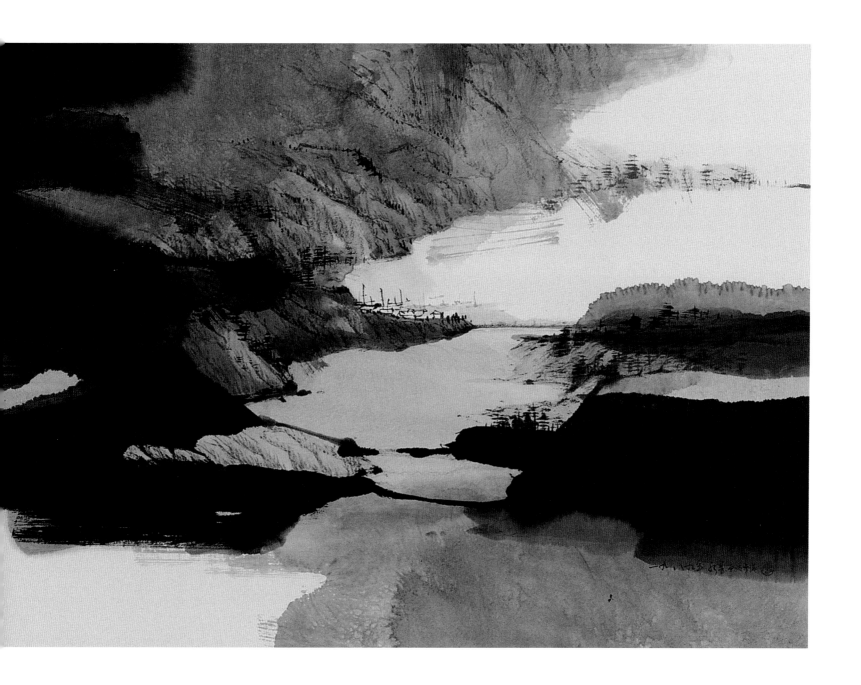

吾土吾情 Homage to Our Land ｜ 水墨设色纸本 Ink and colour on paper ｜ 72 X 145cm X 2 ｜ 1996
香港文化博物馆藏品 Collection of Hong Kong Heritage Museum

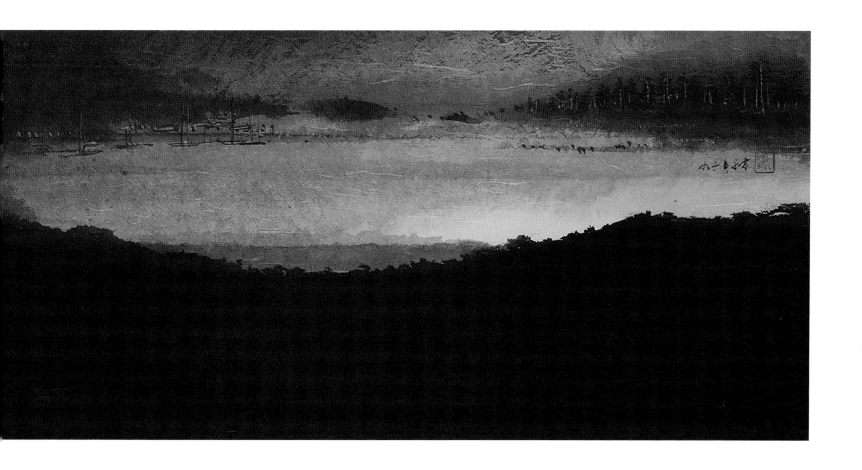

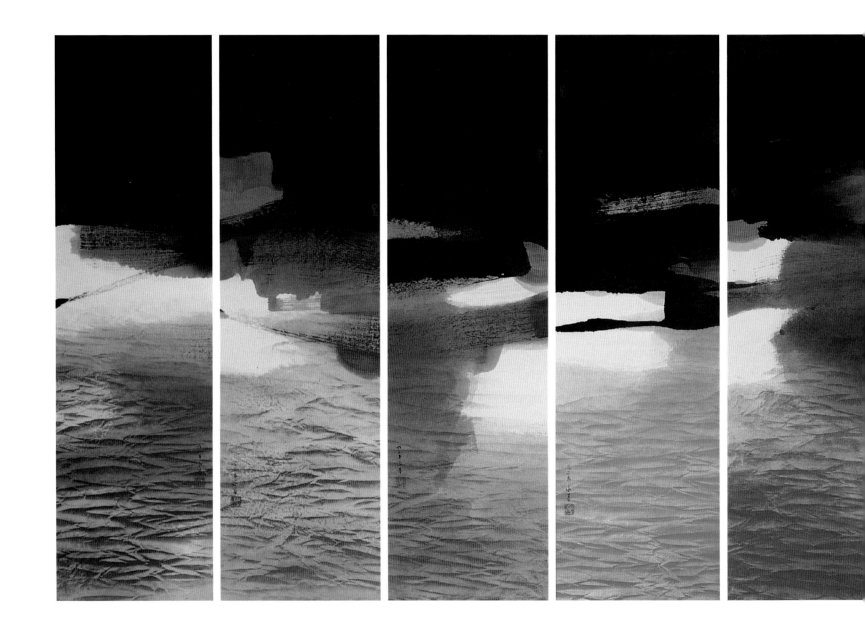

画作描绘了天与水相遇的画面，随着太阳的高低，仿如将时间定格，透过水墨来书写这难忘一刻。

The painting portrays a mesmerizing scene of the meeting of the heavens and the waters. The movements of the sun appear to pause time as the painting captures this unforgettable moment with the use of ink and brushstrokes.

难忘时分 The Unforgettable Moment ｜ 纸本水墨设色 Ink and colour on paper ｜ 112.5 X 33cm X 6 ｜ 1992
香港大学美术博物馆藏品 Collection of University Museum and Art Gallery of The University of Hong Kong

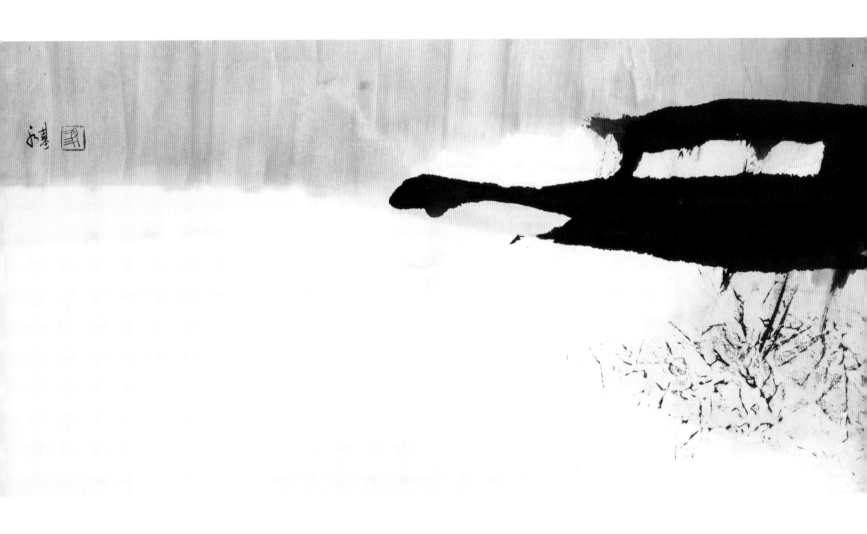

大地系列（十九）The Great Land Series No. 19 ｜ 水墨设色纸本 Ink and colour on paper ｜ 35 X 135.5cm ｜ 1992
私人收藏 Private Collection

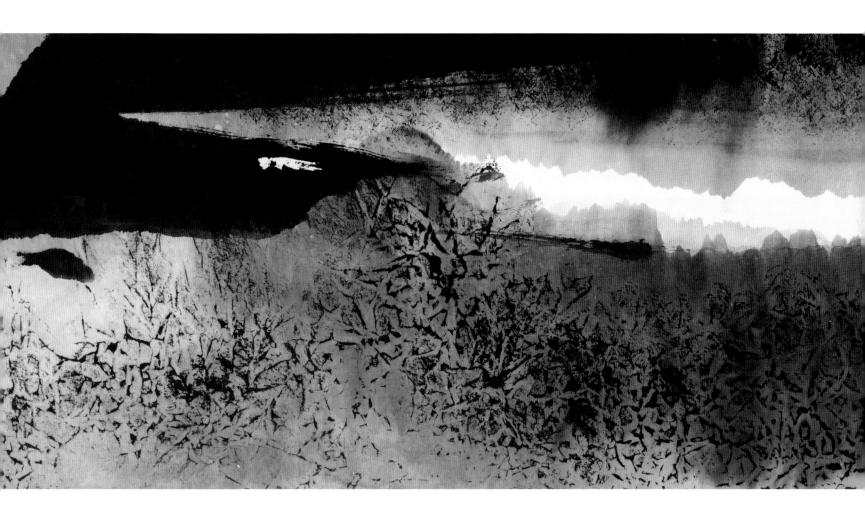

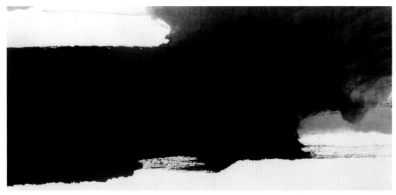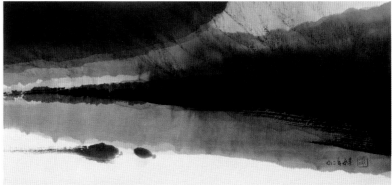

重逢 Reunion ｜ 水墨设色纸本 Ink and colour on paper ｜ 31 X 68cm X 2 ｜ 1992

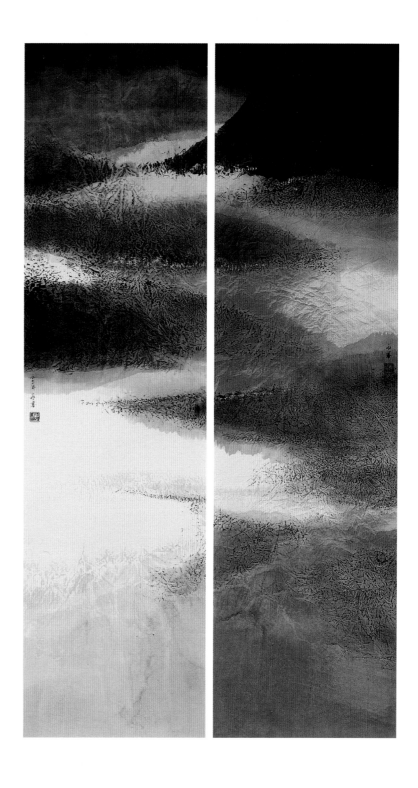

香江情怀 Memories of Hong Kong ｜ 水墨设色纸本 Ink and colour on paper ｜ 152 X 41cm X 2 ｜ 1993
香港艺术馆藏品 Collection of Hong Kong Museum of Art

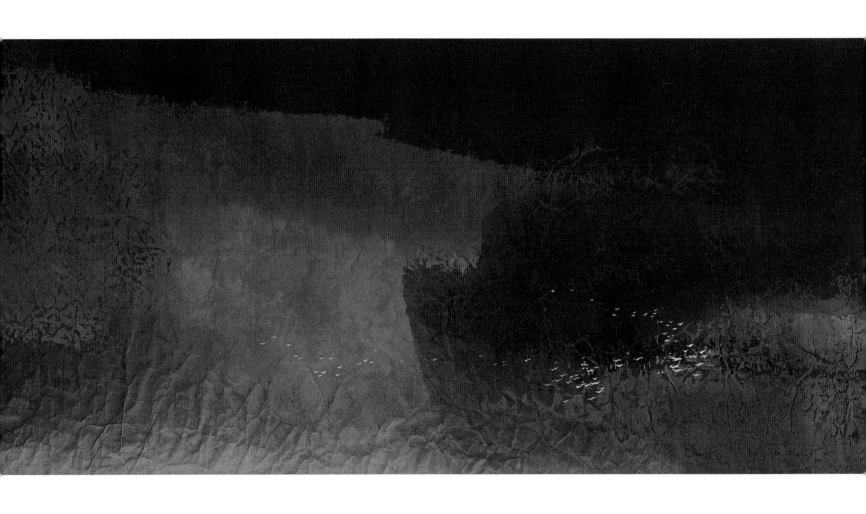

白沙湾的早晨 Morning in Hebe Haven ｜ 水墨设色纸本 Ink and colour on paper ｜ 51.5 X 219cm ｜ 1994
香港艺术馆藏品 Collection of Hong Kong Museum of Art

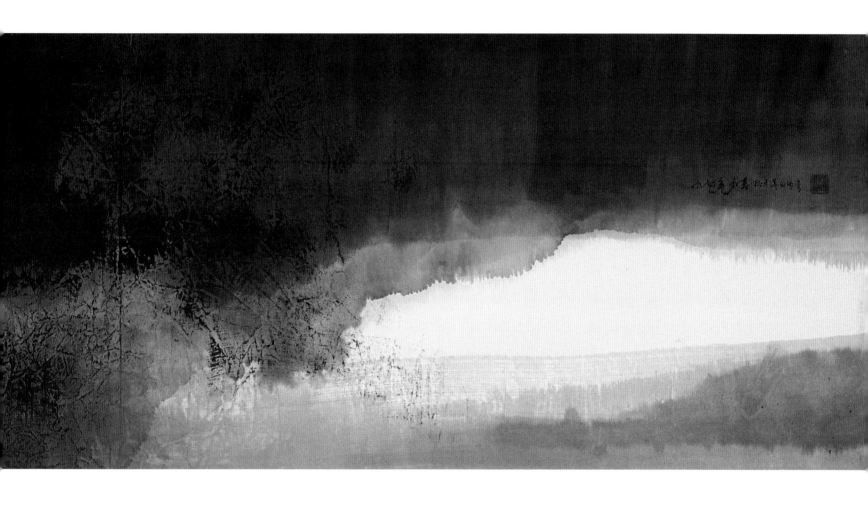

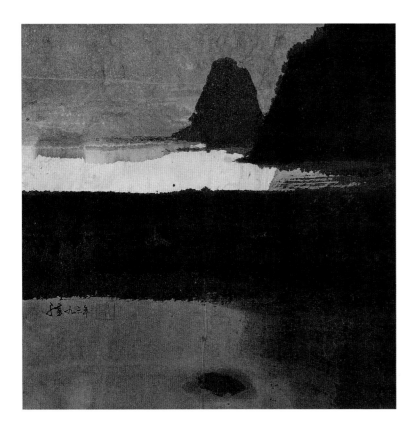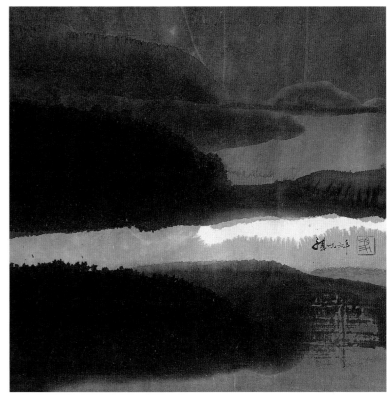

情系香江之万宜水库、浪茄、西湾、海下 Hong Kong Series—High Island Reservoir, Long Ke, Sai Wan, Hoi Ha

水墨设色纸本 Ink and colour on paper | 30.3 X 30.3cm X 4 | 1996

香港艺术馆藏品 Collection of Hong Kong Museum of Art

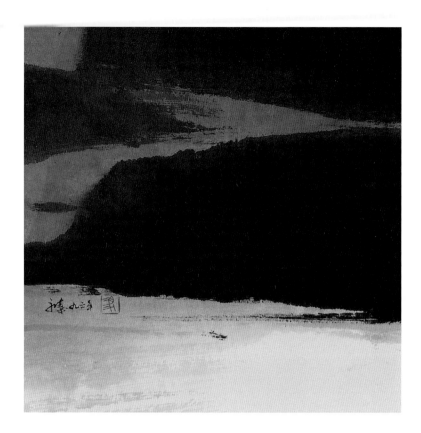
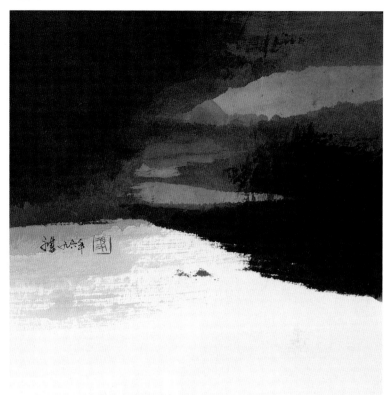

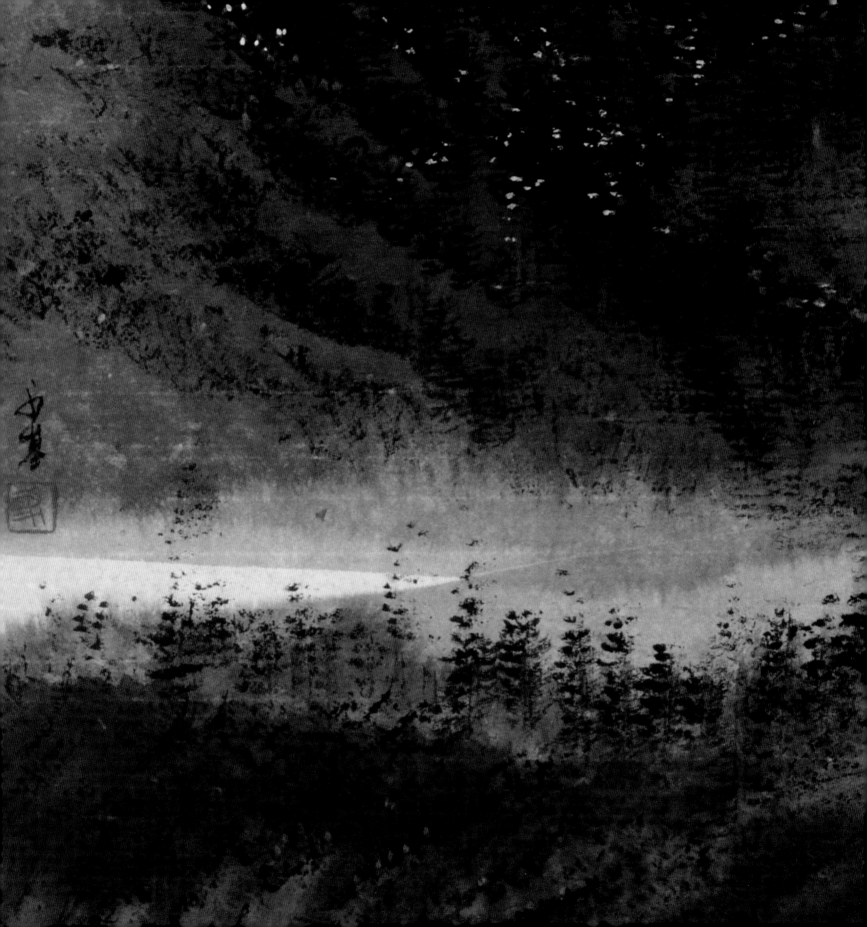

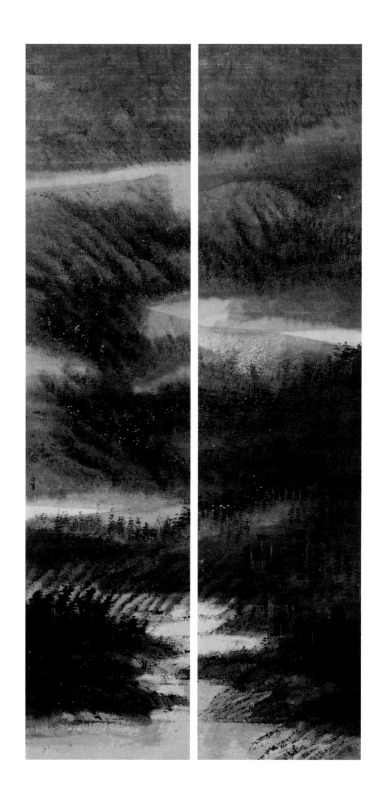

古道行（一）（二）Historical Trail No.1 & 2 ｜ 水墨设色纸本 Ink and colour on paper ｜ 138 X 35cm ｜ 1997

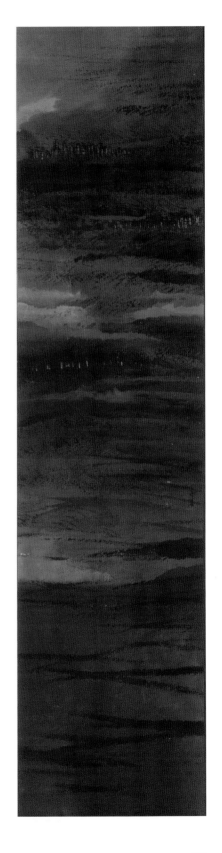

川藏系列（一）Return from Tibet No.1 │ 水墨设色纸本 Ink and colour on paper │ 138 X 35cm │ 1999

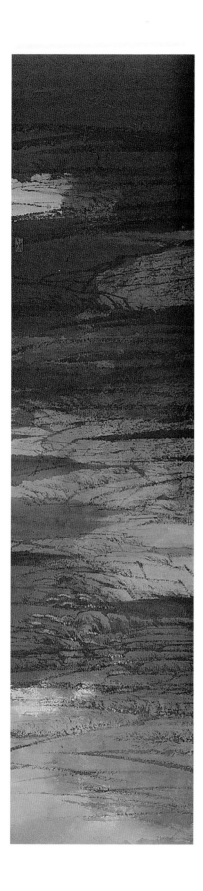

川藏系列（二） Return from Tibet No.2 ｜ 水墨设色纸本 Ink and colour on paper ｜ 138 X 35cm ｜ 1999

天啸（五）Cry of Nature No.5 ｜ 水墨设色纸本 Ink and colour on paper ｜ 137.5 X 34.5cm X 4 ｜ 1998
香港文化博物馆藏品 Collection of Hong Kong Heritage Museum

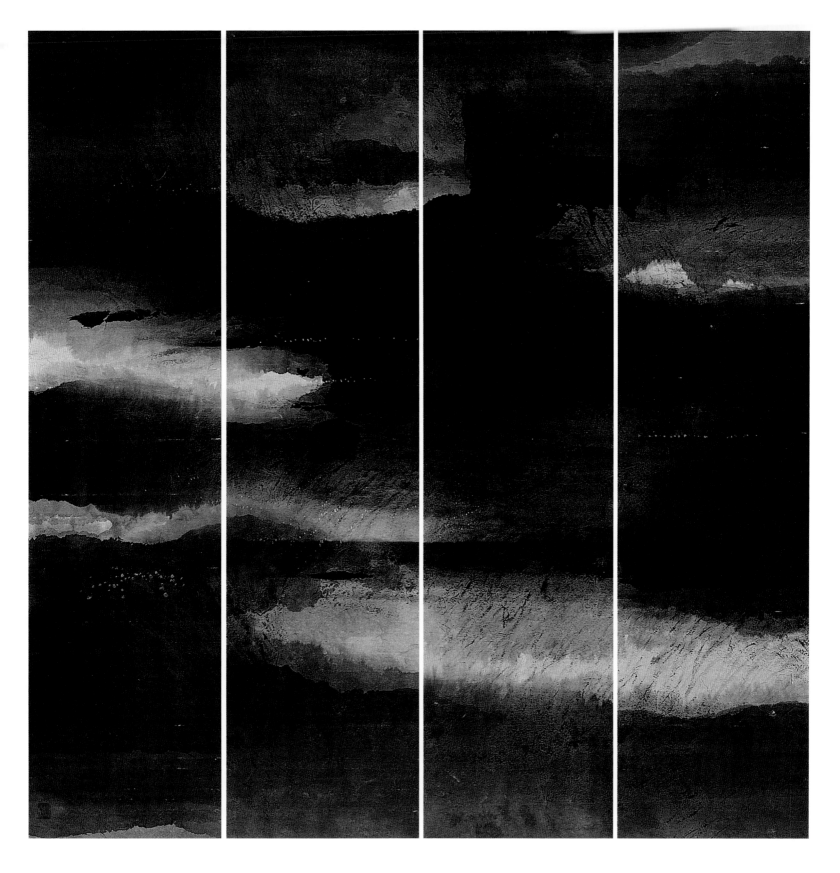

141

付出了什么　WHAT HAVE I GIVEN

重新拾起的，又是什么？　WHAT EXACTLY HAVE I PICKED UP ANEW?

看见了什么　WHAT HAVE I SEEN

听见了什么　WHAT HAVE I HEARD

得到了什么　WHAT HAVE I GAINED

放下了什么　WHAT HAVE I LET GO OF

放弃了什么　WHAT HAVE I FORGONE

建筑师冯永基屡获殊荣，其画作充满色彩。相比于结构明确、形式分明的建筑，绘画为冯氏提供了一个随心实验的避风港。纵然他似乎更钟情于深邃的靛蓝和碧蓝作为画面的主色调，但他亦会用几溅白色拨彩或金点来提亮氛围。冯永基能把大片颜色透过不同色调的自然图案，转化为可识别的形态，这种标志性技巧在他的作品中反复出现。这些透过巧妙使用保鲜膜而创作成的图案亦有着不同用意。在最新的《呼吸》系列中，冯永基运用其标志性的创作技巧，表达其对环保议题的深切关注。

与艺术家早期使用自然图案代替纹理笔触创作的概要风景（schematic landscape)作品相比，《呼吸》既不把重点放在与前人的对话上，也不是为了展示如何以非常规媒介和现代技术进行创作。在《呼吸》系列中，艺术家通过其流畅的艺术性表达，对我们身处的环境进行陈述。作为建筑师，冯永基深深明白建筑物对环境造成的干扰，因此作品的创作目的并非为了展现其标志性风格，而是希望通过建筑师的视角表达对环境的关注。他以绘图铅笔和画笔让大家留意到大自然的匠心独运，从中表达出气候变化对存在主义的威胁，两者相互关联，并且逐步逼近。在《呼吸》系列中，绿色生活和各种污染的暗示性图像比比皆是。

正如我们在巨型画作《河山》中所见，冯永基以其标志性技巧展现连绵山脊，作品以居高临下的视角为观众展示河光山色。颜色丰富的色块部分褪色，模糊了上色与否之间的界线。作品中起始与结束之处似乎无法辨识，暗示了随海平面上升而不断变化的景色与海岸线。在《生命（二）、（三）、（四）、（五）》中，冯永基创作出叶脉般的图象。乍看之下，这些图象让人想起久负盛名的古典大师的写意传统，他们以富有表现力的泼墨描绘荷叶。然而，冯永基不以写实方式表现荷花的形态，为观者留下想象空间。有些人可能会认为这些图象看似海中半分解的塑料废物，为要提醒大众关注人类对海洋生物造成的危害。这种解读也许显得随意，我却认为这是艺术家刻意留给观众的艺术解读空间，而视觉上的模糊性是为了带来不同层次的意义。艺术家经过深思熟虑，表达出模棱两可的视觉效果，将中国艺术传统与迫在眉睫的当代议题联系起来。

冯永基对环境和自然的尊重与前人的不同之处在于：古代大师对自然心存敬畏，而冯永基则对自然的脆弱性保持警惕，尤其是人类对环境造成的变化和退化。这种情感在其作品中清晰可见。纵然在上述作品中并未出现任何海浪或船只，艺术家却以水中之物的形态暗示了自然界中的水元素。《呼吸（八）》似乎展示了自然主义渲染的藻华现象。这种水中生态现象

是如此生动，以至于观者忘却眼前之作实为抽象水墨绘画。基于冯永基对环境议题的关注，这又会否是气候变化的预兆？

作为建筑师，冯永基不单着眼于建造将人类与自然联系在一起的建筑物，更以艺术唤起我们对这种联系的关注，因为这是与大众息息相关的全球性问题。然而我们不需将之过分夸大，故意耸人听闻。就此议题，冯永基以画作取代陈词滥调的谴责，为我们带来一抹清新空气。

姚进庄

香港中文大学文物馆馆长

Paintings by the award-winning architect Raymond Fung are saturated with colours. In contrast to the structured and well-defined forms of architecture, painting offers Fung a refuge for liberal experimentation. While he seems to prefer darker palettes of indigo and aquamarine, he lightens the mood with splashes of white paints or gold specks. Organic patterns in varying tones that transform swathes of colours into recognisable forms is a signature technique and recurring motif in Fung's art. Yet such patterns, executed with ingenious use of cling film, serve different purposes. In his latest series, titled *Breathing*, Fung has deployed his stylistic trademark to evoke images that resonate deeply with the environmentally-conscious artist.

In contrast to his earlier works of schematic landscapes, which use those organic patterns in lieu of texture strokes, *Breathing* is less about a dialogue with the ancients or about the execution of a modern technique using unconventional medium. The series is the artist's statement on the environment, articulated through his artistic resolve and fluency. His signature style is not an end in itself, but the means to an end of raising awareness of the environment through the perspective of an architect, who understands that a building is an intervention in nature. He draws attention—no pun intended—to the artifice in nature with a drafting pencil and the artifice of nature with a brush. The existentialist threat presented by climate change shows these two artifices are interrelated and uncomfortably close. In this *Breathing* series, pictorial allusions of green life and ambiguity of pollution abound.

As we see in the monumental work *Our Land*, Fung's trademark pattern may be construed as mountain ridges, and the painting offers the viewer an aerial view of a vast landmass buoyed—or encroached upon—by unpainted oceans of white. The contours of the colourful masses fade in parts, obscuring the difference between the painted and the unpainted. The indefinite perception of where the painted parts begin and end alludes to the evolving landscapes and changing coastlines in the era of rising sea-levels. In *Life 2, 3 and 4*, Fung's organic pattern approximates leaf veins. At first glance, these images remind one of the xieyi tradition of time-honoured classical masters, who rendered lotus leaves in expressive splash ink

Yet Fung's renderings avoid accurate representation of lotus in order to leave room for the viewers to conjure other images. One could argue that the images resemble semi-decomposed plastic wastes in the sea, which are reminders of manmade hazards to marine life. If such readings appear to be arbitrary, I would suggest that Fung has deliberately given artistic licence to the viewers to interpret his pictures, and that visual ambiguity was calculated to bring in different levels of meanings. This calculated ambiguity bridges Chinese artistic tradition and a pressing contemporary issue.

Fung's respect for the environment and nature differs from that of the ancients in a main aspect. Unlike the ancient masters who viewed nature in awe, Fung is wary of nature's vulnerability, especially changes and deterioration wrought by humans. This sentiment is not lost on his paintings. The above-mentioned paintings already allude to the aquatic elements in nature, and it is not indicated by waves or the presence of boats. Rather, it is implied by how things appear in water. *Breathing 8* appears to be a naturalistic rendering of algal bloom. This aquatic quality is so vivid that one would be remiss to read his paintings as abstract ink art. Given the decorated architect's concern for the environment, could it be a harbinger of climate change?

As an architect, Raymond Fung does not simply set his sights on erecting buildings that bond humans with nature. He uses his art to raise our awareness of this bond, because this is a global issue that concerns all. But we need not sensationalise or dramatise it. In lieu of clichéd condemnations, Fung offers a breath of fresh air through his paintings.

Josh Yiu

Director of the Art Museum, The Chinese University of Hong Kong

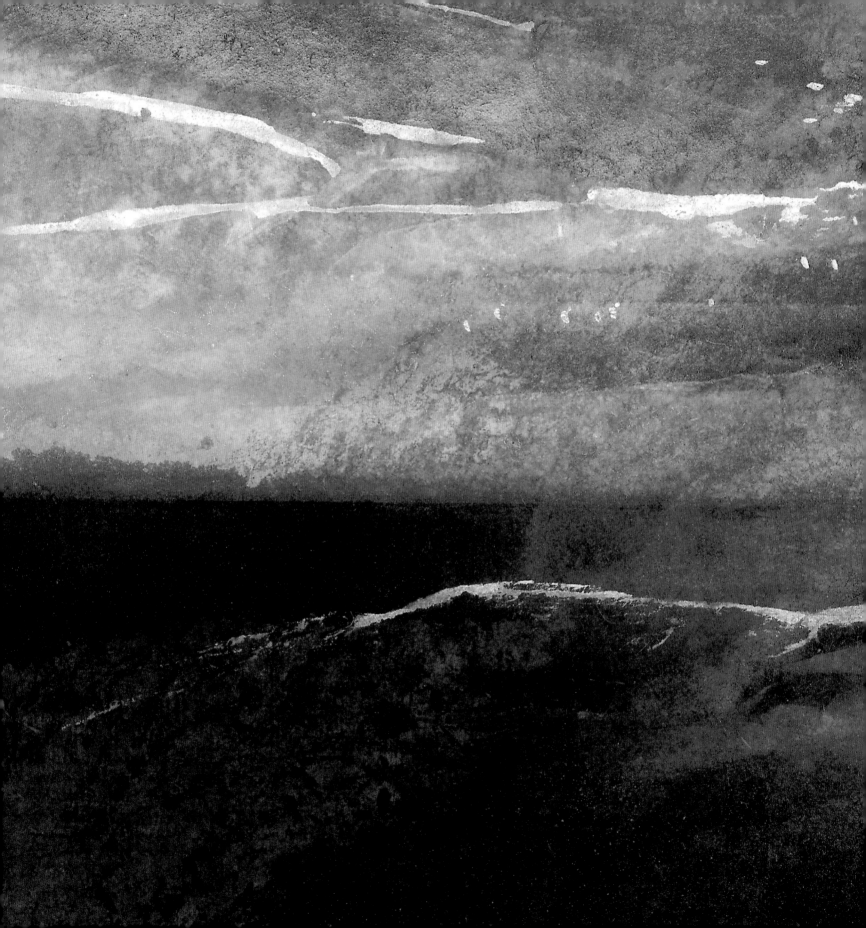

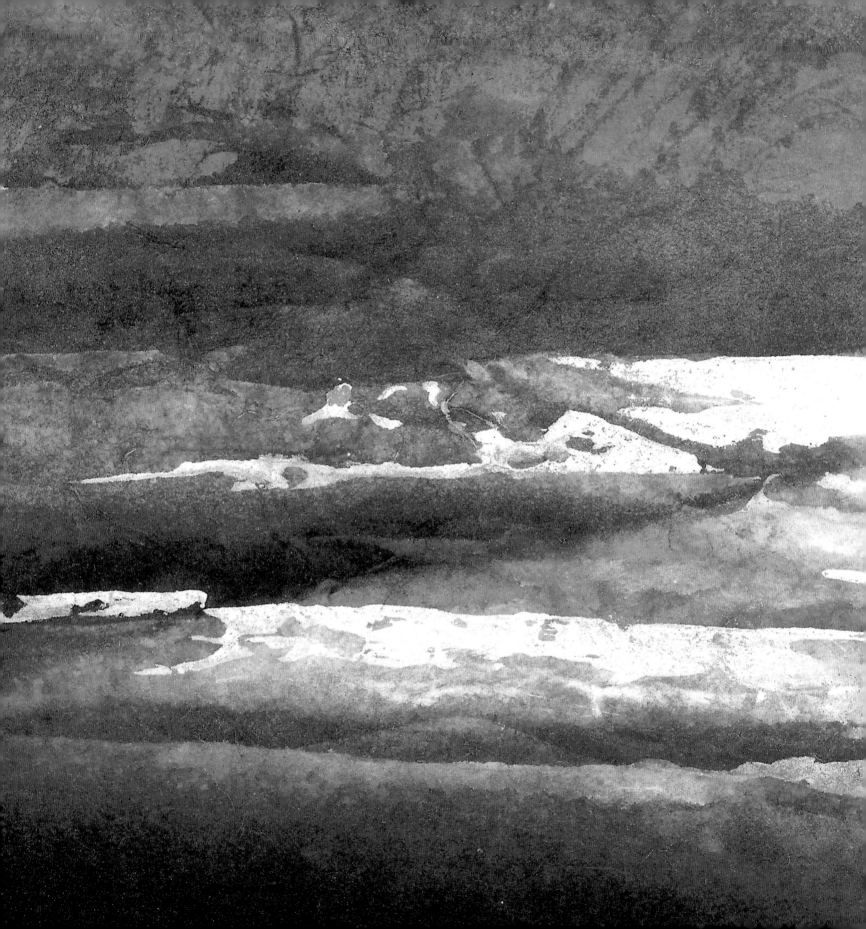

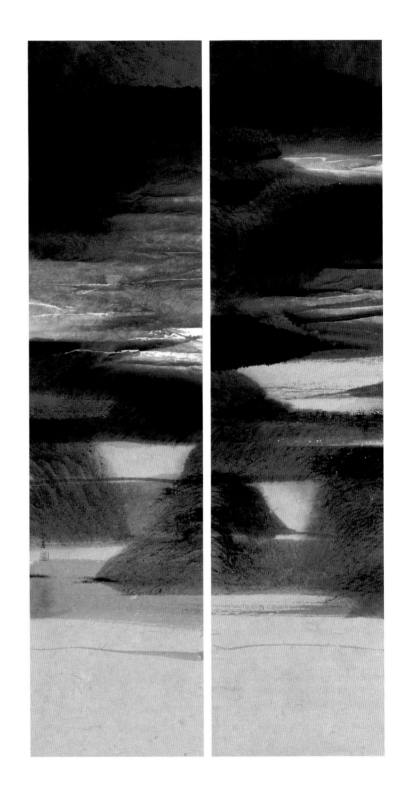

一起走过的日子（一）（二）　Somewhere in Time No.1 & 2 ｜ 水墨设色纸本 Ink and colour on paper ｜ 138 X 35cm ｜ 2009

私人收藏　Private Collection

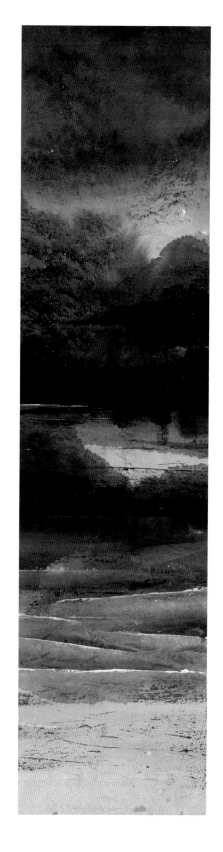

一起走过的日子（五）Somewhere in Time No.5 │ 水墨设色纸本 Ink and colour on paper │ 138 X 35cm │ 2009
私人收藏 Private Collection

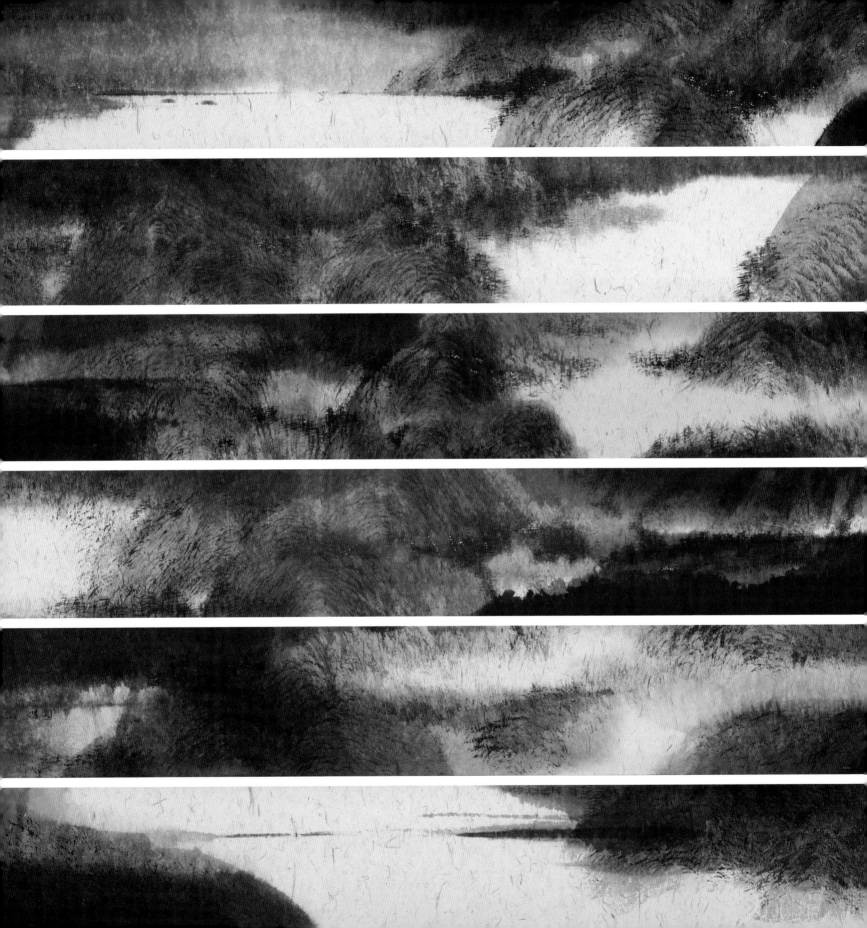

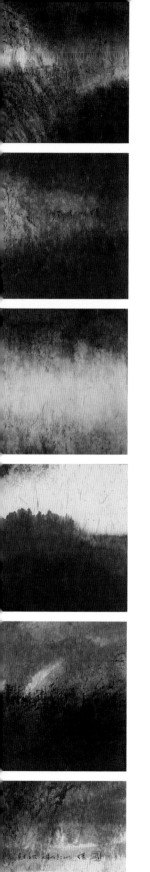

香港百里寻 —"大榄涌""河背水塘""大帽山""毕架山""马鞍山""粮船湾"
Across the Country Road—Tai Lam Chung, Ho Pui Reservoir, Tai Mo Shan, Beacon Hill, Ma On Shan, Leung Shuen Wan

水墨设色纸本 Ink and colour on paper ｜ 26 X 193.8cm X 6 ｜ 2009
香港艺术馆藏品 Collection of Hong Kong Museum of Art

画作以简约的笔触，描绘香港早时期未曾发展的景象。

Utilising simple brushstrokes, the painting portrays the early era of Hong Kong that was largely undeveloped.

细说当年 Once Upon a Time ｜ 纸本水墨设色 Ink and colour on paper ｜ 137.5 X 35cm X 12 ｜ 2009
香港艺术馆藏品 Collection of Hong Kong Museum of Art

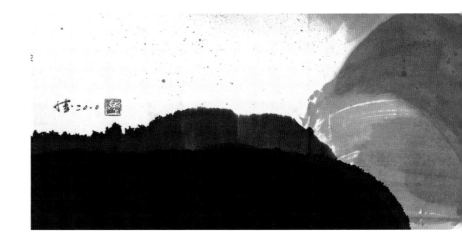

三星湾 Sam Sing Wan ｜ 水墨设色纸本 Ink and colour on paper ｜ 30 X 180cm ｜ 2010
私人收藏 Private Collection

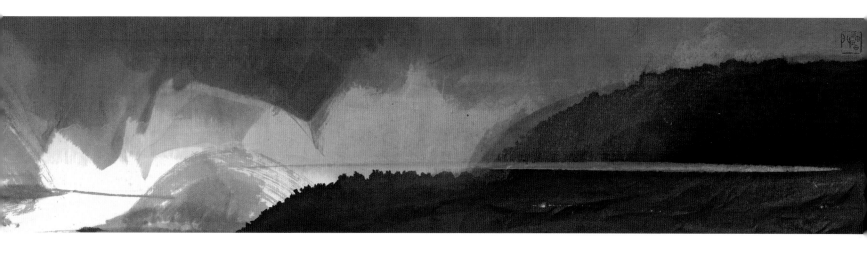

蓝的变奏 Blue Rhythm │ 水墨设色纸本 Ink and colour on paper │ 138 X 35cm X 4 │ 2011
私人收藏 Private Collection

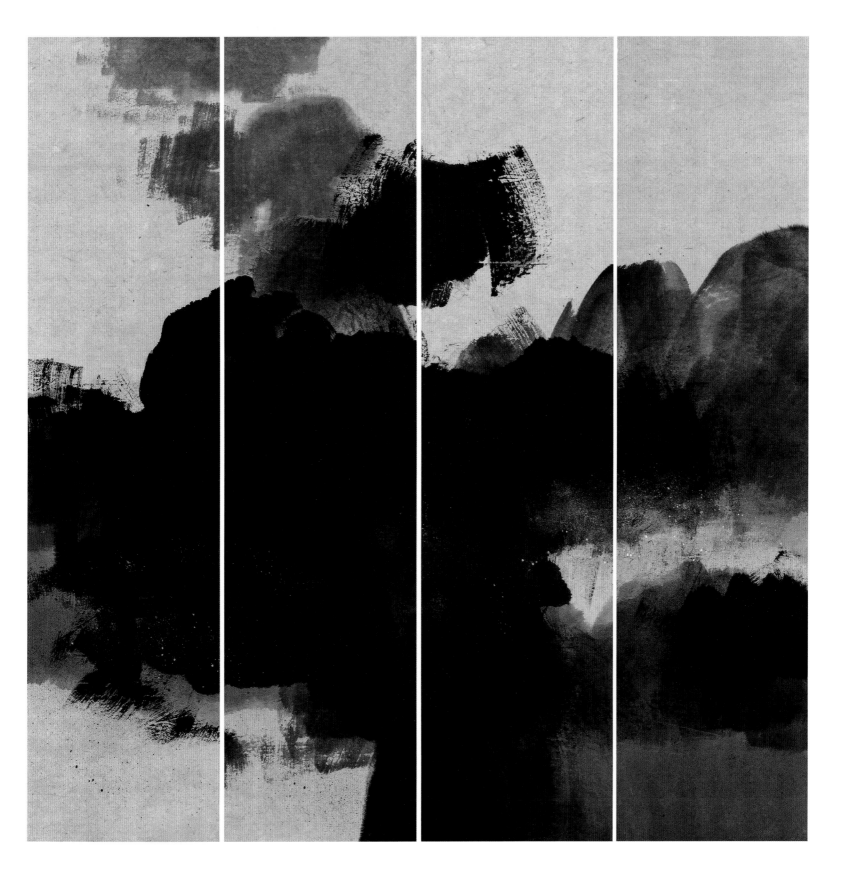

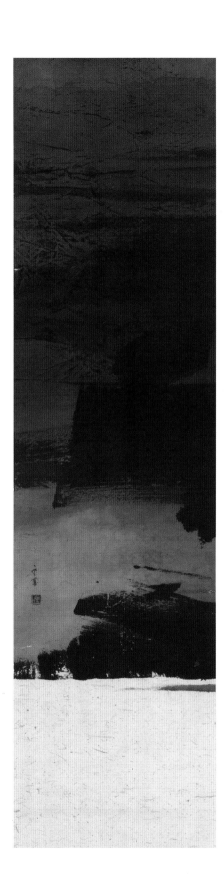

蓝天？ Blue Sky ？│水墨设色纸本 Ink and colour on paper │ 180 X 48cm │ 2011

碧水？ Clean Water？ ｜ 水墨设色纸本 Ink and colour on paper ｜ 180 X 48cm ｜ 2011

宋彩华姿（七）china in China（7）｜水墨设色纸本 Ink and colour on paper｜180 X 48cm｜2013

宋彩华姿（八）china in China（8）│ 水墨设色纸本 Ink and colour on paper │ 180 X 48cm │ 2013

艺术家以六次"拾起"及"生于斯"的景象来构建他人生的阴晴圆缺。

The artist utilises six instances of "picking up" and his "sense of place" to construct the ebb and flow of his life.

六拾 6 Ten ｜ 纸本水墨设色 Ink and colour on paper ｜ 245 X 29cm X 6 ｜ 2012
香港艺术馆藏品 Collection of Hong Kong Museum of Art

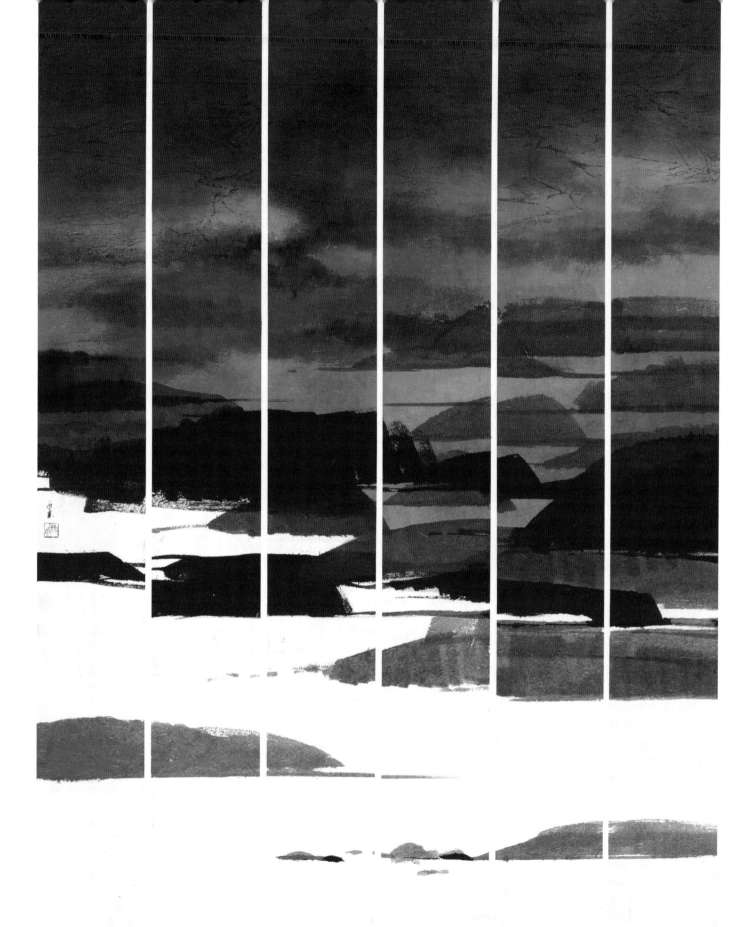

天地凡间 Between Heaven & Earth ｜ 水墨设色纸本 Ink and colour on paper ｜ 35 X 35cm X 4 ｜ 2015
私人收藏 Private Collection

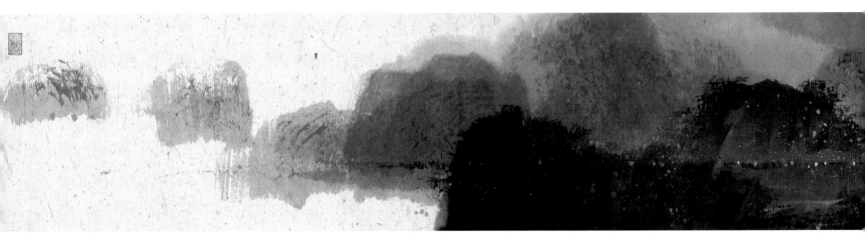

下有印塘（一）Here is Double Heaven No.1 ｜ 水墨设色纸本 Ink and colour on paper ｜ 28 X 235cm ｜ 2015
私人收藏 Private Collection

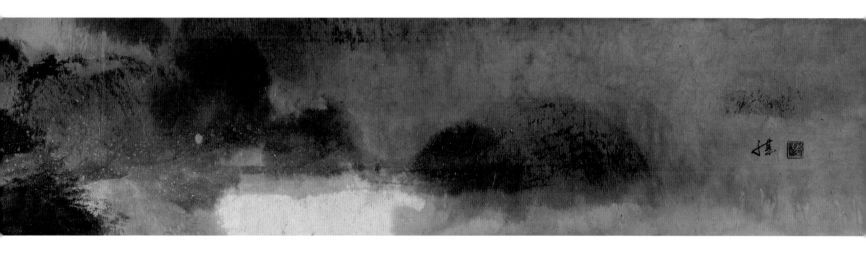

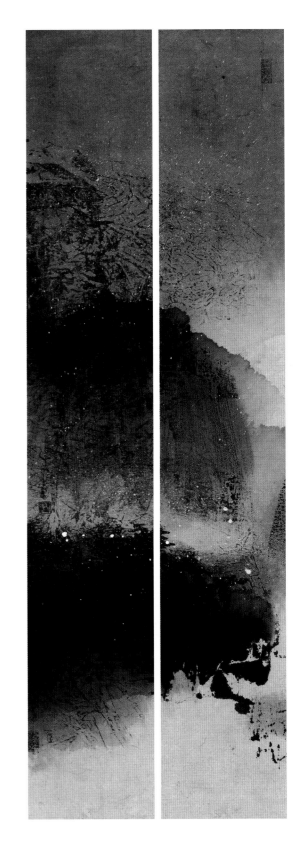

俏江山 Beauty of Lands ｜ 水墨设色纸本 Ink and colour on paper ｜ 138 X 23cm X 2 ｜ 2016

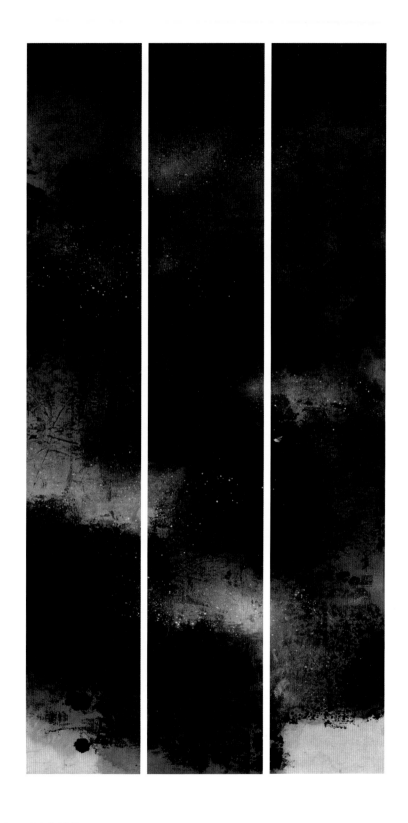

俏江山系列（二）Beauty of Lands No.2 ｜ 水墨设色纸本 Ink and colour on paper ｜ 138 X 23cm X 3 ｜ 2016

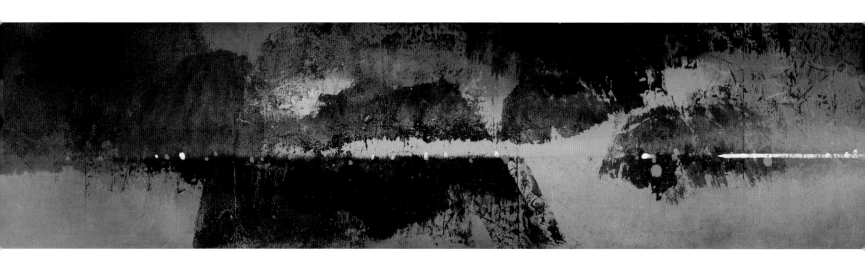

三杯酒 Sam Pui Chau ｜ 水墨设色纸本 Ink and colour on paper ｜ 30 X 240cm ｜ 2017

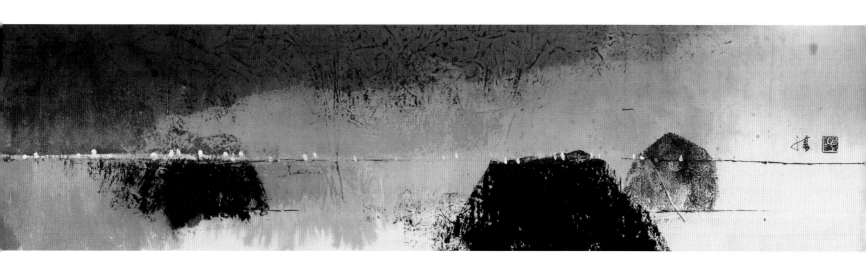

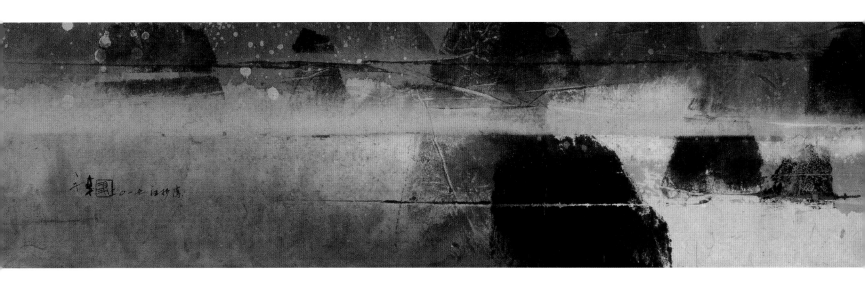

天地有情（一）Scenery with Hills and Waters No.1 │ 水墨设色纸本 Ink and colour on paper │ 27 X 180cm │ 2017
私人收藏 Private Collection

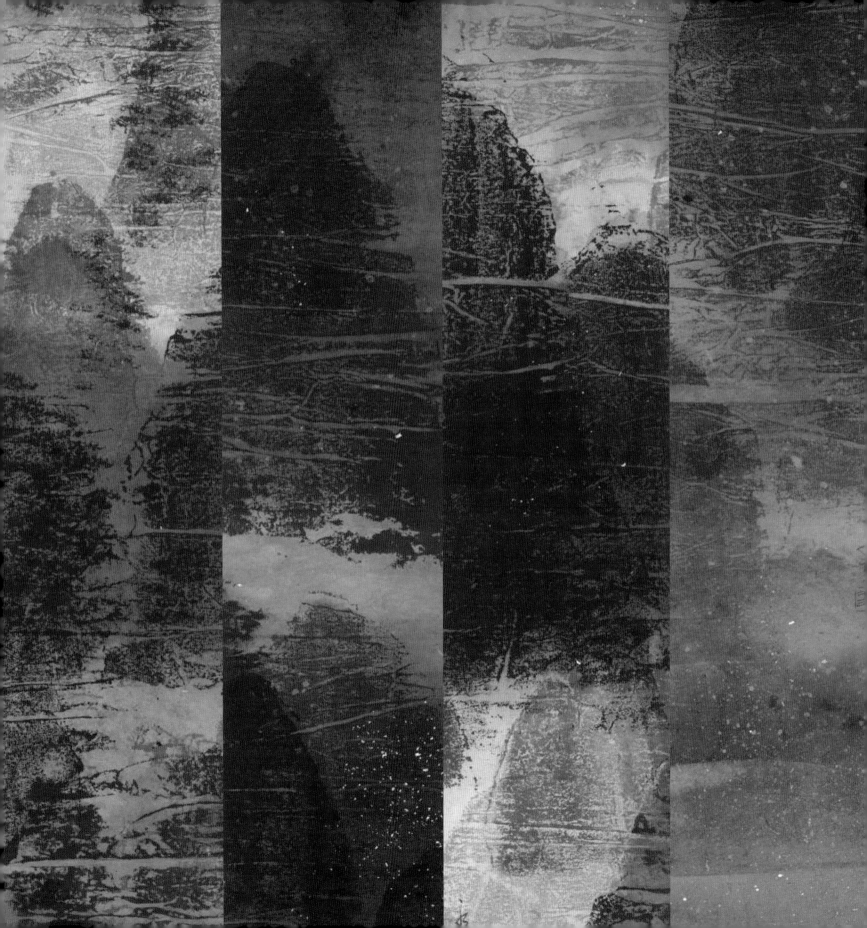

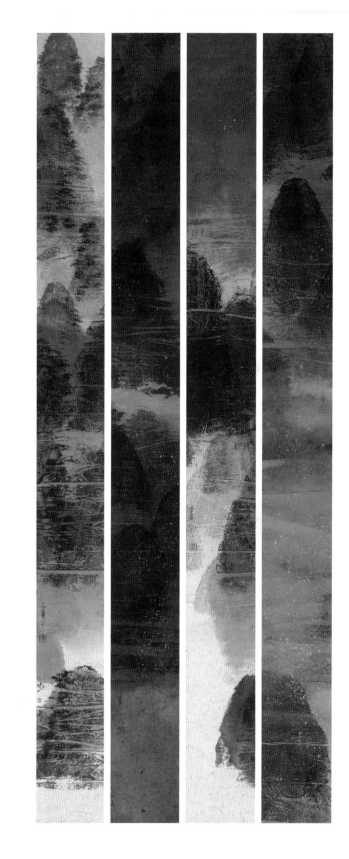

四部曲（一）（二）（三）（四）Four Stages No.1, 2, 3, 4
水墨设色纸本 Ink and colour on paper ｜ 180 X 17cm ｜ 2018

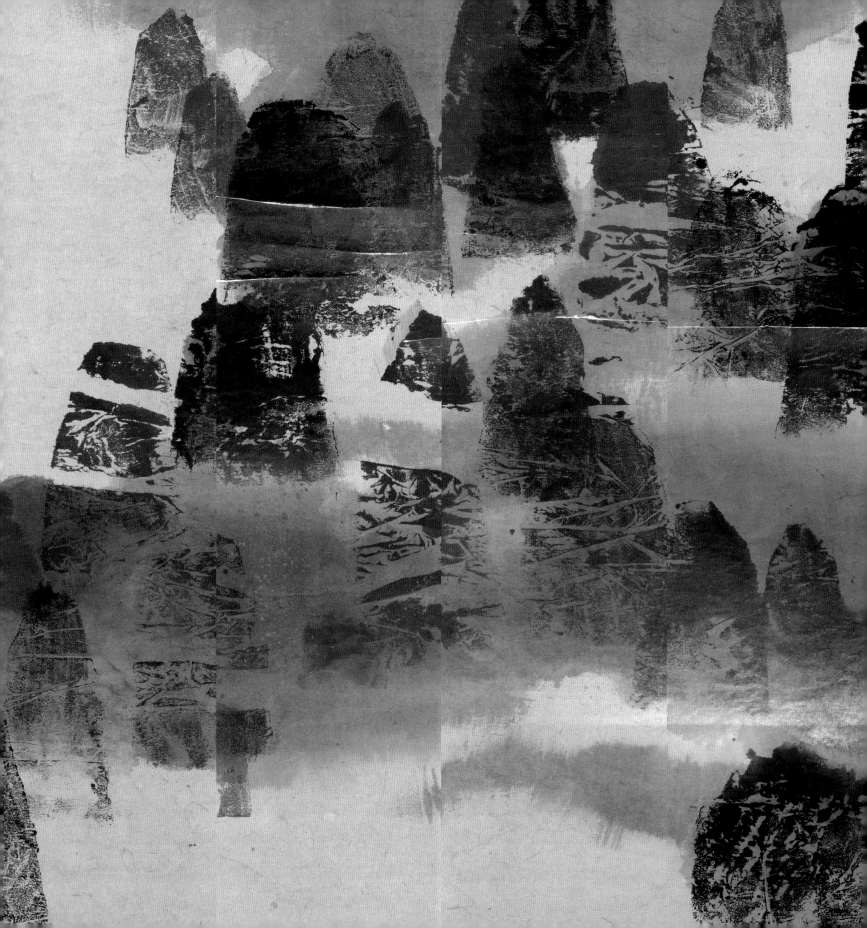

天地之大，人何其渺小，懂得谦卑之道便好。

In the immense expanse of the world, man is merely a minuscule presence.
Embracing the virtue of humility can prove advantageous.

五岳归来不看山 Return of the Five Ridges │ 纸本水墨设色 Ink and colour on paper │ 137 X 173.5cm │ 2019

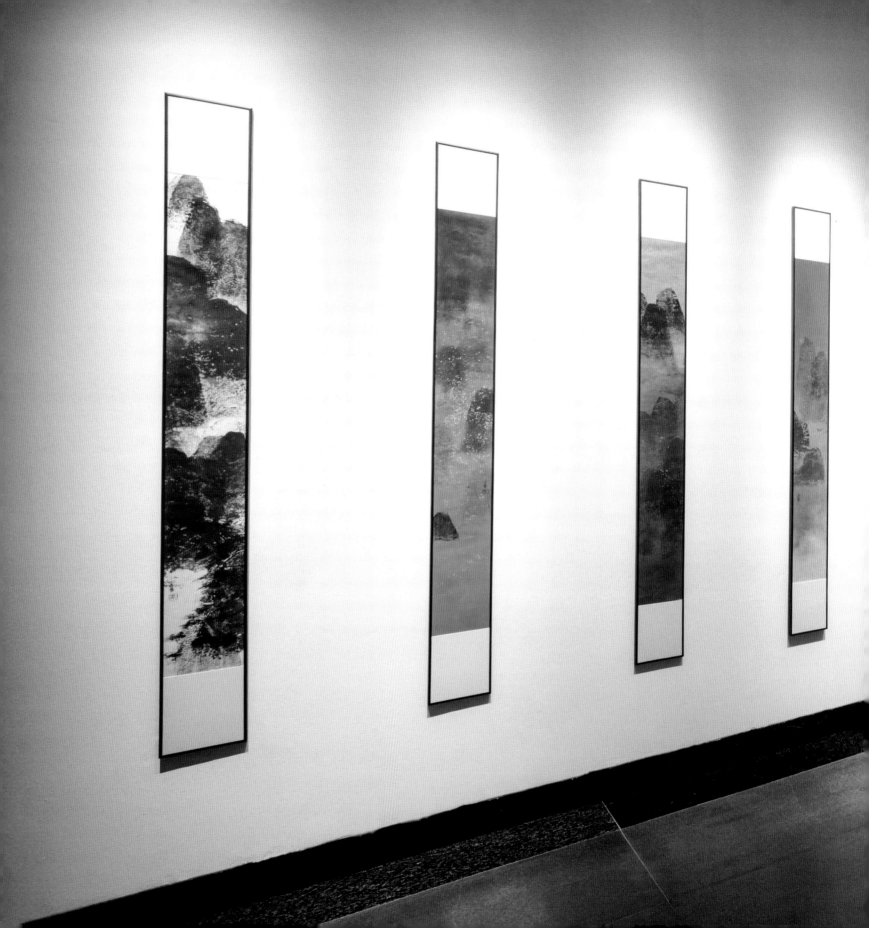

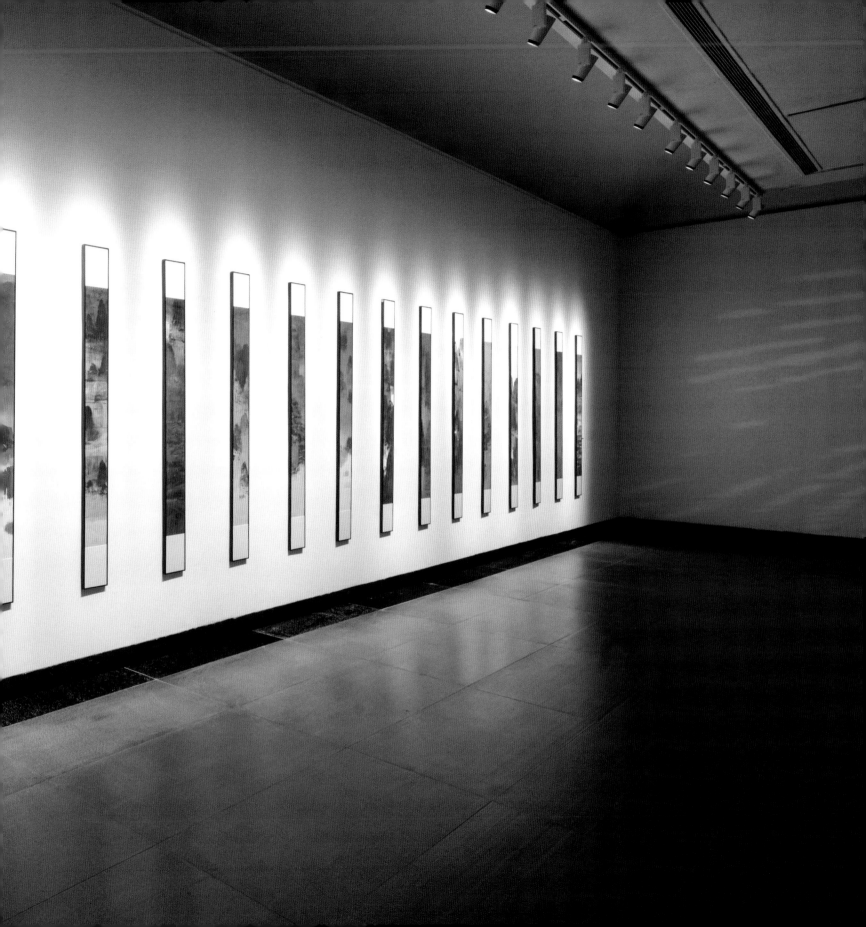

一系列又长又窄的画作，就如窗扉，由内看向外，是风景之美，也是心境的变化。

A series of elongated and slim paintings akin to frames of windows. When viewed from within, it not only showcases the splendour of the external scenery but also the fluctuation of one's state of mind.

十八式 18 Shades in Ink │ 纸本水墨设色 Ink and colour on paper │ 136 X 16.5cm X 18 │ 2018

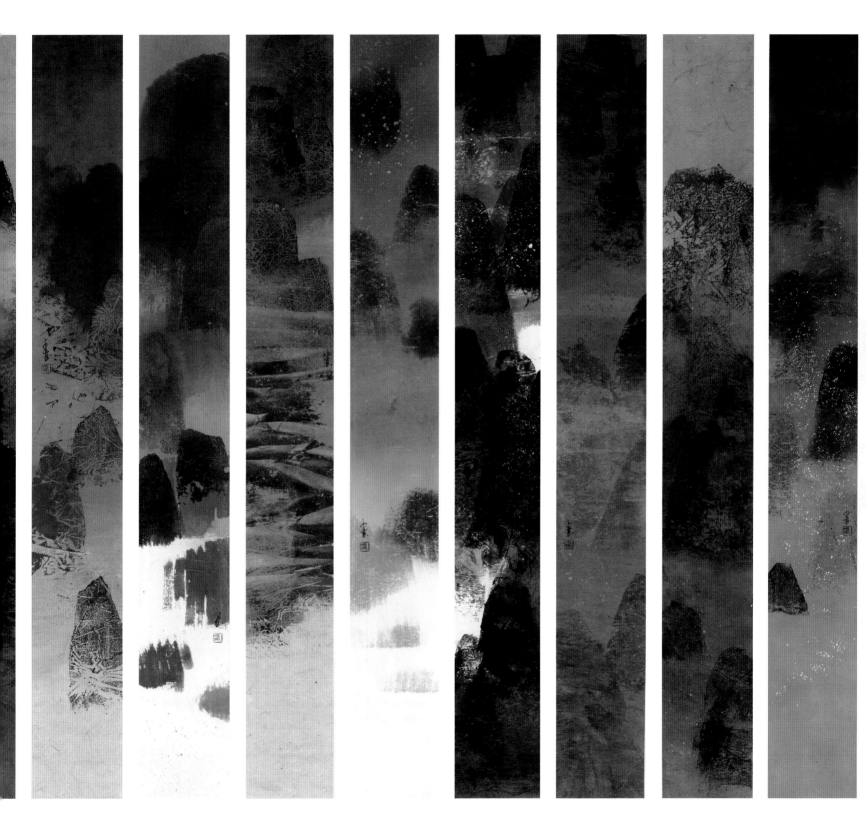

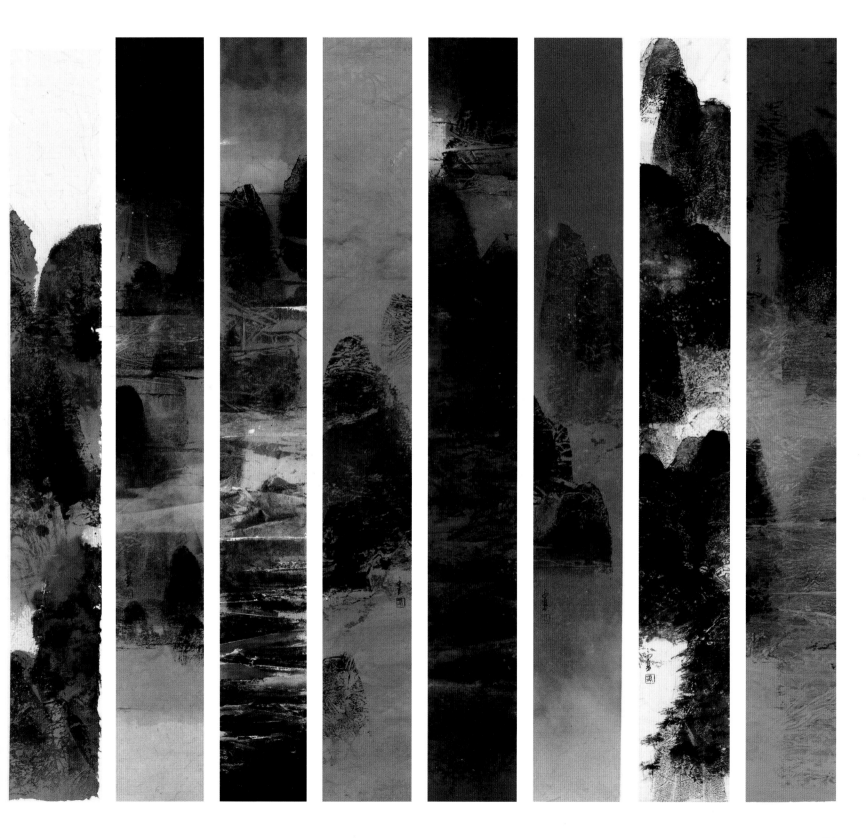

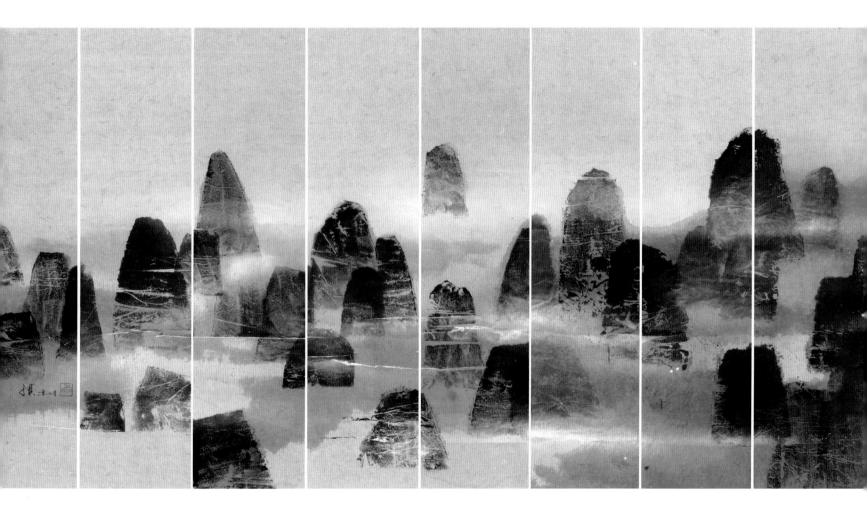

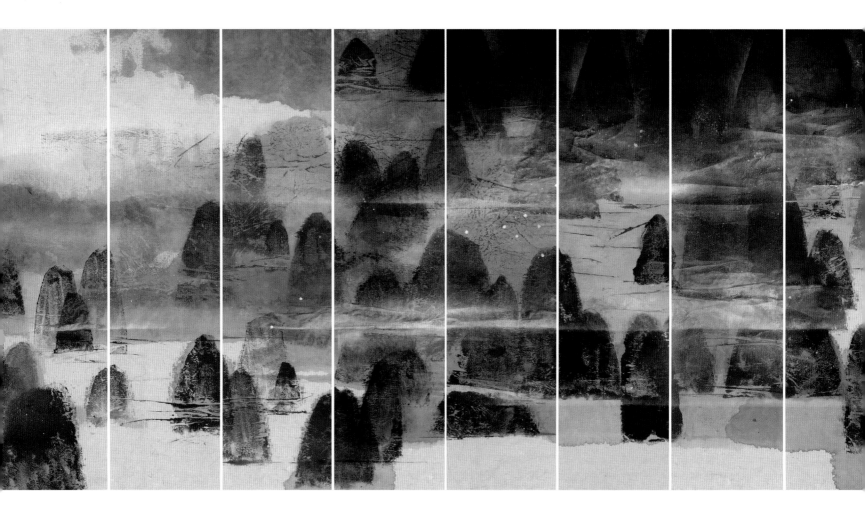

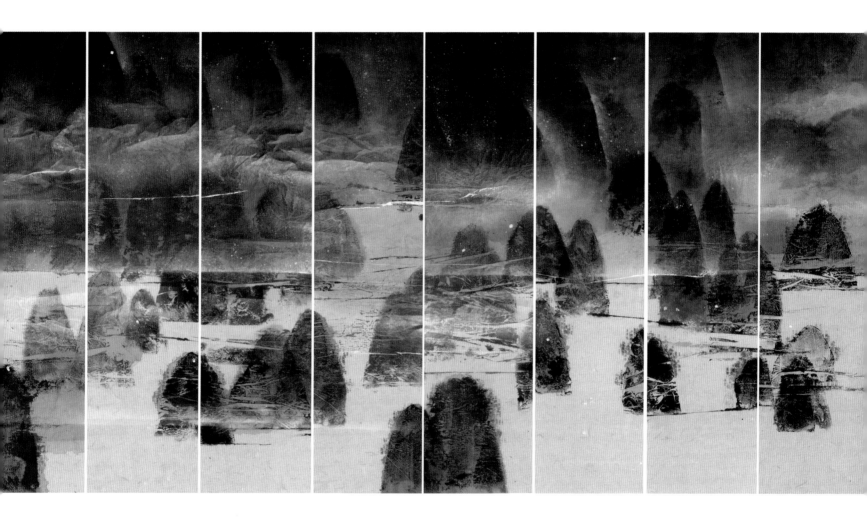

由二十四帧联屏组成的《廿四史》，由东海到西藏，将中国从东至西勾勒于此；峰峦重叠下，印着二十四史的名字，诉说中国史诗式的浩瀚。

The Twenty-Four Histories, which is comprised of twenty-four panels of paintings depicting China from the East China Sea to Tibet, presents a comprehensive outline of the country from the eastern to western regions. The towering peaks and mountains, which have been named after the *Twenty-Four Histories*, seek to recount the expansive and profound history of China.

千秋 Dynasties ｜ 动画片 Animation video ｜ 动画创作 : 又一山人 Creative direction by anothermountainman ｜ 制片 : 黄宏达 Produced by Victor Wong ｜ 尺寸 Dimension: 6000 X 994 ｜ 片长 Duration: 2'24'' ｜ 2023

《千秋》原作为香港故宫文化博物馆藏品 The original artwork of *Dynasties* is now part of the collection at the Hong Kong Palace Museum.

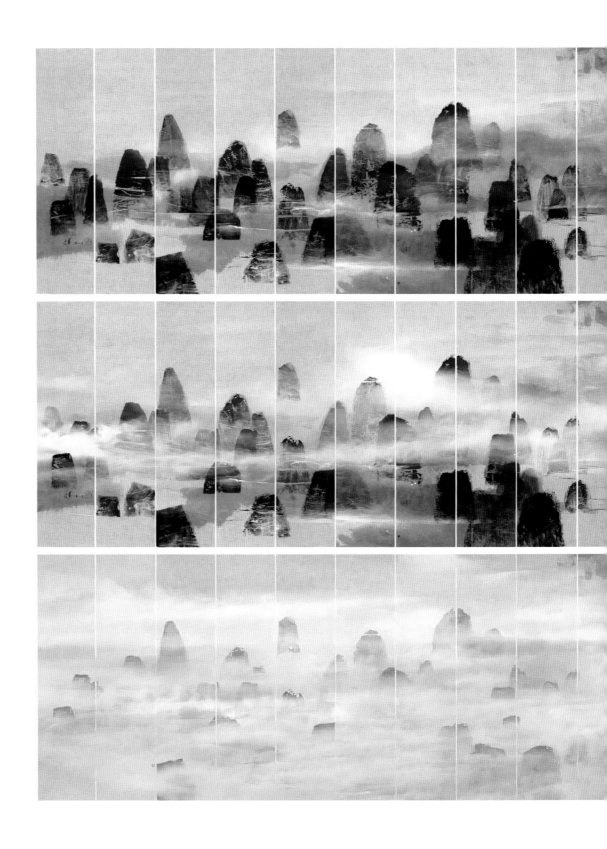

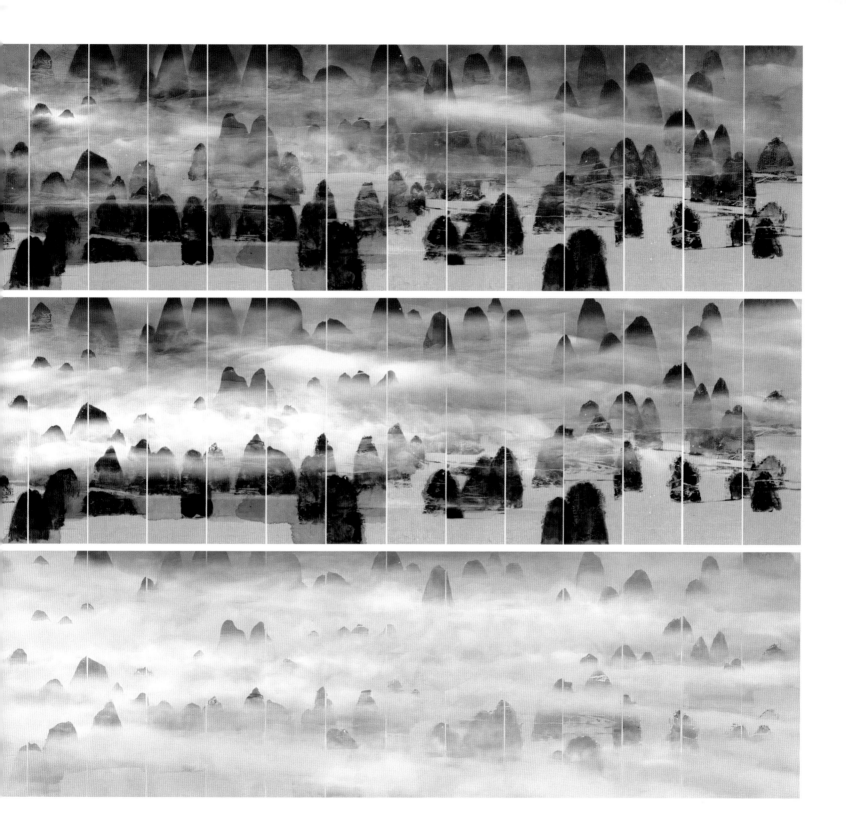

放下了什么

WHAT HAVE I LET GO OF

WHAT EXACTLY HAVE I PICKED UP ANEW?

WHAT HAVE I SEEN

WHAT HAVE I HEARD

WHAT HAVE I GAINED

WHAT HAVE I GIVEN

WHAT HAVE I FORFGONE

冯永基为香港著名水墨艺术家，曾获无数国际艺术奖项，并于亚洲、北美洲及欧洲各地举行多场展览，拥有丰富的展览经历。没有词汇比"多才多艺"更适合形容冯永基，皆因他的画作结合了出色的技巧，以及富有创意与实验性的媒材探索。他常将自己艺术底蕴的形成归功于早期现代水墨的大师，尤其是张大千透过泼墨泼彩构建的形象界，吕寿琨弘扬实验精神的水墨作品，以及香港"新水墨运动"，均对冯永基的创作影响深远。

如今，这些大师的影响早已埋藏于冯永基画作深处。多年来，随着其创作观念不断发展，冯永基的作品逐渐离为人熟知的大师。若仔细观察其于2018年创作的《十八式》，仍依稀可见一丝冯永基早期习训的痕迹，包括对岭南画派色彩渲染的呼应，以及吕寿琨笔触的踪影。然而，从冯永基对大师手法的借鉴与鉴赏具有的作品，无疑低估了他独具一格的风格与特点。他最近的创作并非从固有的手法出发，而是针对人类共处世界所面临的问题而提出拷问。这些原创的画作，足以在观者心中激起一连串的思考。

冯永基丰富而具深度的水墨艺术，令人难以想象他的本业。在过去半个世纪，冯永基是一位获奖无数的政府建筑师，致力塑造香港的公共建筑和空间，从近年的艺术作品，感发可见其建筑及艺术手法的呼应及融汇，尤其是他对空间的理解，对居住环境的关注，以及对自然环境的保护意识。

在《十八式》中，一组多姿多彩的水墨设色作品有如一幅幅局屏，引领观众通往各自的心景。冯永基在素描簿中绘画了整个系列的《十八式》的草稿，透过构思每件画作的空间关系，带出了整个作品的一体性。在本次展览的一场访问中，冯永基指出这组作品当中的节奏和气势是解读它的关键。举办展览时，冯永基会主动参与作品在画廊空间中的呈现，并透过建筑师精锐的眼光监督展览的设计及作品的摆放。

另一组创作于2019年的作品《千秋》由24幅联屏巨型风景画组成，当中每幅分别象征一个中国朝代或时期，使人联想起中国的千年历史。作品于巴黎当代艺术博览会，台北国际艺术博览会及香港水墨艺术博览展出时，冯永基更在复制版本上添上一层如雾般的投影，从橘红色的天空蔓延开来，象征着过往的社会纷争与动荡。冯永基还对现今世人反复及《千秋》背后的创作动机源于他对中国朝代结构的审视，并对现今世人反复歌颂历史胜利者提出的另类见解：他笔下的《千秋》，更像是为历代兴替中数以百万失去性命的

Raymond Fung is one of Hong Kong's leading ink artists. He has received numerous international artistic awards, and has an enviable track record of exhibitions in Asia, North America and Europe. Fung is nothing if not versatile. His paintings combine technical excellence with an innovative, experimental approach to media and materials. He has often identified his early artistic foundations with the study of modern ink painting masters: particularly Zhang Daqian's chromatic fields of splashed colour, and the experimental spirit that characterises the work of Lui Shoukwan and Hong Kong's New Ink movement.

Today, Fung's formative influences sit far beneath the surface of his paintings. As his conceptual complexity has deepened over the years, identifiable techniques have receded from view. Look long and hard at *18 Shades in Ink* (2018), and you may still see a trace of Fung's formal training. An echo in a Lingnan colour-wash here, a hint of Lui Shoukwan's brush strokes there. Yet to appraise Fung's work on the basis of his borrowings from past masters is to significantly undervalue his originality. His latest projects are not concerned with channelling or reformulating received artistic processes. Fung's paintings are interrogative spaces that question the world around us. They are original graphic stimuli to mental reflection.

The complexity and depth of Fung's ink art belie the fact that painting has not always been his primary career. He is also an award-winning municipal architect: actively shaping Hong Kong's public structures and spaces over the past half-century. The resonance and cross-fertilisation between Fung's architectural and artistic practices have become increasingly visible in recent years. Particularly in his approach to space, his concern with lived experience, and his environmental consciousness.

In *18 Shades in Ink*, a diverse chromatic chorus provides windows through which the viewer can reflect on their own mental landscape. Fung's sketch book offers an insight into his preparation for this series of paintings. His preparatory drawings conceive of the series

无名氏而立的纪念碑。

最新的《呼吸》系列反映出冯永基一直以来的建筑作品背后对生态环境的意识。他以创新手法创作这个水墨艺术系列，传达对环境保护的关注。该系列的每幅画均经历三大阶段：首先，冯永基用大笔刷沾上水墨及颜料，在厚厚的日本纸上作画；接下来，他在表面覆上一层保鲜薄膜，把空气困于其内并形成气泡，使颜料在二十四小时后风干。揭开保鲜薄膜后，冯永基所形成的效果游走于晕开的色彩与尖锐的线条之间，最终集中所形成的接缝勾勒出半抽象的景象，画面充满肌理和迷蒙的色调，构成一幅又一幅精彩绝伦、引人入胜的水墨画。在这个过程中，笔触技巧并非主角。《呼吸》系列可谓是冯永基受传统笔墨训练以来，最"离经叛道"的创作。

在了解创作过程后再观赏《呼吸》系列作品，我们的视野仿佛延伸至画面之外，并超越了水墨画的种种规和文化意涵。这些风景诞生于双手控制下产生的气体交换现象，恰好反映了现今人类对大自然的操控，有如一幅展示了人类活动如何改变和限制生生不息的大自然的缩影。《呼吸》系列的反是对"人类世"（现今由人类活动主导物理环境的改变的地质年代）的反思，其崭新的美学效果吸引着我们，并借此引发对地球生态健康的思考。冯永基透过水墨艺术提出了最本质的问题：我们的地球是否仍在"呼吸"？

黄友柯
伦敦大学亚非学院亚洲艺术研究院总监

holistically, carefully mapping the spatial relationships between each work. In an interview for this exhibition, Fung stated that the rhythm and momentum of this series are integral, even imperative, to a full reading of the work. He is very active in shaping the presentation of his paintings in a gallery space, overseeing the design and layout of his exhibits with architectural precision.

In *Dynasties* (2019), shown at Art Paris and Art Taipei, Fung created a monumental serial landscape in 24 parts. Each section embodies a historical period, evoking the millennial span of China's past. When exhibiting this work at Art Paris, Art Taipei, and Ink Asia Hong Kong, Fung funnelled projections of steam through replicas of the original artwork. This simulated smoke billowed from the red and orange skies of the landscapes, evoking the tumult of historical conflict. Fung told me that he wanted the series to question the dynastic structure of China's historical narrative. Dynasties offer an alternative to the recurrent glorification of the victors in ancient conflicts. Fung's landscapes are a monument to the nameless millions lost in violent political transitions of the past.

Most recently, Fung's *Breathing* series reflects on the ecological consciousness that informed his architectural practice. He developed this environmentalist ink art using an innovative new technique. Each work in the *Breathing* series is created in three stages. First, Fung applies ink and colour pigments to thick Japanese paper with a large brush. Second, he covers the paper surface with clingfilm. Air bubbles are trapped beneath the plastic sheet, pushing the pigments to coalesce around the folds in the film. Finally, Fung massages the air and pigments beneath the plastic, guiding their evaporation over a 24-hour period. When he lifts the clingfilm off, the resulting image oscillates between diffuse fields and sharp lines. Concentrated seams of pigment outline the contours of semi-abstract landscapes, textured with loose clouds of colour. These residual images are arresting and immersive ink paintings. Yet brushwork was only tangential to their production. *Breathing* is Fung's furthest departure yet from the foundations of his formal training.

Viewed with its process of production in mind, the *Breathing* series also prompts us to look beyond the pictorial surface, and outside the rubric and cultural associations of ink painting. These landscapes are shaped by gaseous exchange, manipulated and constricted by human action. *Breathing* mirrors modern humans' manipulation of the natural world. The paintings are a micro illustration of the process by which human activity constricts and controls the flow of vital vapours in our natural environment. *Breathing* is a meditation on the Anthropocene: our current geological period in which human action is the primary agent shaping the physical world. The series demands our eye's attention with innovative aesthetic effects. This visual stimulus in turn prompts us to consider the health of the global ecosystem we all inhabit. At a fundamental level, Raymond Fung has used ink art to ask if the earth itself is still breathing.

Malcolm McNeill

Director of the Postgraduate Diploma in Asian Art SOAS,
University of London

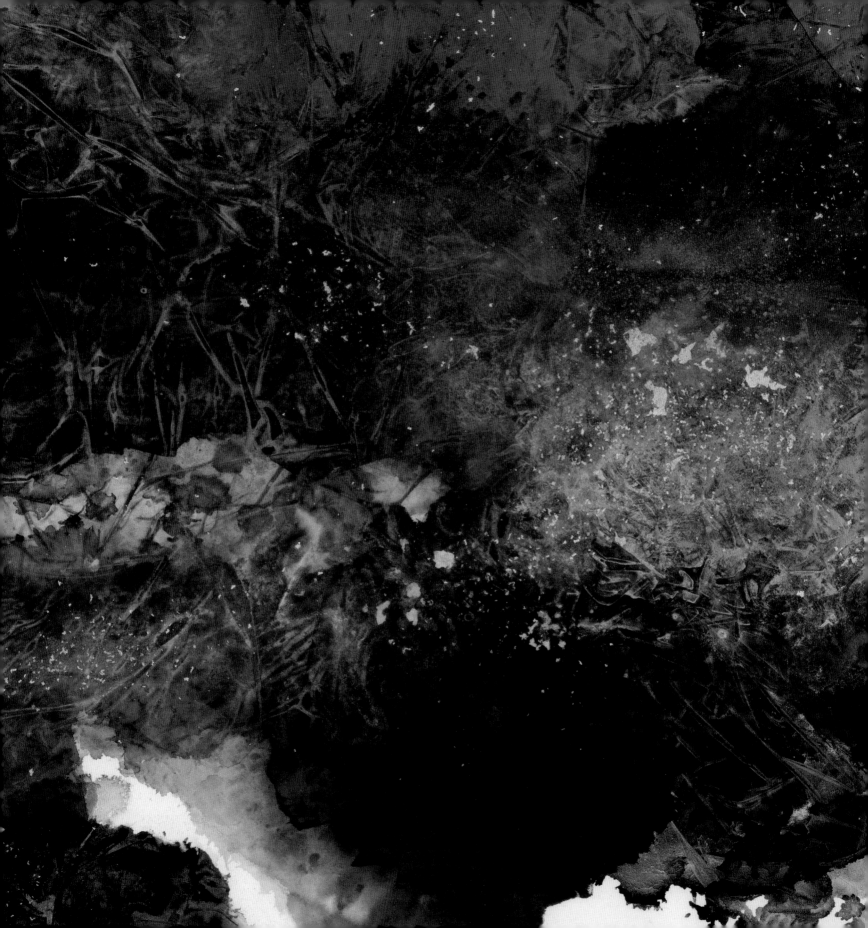

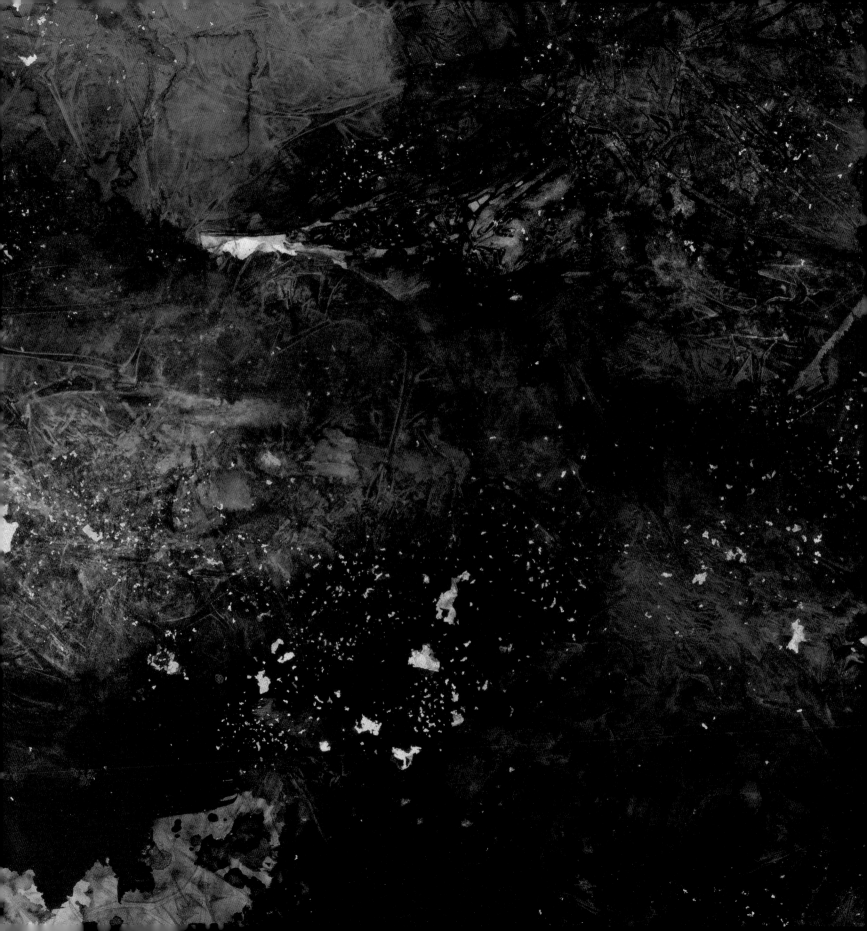

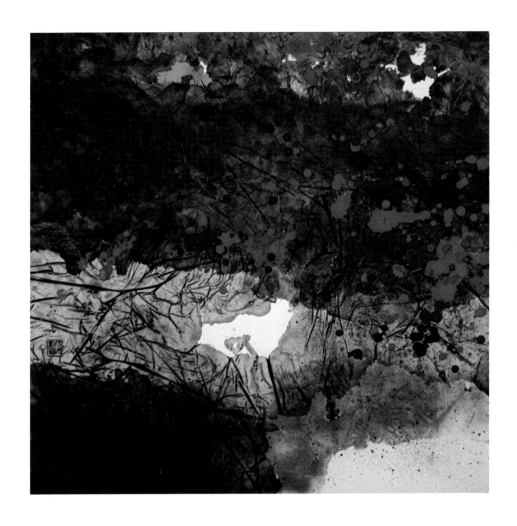

自然生态（一）Ecosystem No.1 ｜ 水墨设色纸本 Ink and colour on paper ｜ 60 X 60cm ｜ 2019

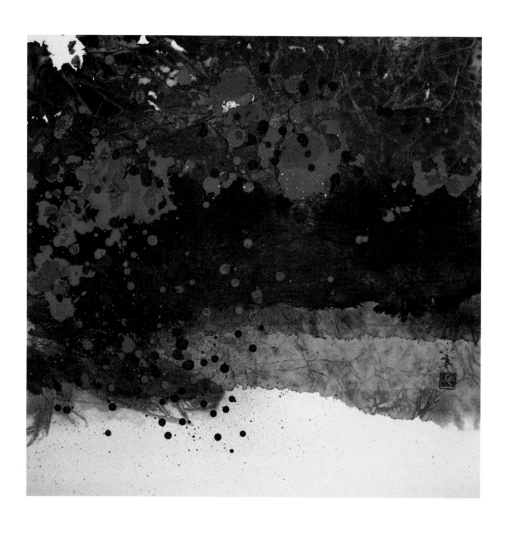

自然生态（二）Ecosystem No.2 ｜ 水墨设色纸本 Ink and colour on paper ｜ 60 X 60cm ｜ 2019

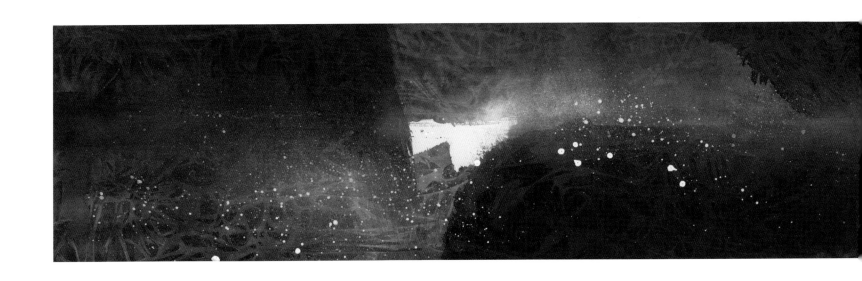

平衡空间（一）Multiverse No.1 ｜ 水墨设色纸本 Ink and colour on paper ｜ 26 X 180cm ｜ 2019

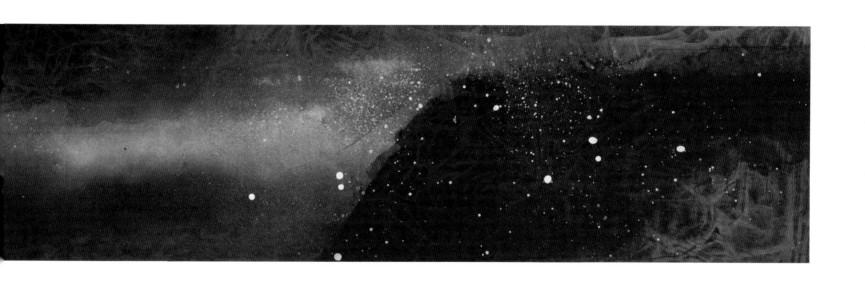

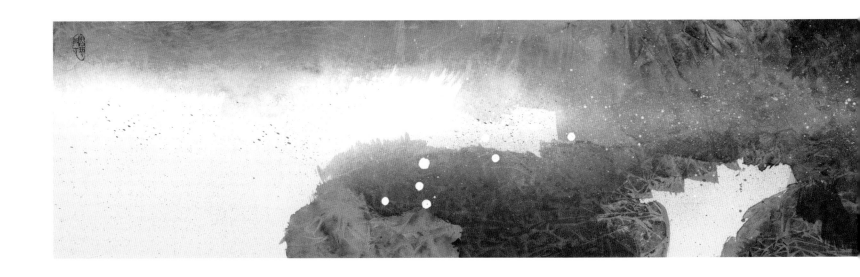

平衡空间（二）Multiverse No.2 ｜ 水墨设色纸本 Ink and colour on paper ｜ 26 X 180cm ｜ 2019
私人收藏 Private Collection

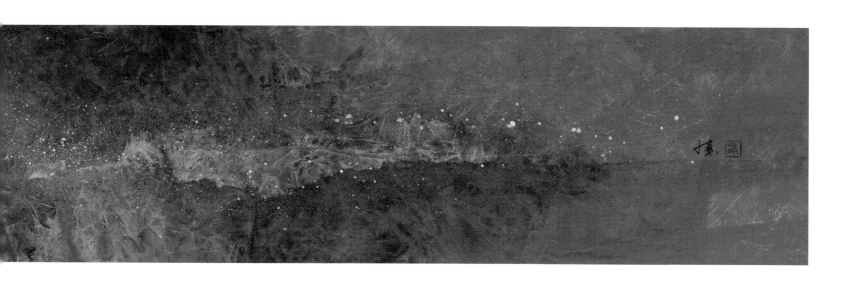

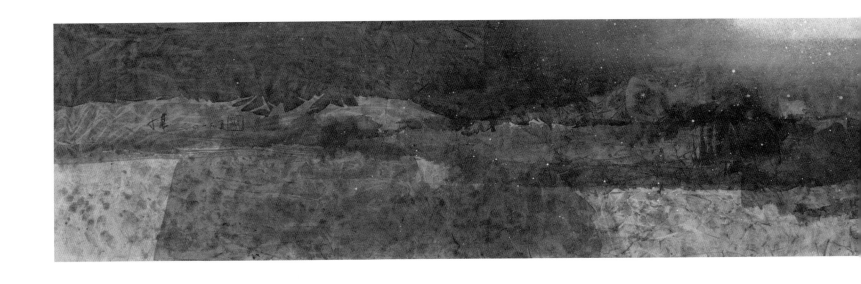

平衡空间（三）Multiverse No.3 ｜ 水墨设色纸本 Ink and colour on paper ｜ 26 X 180cm ｜ 2019

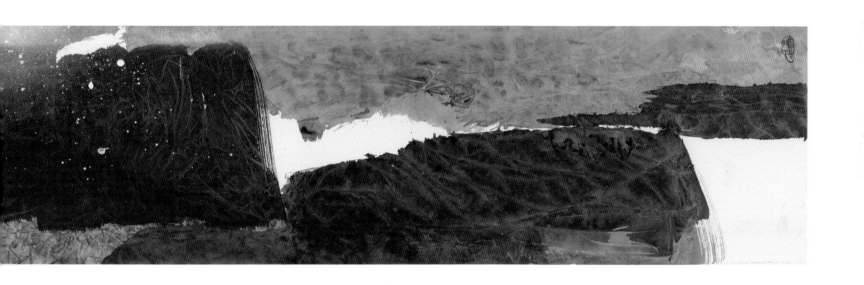

傲雪寒梅 Silvery Snow ｜ 水墨设色纸本 Ink and colour on paper ｜ 26 X 138cm ｜ 2019

生命的规律 Principal of Life ｜ 水墨设色纸本 Ink and colour on paper ｜ 26 X 138cm ｜ 2019

点线面 Point, line and Plane ｜ 水墨设色纸本 Ink and colour on paper ｜ 26 X 138cm ｜ 2019

问苍天 Only God Knows ｜ 水墨设色纸本 Ink and colour on paper ｜ 14 X 140cm ｜ 2009
私人收藏 Private Collection

生命（七）Life（7）｜ 水墨设色纸本 Ink and colour on paper ｜ 43 X 43cm ｜ 2020
私人收藏 Private Collection

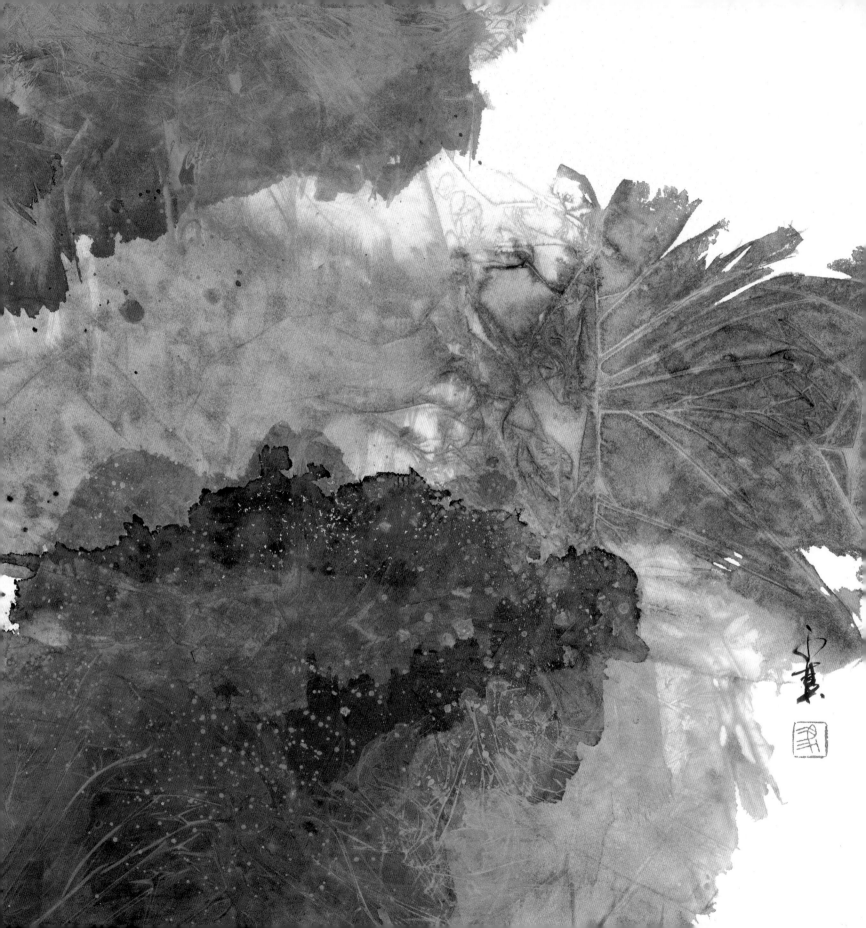

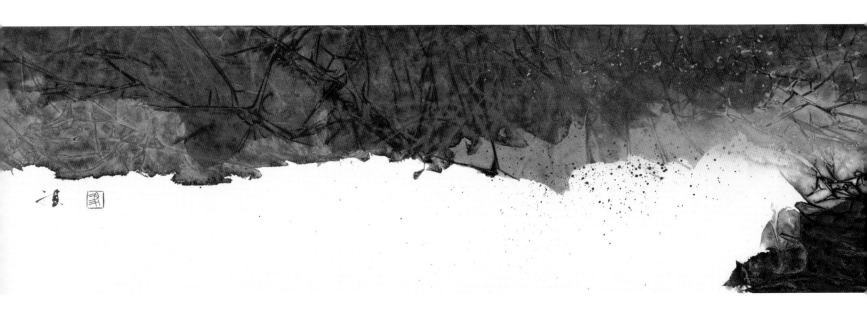

呼吸（五）Breathing（5）｜水墨设色纸本 Ink and colour on paper｜26 X 180cm｜2020

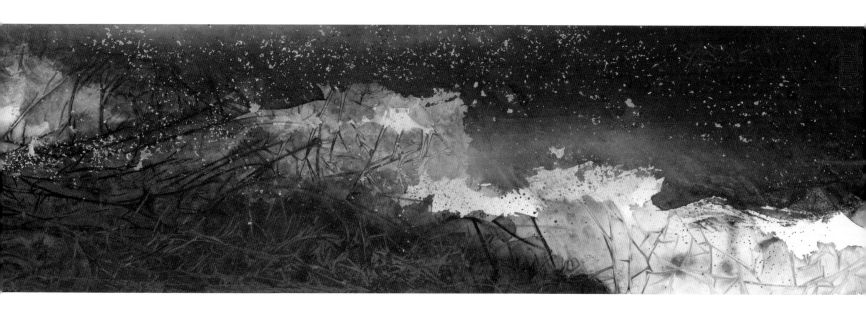

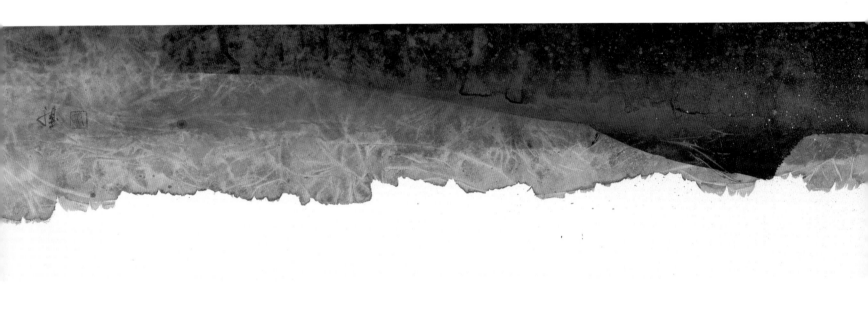

呼吸（二十）Breathing（20） ｜ 水墨设色纸本 Ink and colour on paper ｜ 26 X 180cm ｜ 2020

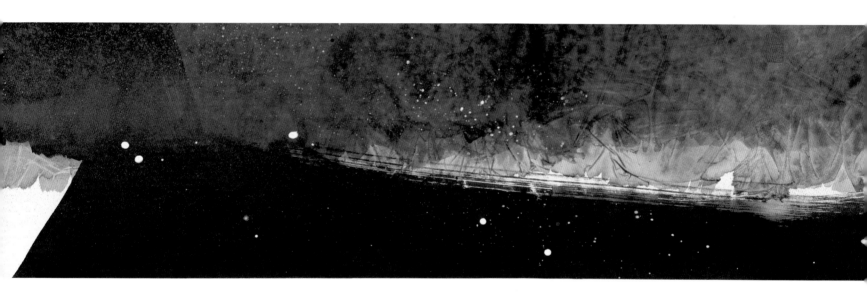

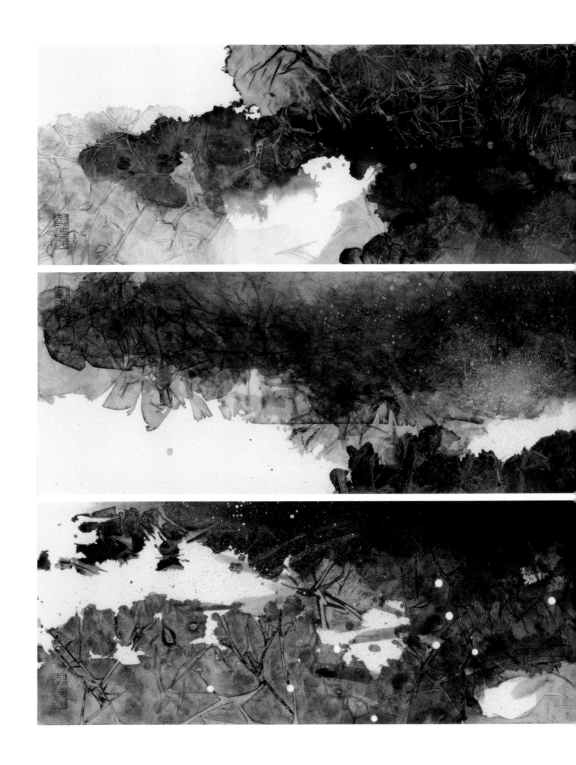

呼吸（二十四）（二十五）（二十六）Breathing （24）（25）（26）│水墨设色纸本 Ink and colour on paper │ 26 X 180cm │ 2021

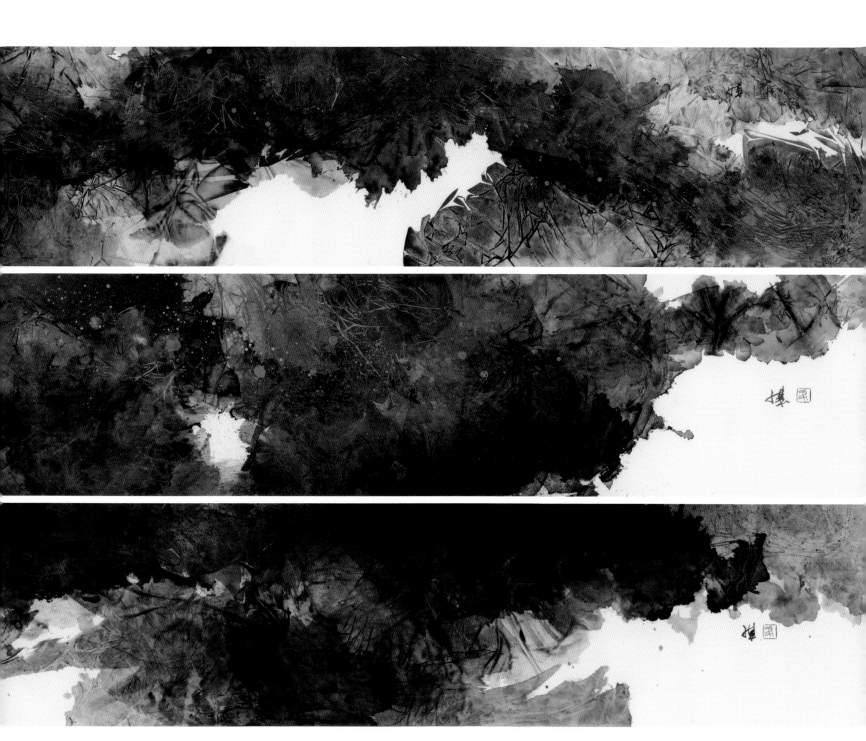

生命系列是呼吸系列的延伸，描绘植物的生命在全球环境污染下，受到的呼吸阻碍，而衍生的肌理效果，探讨地球生态的变化。

The *Life* series builds upon the *Breathing* series by illustrating the survival of plants in the midst of global environmental pollution and the consequential respiratory hindrances that cause textural variations. This series seeks to explore the changes occurring in the Earth's ecosystem.

生命（十五）（十六）（十七）Life （15）（16）（17）│ 纸本水墨设色 Ink and colour on paper │ 180 X 70cm X 3 │ 2021
广东美术馆藏品 Collection of Guangdong Museum of Art

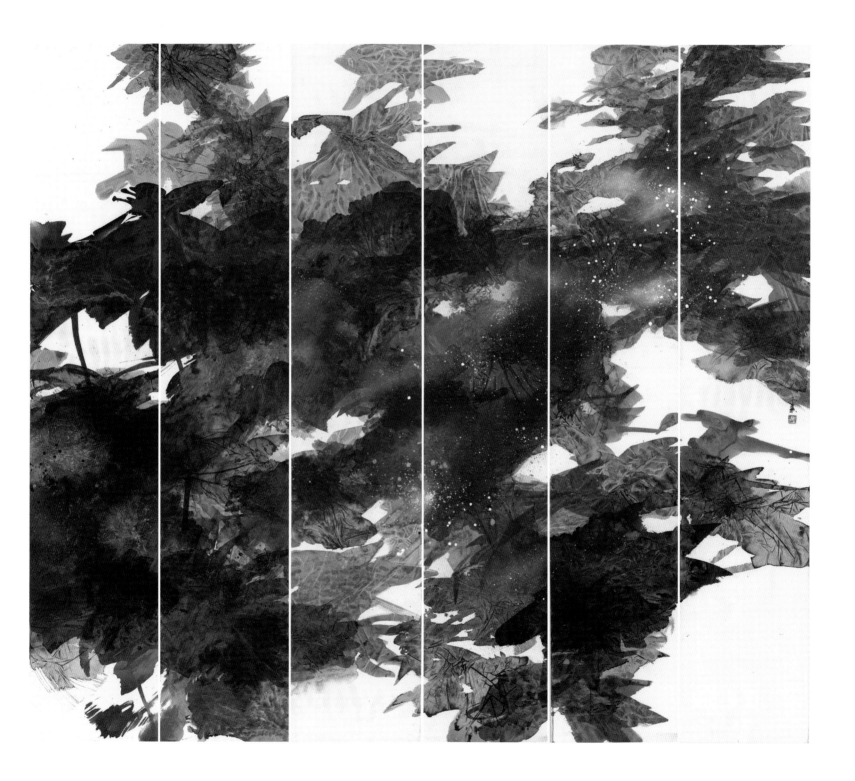

221

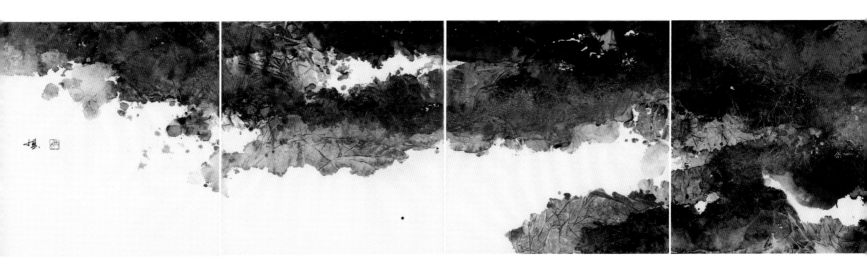

艺术家以标志性的蓝调紫调，描绘出大山大水的壮丽，连绵山脊透出亮丽的河光山色。

The artist portrays stunning mountain and water landscapes using iconic blue and purple shades, with dazzling river and mountain views shining through the uninterrupted mountain ranges.

河山 Our Land ｜ 水墨设色纸本 Ink and colour on paper ｜ 90 X 90cm X 8 ｜ 2021

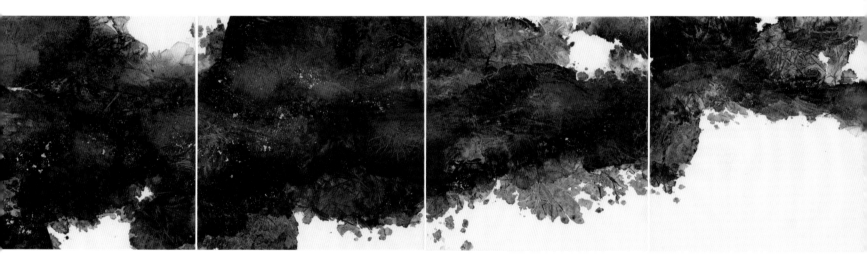

七联屏水墨画《七拾》是艺术家人到七十的自勉，折射更深层次的心路历程。

The seven-panel Chinese ink painting titled *Qī Shí* serves as a source of inspiration for the artist, reflecting a more profound level of personal experience as he reaches the age of seventy.

七拾 Qī Shí │ 水墨设色纸本 Ink and colour on paper │ 90 X 90cm X 7 │ 2022

画作是对"人类世"的反思、对全球环境议题的关注，以鲜艳的色调，独特的肌理，诉说世界不能呼吸后的现象。

The artwork is a reflection upon the "Anthropocene" era and concerns surrounding global environmental issues. Employing vibrant colours and distinctive textures, it portrays the phenomenon of stifled breath, which has rendered the planet incapable of breathing.

呼吸（二十七）Breathing（27）｜水墨设色纸本 Ink and colour on paper｜90 X 90cm X 3｜2022

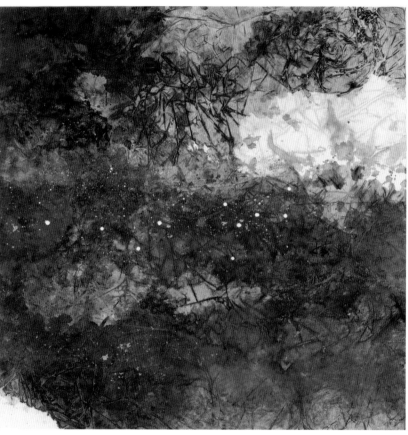

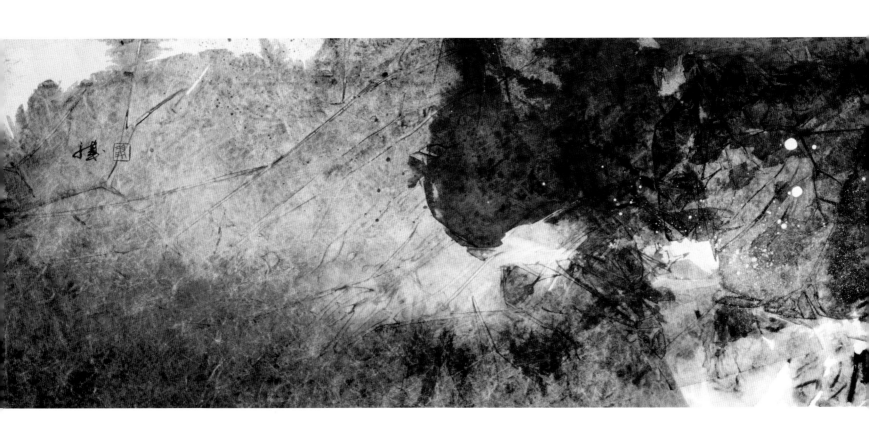

呼吸（二十八）Breathing（28）｜水墨设色纸本 Ink and colour on paper｜35 X 180cm｜2022

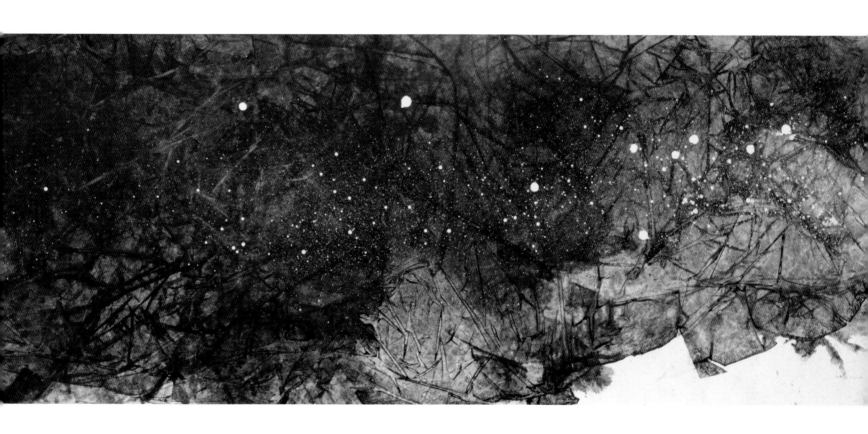

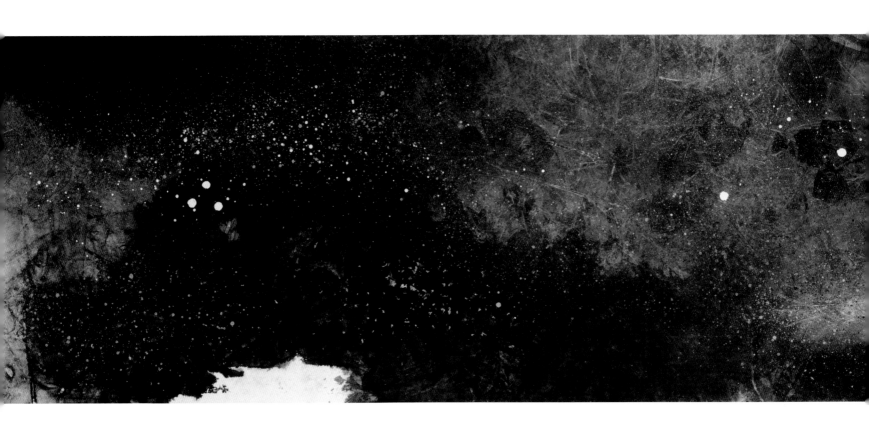

呼吸（二十九）Breathing（29）｜水墨设色纸本 Ink and colour on paper｜35 X 180cm｜2022

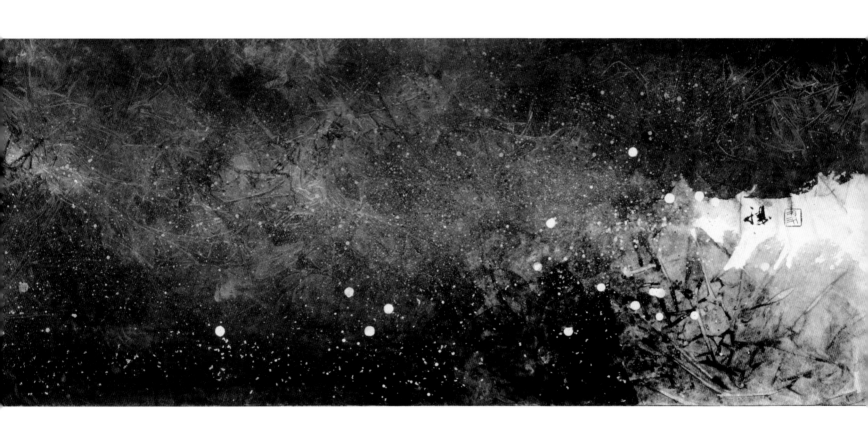

生命（十八）Life (18)｜水墨设色纸本 Ink and colour on paper｜35 X 180cm｜2022

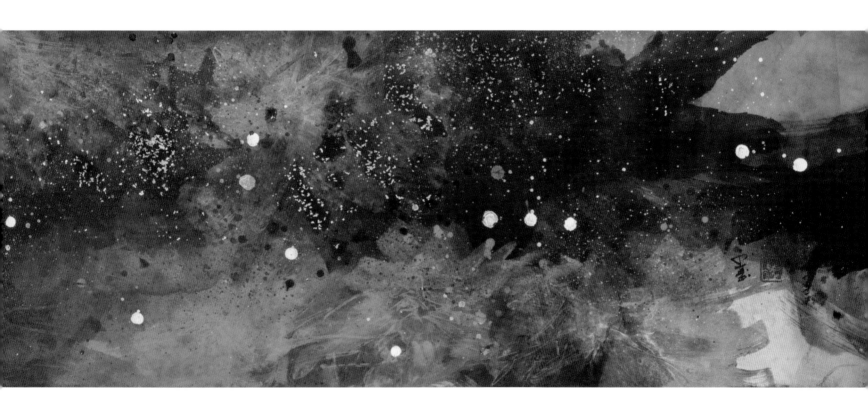

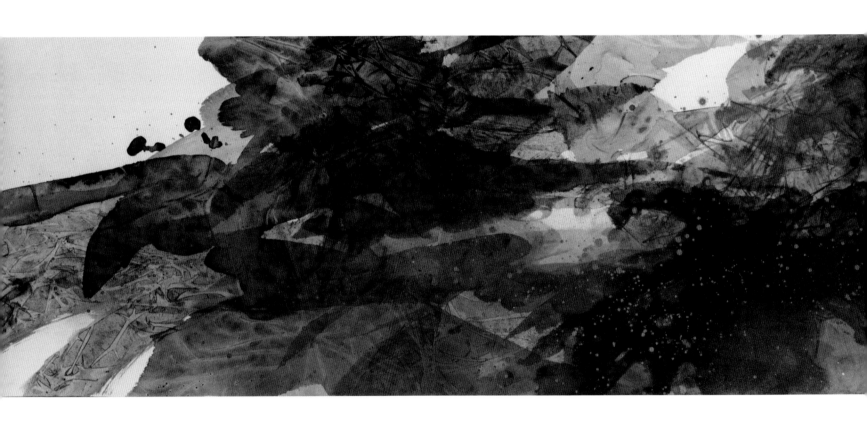

生命（十九）Life (19) ｜ 水墨设色纸本 Ink and colour on paper ｜ 35 X 180cm ｜ 2022

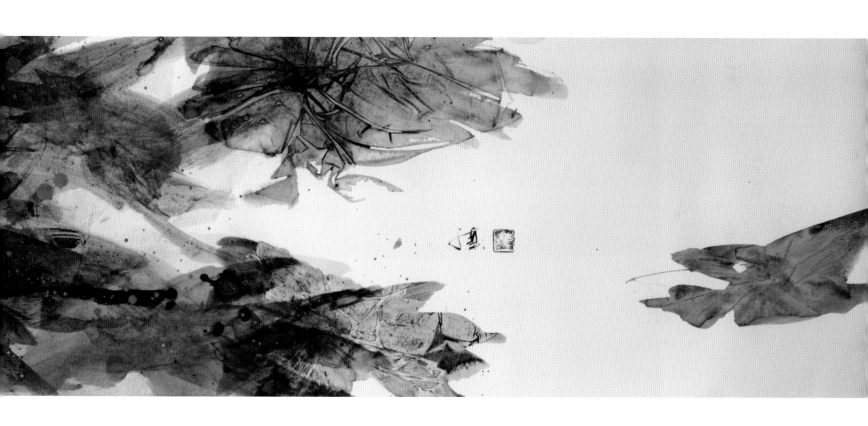

重新拾起的，又是什么？
WHAT EXACTLY HAVE I PICKED UP ANEW?

看见了什么
WHAT HAVE I SEEN

听见了什么
WHAT HAVE I HEARD

得到了什么
WHAT HAVE I GAINED

放弃了什么
WHAT HAVE I LET GO OF

付出了什么
WHAT HAVE I FORGONE

纪录短片《七拾》以艺术家喜爱的乒乓运动为主线，随着乒乓球的一来一回，细细诉说艺术家的建筑与水墨人生。

The short documentary film *Qī Shí* focuses on the artist's favourite sport table tennis. The artist's encounters in between architecture and ink painting are depicted through the back-and-forth exchanges of table tennis.

七拾 Qī Shí | 纪录短片 Documentary short film | 导演/制片 Director/Producer: 又一山人 anothermountainman | 尺寸 Dimension: 720px X 720px | 片长 Duration: 11'45" | 2023

胡斌
Hu Bin
广州美术学院艺术与人文学院院长
Dean, Department of Art
and Humanities, Guangzhou
Academy of Arts

邓民亮
Raymond Tang
香港文化博物馆(艺术)馆长
Curator, Hong Kong
Heritage Museu

皮道坚
Pi Daojian
策展人、华南师范大学教授
Curator, Professor, South
China Normal University

王绍强
Wang Shaoqiang
学术主持 、 广东美术馆馆长
Academic Host
Director, Guangdong
Museum of Art

冯永基
Raymond Fung
艺术家
Artist

洪亮
u Hongliang
京画院院长
ector, Beijing Fine
Academy

薛求理
Charlie Xue
香港城市大学建筑系教授
Professor, Department
of Architecture and
Civil Engineering of City
University Hong Kong

颜勇
Yan Yong
广东工业大学艺术与设计学院副教授
Assistant Professor, Art and
Design School, Guangdong
University of Technology

王绍强：首先，非常感谢各位来到广东美术馆参加冯永基老师展览的研讨会；这个展览以"七拾"为题，既寓意冯老师凭借对建筑、水墨，以及乒乓球的热爱，缓缓走过人生的七十年，亦指拾起的七个十年；透过逾百项作品，包括水墨画、建筑图片、建筑模型、装置艺术、影片等不同媒介的创作，多面向呈现冯老师在七十年来，游走于建筑和艺术之间的人生道路，而这个研讨会将以冯老师在建筑与水墨的发展上，去探讨其艺术进程及影响。

我介绍一下今天参加研讨会的几位老师：首先，是此次展览的策展人皮道坚老师。一直以来皮老师都很关注当代水墨等传统媒介在当代语境中的探索与发展，而且很有深度和见解；香港文化博物馆(艺术)馆长邓民亮博士，是我们多年的好友，这次展览很感谢邓馆长的支持，为我们借展了很多冯老师的重要作品；还有关注建筑领域的香港城市大学建筑系教授薛求理博士；一直关注水墨和当代艺术的北京画院吴洪亮院长；广州美术学院人文学院院长胡斌；广东工业大学艺术与设计学院的副教授颜勇。除了在座之外，我们还邀请了鲁虹老师，不过很遗憾，他临时有事未能出席，但专门写了一篇评论，非常值得一读，建议放在冯老师的出版物上。

感谢大家对冯老师展览的关注和支持。

皮道坚：今天很高兴，我们有这么一个机会，在这里研讨冯永基先生的艺术。他的艺术成就不仅在于水墨，还包括文化、建筑领域。这个展览和研讨，我认为有一些特别的意义。

首先，广东跟香港现在是粤港澳大湾区连成一体，我一直都在关注现当代水墨，而现当代水墨艺术的交流在广东美术馆和香港艺术馆也是很早就进行了。广东美术馆一直致力于推动现当代水墨的发展，包括关注现当代水墨由传统向现当代的转换。2001年，王璜生馆长邀请我在这里做了展览"中国水墨实验20年：1980-2001"，当时香港艺术馆总馆长是朱锦鸾女士，她知道后马上来到广州，很积极地参与到展览的学术活动。那是大陆体制内美术馆举办的第一个实验水墨展，朱锦鸾馆长很有眼光，通过这次展览收藏的实验水墨作品，成为香港艺术馆第一批关于大陆当代水墨的收藏。

第二，内地的现当代水墨受香港和台湾的影响非常大。回看香港和台湾的现当代水墨，要比中国大陆早三十多年产生，例如香港新水墨的代表吕寿琨先生活跃于20世纪七十年代，而那时中国内地尚未出现现代水墨。后来，香港的现代水墨直接影响了内地的现当代水墨的发生、发展和壮大。而冯永基先生就是直接受吕寿琨先生的影响，走上现在这条路。

广东美术馆一直推进现当代水墨，为此做了很多展览，也推到国际。香港更是如此，我记得十多年前，香港的现当代水墨在伦敦做了一个很大的展览，在2019年时，王馆长、邓馆长又一同发起，做了一个粤港澳的当代水墨展，

你（冯永基）也参加了，那个展览叫作"臆象——粤港澳当代水墨艺术谱系（2000-2020）"。

我为什么要讲这些？因为冯先生在香港当代水墨领域是一个很有意义的个案。香港的当代水墨艺术有一个特点，就是跟设计的关系非常密切。比如说像王无邪、靳埭强等先生，这些都是设计领域的艺术家。而冯先生也是跨界于建筑和水墨这两个领域。

皮道坚：我在广东美术馆为香港艺术家做个展的策展，冯先生是第一位。这个主题叫做"水墨心境 时空赋能"，是研究了冯先生的整个艺术之后，我所得出的结论，大家也可以展开讨论。在这里，我想先请邓馆长。

邓民亮：刚才皮老师给我们一个很好的开端，我再做一点补充。

我在看了冯先生的图录后，马上有了一个想象。首先，他用了乒乓球。乒乓球是两个人来打，其实是两个平行空间，平行的空间好像是我们世界一样，有很多事情在发生，它们不一定发生一个互相的关系，但是当它发生一个互相影响的时候，这个影响可以很大。我想从香港的艺术背景对冯先生的发展，有一个怎样的影响来展开讨论。

20世纪五十年代的中国香港是怎样的呢？我们看到广东的赵少昂来到香港来定居，然后成立了他的岭南艺苑，"岭南派"可以说是中国近现代最重要、对海外影响最大的画派，而这个画派就是通过赵少昂这一代人从香港传到全世界。

今天我们熟知的艺术家赵无极，其实也跟香港地区的关系很密切，他在1958年到香港中文大学授课，当时影响了很多朋友，吕寿琨先生就是其中之一。吕寿琨当时还在挣扎，究竟是往前走，还是留在像"岭南派"一样的路线去继续他的艺术方向，但当他遇见赵无极后，就下定了决心。在1959年，他第一次举办了一个半抽象的水墨展览，成为他迈向抽象水墨的开端。

其实张大千也跟香港地区的关系很密切，他常常来香港，而且在香港跟很多人有交往，也是从20世纪五十年代移民巴西以后，他对西方现代绘画，特别是抽象绘画有了一个比较新颖的概念。从那时起，他便开始想如何使中国的绘画迈向国际。因此，五十年代是中国绘画发展的一个很重要时期。

20世纪六十年代是水墨发展的重要时期。刚才皮老师提到的王无邪，以及张大千都是在这一时期把抽象山水画发展成熟。吕寿琨则从解构中国传统水墨的角度来建立自己的水墨画系统。还有刘国松先生其实也是从1959年开始，重新思考回到中国水墨画的发展方向。但直到他于1966年到美国以后，才真正把他的水墨系统重新建构起来。所以说六十年代是很重要的一个年代。

在这一时期，冯先生9岁时，画了一张关于香港维多利亚港的绘画，展示了香港现代化城市面貌，并在绘画方面呈现出西方影响下的风貌，另他十五岁时用水墨画香港花市。冯先生在这个环境里，没有人跟他说中西融合，他自己已经在中西融合了。

七十年代，新水墨开始在香港蓬勃发展，差不多后来很多很有名的艺术家都是出现在这个时候。刚才皮老师说香港艺术馆对新水墨的推动很大，他们在1970年，首次把香港的新水墨绘画展拿到英国展出，到九十年代是第二次。这两次对欧洲以及对国际的交流和认识，对于我们在亚洲地区有一个新水墨的发展具有重要意义。这段历史很重要，所以我点出来。

那么，七十年代冯先生在做什么呢？他去了美国学习建筑，读建筑的经历对他来说很重要。当时美国最流行的是国际风格，而其中最有名的就是贝聿铭的那种风格。现代风格的建筑普遍是考虑怎样用最简练的材料来完成，但是有一点，现代风格要加一些自然的元素在里面，你看到很多很重要的建筑都是在考虑如何将自然元素怎样与现代元素融合，这对冯先生后来的发展有很大的影响。

刘国松先生于八十年代初到北京举办画展，往后三年的时间从黑龙江到武汉，几乎跑遍中国。这是中国近现代或者说是当代水墨的一个开端、一个起点。其实同一时间，香港另外一群画家，比如王无邪、靳埭强，他们不仅将当代中国的设计带到中国内地来，还带来了中国香港风格的新水墨。八十年代另一个很重要的点是，85'美术思潮，是中国水墨步入当代艺术的开端。八十年代，冯先生回到香港以后，他新的绘画风格，其实是一种融合的风格。例如《山水协奏曲第一乐章》，我觉得这个第一乐章很有意思，这其中的"音乐"有很多来源，有岭南派，从徐子雄走向吕寿琨，同时也有张大千的影响在里面。

因为我们在香港看到的这些东西都可以融合起来。从1985年到1989年，我特别把这两个年份放在一起，就是看他怎么思考水墨。刚才皮老师说香港很特别，很多艺术家同一时间既从事绘画，又是设计师，设计师把设计的概念放到水墨画里面，这是很重要的影响，而冯先生则加入了他的建筑概念，在往后的创作中就更明显了。

到了九十年代，在中国内地的实验水墨讨论中出现了东方和西方、传统和现代、内容和形式的二元对立的讨论，在当时是一个很重要的讨论。通过这个讨论，我们打开了一个多元的思维，对中国水墨来讲，把既有的框架打破了，甚至走到水墨能不能立体？能不能做装置？能不能用行为艺术的方法来表现？往后我们就看到中国当代水墨的发展，不仅仅是在平面上。这一时期，水墨在艺术语言方面有了很大的开创性。

九十年代，冯先生一边从事建筑设计工作，一边继续绘画。他的建筑手法多以简单的几何为主，还加了自然元素在内。而这个融合也能体现在他的水墨里。例如，他的装裱形式，就好像建筑里面已经有一个现代的人工的框架，但是那个框架包含了很多元素在里面，如色彩、水墨等。其中一幅作品《难忘时分》还加入了时间的元素，他把重要的元素放在时间点里，好像中国绘画的手卷一样，手卷有一个时间轴，但是冯先生用一个现代的概念来表达那个传统的中国手卷的时间观念。

冯永基：对，这是太阳从升起到下山的过程。

邓民亮：2000年也是很重要的一个年份，这一年举办了"深圳国际水墨画双年展"，让我们看到水墨如何走进国际视野。同一时间，我们看到冯先生对抽象进一步探索。他用很多香港的地貌、风景，他见到的、他家里附近的景色入画。其实这种观念就是我们对海岸地貌的一种解读，这个跟中国内地的画家对大山大河的研究是不一样的，这个水是横的。还有天气的变化，晨间烟雾弥漫，黄昏水光潋滟，这些都反映在他的作品里面，但是他把这些形都进一步抽象化了，抽象到好像一个结构，他放弃了传统的皴法，所有具体的，他都放弃了。

香港湿地公园的设计是他建筑设计中一个非常好的作品，因为融入了现代建筑的风格，还有清水混凝土，具有一种很简约的风格。这种简约与他的画其实是一脉相通的。他把现代的建筑物放到一个非常自然，而且是我们刻意要保存的自然环境里，但却不张扬，而是从两方面来融合。湿地公园的游客中心，采用了鸟笼的概念，从外向内看，就是从鸟的视角去看人类的世界，但由内看向外，在另一边是用人类的眼睛来观鸟，是一个相对的视觉，就如对打的乒乓球。到了2009年时，也是一样。他把香港的山水、历史用一个比较抽象的观念来表现，放弃了一些具象的城市、空间。

冯永基：为什么我把香港画的最简单？其实是对建筑的一个反思。因为做建筑，常常很容易将整个城市以楼宇、建筑去填满。但是我作为建筑师不是要建最多的楼宇，而是想把香港最原始的、自然的部分表现出来。所以我故意把香港画成这样，隐去城市的景观，用不同颜色的墨来表现香港。

邓民亮：是，你看为什么我把建筑放在前面讲，因为冯先生已经有意把他的概念放到建筑里面，用清水混凝土，用最简单的结构、最简单的线条去呈现，这跟他画里简单的笔触，没有皴法，没有这些暗示现实的手法相似，在《三星湾》《赤门》《高流湾》等呈现香港的风景地貌的作品中，他也用抽象化的语言来表现。

2014年，香港开始做水墨艺术博览会，就是要把中国当代水墨推到更宽广的国际市场和国际舞台上。是香港在推广水墨方面的新的方向，在里面我们看到很多很当代的、用装置的方法来做水墨的艺术家，有很多新的概念。

香港艺术馆在扩建以后，重新开幕之际，我们做了一个开幕展览，邀请了不同的香港艺术家跟我们的藏品来做对话，我请了冯先生跟吴冠中老师"双燕"来做一个对话。

冯永基：当邓博士邀请我时，他说要我跟吴冠中大师对话，我就在思考怎么能跟他对话呢？我觉得吴冠中老师对建筑是有他的概念、他的感情，尤其是对江南建筑的感情。我对香港的建筑当然也有感情，于是在茶具文物馆翻新时，我运用了建筑上那些六十年代的旧瓦片做了一个装置《与吴冠中对话》。而瓦片的呈现就是双燕的形态，与吴冠中的"双燕"刚好呼应。

另外一方面，我并没有把我的作品展示出来，但是中间的镂空就是"留白"。"留白"后面就是香港的维多利亚港，而香港的风景蕴藏着我想表达的一个很重要的感情。还有更重要的是你看外面有更大的"双燕"，这个"双燕"就是香港会议展览中心。我对香港的情感表达并不是通过我要怎么去画香港，而是我怎么把它留出。而这个装置所呈现的颜色，其实就是我作品中常常出现且最喜欢的颜色，这就足够了。太阳从升起到落下，会呈现出不同的颜色，这其实就是我想表现香港的一个景象。

近年来的作品跟我们的"呼吸"有关。全球暖化和环境污染是我们近年非常关注的议题，当我们的水、空气、海洋都受到污染，呼吸自然也会出现问题。所以我用了这个概念放在作品中，并采用了我的代表色，而我表达墨的方式也是通过"呼吸"的手法，看颜色跟水怎样受外面空气影响而变化，非常化学方面的变化，这是用与大气候的对话来表现中国文化。

尤其是这几年，我常常去不同的地方。跟外地不同水平的学者、艺术家、平台交流，彼此增进理解，尽管在文化、历史背景方面有所差异，但因共同的历史基础和现代人的共通性，因此具备一起看待问题、解决问题的共同看法，这是这个作品的重点部分。

邓民亮：我总结一下，我看到冯先生一路走来的脚印，好像是一个探索，但尚不知未来如何发展。呼吸是冯先生自己的感受，但在我看来，似乎有一个更大的理想，就是水墨将来能跨到怎样的一个边界？是不是好像我们探索星空一样？所以我把这个问题放到最后结尾的位置。

皮道坚：刚刚邓博士的题目叫"平行时间线上的个人与水墨的世界"，这个"世界"非常奇特，这个"世界"既跟国际接轨，又有丰富的本土的在地文化元素，我觉得这是冯先生艺术一个非常重要的特点，我看到的水墨心境跟你的个人世界应该是相通的。最后邓博士提出来了一个问题：水墨的未来、水墨的走向、水墨的边界。水墨的边界涉及到与他者的关系，就是中国文化与他者的关系，这个我们也可以讨论一下。

下面有请薛求理博士，他是香港城市大学建筑系的教授，也是建筑方面的专家。

薛求理：谢谢皮老师，谢谢冯老师邀请我到广东来。从今天的展览来看，冯老师的展览分布在四个展厅，但只有一个大厅是以建筑为主题，其余三个展厅都是以画为主，但我认为冯先生的建筑成就在这里面是超过四分之一。

冯先生的建筑设计，主要包括公共建筑设计、公园景观和小品、小住宅、历史建筑改建、室内设计等。而当我近一步了解冯先生，我觉得他是以规划、建筑、环境、室内、保育等，在实践全面的 "美好城市建筑" （total architecture）。冯先生和建筑署团队的建筑设计，是对发展商为主的地产建筑潮流的一种本土抵抗。而我看冯老师的建筑设计，可以从以下几个角度来解读：

1. 建筑、乡郊、风土、环境艺术融为一体
冯先生的设计和创作，边界拓的很宽，有时很难用 "建筑（物）" 来定义。为了达到理想的环境，冯先生的团队，承揽了很多建筑之外的环境整饰工作，如雕塑、环境艺术等，为整体环境和以后的建筑设计铺垫。这种工作有时悄无声息，有时画龙点睛。实例如赤柱规划、西贡视觉走廊、西贡公园规划和建筑景观设计、湿地公园、九龙公园卫生教育展览及资料中心、石硖尾公共卫生中心，以及心经简林。

2. 现代主义的原则，空间实用，简洁，以材料和构造作为建筑的表达
香港政府的建筑师，是香港现代主义的早期倡导者，但以往的作品比较严肃，可能经费也比较紧细。我们可称之为 Frugal Modernism。冯先生和建筑署团队的作品，坚守现代主义的信念，坚拒商业浮华。但他们的手法比较轻松，下面再谈。实例如班门弄，湿地公园，尖东景观亭等。

3. 尊重历史和传统
但凡牵涉到历史遗迹、保育建筑时，冯先生和团队都十分尊重文物和历史建筑，将之放到首要地位，其余的修建都环绕突出历史建筑的做法、环境、格局、材料等等，实例如湾仔邮局、茶具博物馆、九龙公园卫生署展厅等，改善了历史建筑的使用条件，也尽可能突出和保留了历史建筑的本来面貌。

4. "玩耍性" （playfulness）
相对于政府建筑师20世纪五十年代的设计，冯先生的设计，更为轻松，令人愉悦。我们可以称之为 Playful Modernism。部分现代主义崇尚纪念性，崇高伟岸。但冯先生的设计，则轻松亲切。许多民间材料和做法，信手拈来。如西贡海滨公园，湿地公园，爱丁堡广场上人像剪影，抽象雕塑"家书"，香港艺术馆装置"与吴冠中对话"等，还有他指导的"油街实现"等。

刚才邓馆长、皮老师都讲了冯老师在水墨画方面的贡献。现在实际上他在中国整个建筑领域也很活跃，不仅是香港地区，还包括广州和上海等地，都有着重要的地位和影响力。这个地位主要表现在冯老师和他的作品中。冯老的作品可能与今天所展览的不同，但是他后面的徒弟、他带的建筑师团队还是一直在走这条路，冯老师和他后面的团队，实际上也是一个学派，这个学派最大的贡献还是对建筑公共性的尊重，怎样把有限的土地资源、有限的公共空间让大众来享受。我觉得这一点在冯老师的设计里面非常突出。同时，冯老师他们的设计能够潜移默化的，把一个严肃的现代主义建筑和大众拉近距离，并且在拉近距离以后，让建筑起到教化心灵、美化心灵的作用。

冯永基：你刚才讲了一点，我想很多人都没有留意的。首先我很喜欢公共建筑，因为公共建筑是为大众而建。公共建筑中，如果走现代主义路线，很多时候确实是严肃的，但是我觉得建筑就是要大家一起享用的，一起玩的，而不是说要建什么monument、个人主义，什么全世界最大、最怎么样。公共区域就应当是属于公众的地方，要亲切，要能和公众一起找到回应和互动才是最重要的。这也是我一直在香港从事政府工程中，经常跟我的团队所提及的，就是不要搞个人风格，而是要搞一个让大家一起感到开心的风格，当然水平要高。

皮道坚：谢谢薛博士和大家分享关于冯先生的建筑艺术。这是一种深入浅出的介绍，让我很受教。我觉得冯先生应该可以称作是一位后现代的设计大师。刚刚薛博士谈了几点：一是他的建筑设计和环境融为一体，这也是我们中国人历来在建筑方面的理念；二是，它是一种好玩的、轻松的现代主义；三是融入了很多传统的元素，这跟他在绘画方面对于传统的学习也有关系，跟邓博士刚刚讲的一样，他的艺术的发展是相通的；第四，最有意思的是你后面谈到的，他拉近了和大众的距离。你说，冯先生是润物无声，好雨知时节，随风潜入夜，潜移默化。这就是表现出，包括他自己刚刚也谈到的，作为一个艺术家，对于公共性的尊重。你关于他建筑的介绍，加深了我们对冯先生水墨艺术的理解，谢谢薛博士。

下面有请吴洪亮馆长。

吴洪亮：谢谢皮老师。首先表达一下，冯老师邀请我来参加这个展览的开幕活动及研讨会，我挺意外的，尽管只有少许交往，但我作为晚辈，也一直在关注冯老师的创作，很荣幸今天来到广东美术馆参加这次展览活动。尤其是策展人皮老师，作为一位美术史家和策展人，几十年来对于水墨，以及水墨未来的关注，确实是对水墨的发展起到了很大的推动作用。

我先回应一下刚才邓馆长谈的，关于平行时间线上个人与水墨世界这个点。我平时做20世纪中国美术史的个案研究为多，其实我们一直在想，当你做每个个案的时候，其实在很大程度上也像很多平行线。

突然有一天你发现这些平行线，在某一个时间点或者某一个地点形成了交叉，并且这种交叉频率越高越有意思。尤其是在今天，当分科这种概念已经到了极细的时候，可能也就是在思维模式上，平行线越做越多的时代。因此，今天对于合的概念或者交叉点的概念就显得特别重要，这也是我对冯先生作品非常感兴趣的原因。

变化与融合新的方式成为20世纪以来水墨发展的特点之一。刚才谈到张大千，为什么张大千1956年去法国一定要去见毕加索？他和作为外交家的郭有守，当时在法国一起见到了什么而改变了他之后的创作，转变成泼墨泼彩的概念？张大千有一个愿望，要主动融入世界，希望在20世纪的中后期能建立自己与世界更紧密的关系。他是有意在改变。

八十年代初，刘国松来到大陆推广他的艺术，开始跟李可染等艺术家交往。

那时刘国松是神一样的人物。他的思维方式、创作水墨的方式非常新鲜，把当时在北京的一票大师给震惊了。刘国松先生后来和大家分享了他的创作，我认为他是有胸怀的。

卢沉、周思聪也值得关注。这十几年，我花最多时间的是关于周思聪和卢沉的研究，现在他们的作品不少收藏在北京画院。卢沉在中央美院开"水墨构成"课，他们两人一起创作《矿工图》都是变化中的交叉点。

因此，水墨中的这个交叉点就变的非常有意味，我甚至觉得我们是不是可以做一个课题，请皮老师做总监或者做总顾问，来研究一下20世纪八十年代水墨画的发展，包括中国香港地区、中国台湾地区，以及东南亚范围内的新加坡等国家，甚至最近我看到一些韩国的资料，至少我们可以在东亚系统内来进行探讨，这是您激发我的。

再有我所在的北京画院是这样一个传统的、以中国画传承和研究为主的机构，跟香港中文大学有多年的来往，尽管疫情期间有一些中断，但像溥松窗、王明明都曾在香港中文大学驻留创作。像冯先生1971年那种传统的作品，在北京画院，有一些老师们一直深耕其中。但在八十年代以后，包括溥松窗他们的创作都开始有变化了。这些前辈为什么有这样的变化，也是我比较关心的一个点。

所以，在这样的背景下，到九十年代，甚至是到现在来看，我想借用西川的诗来进行一个总结，叫"把竹子种在5G的时代"。这句诗的概念如果放到中国画或者水墨画的逻辑里，是假设我们把竹子象征于中国文化或者水墨画的话，那么在这个时代它还有什么生存的可能性。今天，尤其是当数据化极度发展之后，绘画出现了两个趋向：一是我们如何让这样一个水墨精神性的东西在网络和数字世界中具有合理性，而且还有能量，这是我们研究的一个趋向；二是当过度数字化之后，你会发现它的不稳定性日渐彰显，它的脆弱性也日渐彰显。

最近我们另外一部分触角就开始回到物质本身的研究，在这个时代，物质化的坚强能量在哪里，中国画绘画方式的本质到底是什么？包括冯先生作品的横向思维，都是很有价值的。尤其是这种横向思维，比如说当年影响大卫·霍克尼这些人的创作，就有包括首卷的时间性、测验的时间性价值。包括咱们说以白当黑、迁想妙得。所有这些，在我上学的时候，其实在心里上是有排斥和批评的。中国画的思维方式和创作理念，在今天我突然发现它好像有新的可能性、新的能量，这个时候我们需要思考怎么把它继续运用下去。

皮道坚：我最近听北京大学的杨立华讲老子和孔子，很受启发。他说我们很多中华文化的内容应该成为普适性的，但还没有成为普适性。西方的很多东西都是具有普适性的，我们承认这种普适性。但是，我们的文化里面有一些普适性的东西，有一些具有普世性品格的，他没有这么直说，但我听出来的意思是，将来会成为普世性的。他讲老子和孔子，孔老同源，这是他的一个观点。

他讲老子，他说我们都认为老子、庄子讲"空""无"，实际上并非空无。他引了王弼的一句话，王弼评老子，老子的核心，关键词是"以无为用"，而不是"空无"。无是一个本体，他说"以无为用"，这是一个很好的思想。那对于当今世界，很多人不是都讲文明的冲突吗？如果对这些方面都缺乏了解，我个人感觉非常遗憾。如果我们深思"以无为用"，能够让大家深入体会一下中国哲学、中国文化、中国的思想，就是你刚才说的，会带来新的可能性。我想刚才两位博士介绍的冯先生的艺术，其背后体现的都是中华文明的精神，他的建筑也好，他的水墨绘画也好。洪亮你刚才讲的让我很受启发，谢谢你！

下面有请胡斌，胡斌是广州美术学院艺术与人文学院院长，我们广东非常优秀的青年学者，他做事很踏实，做学问也很踏实，并且他一直在认真思考中国文化的现状，关注它的未来。

胡斌：谢谢皮老师、冯老师。我今天想借着前面几位老师讲的话题，从我的角度再谈一下，鲁虹老师今天虽然没来，但从他所写的文章中，有提及关于原教旨主义的抽象。如果按照原教旨主义，抽象应该是没有任何具体形象的。但是，经过近些年的研究，我们认为没有一个所谓的标准的抽象，也不存在单向度的学习。比如说中国抽象去向西方学习，它不是单向度的，而是我们今天讲的交叉或者平行，是高度交织在一起的，我想从这个角度谈一点看法。

在西方现代性的叙事当中，现代艺术不断地走向平面化、去形象化，以及去叙事，就是没有任何形象、没有任何叙事了，如果有这些东西感觉就不纯粹。实际上，在西方新的研究中也发现，比如抽象表现主义，它跟梦境、跟原始、跟超现实主义有密切的联系，因此并不存在绝对的抽象。我要讲的第一个方面就是，抽象与具象并不是那么绝对的。当然抽象对于具象来说是另外一种法则，但是它并不见得跟具象完全切割开来，这个是有大量的研究证明的。

第二，我们回到二战以后东亚的背景来看抽象艺术，当然存在一个很强势的话语就是抽象表现主义，它不仅影响了欧洲，也影响了亚洲。但我们往往忽视了亚洲如何影响西方。比如说日本的"具体派"的行动性，后来韩国发展出的单色绘画，还有中国台湾地区的去笔墨中心，以及东亚的书法和水墨性，可以串联起来观察和思考，冯老师在中国香港的文化环境中，受到吕寿琨先生的影响等，都可以与之联系起来。所以，一方面东方的抽象艺术受西方的影响，跟国际潮流相连接，另一方面，东方的水墨性，它的书写性，以及行动性、去边界等形式反过来影响了西方。二战以后，在欧洲有一种反形式的绘画，反形式就是反几何抽象。而东方抽象的书写性跟水墨的渗透性，恰恰就是去几何性的，这两者遥相呼应并产生实在影响。

我觉得无论抽象艺术，还是现代艺术、当代艺术，在全球范围都是高度交织在一起的。因为我们现在不断在讲全球艺术史、跨文化艺术史，从这个角度去研究，其实西方的现代艺术和当代艺术也受到东方的影响，东方又受西方的影响，是相互的。我们以往总是一谈抽象艺术，就说我们是受西方影响，

再如何发展。其实从源头上本身就是互相影响和交织在一起的。关键是这个是话语怎么去构建的问题。

在这种高度交织状态的文化语境下，中国艺术的发展路径能够提示出什么呢？其实有一些研究者，在讨论艺术史时也给了我们一些启发。比如台湾的艺术史家石守谦，他有两本书已经引进到大陆，第一本是《风格与世变》，这个还完全是西方的概念，就是形式分析和社会史的结合。第二本书，我觉得尤为关键，叫作《从风格到画意》，"风格"还是西方的概念，但是"画意"就是中国的概念，表明了作者所思考的如何从中国自身出发探讨中国画的问题。如果从中国自身语境出发，我觉得冯老师的作品正好跟习惯意义上的西方抽象艺术形成反差。我们总是在谈论抽象画的去除形象，但是在他那里，我们能看到山水，看到各种景观，看到生活当中的各种形象碎片，包括鞋印、瓦片等。它们构成创作的诱因。有艺术理论家说，抽象艺术家有根据自己微妙的心灵状态来创造相应的形状的能力。那么这种微妙的心灵状态从何而来？我们不能凭空产生一个微妙的心灵状态，那么一簇竹子，一片瓦片，便可能成为创造这种形状的诱因，而这种诱因既是来源，它也是其艺术的特性。

还需说到的是，东方人有东方人的心理，有东方人的心境，包括这种呼吸感、身体体验，我觉得，这都是谈论中国抽象的一种新的可能性。如果按照某种西方叙述的抽象，是会变得完全平面化，讲究媒介的纯粹性。那么这种呼吸感、身体感、心境，尤其是自然万事所引发的一个微妙的心理情状，恰恰是我们从自身出发的新的起点。而且不同的人群、不同的民族、不同的区域，都会有不同的心理反应，这会变成区别于其他区域同时又能够引起共情的特性。

因为时间关系，最后我还想特别说一下建筑，虽然我不研究建筑，但刚才听了薛老师的发言也很有启发。我们说现代艺术，或者抽象艺术，本身就是跟建筑密切联系在一起。你看苏联的构成主义，塔特林就是很明显的一个例子。而且一个很有意思的地方是，他是特意要反现代主义的自律性，他的艺术形式走向了一种纯粹的几何体、基础色，具有强烈的工业感和未来感。并且再结合薛老师讲的，冯老师的建筑设计具有"好玩"、群众性的特点，其实构成主义就是要建造一种无产阶级的艺术，他反对西方那种现代派和个人主义的自律，具有走向大众的特点。

但是，建筑和抽象的结合，在冯老师这里又有一个不同的地方，是什么呢？构成主义是几何化的，冯老师的作品中更多地融入了一种情感、一种流变。我们说建筑和抽象的结合，本身有基础和某种共通性。但是在冯老师的个人实践中，因为东方文化的背景，它又带来不一样的经验和体验。这个经验和体验跟我前面说的呼吸感、身体的体验、微妙的心理情状可以勾连起来。

皮道坚：胡斌谈了一个很重要的问题，就是关于抽象和具象。当中提及的原教旨主义抽象，涉及到一个话语构建，一个方法论和一个体系的问题。这个抽象原本是西方艺术史中的一个概念，跟我们中国艺术史原来是不搭界的。但是我觉得冯先生的艺术让我想到老子的那句话，叫做"大象无形"。事实

上，在冯先生的艺术中，并不存在抽象与具象的分野，他的建筑、水墨以及所有的艺术表达所呈现出来的，无论是从美学的角度，还是从审美心理的角度，都是相通的，这个是值得我们探讨的。事实上，这涉及到一个创作方法论的问题。

我们老是拿抽象、半抽象、具象来讨论艺术，有些胶柱鼓瑟。艺术家们有了新的创造，我们的理论也要有一些新的说法来探讨。我觉得这也就是要把它和我们本土的哲学结合起来，包括中华文明根子上的老子、孔子的学说。那么中国人是没有彼岸世界的，孔子"不语怪力乱神""不知生焉知死"的那种价值观，还有刚才胡斌说的"以无为用"和"大象无形"，这两者结合起来。会不会是一个新的思路？我认为以上是胡斌刚刚给我们的一个启发。

下面有请，广东工业大学艺术与设计学院副教授、硕士生导师颜勇。

颜勇：谢谢皮老师。刚才邓馆一开始就把冯老师放到他所处的历史时空里来讨论，我觉得这是很好的开端。刚才他提到岭南画派、赵无极、张大千，其实甚至还可以再往早一点，我想徐渭、石涛、清初王翚，这样一些著名的画家，他们的艺术语言在冯老师的作品中都可以看得到一些迹象。我想说的是，冯老师的艺术让我感受到，在以他为代表的这样一批活动在港台的水墨艺术家那里，传统是没有明显的中断的。刚才皮老师说中国香港、台湾地区的当代水墨发展比大陆的要早了30年，我觉得不完全是因为这些地区的艺术家更多地接触到外边的空气，可能还有一部分原因在于，对于传统的延续和保留。

从横向的时空来看，冯老师的成长经历中很明显是在现代主义本身在寻求发展、寻求自我超越的环境中出现的。刚才几位老师也提到了各种各样的现代主义，提到构成主义，包豪斯、塔特林等，包括薛老师提到现代主义建筑，都是非常有意思的话题。再者，皮老师提到中国现代水墨艺术的"大象无形"，我觉得西方经典的现代主义，如果要找一个词来形容它的特征的话，应该是反过来——"大形无象"。因为它把"形"推到了一个极致。这个"大形无象"，至少在很多代表人物和代表作品里面，我们可以感受到强大的创造力，但是有时候确实也把自己逼到一个死胡同。很多现代主义建筑师、设计师是以形式出发，把这个"形"推到了一个极致，让它成为一个类型化的东西。比如说勒·柯布西埃、格罗皮乌斯、密斯·凡德罗，他们是从纯形式的角度来考虑问题的。这个"形"是被抽象出来的，是不具体的，这本身是现代主义的一个弊端。

而中国传统文化也许恰恰能为打开这个僵局提供一些东西。吴馆刚才提到张大千、童寯，他们在思考的事情，是如何从传统中找一些东西来适配当代，而且他们是很主动的，力图去把具有中国传统底蕴的内容以当代的形式拿出来跟西方对话，而他们所发现的东西，确实是可能以某种方式打破这个僵局。他们还有刚才所提到的刘国松、赵无极，都处在这样的语境当中，这个语境便是冯老师成长所在的语境。

刚才薛老师说冯老师有四分之一以上的时间在做建筑。在现代建筑史上，冯

老师作为建筑师的成长历程，正好处于一个人们在尝试超越现代主义建筑的阶段。当然超越现代主义建筑有很多办法，但冯老师所找到的是一个取径于中国传统的路子，在建筑领域所选择的道路，与童寯的相似，正如其在水墨艺术领域所选择的道路，与张大千的相似。

另外，刚才薛老师提到冯老师的建筑是"好玩的现代主义"。我觉得"好玩的"和"现代主义"，这两个词同等重要，而且是非常有意思的话题。我刚才提到的那几位现代主义的建筑师都有很崇高的社会责任感。他们是想解决问题、拯救世界的。比如胡老师说构成主义的塔特林是想打造一个无产阶级的建筑以跟资本主义对抗，他是有这样一个理想。当然现代主义建筑师玩形式玩得太过分了，就会有问题，像密斯·凡·德罗后来在美国创作的那些很冷漠无情、方盒子一般的高楼大厦，很让公众反感。但是现代主义者的那种社会责任感，我觉得是要予以肯定的。冯老师做的这种playful modernism就很有意思，它很轻松，但又保留着强烈的社会责任感。正是因为这样一种社会责任感，所以冯老师才会很主动地以自己的建筑艺术去和香港的房地产经济做对抗，比如很主动地尝试以自己的方式在一定程度上去解决环境问题。而在冯老师的水墨艺术上，我也看到了类似的一种倾向。

我想表达的是，现代主义艺术本身是有弊端的，这个弊端的解决方式有很多种，但是其中一种方式可能是取径于传统——在具体时空中的传统——而避免那种过于"大形无象"的、冷漠无情的东西。我在冯老师的艺术当中看到了这样的路径。

皮道坚：我觉得你把胡斌刚才提出来的问题又往深引了一下，特别是提出"大形无象"的概念，明确说了现代主义的弊端，和您所说的文明的冲突。我们今天不谈冲突，我们谈文明的互补。从这个角度来说，冯永基先生的建筑和他的绘画给我们哪些启示，这是我们后面可以展开研究的课题。

王绍强：所以冯老师的整个经历决定了他的知识结构是完整而丰富的。

冯永基：非常感谢大家给我多方面的看法，很多年来我一直在践行着自己的艺术理念，希望把这个事情做好，我非常认可的一点就是，刚才薛求理形容我的现代建筑，用一个很简单的词，就是"好玩"。"好玩"这个词听起来简单，其实并不容易。因为"好玩"就是要把一个很严肃的问题放到不同的层次、不同的平台，能够与大家分享，令大家把这个建筑或水墨看成是很高兴的事情。

我在贝聿铭那里工作的时候，贝聿铭有一个很重要的观点，他说："我从事很多年的现代建筑，没有什么很大的理论，但最重要的就是，我看到大家在我的作品当中找到自己的乐趣，也许身在其中的人们并不太明白什么是现代建筑，此时无论什么主义都变得不重要了，重要的是人们在建筑当中找到属于自己快乐和趣味。"

现在我们做水墨，当然有很多不简单的理论在背后。但大家参观作品过程中所产生的共鸣，是很难用文字来形容的。当看到观众在我的作品前面交谈、

分享，我觉得如果能把那些重要的理论用最单纯和自然的方式呈现给观众，并让观众在作品当中找到属于自己的语言，就是我心目中理想的作品了，谢谢！

王绍强：今天冯老师这个研讨会谈到现在，我很有感触。冯老师在跟美术馆建立联系以后，我们一直都非常重视这个展览。为什么呢？因为在改革开放以后，尤其是20世纪八九十年代开始，中国大陆的整个艺术生态始终是与香港地区有比较紧密的联系的，而香港因其特殊的地理位置，既有中国传统的文化根基、中国的艺术思潮，同时又面向国际，在不断的交流中变化，形成一种特殊的面貌。我觉得可以通过与香港地区的交流找到一些水墨概念的转换，对于这个转换，我特别看重。

从美术馆的角度来讲，我们基于中国的绘画和艺术走向的问题，把冯老师当作一个当代水墨研究中很重要的案例来探讨。他作为中国香港地区重要的艺术家、建筑师，由于所处地域、文化为其艺术带来的复杂性和丰富性，可以通过其中国画也好，建筑学的原理也好，去思考能否为水墨发展找到一些新的解决办法或是获得一些启发。从这个角度来说，冯老师作为新一代香港画家在中国水墨画推陈出新的道路上不断成长，将传统水墨艺术与西方现当代艺术思潮融合，发展出香港这个独具地区特色的水墨文化和创作面貌，是非常值得关注的艺术家个案。

广东自20世纪以来，一直都在寻求一些变化，寻求艺术的变革，包括早期"二高一陈"岭南画派，像广东国画的探索，其实隐隐约约都是在寻找一条解决的道路，寻找新的解决办法。我们把这个展览放到这样一个重要的体系下来探讨，包括大陆跟香港地区之间通过交流，在今天已经形成了一个非常好的互补关系。中国有着深厚的历史文化积淀，在这个文化积淀里面，如何在当下与未来之间找到一些新的发展、新的路径，对于整个东南亚区域的艺术发展都有着重要启发。这是我要讲的第一点。

第二点，冯老师是很幸运的艺术家，首先，从设计师的角度来说，最幸福的就是做建筑。因为建筑可以留下很多场景，而且可以产生跟人之间的这种关系。冯老师作为建筑设计师，我觉得这是一个很令人羡慕的职业，他能够用他的才华在这个空间里面经营自己的建筑语言，跟他对人类之间关系的理解，把他多维度的知识结构和对自然、对艺术的感受力在建筑学里面做一个很好的结合。另外，作为艺术家也是很幸福，可以用水墨来表达自己的情感。

刚才胡斌老师提到，冯老师对当代水墨的探索，似乎有意回避了一些冷漠的东西，而更多地充满了情感的表达。我看他的建筑，多为现代主义的建筑，但是绘画隐隐约约还是保留了传统的、人文的部分，不会说完全是建筑学的那套系统照搬过来。刚才通过邓馆长播放的幻灯片，能够很系统地看到冯老师的艺术历程，这其中包括对古人的潜心学习，甚至有些临摹的成分。这一块跟他在建筑方面的成就和学习体悟又形成一个很重要的互补。

吴洪亮：很多先生在做中国水墨的探讨时，都是从20世纪初要解决中国画和现代建筑之间的关系问题开始着手。他们做过潘天寿的研究，潘先生试图从

绘画内部改变并解决矛盾。而冯先生的艺术本身就放在建筑这个体系或空间逻辑里面，这个价值恰恰很重要，不然反而会有冲突的成分。

王绍强：香港是一个集多元化文化的地方，冯老师的整个知识结构，也是具备多元文化与思维的结构，因此无论是建筑还是艺术创作，都因多元的知识结构而形成了更多的可能性，从而形成了现在我们所看到的冯老师的艺术面貌。我们现在在解决中国的艺术问题，单一的知识结构很困难，刚才胡院长讲了，光老他们这代人很伟大，但是再往前走一步，怎么走？这是我们需要思考和关注的问题。针对这个发问，冯永基先生的展览为我们提供了一个生动的研究样本，同时也是广东美术馆今年关于粤港澳大湾区年度艺术家的重要个案。此次展览涵盖水墨画、建筑装置、影像等多重媒介，在展览的策划和展陈上都力图尽可能完整地呈现艺术家冯永基的绘画风貌及多维度的艺术成就。并以艺术家至爱的运动——乒乓球作为线索，展现他游走于水墨和建筑之间创作体验。

非常感谢此次展览的策展人皮道坚先生，也非常感谢各位专程赶来现场的专家、学者，感谢冯老师为大家带来精彩的展览。今天的研讨会就到这里。谢谢各位！

文稿整理／赵婉君、侯颖贤
翻译／侯善恒

「七拾」水墨心境 时空赋能 - 冯永基艺术展 研讨会

时间
2023年5月27日 10：30 — 12：30

地点
广东美术馆

研讨会嘉宾
皮道坚／策展人、华南师范大学教授
王绍强／学术主持、广东美术馆馆长
冯永基／艺术家
邓民亮／香港文化博物馆(艺术)馆长
薛求理／香港城市大学建筑系教授
吴洪亮／北京画院院长
鲁　虹／四川美术学院教授、武汉合美术馆执行馆长
胡　斌／广州美术学院艺术与人文学院院长
颜　勇／广东工业大学艺术与设计学院副教授

Wang Shaoqiang: Firstly, I would like to express my sincere gratitude to everyone for attending this symposium on the art exhibition of Mr. Raymond Fung at the Guangdong Museum of Art. The exhibition, titled "Qī Shí" represents Mr. Fung's journey through 70 years of his life and his passion for architecture, ink art, ping-pong and also significance of each the decade of his journey thus far. Through more than 100 pieces of works including ink paintings, architectural photographs, models, installation art, films and other mediums, the exhibition presents the various aspects of Mr. Fung's life journey in between architecture and art over the past 70 years. This symposium will specifically focus on Mr. Fung's artistic development, as well as his impact in the fields of architecture and ink art.

Allow me to introduce the esteemed speakers for today's symposium. Firstly, we have Mr. Pi Daojian, the curator of this exhibition. Mr. Pi has always been interested in the exploration and development of traditional mediums such as contemporary ink art in a contemporary context, and has profound insights. Mr. Raymond Tang, the curator of the Hong Kong Heritage Museum, is a longtime friend of ours. We are very grateful for Mr. Tang's support for this exhibition and for lending us many of Mr. Fung's important works. We also have Mr. Charlie Xue, professor of the Department of Architecture at the City University of Hong Kong, who pays close attention to the development of architecture. Mr. Wu Hongliang, the director of the Beijing Fine Art Academy, has always been intrigued in ink art and contemporary art. Mr. Hu Bin, the dean of the Department of Art and Humanities, Guangzhou Academy of Arts, and Mr. Yan Yong, an associate professor, Art and Design School, Guangdong University of Technology. In addition to those present, we also invited Ms. Lu Hong to attend this symposium. Unfortunately, he is unable to join us today due to unforeseen circumstances. Nevertheless, he has kindly written a commentary, which is definitely worth reading and will be included in Mr. Fung's publications.

Once again, we would like to express our sincere appreciation for your attention and support of Mr. Fung's exhibition.

Pi Daojian: I am delighted to have the opportunity today to discuss the art of Mr. Raymond Fung, whose artistic achievements extend beyond ink art and encompass the fields of culture and architecture. This exhibition and symposium, in my view, hold a particular significance.

Firstly, it is worth noting that Guangdong and Hong Kong are now integrated into the Guangdong-Hong Kong-Macao Greater Bay Area. I have always been interested in modern and contemporary ink art, and the exchange of such has been ongoing between the Guangdong

Museum of Art and the Hong Kong Museum of Art for a long time. The Guangdong Museum of Art has been committed to promoting the development of modern and contemporary ink art, including focusing on the transition from traditional to modern and contemporary styles. In 2001, I was invited by the then museum director Wang Huangsheng to hold an exhibition titled "20 Years of Chinese Ink Experimentation Exhibition: 1980-2001". At that time, the then chief curator of the Hong Kong Museum of Art was Ms. Christina Chu Kam-leun, who came to Guangzhou immediately upon learning about the exhibition and actively participated in the academic activities of said exhibition. The exhibition was a first of its kind held by our institutional art museum within the Mainland, and Ms. Chu had great foresight. Through this exhibition, she was amongst the first to collect experimental ink art works from the Chinese Mainland, which later became the Hong Kong Museum of Art's first collection of contemporary ink art from the Mainland.

Secondly, modern and contemporary ink art in the Chinese Mainland has been greatly influenced by the regions of Hong Kong and Taiwan. Looking back, contemporary ink art in both regions started more than 30 years earlier than it did for the Chinese Mainland. For example, Mr. Lui Shou-Kwan, the representative of the New Ink Movement, was active in the 1970s, a time when modern ink art had not yet emerged in the Chinese Mainland. Later, Hong Kong's modern ink art directly influenced the emergence, development and growth of modern and contemporary ink art in the Mainland. Mr. Raymond Fung, being directly influenced by Mr. Lui Shou-Kwan, went on to embark on the same path.

We at the Guangdong Museum of Art have been promoting modern and contemporary ink art for some time, and have since held numerous exhibitions to extend our reach internationally. The same also holds true for Hong Kong, as I recall over a decade ago, a large exhibition on Hong Kong's modern and contemporary ink art was held in London and in 2019, Director Wang Shaoqiang and Curator Raymond Tang jointly initiated a contemporary ink painting exhibition featuring works from Guangdong, Hong Kong and Macao, in which you, Mr. Fung, also participated. That exhibition was titled "Wild Imagination: Contemporary Ink Art in Guangdong-Hong Kong-Macao from 2000 to 2022".

Why am I discussing this? Because Mr. Fung is a significant figure in the field of contemporary ink art in Hong Kong. Contemporary ink art in Hong Kong has a distinct feature in that it is closely related to design. For example, artists such as Mr. Wucius Wong and Mr. Kan Tai-Keung are from the design field. Mr. Fung, too, crosses over the fields of architecture and ink art.

Pi Daojian: Mr. Fung is the first Hong Kong artist whom I have curated an exhibition for at the Guangdong Museum of Art. The theme of this exhibition—"An Idyllic State of Mind, Coloured by Time and Space," is a conclusion I have come up with upon my research into Mr. Fung's art in its entirety. Let's discuss further on the theme of this exhibition, and I would like take this opportunity to first invite Mr. Raymond Tang to share his thoughts.

Raymond Tang: Mr. Pi has given us a great start earlier, and I would like to add on with some supplementary information.

After reviewing Mr. Fung's catalogue, I was struck with an idea. His use of ping-pong, which is played by two persons and represent two parallel spaces, immediately caught my attention. These parallel spaces can be seen as a metaphor for our world, where many things are happening simultaneously that may not have any direct relationship with each other. However, when they do have an impact on each other, that, can be significant. From the perspective of the arts in Hong Kong, I would like to begin by examining how this background has influenced Mr. Fung's artistic development.

What was Hong Kong like in the 1950s? Mr. Chao Shao—an relocated from Guangdong to Hong Kong and established his Lingnan Art Studio. The Lingnan School of Painting, which is arguably the most important and influential modern and contemporary Chinese painting style with the greatest impact abroad. Its influence has spread from China to the rest of the world by the efforts of Mr. Chao Shao-an and his contemporaries through the city of Hong Kong.

Well-known artist Mr. Zao Wou-Ki actually shared a close relationship with the region of Hong Kong. In 1958, he taught at the Chinese University of Hong Kong and had a significant impact on many of his students, including Mr. Lui Shou-kwan. At the time, Lui was struggling to decide whether to pursue a traditional "Lingnan School" style or to explore his own artistic direction going forward. However, after meeting with Zao Wou-Ki, he made up his mind. In 1959, Lui held his first semi-abstract ink art exhibition, marking the beginning of his journey towards abstract ink art.

Chang Dai-chien too, had a close relationship with the region of Hong Kong. He frequently visited the city and had many connections there. Moreover, since immigrating to Brazil in the 1950s, he had a fresh perspective on modern Western painting, especially on abstract painting. From then on, he began to consider how to bring Chinese painting to the international stage. Therefore, the 1950s was an important period for the development of contemporary Chinese

painting, as artists began to consider how they could work alongside the Western art scene.

The 1960s was an important period for the development of ink art. Wucius Wong and Chang Dai-chien, mentioned earlier by Mr. Pi, both matured the development of abstract landscape painting during this time. Lui Shou-kwan established his own ink painting system from the perspective of deconstructing traditional Chinese ink painting. Mr. Liu Guosong also began to rethink the direction of Chinese ink painting from 1959. However, it was not until he went to the United States in 1966 that he truly reconstructed his ink art system. Therefore, the 1960s was a significant era for ink art development.

During this period, when Mr. Fung was nine years old, he created a painting of the Victoria Harbour in Hong Kong, showcasing the modern urban landscape of the city and presenting a style influenced by the West. In that environment, without anyone telling him about the concept of Chinese-Western fusion, he had already achieved it on his own.

In the 1970s, new ink art began to flourish in Hong Kong and many famous artists emerged during this time. As mentioned earlier by Mr. Pi, the Hong Kong Museum of Art played a significant role in promoting new ink art. In 1970, they held the first exhibition of new ink art from Hong Kong in the UK, followed by a second one in the 1990s. These two exhibitions had important implications for the exchange and understanding of new ink art in Europe and internationally. This period of history is crucial, and therefore, I would like to highlight its significance.

So, what was Mr. Fung doing in the 1970s? He went to the United States to read architecture, and this experience was crucial for him. At the time, the most popular style in the US was the International Style, and the amongst the most famous practitioner was Mr. I. M. Pei. Modern-style architecture generally considers how to use the most concise materials to achieve its design, but there is one thing—modern-style architecture needs to incorporate some natural elements. Many important architectures have been considering the integration of both natural and modern elements. This has had a significant impact on Mr. Fung's development.

Mr. Liu Guosong held an art exhibition in Beijing in early 1980s, and over the following three years he traveled throughout China from Heilongjiang to Wuhan, almost covering the entire country. This marked the beginning, or a starting point, of modern and contemporary ink art in China. Around the same time, another group of artists in Hong Kong, including Wucius Wong and Kan Tai-Keung, were bringing contemporary Chinese design to the Chinese Mainland, while also introducing the new ink art style of Hong Kong. Another important point in time in the 1980s was the '85 Movement, which marked the beginning of Chinese ink art becoming contemporary art. Mr. Fung returned to Hong Kong in the 1980s, and he developed a new painting style that was a fusion of different influences. For instance, in his work "Landscape Concerto No. 1", I find this first chapter to be particularly interesting. This "music" draws from many sources, including the Lingnan School of Painting, which evolved from the styles of Mr. Chui Tze-Hung and towards the style of Lui Shou-Kwan. I also see the influence of Chang Dai-chien in his works.

In Hong Kong, we see how different influences can be blended together. From 1985 to 1989, I place particular emphasis on how Mr. Fung approached ink art. Mr. Pi mentioned earlier that Hong Kong is unique in that many artists are also designers who incorporate design concepts into their ink paintings. This is an important influence, and Mr. Fung added his own architectural concepts, which became more apparent in his later works.

In the 1990s, there was an important debate in the discussion of experimental ink art in the Chinese Mainland, which involved the binary opposition between East and West, tradition and modernity, content and form. This discussion opened up a diverse way of thinking and broke the limitations within the existing framework of traditional Chinese ink art. It posed questions such as, can ink art be three-dimensional? Can it be used in installations? Can it be expressed through performance art? This discussion marked a turning point for contemporary Chinese ink art, as it expanded beyond the two-dimensional plane and explored new possibilities in terms of artistic expression. Therefore, it was a significant breakthrough in the artistic language of contemporary Chinese ink art.

In the 1990s, while Mr. Fung was working on architecture, he continued to paint. His architectural approach was mainly based on simple and geometric techniques with natural elements incorporated into his designs. This blending of styles was also reflected in his ink art. For instance, his framing methods are reminiscent of modern architectural frameworks, but they include many elements such as colour and ink. In one of his works, "The Unforgettable Moment", he added the element of time, placing important elements within specific time points, similar to how traditional Chinese handkerchiefs have a designated time point. However, Mr. Fung used a modern concept to express this traditional Chinese idea of marking time.

Raymond Tang: The year 2000 was an important milestone as the Shenzhen International Ink Painting Biennial was held, marking the moment when ink art showcased itself on the international stage. At the same time, Mr. Fung continued to explore the realm of abstraction, incorporating elements of Hong Kong's terrain and landscapes, as well as scenes from his local surroundings into his paintings. This concept is different from the research focus of Mainland's Chinese artists on mountains and rivers; instead, Mr. Fung's focus is on the coastlines and the horizontal nature of water. He also captured the changing weather conditions, such as the morning mist and the shimmering water at dusk, which are reflected in his paintings. He further abstracted these elements into seemingly structural form, abandoning traditional texture techniques and concrete elements.

The Wetland Park in Hong Kong, which I believe is an excellent piece of modern architecture by Mr. Fung that incorporates elements of simplicity and minimalism. He used exposed concrete in a modern style that is simple yet elegant, and this minimalism has also been reflected in his painting style. He integrated modern architecture into a natural environment that we intentionally preserve, without being overly assertive, achieving a harmonious fusion of the two. The visitor center of the Wetland Park is designed like a birdcage, where visitors can see the human world from a bird's perspective from the outside looking in, while on the inside looking out, people observe birds using their own eyes, creating a relative visual effect akin to the exchange of ping pong. This approach continued in 2009, where he expressed Hong Kong's landscapes and history through a more abstract concept, abandoning some of the representational elements of the city and space.

Raymond Fung: Why have I painted Hong Kong in such a simplistic style? It is actually a reflection on nature of architecture because as an architect, it's all too easy to fill the city with buildings. However, my goal is not to build the most number of buildings, but rather to express the most primitive and natural essence of Hong Kong. Therefore, I intentionally create such a simple portrayal, concealing the city's landscapes and using ink of different colours to represent Hong Kong.

Raymond Tang: Yes, you can see why I have mentioned Mr. Fung's architecture first. He intentionally incorporated the architectural concepts into his designs, using exposed concrete and simple structures and lines. This minimalist approach is also evident in his paintings, similar to how he uses simple brushstrokes and without the use of cunfa or similar techniques to suggest reality. For his paintings such as "Sam Sing Wan", "Tolo Channel" and "Ko Lau Wan" where the landscape of Hong Kong is depicted, he has also chosen to portray

them through the language of abstraction.

In 2014, Hong Kong began hosting the Ink Asia, which aimed to promote contemporary Chinese ink art on the international stage. The fair showcased new directions to promoting ink art, featuring many contemporary artists who used installation methods to create ink art and introduced new concepts to the art form.

On the occasion of the reopening of the Hong Kong Museum of Art after its expansion, we held an inaugural exhibition and invited various Hong Kong artists to engage in a dialogue with our collection. I invited Mr. Fung and Mr. Wu Guanzhong to participate in a conversation titled "Two Swallows".

Raymond Fung: When Mr. Tang invited me to participate in a dialogue with Master Wu Guanzhong, I was hesitant at first because I thought, how could I possibly have a conversation with him? I knew that Mr. Wu had a great appreciation for architecture, particularly the architecture of the Jiangnan region, while I had a deep connection to the architecture of Hong Kong. At the time, the Flagstaff House Museum of Tea Ware was undergoing renovations, and I used some of the old tiles that were being replaced to create an installation called "Dialogue with Wu Guanzhong". The tiles were arranged in the shape of a pair of swallows, which perfectly echoed Mr. Wu's "Two Swallows" painting.

On the other hand, I did not showcase my own artwork, but instead left a "Boundless Space" in the installation. Behind this "Boundless Space" is the Victoria Harbour of Hong Kong, which essentially embodies an imporant emotion that I wish to convey. Another notable feature in the outdoor was the larger "Two Swallows" installation, which beared the shape of the Hong Kong Convention and Exhibition Centre. My connection to Hong Kong is not about how I have painted it, but how have I have preserved it. The colors used in the installation are my favorite colours that often appear in my works, and I am content with the way it is. From sunrise to sunset, the colours of Hong Kong change, and this is what I had wanted to capture in the installation.

My recent works have been related to the concept of "Breathing". Global warming and environmental pollution have become serious issues in recent years. When our water, air and oceans are polluted, our breathing will naturally become affected. I incorporated this concept into my recent works, using my signature colours and expressing ink through the technique of "Breathing". The colours and the way that water changes when affected by the air are chemically expressed in my works, it is a dialogue with the general climate that also expresses the Chinese culture.

Especially in recent years, I have frequently travelled to different places. As an artist with opportunities to interact with different levels and platforms outside of my hometown, it's important to communicate what we want to express, rather than focusing on the differences in culture and historical background. Today, we are all modern individuals, and we share a common perspective in looking at and solving problems. This is the key aspect of my works.

Raymond Tang: To summarise, I see these footprints as a journey of exploration, but it is still unclear how they will develop well into the future. "Breathing" is a personal sentiment of Mr. Fung, but I believe there is a greater ideal for ink art, which is to explore how far it can push its boundaries. Would it be like exploring the universe? And that is a thought I would like to end with.

Pi Daojian: Mr. Tang's topic was "The Individual and the Ink World on Parallel Timelines". This world is unique but also connected to the international art scene, with rich local cultural elements. I believe this is a crucial aspect of Mr. Fung's art, and what I perceive is that the idyllic state of mind is connected to his personal world. Finally, Mr. Tang posed a question about the future, direction and boundaries of ink art. The boundaries of ink art relate to its relationship with others, such as the relationship between the Chinese culture and other cultures, which is also worth discussing.

Now, we would like to invite Mr. Charlie Xue, a professor at the Department of Architecture at City University of Hong Kong and an expert in the field of architecture.

Charlie Xue: Thank you Mr. Pi, and thank you Mr. Fung for inviting me here to Guangdong. Looking at the exhibition today, we can see that Mr. Fung's exhibition has taken up four halls, but only one hall focuses on architecture, while the other three focus on paintings. However, I believe that Mr. Fung's achievements in architecture exceed one-fourth of his overall works.

Mr. Fung's architectural designs mainly include public architectures, park landscapes and sculptures, small residences, historical building renovations and interior design. As I delved deeper into Mr. Fung's works, I noticed that he practises a comprehensive approach to "total architecture", incorporating planning, architecture, environment, interiors and conservation into his designs for creating a beautiful city. Mr. Fung's architecture, along with the team at the Architectural Services Department, is a local resistance to the trend of developer-led real estate construction. From my perspective, there are several ways to interpret Mr. Fung's architectural designs:

1. Integration of architecture, rural areas, local culture and environmental art

Mr. Fung's designs and creations expand beyond traditional boundaries, and it's sometimes difficult to define them solely as "architecture". In order to create an ideal environment, Mr. Fung's team takes on many environmental decoration projects beyond architecture, such as sculptures and environmental art, to set the stage for the overall environment and future architectural designs. These works are sometimes subtle yet critical, as seen in examples like the Stanley Master Plan, Sai Kung Visual Corridor, Sai Kung park planning and landscape design, the Wetland park, Health Education Exhibition and Resource Centre at Kowloon Park, Shek Kip Mei Public Health Laboratory Centre and the Wisdom Path.

2. The principles of modernism—practical use of space, simplicity, and the expression of architecture through materials and construction

Architects of the Hong Kong government were early proponents of Hong Kong modernism. However, their previous works were quite serious, possibly due to tight budgets. We could call this Frugal Modernism. Mr. Fung and the team at the Architectural Services Department adhere to the principles of modernism and reject commercial extravagance, but their approach is more relaxed. Examples include the Archivilla, Wetland Park, and the Pavilion at Tsim Sha Tsui East.

3. Respect for history and tradition

Whenever historical sites or heritage buildings are involved, Mr. Fung and his team show great respect for and give priority to cultural and historical buildings. Construction work is carried out around these historical buildings, focusing on the practice, environment, layout, materials and other aspects that highlight their historical significance. Examples include the Wan Chai Post Office and the Health Education Exhibition and Resource Centre at the Kowloon Park, which have improved the conditions for the use of historical buildings while also highlighting their original features.

4. Playfulness

Compared to the designs of government architects in the 1950s, Mr. Fung's designs are more relaxed and enjoyable. We could call this Playful Modernism. While some forms of modernism emphasise memorials and grandeur, Mr. Fung's designs are light-hearted and approachable while incorporating many folk materials and techniques with ease. Examples include the Sai Kung Waterfront Park, Wetland Park, the silhouettes at the Edinburgh Place, the abstract sculpture "Letters from Afar", the installation "Dialogue with Wu Guanzhong" at the Hong Kong Museum of Art as well as the "Oi! Oil Street Art Space"

project under his guidance.

Earlier, Mr. Tang and Mr. Pi spoke about Mr. Fung's contributions towards ink painting. Currently, architecture in China is very active, particularly in Guangzhou and Shanghai. I believe that Mr. Fung's architectural designs also hold a prominent position in this field. This is reflected in Mr. Fung's works and his influence on his disciples and the architectural team he led. In fact, Mr. Fung and his team represent a school of architecture, which is characterised by a deep respect for the public nature of architecture, and how to allow limited land resources and public spaces to be enjoyed by the masses. This is a significant feature of Mr. Fung's designs. Furthermore, their designs have the ability to subtly bring serious modernist architecture closer to the public, which serve to enlighten and beautify the soul.

Raymond Fung: You mentioned something just now that I think many may have overlooked. Firstly, I really like public architectures because they are built for the masses. While the modernist approach to public architecture can often be serious, I believe that architecture should be something that people can enjoy and have fun with together, rather than building a monument to individualism or trying to create the biggest or most impressive structure in the world. Public spaces should belong to the public and accordingly, they should be friendly and approachable while being able to create resonance and interaction with the public. This is something that I have always highlighted to my team when working on government projects in Hong Kong—we should not pursue personal styles, but rather a style that makes everyone happy while maintaining high standards of quality.

Pi Daojian: Thank you, Mr. Xue for sharing your insights on Mr. Fung's architectural art in a clear and concise manner. You mainly talked about postmodernism, and I believe he is a postmodern design master. You mentioned a few points: first, his integration of architecture and the environment, which is in line with the traditional Chinese approach to architecture; second, his playful and relaxed modernist style; third, his incorporation of many traditional elements, which is related to his art, as Mr. Tang discussed earlier about the development of his art; fourth, and most interestingly, you talked about how he brought himself closer to the public. Your point is that Mr. Fung is a silent influencer, like a gentle rain that knows when to fall, or a breeze that quietly slips into the night. This is the expression of his respect for public-ness as an artist. Your introduction to his architecture can deepen our understanding of his ink art, so thank you, Mr. Xue.

Let's welcome Mr. Wu Hongliang next.

Wu Hongliang: Thank you Mr. Pi. Firstly, I would like to express my surprise and gratitude towards Mr. Fung for inviting me to participate in this opening symposium of this exhibition, despite our limited interactions. As a younger artist, I have always been interested in Mr. Fung's creations, and I am honored to be here at the Guangdong Museum of Art today. Furthermore, I believe that Mr. Pi, as the curator, has played a significant role in promoting the future of ink art, given his decades of experience and attention to this field as an art historian and curator. This has Indeed played a significant role in driving the development of ink art.

Let me respond to the point raised by Mr. Tang earlier regarding the parallel timeline between individuals and the world of ink art. As someone who primarily studies individual cases in 20th century Chinese art history, I often contemplate the many parallel lines that exist in each case.

When these parallel lines suddenly intersect at a certain point in time or place, the more frequent these intersections are, the more interesting they would become. In today's world, particularly when the concept of specialisation has become extremely refined, the era in which parallel lines are drawn more frequently in terms of thinking patterns, the concept of intersections or crossings becomes particularly important. This is also why I am very interested in Mr. Fung's works.

One of the characteristics of ink art development since the 20th century is the emergence of new ways of change and fusion. We talked about Chang Dai-chien, and why he felt the need to meet with Picasso when he went to France in 1956. Along with Guo Youshou, a diplomat, Chang saw something in France that changed his creative approach, leading him to embrace the concept of splashing ink and color. However, Chang Dai-chien had a wis—he actively sought changes and ways to integrate with the world and had hoped to establish a closer relationship with the world during the mid to late 20th century.

In the early 1980s, Liu Guosong came to the Mainland to promote his art and began interacting with artists like Li Keran. At that time, Liu Guosong was considered a god-like figure, and his way of thinking and ink art techniques were refreshing and stunned many of the masters in Beijing. Later on, Mr. Liu Guosong shared his creative process with us, and I believe that he is indeed has a heart of gold.

Chen Lu and Zhou Sicong are notable artists who have my attention. I have devoted a considerable amount time to studying their works, many of which are now on display at the Beijing Fine Art Academy. Lu

Chen teaches "Ink Composition" at the Central Academy of Fine Arts, and both artists collaborated on the "Miner's Painting"(矿工图), which represents an intersection in their evolving styles.

As such, I find this intersection in ink to be very meaningful. I even wonder if we could embark on a project to study the development of ink painting in the 1980s, including the Chinese regions of Hong Kong, Taiwan, as well as Southeast Asian countries such as Singapore. Recently, I have also come across some information from South Korea, so we can at least explore the subject within the East Asian region. Perhaps we could invite Professor Pi to serve as the director or chief consultant of the project. You have inspired me to pursue this idea.

In addition, the Beijing Fine Art Academy, where I work, is a traditional institution dedicated to the inheritance and research of Chinese painting, and it has had a longstanding exchanges with the Chinese University of Hong Kong. Despite some disruptions during the pandemic, artists like Pu Songchuang and Wang Mingming have been able to stay in Hong Kong and create their works. While some of my colleagues at the Beijing Fine Art Academy have been deeply rooted in traditional works, such as those created by Mr. Fung in 1971, there have been changes in the creative output of artists like Pu Songchuang since the 1980s. I am particularly interested in understanding why these senior artists have undergone such changes in their artistic style.

Therefore, against this backdrop, from the 1990s up to the present day, I want to conclude with a poem from Xichuan named "Planting Bamboo in the 5G Era"(把竹子种在5G的时代). If we apply the concept of this poem to the logic of Chinese painting or ink painting, it assumes that if we symbolise bamboo as Chinese culture or ink painting, what possibility does it have for survival in this era? Today, especially with the extreme development of digitisation, painting has developed two trends: first, how do we make this spiritual essence of ink art reasonable and energetic in the network and digital world, this has been one of our research focuses; second, after excessive digitisation, you will find that its instability and vulnerability are increasingly apparent.

Recently, we have also turned our attention back to the research of materiality itself, examining where the strong energy of materiality lies in this era and what the essence of Chinese painting technique is. The lateral thinking in Mr. Fung's works is particularly valuable. This kind of lateral thinking, such as the temporal value of the first volume and the temporal value of measurement that influenced the works of David Hockney and others, includes the use of white as black and the ingenious association of ideas. When I was a student, I actually had some resistance and criticisms towards the way of thinking and creative concepts of Chinese painting. However, I suddenly realised that the thinking and creative concepts of Chinese painting seem to possess new possibilities and energies today, and we need to consider how to continue applying them.

Pi Daojian: Recently, I have been inspired by the lecture on Laozi and Confucius by Yang Lihua at Peking University. He said that much of our Chinese cultural content should become universal, but it has not yet achieved universality. Many things in the West are universal, and we acknowledge this universality. However, there are some universal aspects in our culture, some with universal characteristics. He didn't say it directly, but I understood him to mean that they will become universal in the future. He spoke of Laozi and Confucius, and how they share the same origin, which is one of his viewpoints.

He talked about Laozi and said and how we had this common misunderstanding that, when Laozi and Confucius spoke about the concepts of "emptiness" and "nothingness", it meant nothingness in its literal sense. He quoted from Wang Bi, who commented on Laozi and said that Laozi's core and key phrase is "using nothingness as the way", not "nothingness". "Nothingness" is an ontology, and "using nothingness as the way" is a great idea. In today's world, many people talk about conflicts between civilisations. If we lack understanding of these aspects, I personally feel very regretful. If we deeply contemplate "using nothingness as the way", it can allow everyone to have a deeper understanding of Chinese philosophy, culture and school of thought, and as you said, it can bring new possibilities. I think Mr. Fung's art, which the two doctors just mentioned, embodies the spirit of Chinese civilisation, whether it is his architecture or his ink painting. Mr. Wu, what you just said has been very inspiring. Thank you!

Let us next welcome Mr. Hu Bin, dean of Department of Art and Humanities at Guangzhou Academy of Arts. He is a very outstanding young scholar from Guangdong and is very diligent in his work and academic research, but he has also been pondering on the current state, as well as the future of the Chinese culture.

Hu Bin: Thank you, Mr. Pi and Mr. Fung. Today, I would like to add my perspective to the topics discussed by the previous speakers. Although Mr. Lu Hong is not present today, his articles have mentioned the abstraction of orthodoxy. According to orthodoxy, abstraction should not have any specific image. However, after years of research, we believe that there is no standard abstraction, and there is no one-dimensional learning. For example, when Chinese abstraction learns from the West, it is not one-dimensional, but rather, as we talked about today, it is cross-cultural or parallel, and highly intertwined. I would

like to share my thoughts from this perspective.

In the narrative of Western modernity, modern art constantly moves towards flattening, abstraction, and the elimination of storytelling, as if having any images or narratives would make it impure. However, in new Western research, for example, with abstract expressionism, there is a close connection with dreams, primitivism, and surrealism, so absolute abstraction does not exist. The first aspect I want to talk about is that abstraction and concreteness are not so absolute. Of course, abstraction is another rule for concreteness, but it is not necessarily completely divorced from concreteness, as there is a lot of research to prove this.

Secondly, if we look at abstract art in the context of East Asia after World War II, there is a dominant discourse of abstract expressionism, which not only influenced Europe but also Asia. However, we often overlook how Asia has influenced the West. For example, the action of Japan's "Concrete school", the later development of monochrome painting in Korea, the de-centering of brush and ink in Taiwan, and the calligraphy and ink in East Asia can be observed and considered together. Mr. Fung's influence by Mr. Lui Shou-Kwan in the cultural environment of Hong Kong, China, can also be linked to this. Therefore, on the one hand, Eastern abstract art is influenced by the West and connected to international trends, and on the other hand, the calligraphy and ink in the East, its writing and action, and de-bordering forms have in turn influenced the West. After World War II, there was a kind of anti-form painting in Europe, which was anti-geometric abstraction. However, the calligraphic and ink permeability of Eastern abstraction is precisely anti-geometric, and these two are mutually responsive and have a real impact.

I think that whether it is abstract art, modern art, or contemporary art, they are highly intertwined on a global scale. Because now we are constantly talking about global art history and cross-cultural art history, from this perspective, Western modern and contemporary art are also influenced by the East, and the East is also influenced by the West, it is mutual. In the past, we always talked about abstract art and said that we were influenced by the West and how we developed from there. In fact, from the source, it is mutually influential and intertwined. The key is how to construct this discourse.

In this highly intertwined cultural context, what insights can the development path of Chinese art offer? In fact, some researchers have given us some inspiration when discussing art history. For example, the art historian Mr. Shih Shou-chien from Taiwan has introduced two books to the Mainland. The first one is "风格与世变"(Style and Social

Changes) which is a combination of formal analysis and social history, a completely Western concept. The second book, which I think is particularly important, is called "从风格到画意"(From Style to Artistic Intent). "Style"(风格) is still a Western concept, but "artistic intent"(画意) is a Chinese concept, indicating the author's thoughts on how to explore Chinese painting from China's own perspective. If we start from China's own context, I think Mr. Fung's works are in contrast to the conventional Western concept of abstract art. We always talk about the removal of imagery in abstract art, but in his works, we can see landscapes, various scenes and fragments of various images of daily life, including footprints and tiles. They constitute the inspiration for his creations. Some art theorists say that abstract artists have the ability to create corresponding shapes based on their subtle state of mind. So, where does this subtle state of mind come from? We cannot create a subtle state of mind out of thin air, so a cluster of bamboo or a piece of tile may become the inspiration for creating such shapes, and this inspiration is not only the source but also the characteristic of their art.

It is worth mentioning that those from the East have their own psychology and state of mind, including a sense of breath and bodily experience. I think this is a new possibility for discussing Chinese abstraction. If we follow a certain Western narrative of abstraction, it tends to become completely flat and emphasises the purity of the medium. However, this sense of breath, bodily experience, and state of mind, especially the subtle psychological state triggered by nature and all things, is precisely a new starting point for us to explore from our own perspective. Moreover, different groups of people, different ethnicities and different regions will have different psychological reactions, which will become characteristics that distinguish them from other regions while still being able to evoke empathy.

In the interest of time, I would like to mention architecture specifically, even though I do not study it. Mr. Xue's speech just now was very enlightening. We say that modern art or abstract art is closely related to architecture. Soviet constructivism is a clear example, with Tatlin being a prominent figure. What's interesting is that he deliberately opposed the self-discipline of modernism, and his art forms moved towards pure geometrical shapes, basic colors, and had a strong industrial and futuristic feel. And combined with what Mr. Xue just mentioned, Mr. Fung's architectural design has a "playfulness" and mass appeal, which is actually in line with constructivism's goal of creating a proletarian art. They opposed to the Western modernist and individualistic self-discipline and aimed to appeal to the masses.

However, there is a difference in the combination of architecture and

abstraction in Mr. Fung's works. Constructivism is geometric, while Mr. Fung's works incorporate more emotions and fluidity. We say that the combination of architecture and abstraction has a foundation and certain commonalities. But in Mr. Fung's personal practice, due to the background of Eastern culture, it brings a different experience and perspective. This experience and perspective can be linked to the sense of breath, bodily experience, and subtle psychological state that I mentioned earlier.

Pi Daojian: Hu Bin raised an important issue regarding abstraction and representation, which touched upon the problem of doctrinal abstraction, a discourse construction, methodology and systemic issues. Originally, this concept of abstraction was a Western art history term that had nothing to do with Chinese art history. However, Mr. Fung's art reminds me of Laozi's phrase "great form is beyond shape". In fact, in Mr. Fung's art, there is no division between abstraction and representation. Whether from an aesthetic or psychological perspective, the architecture, ink art and all forms of art expression are interconnected, and this is something worth exploring. In fact, this involves a question of creative methodology.

We often use abstract, semi-abstract, and representation to discuss art, but sometimes it feels like we're beating around the bush. Artists are creating new works, and our theories should also have new ways of exploring them. I think this requires us to combine it with our indigenous philosophy, including the teachings of Laozi and Confucius at the root of Chinese civilisation. Chinese people do not have a concept of a beyond world, and Confucius' values of "not speaking of strange powers or feats" and "knowing life but not death", can be combined with what Hu Bin just mentioned about "using nothingness as the way" and "great form Is beyond shape". Could this be a new way of thinking? I think the above is a new inspiration that Hu Bin has just given us.

Let us next welcome Mr. Yan Yong, Assistant Professor and Tutor at the Art and Design School of Guangdong University of Technology.

Yan Yong: Thank you, Mr Pi. Mr. Tang began the discussion by placing Mr. Fung in the historical context of his time and space, which I think was a good starting point. He mentioned the Lingnan School of Painting, Zao Wou-Ki and Chang Dai-chien, but we can even go further back to famous painters like Xu Wei, Shi Tao and Wang Hui in the early Qing Dynasty, where we can see some traces of their artistic language in Mr. Fung's works. What I want to say is that Mr. Fung's art makes me feel that there is no clear interruption of tradition amongst this group of ink artists represented by him who are active in the regions of Hong Kong and Taiwan. Earlier, Mr. Pi mentioned that the development of contemporary ink art in the Chinese regions of Hong Kong and Taiwan started 30 years earlier than the Mainland, I think this is not solely due to the fact that artists from both regions having more exposure to outside influences, but also partly because of the emphasis on tradition and continuity.

Looking at it from a horizontal time-space perspective, it is evident that Mr. Fung's upbringing occurred in an environment where modernism itself was seeking development and self-transcendence. As some of the speakers have mentioned earlier, various forms of modernism, including constructivism, Bauhaus, Tatlin and modernist architecture as mentioned by Mr. Xue, those are all very interesting topics. Mr. Pi mentioned "great form is beyond shape" in Chinese modern ink art, while in classic Western modernism, if we were to find a word to describe its characteristics, would be the opposite—"shapeless form". This is because it pushes "form" to the extreme. This "great form has no image" can be felt in many representative figures and works of modernism, and it demonstrates a strong creative power, but sometimes it can also lead to a dead end. Many modernist architects and designers start with form, pushing it to the extreme and making it a standardised entity. For example, Le Corbusier, Walter Gropius and Mies van der Rohe approached design purely from a formal perspective. This "form" is abstract and not concrete, which is a disadvantage of modernism in itself.

Perhaps traditional Chinese culture can provide something to break this impasse. Earlier, Mr. Wu mentioned Chang Dai-chien and Mr. Jun Tong, who were thinking about how to adapt traditional elements to contemporary art. They were very proactive, trying to bring out the content with Chinese traditional foundations in contemporary forms to engage in dialogue with the West. What they discovered was very likely to break this impasse in some way. Liu Guosong and Zao Wou-Ki, as mentioned earlier, were also in this context, which is the context in which Mr. Fung grew up.

Earlier, Professor Xue mentioned that Mr. Fung has spent over a quarter of his time working on architecture. In the history of modern architecture, Mr. Fung's growth as an architect coincides with a period when people were attempting to transcend modernist architecture. Of course, there are many ways to transcend modernist architecture, but Mr. Fung has found a path rooted in Chinese tradition. The path he has chosen in architecture is similar to that of Mr. Tong Jun, just as the path he has chosen in ink art is similar to that of Chang Dai-chien.

Furthermore, Mr. Xue mentioned architecture of Mr. Fung as "playful

modernism". I think both "playful" and "modernism" are equally important and they are very interesting topics. The modernist architects I mentioned earlier all had a strong sense of social responsibility. They wanted to solve problems and save the world. For example, Mr. Hu mentioned that Tatlin, a constructivist architect, wanted to create a proletarian building to fight against capitalism. Of course, if modernist architects play with form too much, there can be problems, like the very cold and boxy skyscrapers that Mies van der Rohe created later in the United States, which were very unpopular with the public. However, I think we should acknowledge the social responsibility that modernists had. Mr. Fung's playful modernism is very meaningful. It's light-hearted, but still retains a strong sense of social responsibility. It's precisely because of this sense of social responsibility that Mr. Fung has taken the initiative to confront Hong Kong's real estate economy with his own architectural art, as well as solving environmental issues to some extent in his own way. I also see a similar tendency in ink art of Mr. Fung.

What I want to express is that modernist art itself has its drawbacks, and there are many ways to address them, but one way may be to draw on tradition—the tradition in a specific time and space—and avoid the kind of overly abstract and cold-hearted elements that come with the "shapeless form" approach. I see this path in Mr. Fung's art.

Pi Daojian: I think you took the question raised by Hu Bing deeper, especially with the concept of "shapeless form", which clearly points out the drawbacks of modernism, as well as the conflicts between civilisations that you mentioned. Today, we are not discussing conflicts, but rather the complementarity of civilisations. From this perspective, what inspirations can Mr. Fung Yongji's architecture and painting give us? This is a topic we can explore further.

Wang Shaoqiang: Therefore, Mr. Fung's experience in its entirety has determined that his knowledge structure is sound and rich.

Raymond Fung: Thank you very much for your various perspectives. For many years, I have been practising my own artistic philosophy, hoping to do it well. One point that I strongly agree with is what Mr. Xue just described about my modern architecture, using a very simple word—"playful". The word "playful" may sound simple, but it is not easy to achieve. Because "playful" means putting a very serious problem on different levels and platforms, being able to share it with everyone, and making everyone happy to see this architecture or ink art.

When I was working with I. M. Pei, he shared with me a very important perspective of his. He said, " I have been involved in modern architecture for many years, and there is no big theory behind it. But the most important thing is that I see people finding their own fun in my work. Perhaps those who enjoying the architecture do not understand what modern architecture is. At this point, no matter what the theory is, it becomes unimportant. What is important is that people find their own happiness and interest in the architecture."

Of course there are many complex theories behind the ink art that we create. However, the resonance that arises in the process of people viewing our works is difficult to describe in words. When I see visitors conversing and sharing thoughts in front of my works, I feel that if we can present the important theories in the simplest and most natural way possible to allow viewers to find their own language within the work, that will be the ideal work in my mind. Thank you!

Wang Shaoqiang: Today's seminar with Mr. Fung has left a strong impression on me. Ever since the Museum has gotten in touch with Mr. Fung, we have always attached great importance to this exhibition. Why? Because in the entire art ecology of the Chinese, especially starting from the 1980s and 1990s after the reform and opening up, the Chinese Mainland has always had a close relationship with Hong Kong. Due to its unique geographical location, Hong Kong has both a traditional Chinese cultural foundation and Chinese artistic trends, while also being open to the international community and constantly evolving through exchanges, forming a unique identity in the process. I believe that through exchanges with Hong Kong, we can find some transformations in the concept of ink art, and I attach great importance to these transformations.

From the perspective of the Museum, we regard Mr. Fung as an important case study in contemporary ink art research from the angles of Chinese painting and art trends. As an important artist and architect in the Chinese region of Hong Kong, the complexity and richness brought to his art by his geographical location and culture can be used to explore whether new solutions or inspirations can be found for the development of ink art, whether through his Chinese painting or architectural principles. From this perspective, as a new generation of Hong Kong artist, Mr. Fung has continuously grown on the path of promoting innovation in Chinese ink art, integrating traditional ink art with Western contemporary art trends, and developing a unique ink culture and creative style of the Hong Kong region. He is a very noteworthy artist to be studied upon.

Since the 20th century, Guangdong has been seeking change and artistic innovation, including the three forefathers of the Lingnan School of Painting and the exploration of Guangdong-style Chinese

painting. In fact, they were all looking for solutions, and searching for new ways to resolve problems. We have placed this exhibition in an important context, including the relationship between the Chinese Mainland and the region of Hong Kong; the two have formed a very good complementary relationship today. Chinese Mainland has a profound cultural heritage, and finding new developments and paths between the present and the future within this cultural heritage is of great inspiration to the artistic development of the entire Southeast Asian region. This is the first point I would like to stress.

My second point is that Mr. Fung, as an artist, has been very fortunate. Firstly, from a designer's perspective, the happiest profession would be to engage in architecture, as the profession itself allows for the creation of many scenes and human connection. As an architect, Mr. Fung has a profession that many envy. He can use his talent to cultivate his own architectural language in this space, combining with his multidimensional knowledge structure and his understanding of human relationships, as well as his sensitivity to nature and art within architecture. Moreover, as an artist, he is also fortunate to be able to express his emotions through ink art.

Earlier, Mr. Hu Bin mentioned Mr. Fung's exploration of contemporary ink art seems to deliberately avoid the style of coldness and instead focus more on expressing emotions. I have noticed that his architecture is mostly modernist, yet his paintings still retain some traditional and humanistic elements, without completely applying the same system found in architecture. Through the presentation by Mr. Tang just now, we were able to systematically understand Mr. Fung's artistic journey, which includes his dedicated study of ancient masters and even some replication of their works. This aspect of his art forms a very important complement to his achievements and learning experiences in architecture.

Wu Hongliang: Many scholars begin their exploration of Chinese ink art by addressing the relationship between Chinese painting and modern architecture starting from the early 20th century. They have studied Pan Tianshou's work, who attempted to resolve internal conflicts within the structure of paintings. However, Mr. Fung's art is inherently placed within the context of architecture its special logic. This is feature crucial, as it prevents conflicting elements within the artwork.

Wang Shaoqiang: Hong Kong is a place that embodies diverse cultures, and Mr. Fung's knowledge structure also possesses a structure of diverse cultures and thinking. Therefore, whether in architecture or art creation, possibilities are formed due to his diverse knowledge structure, resulting in the artistic appearance that we see today. We are now facing difficulties in solving China's art problems with a single knowledge structure. As Mr. Hu mentioned earlier, the older generation has achieved great things, but how do we move forward? This is a question we need to think about and pay attention to. In response to this question, Mr. Fung's exhibition provides us with a vivid research sample, and it is also an important case study for the annual artist of the Guangdong Museum of Art in the Greater Bay Area of Guangdong, Hong Kong and Macao. The exhibition covers multiple media such as ink painting, architectural installations and videos. The exhibition planning and display aim to present the artist's painting style and multidimensional artistic achievements as completely as possible. Using his favorite sport of ping pong as a clue, the exhibition showcases his creative experience between ink art and architecture.

We would like to thank Mr. Pi Daojian, the curator of this exhibition, and all the experts and scholars who have come to join us here today. We also thank Mr. Fung for bringing us this wonderful exhibition. This concludes today's symposium. Thank you, everyone!

Edited by ／ Zhao Wanjun, Helena Hau
Translated by ／ Christopher Hau

Qī Shí: An Idyllic State of Mind, Coloured by Time and Space - A Raymond Fung Art Exhibition

Time
27th May 2023 10:30 a.m. to 12:30 p.m.

Venue
Guangdong Museum of Art

Guests Present
Pi Daojian ／ Curator, Professor, South China Normal University

Wang Shaoqiang ／ Academic Host; Director, Guangdong Museum of Art

Raymond Fung ／ Artist

Raymond Tang ／ Cuator, Hong Kong Heritage Museum

Charlie Xue ／ Professor, Department of Architecture and Civil Engineering of City University Hong Kong

Wu Hongliang ／ Director, Beijing Fine Art Academy

Lu Hong ／ Professor, Sichuan Fine Arts Institute. Executive Director, United Art Museum, Wuhan

Hu Bin ／ Dean, Department of Art and Humanities, Guangzhou Academy of Arts

Yan Yong ／ Assistant Professor, Art and Design School, Guangdong University of Technology

冯永基于1952年生于中国香港,是香港著名艺术家和建筑师。他曾于1990年获得香港十大杰出青年奖,多年来荣获众多海内外艺术及设计大奖。他于1997年获得佛蒙特州艺术村奖学金;于2008年获得香港特别行政区民政事务局长之艺术推广嘉许奖状,以表彰他在促进香港艺术文化发展的杰出成就;于2009年被授予香港十大杰出设计师大奖;并于2011年获香港特区政府委任为太平绅士。

冯氏参与的建筑项目约七十项,包括香港湿地公园、尖沙咀海滨美化项目、心经简林、山顶公园美化计划、爱丁堡广场、西九海滨、西贡海滨公园、大会堂纪念公园等,曾获香港建筑师学会周年设计奖,以及有关视觉艺术、建筑和室内设计等共五十余奖项。

艺术方面,他曾在伦敦、北京、上海、杭州、台北、香港、东京、纽约、巴黎和亚维侬等世界各地的城市举办过大型展览。他的作品广为国际企业及博物馆收藏,包括旧金山亚洲艺术博物馆、中国美术馆、上海美术馆(现更名为中华艺术宫)、广东美术馆、香港艺术馆、香港文化博物馆、香港大学美术博物馆、香港故宫文化博物馆、M+、伦敦大学文莱美术馆。

1989年是冯永基创作的分水岭,其作品入选哈佛大学"中国的新风貌1984-89"展览,该展览由著名哈佛大学学者和艺术策展人巫鸿教授策划。他曾入选威尼斯建筑双年展,其作品《鱼蛋》反映了香港急速的生活节奏及致力于量产、便捷和高效益的紧凑性。《千秋》是冯永基极具纪念意义的作品,现永久收藏于香港故宫文化博物馆。

冯永基的职业生涯始于景观美化,并相当关注中国香港的乡郊环境,这反映出他对中国香港的深厚感情和归属感。近年来,他开始探索人们对环境和全球社会问题的觉知。

冯永基现为香港故宫文化博物馆董事及入藏委员会委员、香港特别行政区康乐及文化事务署博物馆专家顾问、香港建筑中心顾问、香港海事博物馆教育委员会委员、香港赛马会芝加哥大学文物庭院及展示中心顾问委员会委员。冯永基曾为中央美术学院客席教授及香港中文大学兼任教授。冯永基著有由中华书局出版的《谁把烂泥扶上壁》和《你所不知的香港建筑故事》,以及香港大学美术博物馆出版的《冯永基艺术作品集》,同时为七本文化艺术、建筑书籍的合著者。

Raymond Fung Wing Kee, a distinguished artist and architect from Hong Kong, China, was born in 1952. He was recognised as one of the Ten Outstanding Young Persons in Hong Kong in 1990 and has received numerous accolades and awards for his art and design work. In 1997, Fung received the Vermont Artist Village Scholarship, and in 2008, he was presented with the Certificate of Commendation from the Hong Kong SAR Home Affairs Bureau for his exceptional contribution to the promotion of arts and culture in Hong Kong. Fung was awarded the Hong Kong Ten Outstanding Designers Awards in 2009 and appointed Justice of Peace in 2011.

Fung has been involved in over 70 architecture projects, including the Hong Kong Wetland Park, Tsim Sha Tsui Promenade Beautification Project, Wisdom Path, Victoria Peak Garden Beautification Project, Edinburgh Place, West Kowloon Waterfront Promenade, Sai Kung Waterfront Park and City Hall Memorial Garden. He has received many awards for his work, including the Hong Kong Institute of Architects Annual Awards and more than 50 other awards in visual arts, architecture and interior design.

As an artist, Fung has held large-scale exhibitions in cities around the world including Beijing, Shanghai, Hangzhou, Taipei, Hong Kong, Tokyo, New York, London, Paris and Avignon. His works are widely collected by international corporations and museums, including the Asian Art Museum of San Francisco, National Art Museum of China, Shanghai Art Museum (currently known as China Art Museum, Shanghai), Gunagdong Museum of Art, Hong Kong Museum of Art, Hong Kong Heritage Museum, University Museum and Art Gallery of the University of Hong Kong, and the Hong Kong Palace Museum, M+, Brunei Gallery, amongst others.

Fung's watershed moment was in 1989 when his works were chosen to be exhibited at the Contemporary Chinese Painting 1984-89 exhibition at Harvard University (Boston). This exhibition was curated by renowned scholar and curator Professor Wu Hung. Fung was also selected to exhibit at the Venice Biennale (Architecture). His exhibited work, titled *Fish Ball*, reflected the fast-paced lifestyle of Hong Kong and the local nature of compactness that strived for mass production, convenience and efficiency. Fung's monumental work *Dynasties* is now on permanent display at the Hong Kong Palace Museum.

Fung began his career in landscaping, with a specific concern on the countryside of Hong Kong, China, which reflects his deep attachment and sense of belonging to his hometown. In recent years, he has begun to explore meaningful ways to raise awareness for environmental and global social issues.

Fung has also lectured as a Visiting Professor of Central Academy of Fine Arts and was an Adjunct Professor of Chinese University of Hong Kong. He is presently a Board Member of Hong Kong Palace Museum and member of Acquisition Committee, a Museum Expert Advisor of the Leisure and Cultural Services Department, HKSAR, Advisor of Hong Kong Architecture Centre, Advisor of Hong Kong Maritime Museum Education Committee, Advisor of Heritage Interpretation Centre, Unversity of Chicago(Hong Kong). Raymond has also authored several books, including *Untold Stories: Hong Kong Architecture* and *The Untold Stories of Raymond Fung*, both published by Chung Hwa Book Co. (HK); as well as *The Art of Raymond Fung* published by The University Museum and Art Gallery, University of Hong Kong. Raymond is also a co-writer of seven books on culture and architecture.

个人展览 Solo Exhibitions

2023	"七拾"冯永基回顾展 游走于水墨与建筑之间	西九文化区艺术展亭	香港
2021	"冯永基：息 / 间"个展	3812 画廊	伦敦
2019	"细看人生"冯永基创作展 巴黎艺术博览会 东京艺术博览会	名山艺术 Bosco Hong 画廊 / 巴黎大皇宫 Bosco Hong 画廊 / 东京国际论坛	台北 巴黎 东京
2017	水风清·山色扬	名山画廊	台北
2016	天地凡间	荣宝斋	香港
2015	宋彩华姿	黎画廊	台北
2012	宋彩华姿 宋彩华姿 宋彩华姿	万玉堂 Cloître Saint Louis 苏荷456画廊	香港 亚维侬 纽约
2011	冯永基的艺术世界	东方元素画廊	北京
2010	香江恋曲：冯永基水墨画 香江恋曲：冯永基水墨画 香江恋曲：冯永基水墨画	YR 画廊 东方元素画廊 香港大学美术博物馆	巴黎 巴黎 香港
2001	水墨画个展	上海美术馆（现更名为中华艺术宫）	上海
2000	冯永基新作展	香港交易广场	香港
1998	水墨画个展：杭州艺术博览会	浙江展览馆	杭州
1997	水墨画个展	苏荷士林画廊	纽约
1996	香港艺术家系列：冯永基	香港艺术馆	香港
1992	"水墨画"个展	香港艺术中心	香港
1986	"水墨画"个展	美国图书馆	香港
1985	"水墨画"个展 "水墨画"个展	Le Cadre Gallery 置地广场	香港 香港

2023	Qǐ Shí - Raymond Fung: A Retrospective In Between Art and Architecture, solo exhibition	Arts Pavilion, West Kowloon Cultural District	Hong Kong
2021	Raymond Fung: Between Breaths, solo exhibition	3812 Gallery	London
2019	Raymond Ink Painting, Life	Mingshan Gallery	Taipei
	Raymond Ink Painting, ART PARIS	Bosco Hong Ltd. / Grand Palais	Palais
	Raymond Ink Painting, ART FAIR TOKYO	Bosco Hong Ltd. / Tokyo International Forum	Tokyo
2017	Raymond Ink Painting	Mingshan Gallery	Taipei
2016	Between Heaven & Earth	Rong Bao Zhai Hong Kong	Hong Kong
2015	china in China	Lei Gallery	Taipei
2012	china in China	Plum Blossoms Gallery	Hong Kong
	china in China	Cloître Saint Louis	Avignon
	china in China	Gallery 456	SoHo, New York
2011	The Art of Raymond Fung	Sinitude Gallery	Beijing
2011	Hong Kong Lyric: Paintings by Raymond Fung	YR Gallery	Paris
	Hong Kong Lyric: Paintings by Raymond Fung	Sinitude Gallery	Paris
	Hong Kong Lyric: Paintings by Raymond Fung	The University Museum and Art Gallery (UMAG) of The University of Hong Kong	Hong Kong
2001	Raymond Ink Painting	Shanghai Art Museum (now renamed as China Art Museum)	Shanghai
2000	New Paintings by Raymond Fung	Exchange Square	Hong Kong
1998	Raymond Ink Painting, Hangzhou Art Fair	Zhejiang Exhibition Centre	Hangzhou
1997	Raymond Ink Painting	Caelum Gallery	SoHo, New York
1996	Hong Kong Artists Series: Fung Wing-kee	Hong Kong Museum of Art	Hong Kong
1992	Raymond Ink Painting	Hong Kong Arts Centre	Hong Kong
1996	Raymond Ink Painting	American Library	Hong Kong
1985	Raymond Ink Painting	Le Cadre Gallery	Hong Kong
	Raymond Ink Painting	The Landmark	Hong Kong

2023	Treasure House Fair	切尔西皇家医院	伦敦
2022	伦敦巨匠臻藏艺博会	切尔西皇家医院	伦敦
2021	"天地·踪"第一部分展览, 艺术家联展	3812 画廊	香港
2020	Longing for Nature: Redefining Landscapes in Chinese Art	雷特博尔格博物馆	苏黎世
	"重新连线"夏季特展, 艺术家联展	3812 画廊	伦敦及香港
	"无穷于水墨" / 艺术家联展	3812 画廊	伦敦及香港
	臆象 — 粤港澳大湾区当代水墨艺 术谱系 (2000 – 2020)	广东省美术馆	广州
	香港画廊协会筹款 Take 2	香港会议展览中心	香港
	艺荟香港 — 由巴塞尔艺术展呈献		
2019	原典变奏 — 香港视点	香港艺术馆	香港
	第十三届全国美术作品展览港澳台.海外华人邀请作品展	广州美术学院大学城美术馆	广州
	"齐物" / 水墨艺博 2019	香港会议展览中心	香港
	水墨艺博 2019	香港会议展览中心	香港
	2019 台北国际艺术博览会	台北世贸展览馆	台北
2018	东京艺术博览会 2018	Bosco Hong 画廊 / 东京国际论坛	东京
	All About Ink	Bosco Hong 画廊 / 摩尔画廊	伦敦
	2018 台北国际艺术博览会	台北世贸展览馆	台北
	鉴古赏今：二十世纪中国的水墨与艺术发展	香港大学美术博物馆	香港
	香港艺术中心四十周年筹款晚会展览	香港艺术中心	香港
2017	全球水墨画大展	香港会议展览中心	香港
	图绘香港	香港科技大学	香港
	福尔摩沙国际艺术博览会	诚品行旅	台北
	2017 台北国际艺术博览会	台北世贸展览馆	台北
2016	情系双城	上海书画院	上海
	2017 台北国际艺术博览会	香港会议展览中心	香港
2015	情系双城	香港艺术中心	香港
	水墨双城 — 深港都市水墨交流展	香港中央图书馆	香港
	2015 台北国际艺术博览会	台北世贸展览馆	台北
	高雄艺术博览会	驳二艺术特区	高雄
	水墨艺博 2015	香港会议展览中心	香港
	新艺潮 — 国际艺术学院新进博览	澳门威尼斯人金光会展	澳门

2014	上海·香港·澳门当代水墨画联展	上海书画院	上海
2013	"筑·自室"香港建筑师学会展览	Artistree	香港
	水墨双城 — 深港都市水墨交流展	深圳画院	深圳
2012	辛亥革命百周年展览	中国国家画廊	北京
	水墨双城 — 深港都市水墨交流展	深圳画院	深圳
	第七届深圳国际水墨双年展	关山月美术馆	深圳
	承传与创造 — 水墨对水墨	香港艺术馆	香港
2010	国际水墨画大展	中华世纪坛	北京
	承传与创造 — 水墨对水墨	上海美术馆（现更名为中华艺术宫）	上海
2009	香港水墨画大展	国父纪念馆国家画廊	台北
	香港·水·墨·色	香港中央图书馆	香港
2008	新水墨艺术	香港艺术馆	香港
	香港当代艺术展	Atting 画廊	香港
	中国当代艺术馆慈善展	太古广场三期	香港
2007	当代水墨大展	牛棚艺术村	香港
	香港回归十周年艺术展	四川美术馆	成都
2006	香港当代水墨大展	深圳美术馆	深圳
2005	艺术万花筒	万玉堂	香港
2004	香港风情	伦敦大学	伦敦
2000	香港台湾水墨画大展	台湾师范大学	台北
1999	德国国际艺展	—	德国
1998	香港艺术家联展	四川展览馆	成都
1997	香港艺术	中国美术馆	北京
1995	香港现代绘画展	日本福冈美术馆	福冈

1994	第八届全国美术作品展览港澳台·海外华人邀请作品展	中国美术馆	北京
	洛杉矶香港艺展	圣塔莫尼卡购物中心	洛杉矶
	香港艺术	日本鹿儿岛黎明馆	鹿儿岛
1992	汉城画家会议美术展	—	汉城
	五人展	周界画廊	芝加哥
1991	香港新派水墨画展	市政厅画廊	澳门
1990	第五届亚洲国际美术展	马来西亚国家画廊	吉隆坡
	当代香港艺术	美国伊利洛州修伯特市	修伯特
	香港当代水墨画	台中市立文化中心	台中
	香港水墨画	艾蒙特博物馆	艾蒙特
1989	中国的新风貌1984 – 89	哈佛大学	波士顿
	新风格 — 香港当代画家展	澳华博物馆	墨尔本
	第七届全国美术作品展览港澳台·海外华人邀请作品展	中国美术馆	北京
	第四届亚洲国际美术展	汉城大都会美术馆	艾汉城
	香港十三名家展	三越百货美术馆	名古屋
1988	香港现代艺术	中国美术馆	北京
	香港水墨	香港艺术馆	香港
	冯永基·郭汉深二人展	艺倡画廊	香港
	国际水墨画展	—	武汉
	冯永基·徐子雄二人展	东西画廊	墨尔本
	长城首届美术画画展	台湾省立美术馆	台北
	香港水墨	巴比肯中心	伦敦
1985	当代香港艺术双年展	香港艺术馆	香港
1987	香港美术家作品联展	福州省展览馆易 / 湖北美术学院	福州 / 武汉
	夏利豪现代艺术比赛展	香港大学冯平山博物馆	香港
	山水五步	澳门贾梅士博物馆	澳门
1986	香港周艺术展	联合广场	三藩市

2023	Treasure House Fair	Royal Hospital Chelsea	London
2022	Masterpiece London Art Fair	Royal Hospital Chelsea	London
2021	After Nature: Part I, group exhibition	3812 Gallery	Hong Kong
2020	Longing for Nature: Redefining Landscapes in Chinese Art	Museum Rietberg	Zürich
	RECONNECT: The Summer Exhibition 2020, group exhibition	3812 Gallery	London & Hong Kong
	More than Ink, group exhibition	3812 Gallery	London & Hong Kong
	Wild Imagination—Contemporary Ink Art in Guangdong-Hong Kong-Macao from 2000 to 2020	Guangdong Museum of Art	Guangzhou
	HKAGA Fundraiser 2020 \| TAKE 2, Hong Kong Spotlight by Art Basel	Hong Kong Convention and Exhibition Centre	Hong Kong
2019	Classics Remix: The Hong Kong Viewpoint	Hong Kong Museum of Art	Hong Kong
	The 13th National Exhibition of Fine Arts—Exhibition of Works of Artists from Hong Kong SAR China, Macao SAR China, Taiwan China and Oversea Chinese Artists, University City Art Museum	Guangzhou Academy of Fine Arts	Guangzhou
	From Infinity to One, Ink Asia 2019	Hong Kong Convention and Exhibition Centre	Hong Kong
	Ink Asia 2019	Hong Kong Convention and Exhibition Centre	Hong Kong
	ART TAIPEI 2019	Taipei Convention Centre	Taipei
2018	ART FAIR TOKYO	Bosco Hong Ltd. / Tokyo International Forum	Tokyo
	All About Ink	Bosco Hong Ltd. / Mall Galleries	London
	ART TAIPEI 2018	Taipei Convention Centre	Taipei
	Tradition to Contemporary Ink Painting and Artistic Development in 20th-century China	The University Museum and Art Gallery (UMAG) of The University of Hong Kong	Hong Kong
	Hong Kong Arts Centre 40th Anniversary Fundraising Gala Exhibition	Hong Kong Arts Centre	Hong Kong
2017	Ink Global	Hong Kong Convention and Exhibition Centre	Hong Kong
	Picturing Hong Kong	Hong Kong University of Science and Technology	Hong Kong
	Art Formosa	Eslite Hotel	Taipei
	ART TAIPEI 2017	Taipei Convention Centre	Taipei
2016	A Tale of Two Cities	Shanghai Art Academy	Shanghai
	Ink Asia 2016	Hong Kong Convention and Exhibition Centre	Hong Kong

2015	A Tale of Two Cities	Hong Kong Arts Centre	Hong Kong
	Ink Painting Two Cities Hong Kong & Shenzhen	Hong Kong Central Library	Hong Kong
	ART TAIPEI 2015	Taipei Convention Centre	Taipei
	Art Kaohsiung	The Pier-2 Art Center	Kaohsiung
	Ink Asia 2015	Hong Kong Convention and Exhibition Centre	Hong Kong
	New Art Wave EXPO	The Venetian Macao	Macau
2014	Shanghai/ HK/ Macau Contemporary Ink Exhibition	Shanghai Art Academy	Shanghai
2013	Reveal Art Exhibition	Artistree	Hong Kong
	Ink Painting Two Cities Hong Kong & Shenzhen	Shenzhen Fine Art Institute	Shenzhen
2011	The 100th Anniversary of Chinese Revolution Exhibition	China National Art Gallery	Beijing
	Ink Painting Two Cities Hong Kong & Shenzhen	Shenzhen Fine Art Institute	Shenzhen
	7th Shenzhen Ink Art Biennale	Guan Shanyue Art Museum	Shenzhen
	Ink vs Ink Exhibition	Hong Kong Museum of Art	Hong Kong
2010	International Ink Art Exhibition	The China Millennium Monument	Beijing
	Ink vs Ink Exhibition	Art Museum (now renamed as China Art Museum)	Shanghai
2009	Hong Kong Ink Painting Exhibition	National Gallery, National Dr. Sun Yat-sen Memorial Hall	Taipei
	Hong Kong, Water, Ink, Colour	Hong Kong Central Library	Hong Kong
2008	New Ink Art: Innovation & Beyond	Hong Kong Museum of Art	Hong Kong
	Hong Kong Contemporary Art	Atting House	Hong Kong
	MOCA China Charity Exhibition	Pacific Place 3	Hong Kong
2007	HK Contemporary Chinese Ink Painting Exhibition	Artist Commune of Cattle Depot	Hong Kong
	HK Return to China 10th Anniversary Art Exhibition	Sichuan Art Gallery	Chengdu
2006	Contemporary Hong Kong Ink Exhibition	Shenzhen Art Gallery	Shenzhen
2005	Art Kaleidoscope	Plum Blossoms Gallery	Hong Kong
2004	HK Cityscapes	University of London	London
2000	Chinese Ink Painting	Taiwan Normal University	Taipei
1999	International Biennale Neues Aquarell Kleinsassen	—	Germany

1998	Hong Kong Artists Exhibition	Sichuan Exhibition Centre	Chengdu
1997	Hong Kong Art Exhibition	The National Art Museum of China	Beijing
1996	Ink Paintings by Great Masters	Duoyunxuan	Shanghai
1995	Contemporary Hong Kong Painting Exhibition	Fukuoka Art Museum	Fukuoka
1994	The 8th National Art Exhibition	The National Art Museum of China	Beijing
	Hong Kong Art in LA	Santa Monica Place	Los Angeles
	Hong Kong Art Exhibition	Kagoshima Prefectural Museum of Culture Reimeikan	Kagoshima
1992	Art Exhibition of the Artists Conference	—	Seoul
	5 Artists Exhibition	Perimeter Gallery	Chicago
1991	Contemporary Hong Kong Art by 4 Major Artists	Galeria De Leal Senado	Macau
1990	The 5th Asian International Art Exhibition	Malaysia National Art Gallery	Kuala Lumpur
	Hong Kong Contemporary Art	Schaumburg	Illinois
	Hong Kong Contemporary Ink Painting	Taichung Cultural Center	Taichung
	Hong Kong Ink Painting	Edmonton Provincial Museum	Edmonton
1989	Contemporary Chinese Painting 1984-89	Harvard University	Boston
	New Sprit by Hong Kong Artists	Chinese Museum	Melbourne
	The 7th National Art Exhibition	The National Art Museum of China	Beijing
	The 4th Asian International Art Show	Seoul Metropolitan Museum	Seoul
	13 Major Hong Kong Artists Exhibition	Mitsukoshi Art Gallery	Nagoya
1988	Hong Kong Modern Art	The National Art Museum of China	Beijing
	Ink Paintings by Hong Kong Artists	Hong Kong Museum of Art	Hong Kong
	Fung Wing Kee and Kwok Hon Sum Exhibition	Alison Fine Arts	Hong Kong
	International Ink Painting Festival	—	Wuhan
	Fung Wing Kee and Chui Tze Hung Exhibition	East & West Gallery	Melbourne
	First Great Wall Art Exhibition	Taiwan Museum of Fine Arts	Taipei
	Hong Kong Ink Painting	Barbican Centre	London
1987	Hong Kong Artist Exhibition	Fuzhou Exhibition Gallery and Hubei Academy of Art	Fuzhou and Wuhan
	Phillippe Charriol Modern Art Exhibition	Fung Ping-shan Museum, The University of Hong Kong	Hong Kong
	5 Dimensions	De Camoes Museum	Macau
1986	Hong Kong Week Art Show	Union Square	San Francisco
1985	Contemporary Hong Kong Art Biennale Exhibition	Hong Kong Museum of Art	San Francisco

1952 零岁

生于香港，龙年瑞午节的前一个晚上。从母亲口述，父亲是在我出生后几个月后因心肌梗塞离世。此后，母亲、姐姐和我便搬到几位阿姨在荷李活道的唐楼居住。

1960 八岁

小学就读于香港玛利诺小学。八岁时，画作被刊于该校的校报，亦是我首次被刊登的作品。

1963 十一岁

获小学老师指导，投稿到香港南华早报的"儿童天地"，因经常入选而引起读者生疑。报馆于是安排了我一次访问，向读者解释我的小履历，说明我已先后赢得在日本及东南亚的儿童绘画比赛，并无偏私。

1967 十五岁

初中在香港圣类斯学校，念至初中二年级，因理科成绩太差劲而被迫转到私立的威灵顿中学完成。在离开圣类斯前，被任教美术科的叶哲豪老师邀请为徒。

如是者，潜修了五年的传统水墨。亦由叶老师介绍，于十七岁加入香港中国美术学会。

1970 十八岁

入读香港浸会学院传理学系。其间修读留法画家陈学书先生的油画课。

1971 十九岁

因缘际会，在报章上知悉一间名叫明德中心的慈善机构有岭南派画班。老师是一位年青人，就是日后成为著名国画家的何百里先生。

1972 二十岁

赴美升学，辗转从新闻系、社会系、转至建筑系并副修艺术。获四年的"海外学生奖学金"及美国雷诺铝业颁发的建筑设计奖。

1978 二十六岁

获美国路易斯安纳州立大学建筑学学士。毕业后回港，加入何韬建筑设计公司。其间，曾参与香港银禧体育中心(今天改名为香港体育学院)的设计比赛、西贡海滨美化计划等。

1979 二十七岁

一年后，再转到王董(国际)建筑师事务所，为何承天及唐景彬建筑师主持下的建筑设计团队。集体负责的项目包括：香港愉景湾第一期、香港愉景湾哥尔夫球会所、香港阳明山庄、深水湾道三十七号私人大宅。其间亦参与香港演艺学院设计竞赛及在中环与澳门商业区的设计竞标。

与在广华医院修读护理学的叶婉玲小姐共谐连理。因为彼此早已有计划组织家庭，在那几年，大家都忙于下班后赶接额外工作，不时连夜通宵达旦，是为储够首期买房子。

1979 / 1982 二十七岁 / 三十岁
两度参加全港青年学艺比赛（国画公开组）获亚军。因为熊海亦是得奖者而从此成为好友，并透过他的介绍，随杨善深老师进修岭南画派。

1984 三十二岁
几经辛苦获得建筑师执业资格后，随即报读香港中文大学校外部的水墨画文凭课程。该课程内容以至师资完备，包括刘钦栋、何才安、陈若海、何庆基、金嘉伦等老师。翌年，又报读港大校外部由徐子雄老师主讲的"现代水墨画"课程，是我对现代水墨画重新探索的转折点。不忘初心，在取得专业资格后，便考虑回归艺术的漫长旅途。于是下决心离开要每天工作十二小时的私人公司，加入港英政府的建筑拓展署。

1985 三十三岁
报名参加首届的"艺穗节"，获安排在置地广场的行人桥举行首次的个人展览，名为"旭现"。从名称上，揭示我要走进艺坛的不归路。也许是艺坛新人的原因，或是我少不更事，把画价定得相宜，打从第一天，作品很受欢迎，差点把全部作品卖光。一位建筑师朋友开设在铜锣湾新宁道的LeCadre Gallery，给予我在该处展出。因为行事低调，没有多少人知道我第二次的个展。在建筑拓展署工作只维持了一年零三个月。接受前同事周念申建筑师的邀请，加入周氏建筑师事务所有限公司做设计总监。

1986 三十四岁
我与画廊的合作，是由徐子雄老师引荐给艺倡画廊开始。该画廊是由董建平女士Alice King及Sandra Walters创立，艺倡画廊因而得名。艺倡是当年极少数的画廊，设于荷兰行（即皇后大道中九号的前身），因为该大厦重建，艺倡后来搬到太子行。代理的香港画家，除本人外，还有吕寿琨、王无邪、徐子雄、梁巨廷、熊海、郭汉深等。

那些年，徐子雄老师在美国图书馆负责策划展览，并为我策展个人第三次的展览。长久以来，美国政府在香港的文化事业占有角色，惟随着香港回归的因素，在我个展后不太久，美国图书馆亦停止了展览部分，最后还是完全撤出香港。

这一年，在徐老师主催下，创立了"水墨新流"画会。除推动新一代的水墨活动，更以水墨艺术推广慈善的水墨行动为焦点。先后为香港唐氏综合症协会、中大儿童癌病基金、香港肾病患者信托基金等义卖筹款。

1987 三十五岁
我第一幅获香港艺术馆藏的作品名为《自由的启示》。提名人是香港艺术馆顾问陈福善先生，而为我办理购藏手续是黄易先生，他那时候任助理馆长，在完结手续后说，要离开在博物馆的岗位，避世在大屿山写武侠小说。我当时以为他好浪漫，这么年轻便隐居世外，及后，才知他写的武侠小说好受欢迎。自从1987一面之缘，不幸的，他在六十岁便离逝。

1988 三十六岁
经历三年半在私营的周氏建筑师事务所任高职，此期间，完成第一个在中国内地的设计项目，是位于上海淮海中路的启华大厦，第二个完成的内地项目是在西安的假日酒店。香港方面的项目是参与大量居者有其屋的设计。惟我认为在政府部门任职才有设计公共建筑的机会，因而在同年十二月一日，毅然再入官场，由建筑师的基本职级从头做起。

可能没多少人记得，我第一个由商业性画展正是艺倡画廊主办的"冯永基与郭汉深双人展"。由于我是公务员的关系，不宜和画廊有正式的合约，却一直以自由身透过画廊经销

画作。其间，还包括有世界画廊及曾令画廊界风起云涌的金石画廊；后来因获万玉堂画廊邀请，和他们合作一直至2014年，其间亦在该画廊名下参加几届Art Hong Kong及典亚艺博。因该画廊主持人麦史镝Stephen McGuinness退休，万玉堂画廊亦从此淡出艺坛。

1988年十二月有一件香港艺坛大事，由文楼先生带领我们几十位香港艺术家首次在北京中国美术馆展出。由于名单包括香港当时最具代表性的艺术家，可用艺坛盛事来形容。透过这次行程，我认识到众多只曾闻其名的圈中朋友，亦接触到不少内地名家，间接奠定我日后到北京中央美术学院进修的决心。

1989 三十七岁
这一年是我涉足国际艺术展览的好开始。除了首次入选全国美术展，更难得是被挑选在美国哈佛大学展出。这个名为"中国的新风貌1984 -1989"的推手是波士顿东方艺廊（Mandarin Studio）的Helaine Ohayon 女士。她选了正在冒起的十几位较年轻中国画家的作品，在哈佛大学艺术系主任巫鸿教授协助下，在Adams House展览。我是唯一出席开幕的参展者，之前，还在纽约Amy Schwartz女士家中办了一个预展，是我首次进入西方私人画廊的宝贵经验。

1990 三十八岁
在北京之行期间与韩秉华交谈甚欢。他主动提名我参选翌年的香港十大杰出青年。有幸在1990首次尝试便获选，同届的艺术界特别热闹，当中包括曹成渊、张天爱、叶咏诗及本人四位，是历来杰青得奖者文化人占最多的一届。

这一年，我一幅名为《烛光的启示》的较大作品，入选夏利豪艺术基金会主办的比赛。接着在拍卖会中，周亦卿博士以港币五万一千元投得，创下我作品当时的最贵纪录。

1991 三十九岁
也许是我经常被委派负责高难度的设计任务而获当时的建筑署署长Corsa先生赏识，推荐我到美国学习。我先后选了在波士顿的HughStubbins Architects及纽约的Pei Cobb Freed and Partners，亲身见证贝聿铭先生对建筑艺术的坚持与诚意，深深打动了我，从此深化我对建筑设计的追求。

1992 四十岁
香港艺术中心是我其中一位恩师何韬博士的得奖设计，是当年我认为在香港最美的展览场地，因此，在1992借此举行我第四次的个人展。我其中一套画作《天长地久（一）》，被购藏及展示于汇丰银行的展厅，更以该画作印制成银行圣诞卡。及后，香港怡和集团购藏了一对以香港为景色的横作，一直展示于总部大堂。

1993 四十一岁
香港大会堂适逢三十周年，当年的市政局计划为这经典建筑大修。我被委派这重要任务，心情雀跃。我负责大会堂低座及纪念公园，尤其后者，作出了全面的设计改动，以回应时代的变迁。

1996 四十四岁

在这一年，获香港艺术馆邀请，以"香港艺术家系列"在该馆展出三个月，为自己在艺术事业踏上新的里程。

1997 四十五岁

获香港艺术馆推荐，赴美国 Vermont Studio 两个月交流。其间认识了来自上海的施勇，接着在该年的11月，于纽约苏荷的士林画廊举行第一次在海外的个展。

随同香港艺术馆到北京中国美术馆，参加「香港艺术一九九七——香港艺术馆藏品展·北京·广州」。

1998 四十六岁

在杭州西子湖畔的中国美术学院修读暑期课程。那时仍是老旧校舍，虽然物资缺乏，却处处渗透着前人留下的文化足迹；尤其当时的杭州仍未改变，比对今天的美轮美奂的庞大校舍，物换星移，令人感触。

该课程主任是任道斌博士，他为人随和风趣，不会板着名学者的面孔，所以学习愉快，并成为好友。他经常来香港的艺术馆及大学讲学，我都成为他的座上客。同年，任老师建议我参加在中国新兴起的艺术博览会，首届"西湖艺术博览会"，是我第一次走进艺术展博览会的氛围。

1999 四十七岁

这一年，获香港艺术馆邀请，在九龙公园内设计一座现代美术馆。盖设计美术馆是建筑师的梦想，方案先后在媒体曝光，并做足咨询；惟没料有两位艺坛中人极力阻挠，最后致计划胎死腹中。

2000 四十八岁

香港交易广场有一个很优美的穹苍 The Rotunda，一直是我期待的展览场地。因得到香港置地有限公司艺术顾问金马伦先生 Nigel Cameron 的支持，如愿在那里举行了第八次个展，作品获得不少藏家收藏。其中，庞俊贻先生挑选了《天啸（二）》，并送赠给三藩市亚洲艺术馆作永久藏品。

同年，我设计的"卫生教育展览及资料中心"，夺得香港建筑师学会颁发会长大奖，是我在建筑设计方面获奖的转捩点。

从这一年开始，香港地铁公司在各区大堂设置香港艺术家作品的复制本。包括在太古城站内的"八仙情缘"。

2001 四十九岁

在机缘巧合下，上海美术馆馆长方增先先生邀请我作为新美术馆的海外评判，地点就是在前赛马车会馆旁。最后经两重评选后，决定采纳仿照来二十年代西式建筑设计风格，目的是与赛马车会馆协调。其间，美术馆的团队几度南下深圳，以迁就我作为义务顾问不用往来港沪两地之苦。那时，内地官员对我们香港人非常尊重，也许是这个原因，我成为最早在上海美术馆新馆展览的香港人。作品"印州塘"现收藏于上海美术馆。

这一年，亦是第二度获香港建筑师学会颁发会长大奖，得奖作品是香港湿地公园第一期。协助这个项目还包括李翱建筑师(负责建筑)，李培基建筑师(负责内部展览)。整个项目从概念至完成只用了九个月，全靠很好的团队精神。

为香港特区政府建筑署总部重新室内设计，采用非一般官僚架构的前卫手法设计，惹来部门同事的评论，幸得到鲍绍雄署长支持，获该年度的绿色办公室大奖。

2002 五十岁

我一直渴望设计自己的 Designer's House。机会终于把握在一念之间，在白沙湾找到一间独立屋。于是花光积蓄购入并大事改装，名为"班门弄"。"班门"代表建筑师的门户。"弄"是弄堂，亦可作动词，含"玩弄"之意；简意是指一所让建师把玩的居亭。2002年，获香港设计师协会双年铜奖。

2003 五十一岁

文楼先生介绍我到中央美术学院深造，并短暂跟随贾又福老师的个人指导。之后往返美院多年，捐赠助学金，透过文先生，认识了范迪安、靳尚谊、潘公凯、张宝玮、随建国、吕品晶诸位老师。

2003年，当时中央美院开设环境学系，系主任张宝玮教授邀请我抽时间出任客席教授，如是者，认识了一批优秀的学生，成为我与中央美院的联系。

2004 五十二岁

第三个会长大奖是西贡海滨公园及视觉走廊。这是由当时的财政司司长梁锦松先生提出，是因香港在遇上"非典"以致经济萧凋。他支持本土经济而衍生的旅游工程项目。我们的三人团队，包括景国祥建筑师及施琪珊建筑师，把原有密实封闭的公园重新改造，尤其加入纸船雕塑，很快成为西贡市区的地标。该区市民更习惯称之为"纸船公园"。2016年，香港邮政以"香港公共建筑"为题发行特别邮票，西贡海滨公园是其中一款。

2006 五十四岁

第四度获得香港建筑师学会周年设计奖的得奖作品是香港湿地公园第二期。该作品获得全年大奖及后超过十五项的海外内奖项，包括国际土地协会亚洲区大奖及全球大奖。香港公共建筑特别邮票亦包括香港湿地公园。

2007 五十五岁

第五次获香港建筑师学会周年设计奖是在"城市设计"组别，得奖作品是尖沙咀海滨。团队包括景国祥建筑师及周安远建筑师，亦是我在这个奖项的终结。因我已决定要告别建筑，计划把事业放在水墨艺术。同时期，香港中文大学建筑学系主任 Essy Baniassad 邀请我在建筑学院执教一个名为"体验建筑"的通识课，于是一教十年，由助理教授、副教授升至教授级为止。

2008 五十六岁

该年的二月十四日，借"情人节"与所喜爱的工作单位说再见，递信辞职，以行动证明要放下建筑师的工作，全身投入艺术。同年获香港民政事务局颁发嘉许状。

2009 五十七岁

"图花源"是我离开建筑后的私人建筑作品，是用个人名义参加香港设计协会亚洲大奖，获银奖。我亦获设计界朋友提名，被选为"香港十大杰出设计师"。同年，一个黄昏，香港特区政府行政署突然来电，诚邀我加入政务司司长办公室，安排一个名为"设计顾问"的职位，专责新政府总部在设计方面的督导工作。因为这身份，与当时的政务司司长唐英年先生共事了三年半。

2010 五十八岁

获香港大学美术博物馆邀请，举办"香江恋曲"冯永基水墨个展，同步，由该博物馆出版冯永基艺术作品集。在港大美术馆的大作品、十二屏的《细说当年》，其复制本被长期展示于香港特区政府总部一号大会议室。

接着在巴黎的 Galerie Yvan Roubin 画廊及东方元素画廊分别办了两个展。获唐英年司长邀请，委任为西九文化区管理局董事，至2014年。之后，连续获委任为西九文化区管理局发展委员会委员。

2011 五十九岁

一个名为"冯永基的艺术世界"的水墨及建筑作品在北京朝阳区的东方画廊举行。同年，获委任为太平绅士。获中国美术馆邀请参展纪念辛亥革命一百周年大展。作品《宋

彩华姿》现藏于该馆。著名艺术杂志《艺术界》(*The International Art Magazine of Contemporary China*) 十月号刊载国际著名策展人小汉斯的冯永基专访。

2012 六十岁

六十岁是华人眼中有特别意义。因此为自己写了一套名为《六拾》的大画。借意念上的香港西贡景色，反映香港走过这六十年所经历的阴晴圆缺含意，更是我六段十年的人生体验。作品现藏于香港艺术馆。

正式以"冯永基教授奖学金"名义，每年捐赠给香港中文大学、浸会大学及香港大学。

这一年，分别在三个城市，这包括香港万玉堂、纽约四五六画廊及法国南部亚维侬市的 Cloitre Saint Louis 举办以"宋彩华姿"为题的展览。同一名称的个人展，延续至2015年终结。

2014 六十二岁

获邀出任香港建筑中心主席，与陈翠儿等推出"十筑香港"活动。翌年，该项目获香港艺术发展颁发"年度艺术推广奖"。开始私人授徒，画室名为StudioRay，设于金钟汇中心。所得学费拨作"冯永基教授奖学金"。

2015 六十三岁

再以"宋彩华姿"名称在台北的黎画廊举行个展，同年，首次参加台北艺术博览会及高雄艺术博览会。在香港荣宝斋画廊举办以"天地凡间"为题的个展，亦以荣宝斋在第一届的水墨博览会展场进行个展之预展。获国际性的设计月刊 Design Anthology 邀请专访，在第七期以 A Civic Mind 为题介绍。

2016 六十四岁

个人展览在一月，在荣位于中环长江中心三楼的荣宝斋举行。该次个展的成绩很理想。该年底，再参加了第二届的水墨博览会。

首度在佳士得春季拍卖会拍卖。

由中华书局出版我的自传式新书《谁把烂泥扶上壁》，在该年度香港书展推出，并获选得"金阅奖"。

扩充 StudioRay 工作室，迁至恒威商业大厦。

2017 六十五岁

获名山艺术邀请，作为在台湾的代理画廊，并安排在2017年的Art Formosa 及台北艺术博览会展出。

中国文化部支持在香港西九文化区兴建香港故宫博物馆，获委任为该董事局董事。

获美国建筑师学会(香港分会)颁授荣誉会员。

获香港电台挑选为香港回归二十年"香港有你"特别节目的建筑界别代表。

水墨作品《俏江山》在佳士得秋季拍卖会拍卖。

获香港科技大学邀请参加"图绘香港"五人展，并以讲座配合。

2018 六十六岁

获Bosco Hong Gallery 邀请参加三月在东京艺术博览会，包括有李志清、派瑞芬及陈镜田的四人展，展览成绩非常理想。

获香港建筑师学会邀请参加"威尼斯建筑双年展"。作品名称是《鱼蛋》，喻意香港人

的生活模式，凡事讲求密集、便捷、高效益。

获希腊Copelouzos Family Museum 邀请参与名为"Project 33x33"的艺术项目，并永久展藏用帆布绘画的《香江别景》。这是我首次尝试以水墨用于帆布之上。

作品《俏江山系列(四)》在佳士得春季拍卖会高价成交。

七月，名山艺术的台北馆举行"冯永基、李君毅双人展"。

八月，再获 Bosco Hong Gallery 邀请参加在伦敦摩尔画廊(Mall Galleries)的 "All About Ink"三人展。展出作品名为《十八式》，是十八幅以不同手法表现水墨与色块的多元变奏。

同年下旬，展出于香港大学美术博物馆名为"鉴古赏今"的藏品展。展出的作品名为《难忘时分》，以水波荡漾与阳光夕照，反映又一天的时光消逝。

十月，名山艺术邀请参加2018台北艺术博览会。我最后的得奖建筑作品，是一幢位于九龙塘渭州道的独立屋。借用阳光于十二时正的照射，让铁板上的八个字："庭园静好。岁月无惊"投影在清水英泥墙壁，宁谧典雅，被评为该年度最佳住宅项目奖及两岸四地优异奖。

2019 六十七岁

Bosco Hong Gallery 在东京艺术博览会举行冯永基个人展。获Bosco Hong Gallery邀请，在巴黎大皇宫展览馆的巴黎艺术博览会Art Paris 展出，亦是第三度在巴黎举行的冯永基个人展。

十月，在名山画廊及在台北艺术博览会举行个人展。

十一月，香港艺术馆改建后重开的大型展览，获邀请以"与吴冠中对话"展出大型装置艺术。

2020 六十八岁

这年正发生世纪疫症，全球各地的博览会被迫暂停，唯香港在年底仍能举办 Spotlight by Art Basel 及 Fine Art Asia。本人作品获邀请展于该两处展场及售出，并分别为香港画廊协会及香港癌症基金筹款。

2021 六十九岁

四月，《呼吸》在香港苏富比"超限界：现代艺术晚间拍卖"中突破港元百万元，成为香港水墨画家作品的新里程。

五月，作品于3812香港画廊"天地 · 踪"十周年联展展出，亦被介绍于英文南华早报。

以策展人身份在中环艺穗会陈丽玲画廊举办"本来无一墨"全体同学联展。

受邀为香港机场管理局及香港国际机场政府贵宾室设计首套西式官方餐具。

大型作品《千秋》将永久收藏并展出于香港故宫文化博物馆贵宾厅。

十月，作品《生命》（一）将参与在香港苏富比秋季拍卖及展览。

参与台北国际艺术博览会联展。

十一月，本人首个伦敦个展在3812伦敦画廊举行，亦会在伦敦大学亚非学院同步举行

相关活动。

十二月，参与台中艺术博览会联展。

2022 七十岁

四月，香港特别行政区政府采用"呼吸"系列图案为首套贵宾室专用官方瓷器。

五月，由我参与的香港大会堂被选定为香港最年轻的法定古迹。

六月，参与伦敦巨匠臻藏艺博会展览。

七月，于香港书展发布由中华书局出版的《你所不知的香港建筑故事》。

十一月，Home Journal Awards 2022 终身成就奖

2023 七十一岁

二月，于西九文化区展厅举办冯永基回顾展《七拾》。

五月，由广东美术馆主办冯永基艺术展《七拾》。

作品《生命》（十五）（十六）（十七）捐赠给广东美术馆。

六月，参与The Treasure House Fair。

七月，《你所不知的香港建筑故事》获第四届「香港出版双年奖」出版奖。

由广东美术馆与和中华书局联合出版作品集《七拾》。

八月，《你所不知的香港建筑故事》英文版由独角兽出版社于伦敦发行。

1952 Age 0

Born in Hong Kong on the night before Dragon Boat Festival in the Year of Dragon. As my mother recalled, my father passed away due to myocardial infarction, just a few months after my birth. My mother, sister and I had lived in "tong lau" tenement on Hollywood Road since then.

1960 Age 8

Studied at Hong Kong Maryknoll Sister's School. My first drawing was published on school newspaper at the age of 8.

1963 Age 11

Under the guidance of my primary school teacher, I submitted my artworks to Children's corner of South China Morning Post. Readers were sceptical as my works were constantly accepted and selected. The newspaper interviewed me and explained my portfolio and background to the readers, indicating that I won drawing contests in Japan and East Asia and that the submission process was transparent and fair.

1967 Age 15

Started off my high school education at St. Louis School, then later transferred to Wellington College because I was too weak in science subjects. Before leaving St. Louis, I was apprenticed to Mr. Ip Chit-hoo who taught in arts. As a result, I learned about traditional ink wash techniques for five years and because of Ip, I joined Hong Kong Society for Chinese Art at the age of 17.

1970 Age 18

Attended School of Communication, Hong Kong Baptist College, where I took oil painting class by Mr. Chan Hok-she.

1971 Age 19

Came across Lingnan painting class on the newspaper. The teacher was a young man, who later became the famous He Baili.

1972 Age 20

Studied abroad in the USA, shifting from journalism and sociology to majoring in architecture with a minor in art. I received four years of overseas scholarship and was awarded Reynolds Aluminium Prize for Architectural Students.

1978 Age 26

Received my Bachelor in Architecture from Louisiana State University and joined Tao Ho Design Architects upon returning back to Hong Kong after graduation. The projects in which I participated included a design contest for Hong Kong Sports Institute, the enhancement of the Sai Kung Waterfront Park, etc.

1979 Age 27

Joined the design architect team of Edward Ho Sing-tin and Jim Tong at Wong Tung Group. Projects included Discovery Bay Phase 1, Discovery Bay Golf Club (the project was awarded Silver Medal issued by Hong Kong Institute of Architects (HKIA), Hong Kong Parkview, and private property on 37 Deep Water Bay Road. I also participated in design

contests for Hong Kong Academy for Performing Arts, commercial business districts in Hong Kong Central and Macau, etc. Married to Ms. Salome Yip Yuenling, a nurse from the nursing department of Kwong Wah Hospital. During those years, both of us were busy with our schedules, hoping to save a down payment on a flat.

1979 / 1982 Age 27 / 30
Participated twice in Hong Kong Youth Cultural & Arts Competitions and won the first runner up from the Chinese painting group and became friends with Hung Hoi. He introduced me to further refine my Lingnan style of Chinese brush painting with Mr. Yang Shan-shen.

1984 Age 32
Became a licenced architect and enrolled to Diploma Programme in Chinese Ink Painting at School of Continuing and Professional Studies, The Chinese University of Hong Kong. The curriculum was comprehensive in terms of content and resources, under the master teaching of Liew Cometong, He Cai-an, Chen Ruo-hai, Oscar Ho Hing-kay, Kam Ka-lun. In the following year, I enrolled to Contemporary Ink Painting course at HKU School of Professional and Continuing Education taught by Mr. Chui Tze-hung. This became a cornerstone in my exploration of contemporary ink painting. "Never forget why you started"—after becoming professionally qualified, I quit from working long hours in private company and joined the Building Development Department of former Hong Kong Government.

1985 Age 33
Applied to attend the first Fringe Festival in Hong Kong and held my first solo exhibition "Emergence" on the pedestrian footbridge at The Landmark. They were liked by many and most of them were sold out. An architect friend of mine opened Le Cadre Gallery in Causeway Bay and suggested that I should showcase my work there. I kept this low-key, and as a result, not many people knew I already had my second solo. My work at Building Development Department only lasted for one year and three months, during which I received my first design award from the government for my design of Chai Wan Indoor Games Hall. Shortly after I was invited by my ex-colleague Nelson Chow and joined Chows Architects Ltd as Design Director.

1986 Age 34
I started my collaboration with Alisan Fine Arts, thanks to Chui's recommendation to the gallery. The gallery was co-founded by Alice King and Sandra Walters, giving rise to the name "Alisan". The gallery was located at former Holland House and later moved to Prince's Building. Represented artists included myself, Lui Shou-kwan, Wucius Wong, Chui Tzehung, Leung Kui-ting, Hung Hoi, Kwok Hon-sum, etc.

In those years, Chui planned and organised exhibitions at libraries in the USA, including my third solo exhibition. The USA government played a vital role in Hong Kong's art and culture. However not long after Hong Kong's return to China, such service was ceased. That year, under the influence of Chui, the art society of "Ink Momentum" was founded, aiming to promote contemporary ink paintings to the general public and support charity and great cause, raising money for Hong Kong Down Syndrome Association, Children's Cancer Foundation, Hong Kong Kidney Patients Trust Fund, etc.

1987 Age 35
My first artwork collected by Hong Kong Museum of Art (HKMoA) was "Revelation of Freedom", endorsed by advisor Luis Chan, arranged by Mr. Huang Yi who once worked as the Assistant Curator of HKMoA. After arranging the art collection procedure, he told me he would soon leave his position to get away to Lantau Island, for writing his wuxia novels. When I first heard I admired him for his otherworldly behaviour of withdrawing from the loud society at such a young age, then later I was left in awe that his novels were among the bestsellers. It's sad that I only met him once in 1987. He passed away at the age of 65.

1988 Age 36
Over the three and a half years at Chows on a management level, my first Mainland project was on Qihua Tower on Huaihai Zhong Road in Shanghai, and my second was on Holiday Inn in Xi'an. Hong Kong projects included designing for Home Ownership Scheme.

I thought I could take part in public architecture design work by serving the government department. So, on the first of December, I became a government architect again.

Perhaps it was forgotten by many that my first commercial art show at Alisan Fine Arts was a co-exhibition with Kwok Hon-sum. Due to my role as a civil servant, no contracts were signed between me and any galleries and I could freely exhibit my artworks anywhere. Other galleries included Galerie du Monde and Touchstone Gallery. Upon the invitation from Plum Blossoms Gallery, we collaborated until 2014 during which my work was showcased at Art Hong Kong and Fine Art Asia. Since the retirement of Stephen McGuinness, Plum Blossoms Gallery gradually left the art scene.

In December that year, Mr. Van Lau led a number of Hong Kong artists to hold an exhibition at National Art Museum of China for the first time. The line-up included some of most influential artists in Hong Kong and the event was highly anticipated. Throughout the journey, I finally got to meet many artists in person and was able to exchange ideas with well-known artists from the Mainland. All these sparked my determination to further my education at the Central Academy of Fine Arts (CAFA) in Beijing.

1989 Age 37
This year began my international art exhibition. Apart from being selected into National Art Exhibition, my artworks were also showcased at Harvard University. "Contemporary Chinese Painting 1984 – 89" was organised by Mrs. Helaine Ohayon from Mandarin Studio. She selected artworks from young and emerging Chinese painters and displayed them at Adams House, with the help from Mr. Wu Hung from Harvard University Arts Department. I was the only participator who attended the opening. Before that, I held a preview of the featuring artworks at Mrs. Amy Schwartz's house in New York, giving me a valuable experience exhibiting in the West.

1990 Age 38
During the trip I had a great time talking with Hon Bing-wah. He proposed to nominate me for the Ten Outstanding Young Persons Selection. With beginner's luck I was fortunate to be awarded right away in 1990, alongside renowned artists including Willy Tsao Sing-yuen, Flora Zeta

Cheong-leen, Yip Wing-sze.

In the same year, my larger work "Revelation of Freedom" entered a contest held by Philippe Charriol Foundation. Dr. Chow Yei-ching OBE bid HK$51,000 on my painting at the auction, marking my most expensive work ever sold at that time.

1991 Age 39

Perhaps my capability of accomplishing challenging tasks gained recognition from Director of Architectural Services, Mr. Corsa, he recommended me to work in the USA I chose to be in Hugh Stubbins Architects in Boston and Pei Cobb Freed and Partners in New York, respectively. I got to see how dedicated and determined the legendary Ieoh Ming Pei was. I was touched and inspired by his endurance in the pursuit of architectural designs.

1992 Age 40

Hong Kong Arts Centre designed by one of my truly admirable master Tao Ho was an award-winning local architecture. It was the finest and most perfect exhibition venue, so in 1992, I held my fourth solo exhibition there.

One of my series "Everlasting No.1" was collected and displayed at HSBC building, and was chosen to be the Christmas card of the bank. Later in the year, Jardine Matheson collected a pair of paintings on Hong Kong landscape and displayed in the lobby of the headquarter building.

1993 Age 41

With Hong Kong City Hall's 30th Anniversary, Urban Council planned to renovate the classic building. I was assigned to this project and my excitement was beyond words. I was responsible for renovating City Hall Low Block and Memorial Garden, focusing more on the later, with modern elements that reflected social change and transformation of the city while retaining the original architectural style.

1996 Age 44

Invited by HKMoA, I exhibited my artworks for three months as part of the Hong Kong Artists Series, reaching a new milestone in my career.

1997 Age 45

Recommended by HKMoA, I travelled to Vermont Studio in the USA for exchange and met Shi Yong from Shanghai. In November, I held my first overseas solo exhibition at Caelum Gallery in New York. I followed HKMoA to the National Art Museum of China and attended "Hong Kong Art 1997".

1998 Age 46

Registered to a summer programme at China Academy of Art near West Lake in Hangzhou. Back then the historical building was full of stories and cultural elements. Compared to the modernised building now, the essence of that original environment made me emotional.

Professor Ren Dao-bin was the course director. He was gentle and kind, full of wit and humour. We soon became friends. I would listen to his talks when he spoke at museum and universities in Hong Kong. In the same year, Professor Ren suggested. In the same year, Professor Ren suggested I join the first West Lake Art Fair, which is also my first time joining an art fair.

1999 Age 47

Invited by HKMoA to design a Museum of Contemporary Art within Kowloon Park. Building a gallery is a dream of an architect. The project was fully consulted, and widely reported by media. Unfortunately, the idea did not come to life due to the cease of the project.

2000 Age 48

The Rotunda at Exchange Square was an exhibition venue where I highly anticipated to display my work. With the support from Art Advisor of Hong Kong Land Nigel Cameron, I held my eighth solo exhibition there, with works collected by many. Among the collectors, Mr. David Pong Chun-yee selected "Cry of Nature No.2" and donated to Asian Art Museum of San Francisco as their permanent collection.

In the same year, the Health Education Exhibition and Resource Centre that I designed was awarded President's Prize by HKIA, a key turning point and a huge accomplishment in my career.

From that year onwards, MTR Corporation Limited had printed copies of artworks by Hong Kong artists placed in lobbies of various locations. The first production included "Hong Kong Mountain Series—Pat Sin Range" in Tai Koo station.

2001 Age 49

Invited by Mr. Fang Zeng-xian, Director of Shanghai Art Museum (later renamed The China Art Museum), to be the overseas juror for the design of a new museum, which would be moved to the former Shanghai Race Club building. After rounds of adjudication, we decided to implement Western architectural style from the '20s, keeping abreast of the structure of Shanghai Race Club building. During that period, the team from the Museum went to Shenzhen back and forth a number of times, in order to minimise my travel, respecting me as their honorary advisor. We were highly respected by the Chinese officials, and perhaps for this reason, I later became the first person from Hong Kong who had a solo show at The Shanghai Art Museum.

This year, I was awarded President's Prize by HKIA, for the second time, for my work of Hong Kong Wetland Park 1, supported by the team: architecture by Michael Li Kiu-yin and exhibition by Kevin Li Pui-K. The entire project was executed within nine months, from concept to completion, reflecting an outstanding team spirit and collaboration among us.

Renovated the interior of Architectural Services Department. Because of the cutting-edge design different from conventional structure, many fellow members from the department had their own critics and comments. Luckily with the support from Director, Mr. Pau Shiu-hung,

the design was awarded Green Office Awards of the year.

2002 Age 50

It was always my goal and desire to have my own Designer House. That year, I purchased a house in Pak Sha Wan and renovated it, named it as "Archivilla". "Archi" represented the students of the legendary master carpenter Lu-Ban, while "villa" in Chinese indicated the alley (longtang in Shanghai) or sometimes known as the lane house (lilong), and had an alternative Chinese meaning of making fun. It was awarded a Bronze by Hong Kong Designers Association (HKDA).

2003 Age 51

Mr. Van Lau introduced me to further my studies at Central Academy of Fine Arts (CAFA), and I was temporarily taught under Mr. Jia You-fu. Later I returned to the Academy to donate scholarships. Because of Mr. Van, I met masters including Fan Di'an, Jin Shang-yi, Pan Gong-kai, Zhang Bao-wei, Sui Jian-guo, Lu Pin-jing. In the same year, the Academy introduced environmental studies—course director, Professor Zhang Bao-wei invited me to be their visiting professor.

2004 Age 52

Sai Kung Promenade and Visual Corridor was awarded President's Prize, my third time receiving this award. The project was initiated by Mr. Antony Leung Kam-chung, Financial Secretary at that time. Due to the large impact of SARS on the economy of Hong Kong, Leung supported local tourism to promote economic growth in the city. Our team of three including King Kwok-cheung, Ida Sze and me, proposed a series of paper boat sculptures while it soon became a landmark spot in Sai Kung town. The public named it as Paper Boat Park. In 2016, Hong Kong Post issued a set of special stamps on "Public Architecture in Hong Kong", the park was one of the six unique designs showcased.

2006 Age 54

Hong Kong Wetland Park II marked my fourth time winning HKIA Annual Awards. It was the Building of the Year, and received over fifteen overseas awards including Global Award and Asia Award by Urban Land Institute. The Wetland Park was also showcased on "Public Architecture in Hong Kong" Special Stamps Issue in 2016.

2007 Age 55

I was awarded HKIA Annual Awards for the fifth time for the design of Tsim Sha Tsui Promenade. Our team included King Kwok-cheung and Chow On-yuen and this project also marked my last award and recognition in public architecture accomplishment. I decided to quit from the practising architecture while dedicating myself wholeheartedly to ink painting.

At the same time, Essy Baniassad from School of Architecture, Chinese University of Hong Kong, invited me to teach a class on Experiencing Architecture. For ten years, I was promoted from Assistant Professor, Associate Professor, to Professor.

2008 Age 56

On February 14, Valentine's Day, I left my department with the sweetest goodbye. I no longer worked in the field of public architecture. In the same year, I received Commendation Award from Home Affairs Bureau.

2009 Age 57

"The Flower Box" was my personal architectural work, and received a Silver Award from HKDA. In the same year, I was nominated and selected as one of the Ten Outstanding Designers.

On one evening, I received a call from the Administration Wing, and was invited to join Administration's Office as Design Advisor, monitoring design and construction work at the Central Government Offices. As a result, I worked collaboratively for three and a half years with Henry Tang Ying-yen, Chief Secretary for Administration's Office at that time.

2010 Age 58

Invited by University Museum and Art Gallery (UMAG) of The University of Hong Kong, I held my solo exhibition, "Hong Kong Lyric". At the same time, the Museum published "The Art of Raymond Fung". The main artwork, twelve strolls of "Once Upon a Time", was displayed at the Museum, with a replica being displayed at the conference room of Central Government Offices.

I then exhibited my artworks at Galerie Yvan Roubin and Sinitude Gallery respectively in Paris.

Invited by Mr. Henry Tang Ying-yen as the Director of the Board of the West Kowloon Cultural District Authority until 2014, and as the Committee Member of the Development Council since then.

2011 Age 59

"The Art of Raymond Fung" exhibition was held at Sinitude Gallery in Beijing, featuring both ink paintings and architecture work. In the same year, I was appointed the Justice of the Peace.

Invited by National Art Museum of China (NAMOC) to exhibit, memorising the 100th Anniversary of 1911 Revolution. "china in China" is now part of NAMOC collection.

Interview feature of Fung Wing-kee by the art curator Hans Ulrich Obrist was published on October issue of *The International Art Magazine of Contemporary China*.

2012 Age 60

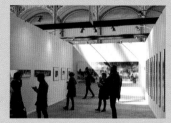

In oriental tradition, sixty was a meaningful number. It became the theme of a series of paintings I made for myself, depicting the landscape of Sai Kung and reflecting the changes and transformation of Hong Kong over the past sixty years, as well as personal life experiences in the past six decades. The artworks are now at HKMoA.

Established and donated to "Professor Raymond Fung Chinese Scholarship" at The Chinese University of Hong Kong, Hong Kong Baptist University, and University of Hong Kong.

That year, "china in China" solo exhibition was held in three cities, including Plum Blossoms Gallery in Hong Kong, Gallery 456 in New

York, and Cloitre Saint Louis in Avignon, France, respectively, until 2015.

2014 Age 62
Co-organised "My 10 Most 'Liked' Hong Kong Architecture of the Century" with Corrin Chan as the Chairman of Hong Kong Archi tecture Cent re (HKAC). The programme received Ar t Promotion Award from Hong Kong Arts Development Council in the following year.

Opened a new studio "StudioRay" and held private classes, located at Tesbury Centre. Admission Fees were all donated to "Professor Raymond Fung Scholarship".

2015 Age 63
"china in China" solo exhibition was held again at Lee Gallery in Taiwan. In the same year, I attended Art Taipei and Art Kaohsiung for the first time. Held "Between Heaven & Earth" solo exhibition at Rong Bao Zhai, and a preview at the first Ink Asia at fair.

Interview feature was published on the seventh issue of *Design Anthology*, under the theme of "A Civic Mind".

2016 Age 64
Solo exhibition was held in January, at Rong Bao Zhai on the third floor of Cheung Kong Center in Central. I was pleased with the outcome of the exhibition. My work was showcased in their second Ink Asia at the end of that year.

My work was on auction for the first time at Christie's Spring Auction and Ravenel Auction.

Chung Hwa Book Company (Hong Kong) Limited published my autobiography book, "The Story of Raymond Fung", and the book was awarded Hong Kong Golden Book Awards.

I expanded my studio and moved it to Hang Wai Commercial Building.

2017 Age 65
Represented by Mingshan Art, who arranged to exhibit my work at Art Formosa and Art Taipei.

Ministry of Culture of the People's Republic of China supported the West Kowloon Cultural District Authority on the development of Hong Kong Palace Museum and I was appointed as the Board Member.

Became the Honorary Member of American Institute of Architects (Hong Kong Chapter).

Selected as the architectural representative by RTHK for their programme "Transformers 2017" celebrating Hong Kong twentieth Anniversary of its return to China.

Ink painting "Beauty of Lands" was on auction at Christie's Autumn Auction.

Invited to participate in Picturing Hong Kong by the HKUST Lee Shau Kee Library and Division of Humanities, conducting talks and demonstrations.

2018 Age 66
Invited by Bosco Hong Gallery to participate in Tokyo Forum at Art Fair Tokyo 2018, together with Lee Chi-ching, Nina Pryde and Chan Keng-tin. The outcome of the exhibition was satisfying.

Invited by HKIA to participated in La Biennale di Venezia. The exhibited work was called "Fish Ball", reflecting the fastpaced lifestyle of Hong Kong and the local nature that strived for mass production, convenience and efficiency.

Invited to participate in the "35x35 Art Project" by the Copelouzos Family Museum based in Athens, and painted "The countryside of Hong Kong" on canvas. This was the first time I ink-painted on canvas.

My work "Beauty of Lands" was auctioned at a high price at Christie's Spring Auction.

In July, we held "Group Exhibition—Raymond Fung; Lee Chun-Yi" at Mingshan Art in Taipei.

In August, I was invited by Bosco Hong Gallery again to participate in "All About Ink" group exhibition. "18 shades in ink" was displayed, featuring eighteen different styles and compositions of ink painting.

Later in the year, I participated in Chinese painting exhibition "Tradition to Contemporary: Ink Painting and Artistic Development in 20th-century China" presented by UMAG. "The Unforgettable Moments" was displayed, featuring the glistening waters at sunset golden hour that end the day beautifully.

In October, I participated in Art Taipei, invited by Mingshan Art.

My last architecture prize was won for the design of a private house on Wiltshire Road in Kowloon Tong. Sunlight at noon penetrates through an iron plate, reflecting the saying of "time does not matter, all is divinely calm" onto the concrete wall. The home design received "Best of Residential" of the year, plus a Merit Certicate at the CADSA 2019.

2019 Age 67
Bosco Hong Gallery organised and held Fung Wing-kee solo exhibition at Art Fair Tokyo.

Invited by Bosco Hong Gallery, artworks were showcased at Grand Palais in Paris, my third time holding solo exhibition in Paris.
In October, a solo exhibition was held at Mingshan Art and Art Taipei, respectively.

In November, I was invited to participate in an exhibition organised by HKMoA after its renovation—"Dialog with Wu Guanzhong".

2020 Age 68
Exhibitions across the world were forced to a pause due to the global pandemic, except for Spotlight by Art Basel and Fine Art Asia in Hong Kong at year end. I was invited as a participating artist and the proceeds of the exhibitions went into the Hong Kong Art Gallery Association and Hong Kong Cancer Fund.

2021 Age 69

A milestone in establishing Hong Kong ink art, *Breathing* hit over a million sales at Sotheby's Hong Kong "Beyond Legends: Modern Art Evening Sale" in April.

Participated in the group exhibition held in the new art space of 3812 Gallery Hong Kong in May. My works were featured in the South China Morning Post.

In May, I curated the INKFINITY group show for my classmates at the Fringe Gallery.

I was invited to design the first set of western-style official tableware for the Hong Kong Airport Authority and HKSARG VIP Suites.

My large work "Dynasties" will be on permanent display at the Hong Kong Palace Museum VIP Suite.

In October, my work, *Life*, was offered at Sotheby's Hong Kong Modern Art Autumn Sales.

Participated in Art Taipei 2021 in October.

Invited by 3812 Gallery to curate my first solo exhibition in London and participate in related academic events hosted by SOAS in November.

Participated in Art Taichung 2021 in December.

2022 Age 70

In April, HKSARG has adopted the "Breathing Series" as the pattern for its first set of official tableware.

In May, the Hong Kong City Hall has been declared the youngest historical monument, of which I was involved in its major renovation.

In June, my works were selected at the Masterpiece London 2022.

In July, my new book *Untold Stories—Hong Kong Architecture* published by the Chung Hwa Book Company (Hong Kong) Limited was launched at the Hong Kong Book Fair.

In November, I was rewarded with the Home Journal Awards 2022 Lifetime Achievement.

2023 Age 71

In February, my Retrospect Exhibition titled "QĪ SHÍ" was held at the Pavilion West Kowloon Cultural District.

In May, the Guangdong Museum of Art hosted my solo exhibition titled "QĪ SHÍ".

Donated Life (15)(16)(17) to Guangdong Museum of Art.

In June, my works were selected for the Treasure House Fair.

In July, received Publication Award from "The 4th Hong Kong Publication Biennale".

My book "Qī Shí" was jointly published by Guangdong Museum of Art and Chung Hwa Book Company (Hong Kong) Limited.

In August, the English version my architecture book *Untold Stories—Hong Kong Architecture* published by Unicorn Publishing Group will be launched in London.

广东美术馆馆庆系列丛书

《人文广东——馆藏20世纪以来广东美术作品选集》

《追补的历史——馆藏中国当代艺术作品选集》

《自觉与自主——广东美术馆展览策划和学术理念》

《拓荒与前行——广东美术馆筹建和开馆十年历程》

《风 · 雅 · 颂——广东美术馆开馆十五周年馆藏精品展》

《追远历新——广东美术馆建馆二十周年作品展》

《视觉与观念——广东美术馆展览策划和学术理念（2008—2017）》

《继往与开来——广东美术馆历程（2008—2017）》

20世纪中国美术状态丛书

《现实关怀与语言变革》

《主流的召唤》

《创作的意义》

《进入都市》

《南方语境》

《古道西风 · 高剑父 、 刘奎龄 、 陶冷月》

《中国 · 水墨实验二十年》

《毛泽东时代美术（1942—1976）文献展》

《抗战中的文化责任——"西北艺术文化考察团"六十周年纪念展》

《人与人 · 20 世纪中国美术的人文性》

《历程 · 广东新中国一代美术家》

《新兴版画与广东木刻——广东美术馆藏版画作品陈列展（1930—1949）》

《碰撞与交融——中国二十世纪早期留洋艺术家作品集》

《丹青京华——20世纪的北京中国画坛》

《艺圃开荒——从赤社到广州市立美术学校》

《时代风华——二十世纪中国美术名家精品展》

《图绘新中国 ： 广东国画的改造与转型》

《一九四九年的廖冰兄 — 历史转型期的廖冰兄漫画作品文献集》

21世纪中国美术状态丛书

《艺术中的个人与社会——中国十一位青年艺术家作品集》

《南方的阳光》

《虚拟未来——中国当代艺术展》

《现象 ： "后岭南"与广东新水墨》

《守望与前瞻 · 当代中国书法十二人展》

《墙里墙外 · 当代中国书法十人展》

《距离 · 广东美术馆当代艺术邀请展》

《开放的姿态 · 首届广东新青年艺术大展》

《点 · 辐射与深入——来自纸墨的视觉表达》

《墨和纸 · 中国当代艺术展作品集》

《里里外外——中国当代艺术》（中文版 、 英文版 、 法文版）

《与摩尔对话 · 中国当代雕塑展》

《第二届当代水墨空间 ： 渗——移景和幻想》

《关系 ： 与十二位艺术家的书信集》

《非形之形 · 台湾抽象艺术》

《机构生产——广州青年当代艺术生态考察》

《时空中的一个点——广东美术馆馆藏当代艺术作品展》

《甲午 · 甲午 ： 百年强国梦——广东美术馆馆藏作品展》

《黑白的现代性》

《人民的体育——广东美术馆藏品专题集》

《图像就是精神——改革开放30年广东美术馆藏作品专题集》

《"后岭南"与珠三角》

《变相 ： 水墨的维度——第三届当代水墨空间》

《后笔墨时代 ： 中国式风景》

《万川曾映月 ： 四人风景研究展》

《边界的自觉》

《青年力量 1》

《夜游珠江》

《在思想中——中国当代艺术的思想史与方法论》

《绘画 ： 宏》

《水墨进行时》

《思想与践行》

1985年以来现象与状态系列展丛书

《从"极地"到"铁西区"——东北当代艺术展 1985 — 2006》

《从西南出发 · 西南当代艺术展 1985 — 2007》

《从西南出发 · 西南当代艺术批评文集 1985 — 2007》

《两湖潮流 · 湖北湖南当代艺术展 1985 — 2009》

大展丛书

《重新解读·中国实验艺术十年（1990—2000）》（中文版、英文版）

《别样 ： 一个特殊的现代化实验空间》

《别样 ： 一个特殊的现代化实验空间/三角洲实验室1D- Lab I》

《别样 ： 一个特殊的现代化实验空间/三角洲实验室1D- Lab II》

《与后殖民说再见——第三届广州三年展》

《第三届广州三年展读本 1 》

《第三届广州三年展读本 2 》

《元问题 回到美术馆自身——第四届广州三年展启动展》
《见所未见——第四届广州三年展主题展》
《亚洲时间——首届亚洲双年展暨第五届广州三年展》
《诚如所思：加速的未来——第六届广州三年展》
《立场——第六届广州三年展文献展》

现代影像丛书

《中国人本 · 纪实在当代》(中文版 、 法文版 、 德文版)
《城市 · 重——2007 广州国际摄影双年展》
《看真D.com第三届广州国际摄影双年展2009》
《沙飞摄影全集》
《首届 "沙飞摄影奖" 获奖者作品集》
《第二届 "沙飞摄影奖" 获奖者作品集》
《异向 · 魔幻的面孔——佩德罗·梅约尔的摄影世界》
《庄学本全集》
《许培武 · 南沙最后一只蜥蜴》
《阮义忠 · 转捩点 : 一个时代 、 一本杂志 、 一个人》
《残影寓言 · 马乔摄影》
《觅金山鸿——郑森池摄影》
《复相 · 叠影——广州影像三年展2017》
《映像293'——广东美术馆藏影像作品回顾展（2000 — 2010)》

现当代艺术家丛书

《潘鹤·走进时代的艺术》
《符罗飞 · 关于人民的素描》
《王兰若 · 清逸的粤东情怀》
《邵增虎 · 镌刻金秋的油画》
《鸥洋 · 东方意象》
《陈永锵 · 熏风1998》
《罗宗海 · 感受乡土》
《许钦松版画集》
《关山月新作选集》
《黄少强 · 走向民间》
《黄志坚 · 龙虬风骨》
《郭绍纲 · 平和中的隐秀》
《廖冰兄 · 香港时期的漫画》
《杨之光 · 生活与创作》
《陈卓坤 · 苍凉的天真》
《徐坚白 · 礼赞生命》

《谭雪生 · 感怀大自然》
《项而躬 · 磨难与风采》
《王琦 · 感受时代》
《苏天赐 · 信步与回眸》
《王肇民作品集》
《世纪经典 · 潘天寿》
《大道之道——赖少其作品集》
《林墉 · 霸悍的恣丽》
《唐大禧 · 激情与经典》
《苏晖 · 少先队员之歌》
《土地与人民 · 力群版画艺术七十年》
《梁明诚 · 信马人生》
《吴海鹰 · 大度的朴实》
《李醒韬 · 历史穿越》
《丹青发嗟愤——黄少强作品集》
《雕刻时光——罗映球的版画艺术》
《天地悠然 · 王璜生的水墨天地》
《丹青回眸 : 刘济荣从艺60周年》
《李绪洪 · 情感的唤回》
《从容中道——梅墨生画诗书》
《吴静山——默如雷》
《田园诗情——可谷画集》
《郭莽园 · 狂狷与性灵》
《魂系黄花 · 纪念潘达微诞辰120周年》
《雷坦水彩水粉画作品集》
《王公懿版画作品1997——2002》
《于无画处笔生花——石鲁的时代与艺术》
《罗尔纯 · 大彩至朴》
《印记时代——杨先让版画彩绘作品》
《丹青不老——饶宗颐艺术特展》
《梁世雄绘画六十年》
《漆彩人生——乔十光漆画艺术回顾展》
《一天一叶 · 蒋悦水墨新作》
《铁马野风 : 野夫的木刻艺术》
《水墨界限——黄光男现代水墨画展》
《花逢时雨俏 : 阮云光的艺术历程》
《山川无尽——罗一平水墨山水画》
《我爱阳光与花朵——郑爽作品集》

《存真绘心——王玉珏作品集》
《脚印 : 钱海源艺术人生》
《林墉 · 似山还似非山》
《大地行踪——郝鹤君山水画集》
《穿行——吴武彬作品集》
《汤小铭 · 铭刻时代》
《尘土 — 邵增虎风景油画作品集》
《伟大的风格——王肇民艺术研究》
《自然与田园 : 林丰俗的绘画世界》
《春山沐金田——黄文波作品集》
《丁立人 <西游记> 百图》
《墨履新游踪——张彦水墨写生暨捐赠作品集》

20世纪早期中国油画家丛书

《冯钢百 · 中国早期油画大家》
《谭华牧 · 失踪者的踪迹》
《梁锡鸿 · 遗失的路程》
《赵兽 · 神秘的狂气》

民间美术丛书

《广东民间美术生态考察 · 粤东篇》

当代艺术个案丛书

《刘小东 · 写生》
《宋永红 · 欲望广场》
《时间内外 : 喻红》
《吴山专（但仍然是红的）国际红色幽默》
《方力钧 : 时间线索》
《表现与抽象 : 王琰油画作品》
《静 · 夜 · 思——白明物语》
《水墨终结者的历程——张羽访谈录》
《何多苓 · 士者如斯》
《严培明画集》
《张小涛 · 流行病毒学》
《尹朝阳 · 正面》
《非修正 — 李松松作品》
《仿宋体——沈勤作品》
《本之末——杭春晖的艺术实践》
《彭薇 · 女性空间》
《变像——薛松作品集》

《冯永基——七拾》

现当代美术文献丛书

《潘鹤少年日记》

《潘鹤青少年日记》

《黄志坚诗文选集》

《符罗飞研究资料汇编》

《黄少强诗文资料选编》

《石鲁与那个时代——2007学术研讨会文集》

《历史的脚印——中国名家书信》

《观念与艺术——邹跃进文集》

《关系：与十二位艺术家的书信集》

博物馆精品丛书

《广东美术馆藏品图录（1996.12 — 2002.7）》

《广东美术馆藏品图录（2002.8 — 2004.12）》

《广东美术馆藏品图录（2005.1 — 2007.12）》

《广东美术馆藏品图录·摄影Ⅰ中国人本》

《广东美术馆藏品图录·摄影Ⅱ时代影像·朱宪民（1966 — 1976）摄影集》

《广东美术馆藏品图录·版画Ⅰ张信让藏书票》

《浙江省博物馆藏书画精品选》

《辽宁省博物馆藏齐白石、黄宾虹、徐悲鸿精品选》

《中国美术馆藏路德维希夫妇捐赠国际艺术品集》

博物馆学丛书

《文物保护与修复纪实》

《无墙的美术馆》

《生产》丛刊

《美术馆》丛刊

《广东美术馆年鉴》丛书

现代陶艺丛书

《感受泥性》

《超越泥性》

《演绎泥性》

《单纯空间》

《延伸与突破》

《新陶说》

新状态丛书

《新状态第一回·薛继业油画》

《新状态第二回·唐颂武、魏华雕塑》

《新状态第三回·江衡、孙晓枫油画艺术》

《新状态第四回·亢奋期》

《新状态第五回·杨培江作品展》

《新状态第六回·刘源油画》

《新状态第七回·林蓝、彭薇作品》

《新状态第八回·常晓冰版画》

《新状态第九回·彩色家园——肖庆书作品》

《新状态第十回·记忆的温度——秦晋作品展》

《新状态第十一回·守望者——罗灵油画作品展》

《新状态第十二回·一版一眼——广东青年版画展》

七号空间丛书

《七号空间第一回·夜奔——林于思作品展》

《七号空间第二回·天高云淡——杜小同作品展》

《七号空间第三回·我的困惑隐没在细枝之间——林芮襄作品展》

《七号空间第四回·人与大地——李宁当代水墨叙事展》

《七号空间第五回·出口——苏畅作品展》

《七号空间第六回·四张机——孙策作品展》

《七号空间第七回·移步换景——漆澜作品展》

《七号空间第八回·干涉——黄一山作品展》

《七号空间第九回·映射之地——张文心作品展》

《七号空间第十四回·172克之思——汪凌作品展》

《七号空间第十五回·颜色的尽头——杜松儒作品展》

《七号空间第十七回·必要的冗余——胡庆雁个展》

海外华人美术丛书

《天地本相·美国王己千、马承宽近作展》

《纽约20年·美国钟耕略的绘画艺术》

《时空交织·郭桓作品集》

《从西方抽象主义到东方赵无极》

《陈建中·巴黎三十年》

《黄中羊·生活的和音》

《旅美一代绘画大家——王少陵》

《抽象的意蕴·旅法华人画家吴昊油画展》

《归源之旅——萧勤1954—2004》

国外现代美术丛书

《欧洲新版画》

《慕尼黑当代抽象画展作品集》

《走出传统——瑞士陶艺三人展作品集》

《墨西哥绘画：从壁画三杰到当代》

《意大利二十世纪艺术展》

《意大利托斯卡纳油画 — 光的现代性》

《凝视·墨西哥当代摄影》

《眼睛与思想——印度艺术新的介入》

《绘画在绘画在绘画之后——德国当代艺术形式的创造》

国外艺术家丛书

《罗丹 · 思想者》

《巨匠心影 · 毕加索版画》

《狂想的旅程 · 达利作品集》

《米歇尔 · 马多——隐逸之境》

《洋子——飞》

《肖恩 · 斯库利在广州》

国际艺术交流丛书

《澳大利亚油画三人展》

现代设计艺术丛书

《中国平面设计2001》

《魁北克当代海报艺术》

《靳埭强——生活 · 心源》

现代美术教育丛书

《童心 · 爱心 · 匠心》

《三双眼睛看世界》

《游戏泥土》

《材料的幻想》

《向摩尔致敬》

《大师画我也画》

《我梦达利》

《还孩子一个率真的童年》

《首届广东省少儿美术教师优秀美术作品暨优秀教案展》

《第三届全国少年儿童美术理论研讨会文集》

《我的相机不撒谎》

（此目录为广东美术馆部分出版书目）

七拾
水墨心境 时空赋能
冯永基艺术展

Qī Shí
An Idyllic State of Mind, Coloured by Time and Space
A Raymond Fung Art Exhibition

主办单位 ／ 广东美术馆
支持单位 ／ 香港艺术馆、香港文化博物馆、香港大学美术博物馆
学术主持 ／ 王绍强
策展人 ／ 皮道坚
艺术顾问 ／ 又一山人
展览统筹 ／ 胡锐韬、江飞

Organiser ／ Guangdong Museum of Art
Supporting Units ／ Hong Kong Museum of Art, Hong Kong Heritage Museum, University Museum and Art Gallery of The University of Hong Kong
Academic Host ／ Wang Shaoqiang
Curator ／ Pi Daojian
Artistic Consultant ／ anothermountainman
Exhibition Coordination ／ Hu Ruitao, Jiang Fei

策展团队 ／ 赵婉君、张艺、徐子晴、王斯琪
展览组织 ／ 黄海蓉
展览陈列 ／ 武鹏飞、苏利民、梁卓然、李漾
文献管理 ／ 温翔、梁家健
宣传推广 ／ 涂晓庞、曾睿洁、温嘉宝
藏品管理 ／ 黄亚群、林薇、黄广林、赖伟雄
公共教育 ／ 植凯鹏

Curatorial Team ／ Zhao Wanjun, Zhang Yi, Karen Tsui, Phyllis Wong
Exhibition Organisation ／ Huang Hairong
Exhibition Display ／ Wu Pengfei, Su Limin, Liang Zhuoran, Li Yang
Literature Management ／ Wen Xiang, Liang Jiajian
Promotion ／ Tu Xiaopang, Zeng Ruijie, Wen Jiabao
Collection Management ／ Huang Yaqun, Lin Wei, Huang Guanglin, Lai Weixiong
Public Education ／ Zhi Kaipeng

鸣谢机构 Acknowledgement ／

香港特别行政区康乐及文化事务署香港艺术馆
Hong Kong Museum of Art, Leisure and Cultural Services Department, Hong Kong Special Administrative Region

香港特别行政区康乐及文化事务署香港文化博物馆
Hong Kong Heritage Museum, Leisure and Cultural Services Department, Hong Kong Special Administrative Region

香港大学美术博物馆
University Museum and Art Gallery of The University of Hong Kong

主编 ／ 王绍强

副主编 ／ 胡锐韬、江飞

执行主编 ／ 皮道坚

执行编辑 ／ 赵婉君、张艺

项目组织 ／ 黄海蓉

特邀编辑 ／ 徐子晴、侯颖贤

设计 ／ 又一山人、宋子泓

校对 ／ 赵婉君、黄海蓉、朱颖、徐子晴、侯颖贤、杨安琪

翻译 ／ 侯善恒

出版 ／
广东美术馆

中华书局（香港）有限公司
香港北角英皇道四九九号北角工业大厦一楼B
电话 ／（852）2137 2338
传真 ／（852）2713 8202
电子邮件 ／ info@chunghwabook.com
网址 ／ http://www.chunghwabook.com.hk

发行 ／
香港联合书刊物流有限公司
香港新界荃湾工业中心16楼
电话 ／（852）2150 2100
传真 ／（852）2407 3062
电子邮件：info@suplogistics.com.hk

印刷 ／
美雅印刷制本有限公司
香港观塘荣业街六号海滨工业大厦四楼A室

Editor-in-Chief ／ Wang Shaoqiang

Deputy Editor-in-Chief ／ Hu Ruitao, Jiang Fei

Executive Editor-in-Chief ／ Pi Daojian

Executive Editor ／ Zhao Wanjun, Zhang Yi

Project Organizer ／ Huang Hairong

Guest Editor ／ Karen Tsui, Helena Hau

Design ／ anothermountainman, Zen Subido

Proofreading ／ Zhao Wanjun, Huang Hairong, Zhu Ying, Karen Tsui, Helena Hau, Angel Yang

Translation ／ Christopher Hau

Publishing ／
Guangdong Museum of Art

Chung Hwa Book Company（Hong Kong）Limited
1B, North Point Industrial Building,499 King's Road, North Point
Tel ／（852）2137 2338
Fax ／（852）2713 8202
Email ／ info@chunghwabook.com
Website ／ http://www.chunghwabook.com.hk

Publishing distribution ／
SUP Publishing Logistics（HK）Limited
16/F, Tsuen Wan Industrial Centre, New Territories, Hong Kong
Tel ／（852）2150 2100
Fax ／（852）2407 3062
Email ／ info@suplogistics.com.hk

Printer ／
Elegance Printing and Book Binding Co.,Ltd.
6 Wing Yip Street, Kwun Tung, Kowloon, HK

广东美术馆 GUANGDONG MUSEUM OF ART